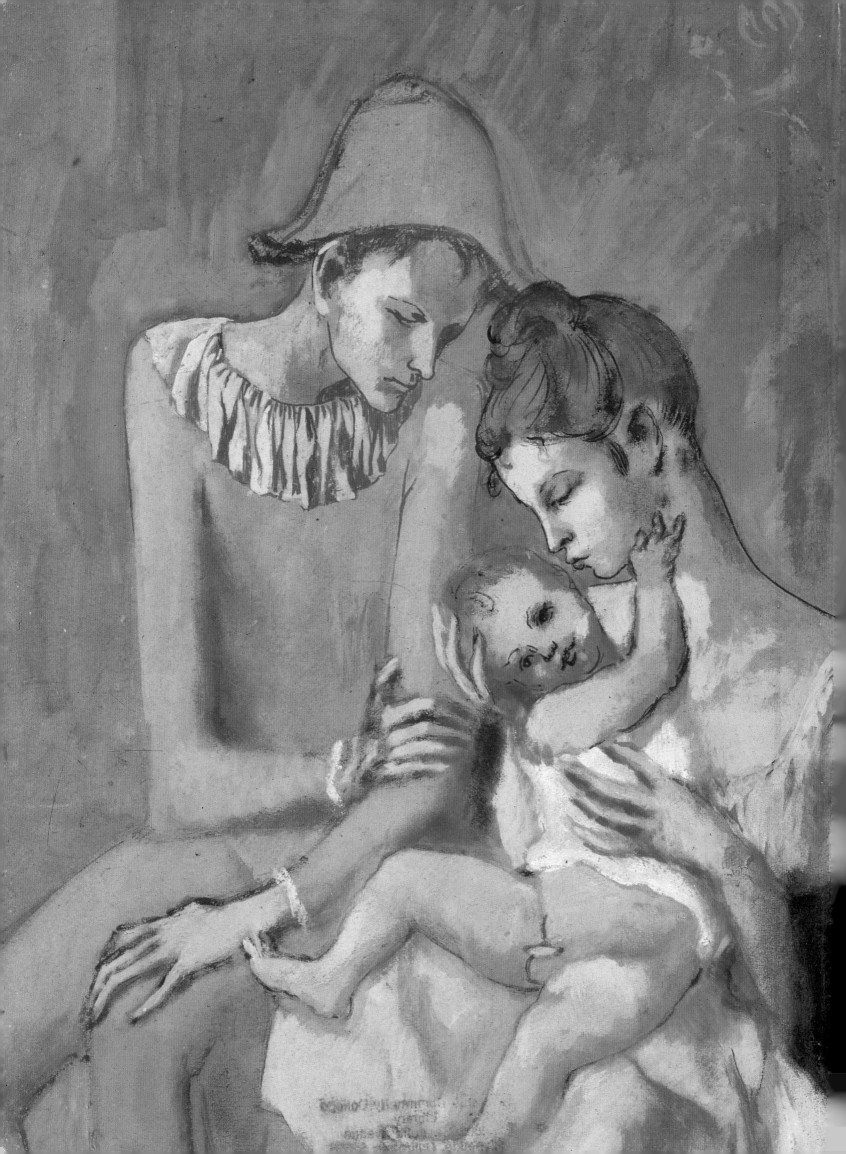

Picasso

The Early Years
1892–1906

Edited by

Marilyn McCully

with contributions from

Natasha Staller

Robert S. Lubar

Phillip Dennis Cate

Robert J. Boardingham

Jeffrey Weiss

Peter Read

Robert Rosenblum

Margaret Werth

Mark Rosenthal

Ann Hoenigswald

National Gallery of Art, Washington

Yale University Press, New Haven and London

Bell Atlantic is proud to sponsor this great exhibition in Washington

The exhibition in Boston is made possible through the generous support of NYNEX

The exhibition has been organized by the National Gallery of Art, Washington, and the Museum of Fine Arts, Boston

This exhibition is supported by an indemnity from the Federal Council on the Arts and the Humanities

Exhibition dates
National Gallery of Art, Washington
30 March–27 July 1997

Museum of Fine Arts, Boston
10 September 1997–4 January 1998

This book was produced by the Editors Office, National Gallery of Art
Editor-in-chief, Frances P. Smyth
Editor, Tam Curry Bryfogle
Designer, Chris Vogel

Display type is Gill Sans, text type is Sabon, set by Duke and Company, Devon, Pennsylvania
Printed on Gardamatt Brillante
Printed and bound by Amilcare Pizzi, S.p.A., Milan, Italy
Clothbound version distributed by Yale University Press, New Haven and London

Front cover: *Woman with a Fan* (detail), 1905, National Gallery of Art, Washington, Gift of the W. Averell Harriman Foundation in memory of Marie N. Harriman (cat. 140)

Back cover: *Self-Portrait with Palette* (detail), 1906, Philadelphia Museum of Art, A. E. Gallatin Collection (cat. 182)

Frontispiece: *Harlequin's Family with an Ape* (detail), 1905, Göteborg Museum of Art (cat. 122)

Library of Congress Cataloging-in-Publication Data

Picasso, Pablo, 1881–1973.
 Picasso—the early years, 1892–1906 / edited by Marilyn McCully with contributions from Natasha Staller . . . [et. al].
 p. cm.
Includes bibliographic references and index.
ISBN 0–89468–268–7 (paper : alk. paper). —
ISBN 0–300–06948–0 (cloth : alk. paper)
 1. Picasso, Pablo, 1881–1973—Exhibitions.
I. McCully, Marilyn. II. Staller, Natasha. III. National Gallery of Art (U.S.) IV. Title
N6853.P5A4 1997
759.4—DC21 96–49663
 CIP

Contents

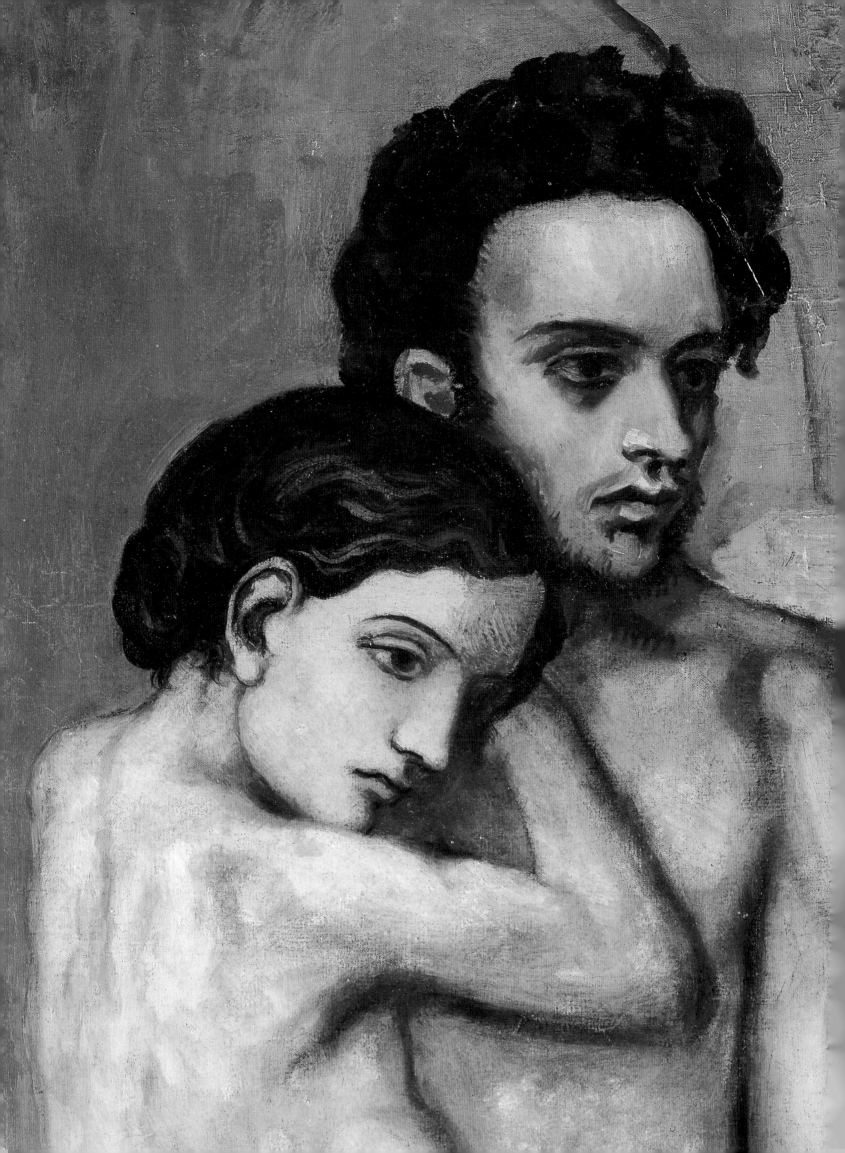

Directors' Foreword

The most celebrated artist of the twentieth century, Pablo Picasso was a prodigy whose virtuosity, inventiveness, and expressive power were evident in his work long before he reached the age of twenty. This exhibition presents and elucidates the artist's earliest work—before the advent of cubism—and shows that Picasso, like many young artists, absorbed diverse artistic influences but made them his own through his extraordinary energy and imagination. Whether in the pathetic, emaciated figures of his Blue period or the more lyrical forms of the harlequins of his Rose period, Picasso consistently revealed himself to be a supremely gifted draftsman and inventor of forms, and an artist capable of deeply compelling images.

The National Gallery of Art, Washington, and the Museum of Fine Arts, Boston, are proud to have collaborated on *Picasso: The Early Years, 1892–1906*. Picasso's work of this fourteen-year period and its meaning and significance are examined and analyzed in the present volume, which provides an occasion to rethink the scholarly and critical issues surrounding Picasso's early work and to bring new art historical approaches to bear on the subject.

We are grateful to the private and public lenders from around the world who have been willing to make their rare and precious works of art available to this show. Paintings on canvas, cardboard, or panel; drawings in pen and ink, charcoal, or pencil; bronze sculpture and one of the artist's earliest ceramics give glimpses into the enormous vitality of Picasso's vision. We single out for special mention the cooperation of the Museu Picasso, Barcelona, and the Musée Picasso, Paris, whose support has been essential to the realization of the exhibition.

The advisory committee for *Picasso: The Early Years* gave substantial direction at a critical time in the development of the exhibition. Jean Sutherland Boggs provided valuable counsel during formative stages, and John Richardson has been a vital supporter and advisor from the outset. The members of our honorary organizing committee are François Bujon de l'Estaing, Ambassador of France to the United States of America; Richard N. Gardner, Ambassador of the United States to Spain; Pamela G. Harriman, Ambassador of the United States to France; and Antonio Oyarzabal, Ambassador of Spain to the United States. We thank them for their willing participation and kind assistance. Mr. Claude Ruiz-Picasso and Ms. Maya Widmaier Picasso have graciously advised us throughout the planning of the exhibition, helping especially to identify works in private collections.

No exhibition is possible without the expertise and commitment of its organizing curators. Mark Rosenthal, former curator of twentieth-century art at the National Gallery of Art; Robert J. Boardingham, assistant curator of European paintings at the Museum of Fine Arts, Boston; and Jeffrey Weiss, associate curator of twentieth-century art, National Gallery of Art, worked diligently and cooperatively to assure the success of this project.

Bell Atlantic is proud to sponsor this great exhibition in Washington, and the exhibition in Boston is made possible through the generous support of NYNEX. The enlightened assistance of the corporate world is an increasingly important factor in the capacity of American museums to present international art exhibitions of the highest caliber, and we are immensely grateful to our corporate sponsors, not only for their financial support but also for their enthusiastic encouragement. The Federal Council on the Arts and the Humanities, through the Art and Artifacts Indemnity Act, provided insurance protection for the loans, without which this exhibition could not have been presented.

Earl A. Powell III
Director
National Gallery of Art
Washington

Malcolm Rogers
Ann and Graham Gund Director
Museum of Fine Arts
Boston

Detail, cat. 93

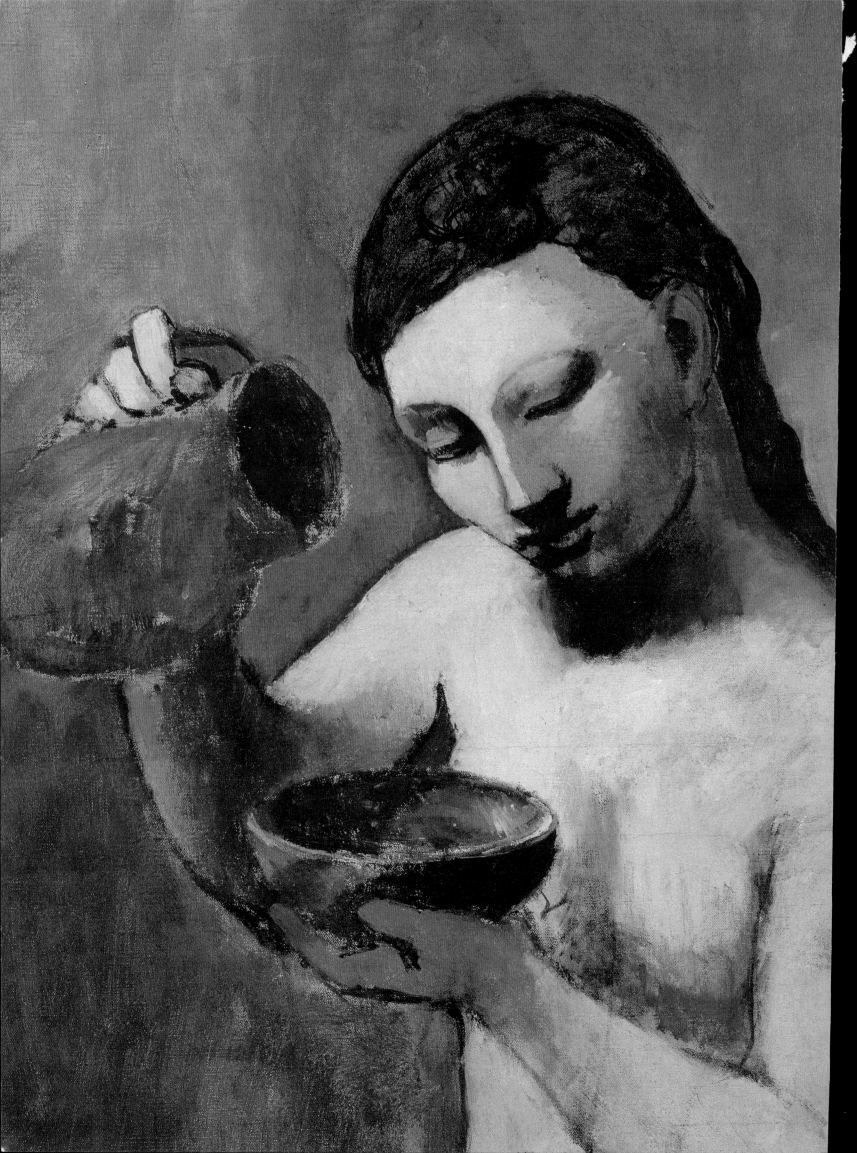

Lenders to the Exhibition

Albright-Knox Art Gallery, Buffalo
Art Gallery of Ontario, Toronto
The Art Institute of Chicago
Ashmolean Museum, Oxford
The Baltimore Museum of Art
Selma W. Black Collection
Centro de Arte Reina Sofía, Madrid
The Cleveland Museum of Art
The Detroit Institute of Arts
Estate of Georges Encil
The Evergreen House Foundation, Baltimore
The Fine Arts Museums of San Francisco
Dr. and Mrs. Martin L. Gecht
Göteborg Museum of Art
Mrs. Melville Wakeman Hall
Harvard University Art Museums,
 Cambridge, MA
The State Hermitage Museum, St. Petersburg
Alex Hillman Family Foundation
Hiroshima Museum of Art
Hirshhorn Museum and Sculpture Garden,
 Smithsonian Institution
Kawamura Memorial Museum of Art, Sakura
Kimbell Art Museum, Fort Worth
Kunsthaus Zürich
Mrs. Alex Lewyt
Susan and Lewis Manilow
Maspro Denkoh Museum, courtesy of Christie's
Werner and Gabriele Merzbacher
The Metropolitan Museum of Art, New York
Musée d'art moderne, Céret
Musée d'Art Moderne de la Ville de Paris
Musée de l'Orangerie, Paris
Musée national d'art moderne,
 Centre Georges Pompidou, Paris
Musée Picasso, Paris

Museu Picasso, Barcelona
Museu de Montserrat, Barcelona
Museum of Fine Arts, Boston
The Museum of Fine Arts, Houston
The Museum of Modern Art, New York
National Gallery, Prague
National Gallery of Art, Washington
Öffentliche Kunstsammlung Basel,
 Kunstmuseum
Mr. Georges Pellequer
Philadelphia Museum of Art
The Phillips Collection, Washington, D.C.
Mr. Bernard Picasso
Mr. Claude Ruiz-Picasso
Ms. Maya Widmaier Picasso
Pushkin State Museum of
 Fine Arts, Moscow
The Saint Louis Art Museum
San Francisco Museum of Modern Art
Scottish National Gallery of Modern Art,
 Edinburgh
Solomon R. Guggenheim Museum, New York
Staatliche Museen zu Berlin, Stiftung
 Preussischer Kulturbesitz
Staatsgalerie Stuttgart
Statens Museum for Kunst, Copenhagen
Collection Valentin, São Paulo
Tate Gallery, London
University of East Anglia
Von der Heydt-Museum, Wuppertal
Mr. and Mrs. Rolf Weinberg
Mrs. John Hay Whitney
John Whitney and Joanne D'Elia Payson
Wildenstein & Co., Inc.
Woodner Collections
and numerous private collectors

Detail, cat. 152

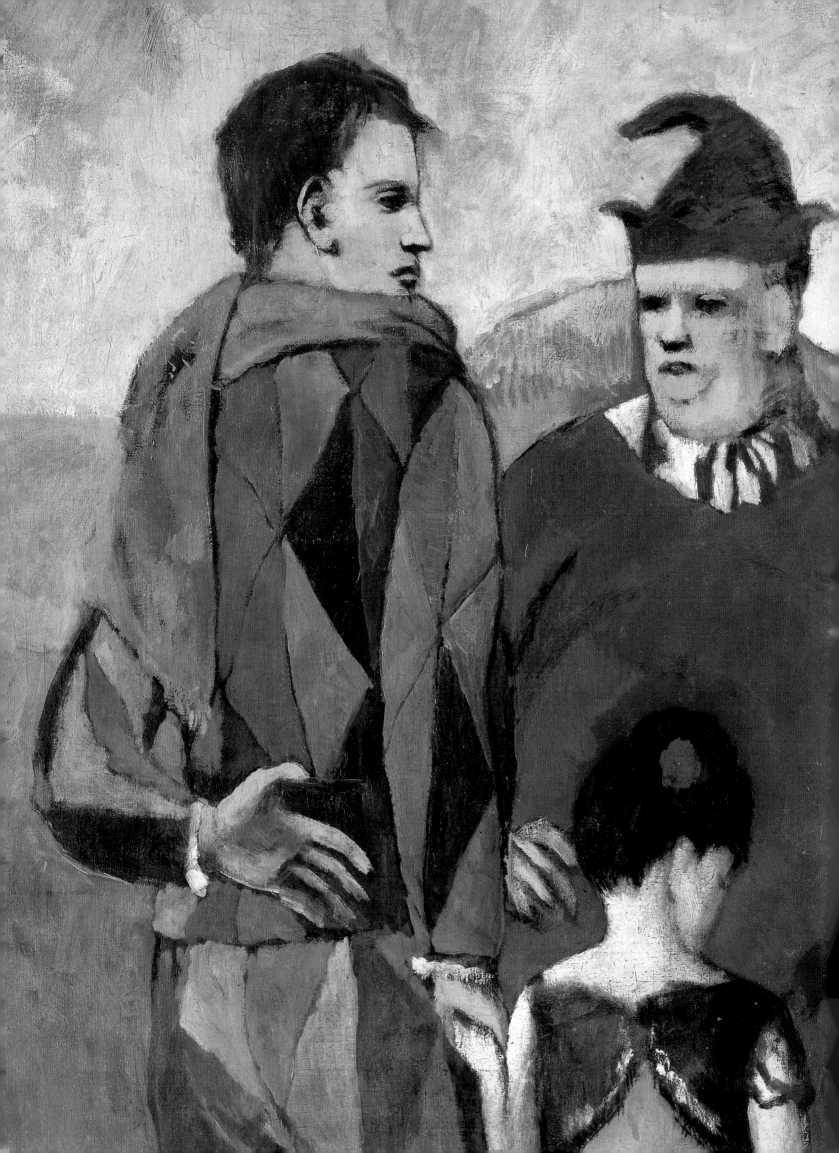

Curators' Preface

Picasso's emergence, unlike that of virtually any other artist, resembles a career unto itself. His initial search for an aesthetic identity was far-ranging and complex, and his earliest work is remarkable both for its intensity and its high degree of accomplishment. An artist's early career is usually valued primarily as the prologue to a longer and more important tale. In some respects, it would be easy to characterize Picasso's art in this way. Cubism, classicism, and surrealism, to name only three later phases of his oeuvre, each constituted work of profound originality that exercised a shaping effect on the subsequent history of art. This cannot be said of the early years. Yet it is equally clear that the period from 1892 to 1906 represents far more than a formative stage. This exhibition is dedicated to representing the work of Picasso's youth as a tale with its own narrative, which reaches a dramatic conclusion in 1906.

The story takes many familiar turns. In stylistic terms, it begins with Picasso's artistic training as a youth in Spain, during which he assimilated—with varying degrees of interest and success—competing traditions of realism that were available to him there, including academic classicism and Spanish genre. His close allegiance to the Catalan *modernista* movement in turn-of-the-century Barcelona and his subsequent introduction to post-impressionist and symbolist painting in Paris each had an impact, however brief, on his art. From 1901 to 1904 the artist shuttled between France and Spain; these years comprised Picasso's so-called Blue period, named for the monochromatic palette he used to depict figures largely drawn from the socioeconomic underclass in Barcelona and Paris. On settling in France in 1904, Picasso entered a new phase in his work, developing a standard of attenuated figure proportions that linked the Blue period with the Rose period that followed. Distinguished by a palette of roseate hues, the works of 1905 are dominated by the motif of the saltimbanque, an itinerant fairground per-

former who appears throughout nineteenth-century painting and poetry, and whom Picasso observed firsthand in Paris. Between 1905 and 1906 Rose period figuration became increasingly hieratic, acquiring a distinctly classical refinement of line influenced partly by the work of Ingres. In the summer of 1906, during a trip to the village of Gósol in the Spanish Pyrenees, the classical mode manifested an archaic air, as figural proportions grew stocky and the artist imbued his subjects with a monumentality that can be traced to ancient Iberian sculpture. Returning to Paris, Picasso continued to purify this manner, which culminated in the latter part of the year in an imposing series of drawings and paintings devoted to the female nude.

Our exhibition ends with this phase of Picasso's work. We have deliberately chosen to exclude the development of his landmark painting, *Les Demoiselles d'Avignon,* as it represents something of a great divide, after which Picasso's work exhibited a rapid unfolding of new pictorial means. In light of the *Demoiselles,* the period of late 1906 is too often seen as merely transitional, whereas the very weight of Picasso's monumental nudes signals the conclusion to a figural metamorphosis of rare drama. Of course, such a resolution was fleeting. Having described the early period as a story in its own right, we should observe that Picasso's career is ultimately characterized less by resolution than by continuity; many defining features of the work prior to cubism recur throughout the artist's life.

Picasso's early art is above all deeply personal. Tragedy, comedy, sentiment, and eros are all expressed in a somewhat confessional fashion, as the artist put himself and his community at the center of his art. This autobiographical element in Picasso's early work, which has long been recognized, lends an epic—or perhaps picaresque—continuity to the period, notwithstanding shifts in style and subject. Moreover, this quality is not confined to the early years. Chronicle and confession recurred throughout

Picasso's career, often hidden within an increasingly recondite formal vocabulary. Using his art to dramatize and mythologize his life, the young Picasso thus has much to tell us about the content and emotional depth of the older artist.

The early career has never been comprehensively mapped in a single exhibition, and it is well served by an overview of the years from 1892 to 1906, rather than the more typical focus on a single phase such as the Blue period. Our approach not only addresses the overall shape of the early work, it also demonstrates how unfamiliar and complex many aspects of the oeuvre remain. For example, given Picasso's range in these early years, his protean capacity is easy to mistake for facile showmanship or technical bravado. A certain amount of swagger does characterize Picasso's artistic persona, and it is clear that he envisioned himself in relation to a pantheon of illustrious precursors from the history of art, forebears he first approached as a truculent challenger and eventually as a peer. Picasso was also apt to assimilate the mannerisms and devices of more recent predecessors. Nonetheless, his transformations reveal as much indecision, impatience, and struggle as they do technical and stylistic command. At times, as one critic of the period remarked, the artist can be observed to be at war with his own restless capabilities.

Also apparent in a survey of the early years, Picasso cultivated the practice of drawing as a traditional means of experimentation. Yet while he produced small sketches for apparently unrealized large-scale narrative compositions, he composed few true preparatory drawings for specific paintings. Rather, his skill as a draftsman allowed him to rehearse new stylizations of the figure before applying them in paint. A shift occurred in 1906, however, when his drawings grew significantly both in size and number; in a sequence of finished presentation pieces devoted to the motif of the standing and seated figure (alone and in pairs), and in a number of heads,

Picasso achieved a remarkable distillation of formal means. At that point drawing achieved parity with painting—and came close to superceding it—as the medium through which Picasso created his most stylistically modern work.

Given the longevity of terms such as "Blue" and "Rose," with which we will always be prone to classify Picasso's early paintings, it is also important to observe the degree to which these descriptions fail to account for the many works that display pictorial qualities relating to more than one phase, or to none. The categories neglect a range of coloristic effects that is further heightened by distinctions between oil, watercolor, and gouache. Some paintings, such as the *Portrait of Benedetta Canals,* do not fit the stylistic distinctions at all. And Picasso's caricatures, a fascinating body of work that appears throughout the exhibition, may relate to subjects or themes in the paintings, but just as often do not relate to the prevailing style. This suggests that Picasso's various manners comprise less a "natural" development than a controlled sequence of options from which the artist could choose to digress. If caricature represents a private accompaniment to Picasso's more public work, the comic element also encourages us to check our assumptions about the dark social and personal themes that dominate the period. After all, in Picasso's own formulation the melancholic Blue period was initiated by the suicide of his friend, Carles Casagemas; yet in addition to several deathbed portraits, the artist's most significant record of the tragedy is *Evocation,* an adaptation of El Greco's *Burial of Count Orgaz* in which the sacred—Casagemas' funeral ceremony—is infiltrated by the profane, a burlesque ascension scene populated by the denizens of a Montmartre bordello.

In the context of this exhibition, then, we hope that Picasso's early career will emerge as having been surprisingly complex, yet possessed of a compelling dramatic arc. Ultimately, the

power of the work, especially beginning with the Blue period, resides in the impression it conveys of a self-contained world, populated by various communities that share a form of bohemian kinship. It is a fictive relationship; little, if any, social realism informs Picasso's vision of underclass life in Barcelona and Paris, or the experience of villagers in Gósol. While social, economic, and political complexities certainly shaped the artist's sympathies and perceptions, his apparent interest is less topical or ideological than dramatic. The result is a lyric realm that is both multivalent and self-referential, as types—the supplicant, the prostitute, the wandering player—interact with Picasso's close acquaintances and with the artist himself. Finally, the arid arcadia of a remote mountain village dispels the spirit of urban ennui. Following Gósol, a climate of abstraction encroaches on the firsthand observation of the preceding years, even as small drawings and sketches of middle to late 1906 reveal that the monumental nudes and related figures correspond to subjects that were intimately observed. Physical monumentality serves not only as a pictorial summation but as an expressive denouement.

Mark Rosenthal
Washington

Robert J. Boardingham
Boston

Jeffrey Weiss
Washington

Acknowledgments

We must begin by paying homage to Picasso's most observant and eloquent biographer, John Richardson. John's book, *A Life of Picasso: The Early Years, 1881-1906*, stands as the essential source from which all other scholars of the artist's early years must draw. Uniquely rich in biographical detail and penetrating yet judicious in its correlation of the life to the art, his portrait of the artist as a young man has been the indispensible model for our narrative of the career. John was also gracious enough to advise us on many aspects of the exhibition.

We have benefited immeasurably from the counsel of Marilyn McCully, who has published extensively on Picasso and serves as collaborating author with John Richardson on his *Life of Picasso*. As scholarly editor of the present catalogue, she has shared her vast reserves of expertise on the artist and has provided a chronology of the early career that constitutes the very backbone of the catalogue. She has also invited an accomplished group of scholars to contribute essays on a range of subjects. We are grateful for the enthusiastic participation of Natasha Staller, Robert Lubar, Phillip Dennis Cate, Peter Read, Robert Rosenblum, Margaret Werth, and Ann Hoenigswald.

Many friends and colleagues have generously assisted with the organization of this exhibition. We would particularly like to thank William Acquavella, Alexander Apsis, Ramon Arus, Lluís Bagunyà, Joseph Baillio, Ida Balboul, Juliet Wilson Bareau, Bruce Beal, Francis Beatty, Roger Benjamin, Huguette and Anisabelle Berès, Peter Beye, Ernst Beyeler, Scott M. Black, Dom Maur Boix, Christopher Brown, Sigfrid Buan, Alla A. Butrova, James Cuno, Pierre Daix, Diane DeGrazia, Lisa Dennison, Rosemary de Carlo, Ingmari Desaix, Mary Adair Dockery, Jay Fisher, Enrique García-Herraiz, Ivan Gaskell, Ulrike Gauss, Carmen Giménez, Thomas Gibson, Arnold Glimcher, Guido Goldman, Tokushichi Hasegawa, Tom Hinson, Nobuyuki Hiromoto, Michel Hoog, Edward M. Kennedy, Marge

Kline, Jan Krugier, Hélène Lasalle, Brigitte Léal, John Leighton, William S. Lieberman, Tomàs Llorens, Alejandro Gómez Marco, Thomas M. Menino, Isabelle Monod-Fontaine, Steven Nash, David Norman, Malen Gual Pasqual, Ivan Phillips, Michael Raeburn, Ruth Rattenbury, Gérard Régnier, Robert Remis, Brenda Richardson, Joseph J. Rishel, Bill Robinson, Barbara Rose, Pierre Rosenberg, Hélène Seckel, Werner Spies, Gloria Spivak, Miriam Stewart, Toni Stoss, Jeremy Strick, Rosa Maria Subirana, Ann Temkin, Gary Tinterow, Akira Tomita, Phyllis Tuchman, Kirk Varnedoe, Junko Watanabe, Ken Wayn, Alan G. Willkinson, Mary Ann Wilkinson, and Henri Zerner. Michael Findlay merits special thanks for his tireless work as a liaison for loans from numerous private collections. In addition to lending important works to the exhibition, Claude Ruiz-Picasso, Maya Widmaier Picasso, and Bernard Picasso have also contributed vital information and generous overall support.

In Washington and Boston we have been fortunate to work with many able and dedicated colleagues. Alan Shestack, now deputy director at the National Gallery of Art and formerly director at the Museum of Fine Arts, has been a strong advocate. Also at the National Gallery D. Dodge Thompson, Linda Thomas, and Naomi Remes were responsible for the complex organizational and administrative details of the exhibition, capably assisted by Jennifer Fletcher Cipriano. Michelle Fondas served as registrar, while Mark Leithauser and Gordon Anson designed and installed the exhibition. In the department of twentieth-century art, staff assistants Shaune Pasch, Jessica Stewart, and Lisa Coldiron lent critical support, and interns Laurence Pollet, Eileen Gonzalez, Julia Friedman, and Jill Martinez provided welcome assistance. In the conservation department Ann Hoenigswald, Jay Krueger, and Heather Galloway treated early paintings by Picasso in the National Gallery collection in preparation for this exhibition and offered expert counsel

regarding the transport of works. Andrew Robison helped identify several prints for display. Sandy Masur and Chris Myers coordinated corporate funding at the National Gallery.

Publication of the exhibition catalogue was directed at the National Gallery of Art by editor-in-chief Frances Smyth. In her office it has been our good fortune to work with editor Tam Curry Bryfogle and designer Chris Vogel, who have managed the production of this project with skill, perseverance, and good will. Jennifer Wahlberg provided technical assistance, and Maria Tousimis oversaw the publication finances. Transparencies and photographs were assembled by two resourceful individuals: Sara Sanders-Buell focusing on works in the exhibition, and Mariah Seagle on comparative illustrations. Luanne McKinnon assisted Marilyn McCully with research at an early stage.

At the Museum of Fine Arts we are most grateful for the curatorial support of current and former colleagues in the department of paintings, Peter C. Sutton, Eric M. Zafran, and Theodore E. Stebbins Jr. Deanna M. Griffin provided essential administrative assistance. George T.M. Shackelford has brought wise counsel and encouragement to the project since coming to the museum in February of 1996. We would like to acknowledge the tremendous organizational support of research assistant Sydney Resendez. Our thanks especially to these past and present staff members in Boston: Clifford S. Ackley, Josh Bassesches, Arthur Beale, Brent Benjamin, Paul Bessire, Desirée Caldwell, Heather Cleary, Joanne Donovan, Gail English, Katie Getchell, Dawn Griffin, Andrew Haines, Peggy Hogan, Pat Jacoby, Irene Konefal, Tom Lang, Pat Loiko, Nicole Luongo, Valerie McGregor, Jeffrey Munger, Karen Otis, Anne Poulet, Roy Perkinson, Cynthia Palmer, Sue Reed, Regina Rudser, Gary Ruuska, Barbara Shapiro, Janice Sorkow, Mary Sluskonis, Marjorie Saul, Marci van Horn, Susan D. Wong, Jim Wright, and Carl Zahn.

We hope that the exhibition and this catalogue will encourage visitors and readers to recognize Picasso's early career as a vital and compelling subject of great drama and rich aesthetic reward.

Mark Rosenthal
Robert J. Boardingham
Jeffrey Weiss

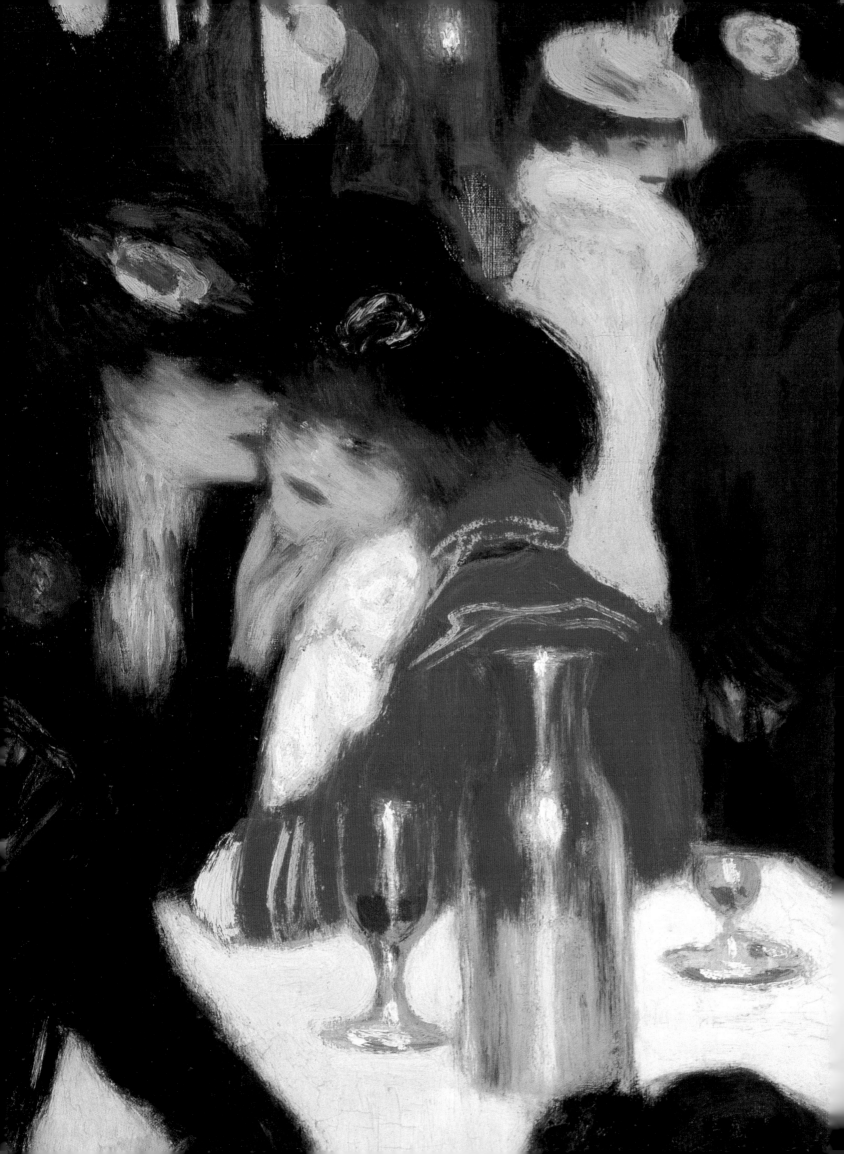

Editor's Preface

The editor of a catalogue of an exhibition devoted to Picasso faces a formidable task, since so much has been written about both the man and the phenomenal body of work he produced over some eighty years. Indeed, no other twentieth-century artist has been studied, documented, argued over, or catalogued as often as Picasso. How, then, can a new publication, which deals with the period of Picasso's artistic formation in his native Spain and his well-known and loved Blue and Rose periods in Barcelona and Paris, make some real contribution to the literature without merely adding to the many words already written about this modern master?

First of all, the catalogue has been prepared to complement the exhibition selection. A full chronology is intended to give the interested visitor (and reader) a digest of documentation and criticism so that the works and their artistic context, as well as the major events and personalities who played a role in the artist's life, can be followed year by year. Second, just as the objects in the show have been chosen to include much unfamiliar material in order to cast new light on well-known works, the catalogue provides sharply focused essays on particular aspects of Picasso's early work to reflect new thinking about this period. Although discussion in the essays is generally confined to the years covered by the exhibition, this should not suggest that this body of work represents a finite episode in the artist's development. From reading the various texts, it becomes apparent that in any number of ways, some of them quite surprising, the aspects of the work that are treated here relate to the work of Picasso's entire career.

In particular the essays have been chosen to reflect areas of new research, which encompass a number of current interpretative methods in twentieth-century art history. These range from the perspectives of political and feminist readings to those based in formalism, critical reception, biography, and technical investigation. By including these different approaches, the cata-

logue contributes not only to the debate about Picasso's work but to wider arguments about the methodology of art history as it is practiced today.

A number of very specific issues arising from a study of Picasso's work and the circumstances surrounding the artist are also touched on in the different essays. One area in which little scholarly work has been done until now is the significance of Picasso's earliest training for the development of his working methods. This and his early identification with the Spanish art historical background are examined from several points of view. Another related topic is the importance of drawing per se. What began as an essential tool of academic practice became for Picasso the primary creative force that underlines his work in many different media. As a young man, like so many of his contemporaries who experienced the flourishing of fin-de-siècle illustrated magazines and the rapid development of printmaking techniques (especially in lithography), he began his career as a graphic artist, working on art journals and designing posters and other printed ephemera. Yet very soon he set his professional sights much higher, and when he determined to establish a career in Paris, he abandoned the opportunity to earn his living as an illustrator, choosing instead to become an *artiste-peintre*. At the same time, the practice of drawing was at the root of everything Picasso did—not only as a means to work out compositions to be transferred to canvas or to three-dimensional form but also as a record of his ongoing creativity and as a source of inspiration in itself.

The intellectual and cultural aspirations of the artists and writers with whom Picasso associated at this formative time both in Barcelona and in Paris provide a rich fabric of ideas for understanding the motivations behind the Blue and Rose periods. The political and philosophical, literary and dramatic interests of his companions were absorbed and transmitted to

the familiar Blue period subjects of beggars and syphilitic whores and to Rose period harlequins and Mediterranean youths. Picasso's identification with the avant-garde, and the related notions of the artist as outsider, bohemian, and provocateur, emerge in several of the essays. The arrival of the new century also brought with it a widely held conviction that the world could make a fresh start. The accident that the onset of Picasso's maturity coincided with the new century led his admirers and detractors to regard him, as he regarded himself, as the archetypal twentieth-century artist—a reputation that remained with him to the end of his life.

New research and new thinking about Picasso in the decades since his death have dispelled many of the old myths and received ideas and allowed a much clearer—at the same time more complex—picture to emerge of the man and his art. Undiscovered works have been brought to light (quite apart from the mass of highly optimistic attributions); archives are gradually being opened up; and works have been examined with the aid of recent technology. The technical essay included here shows how much can be learned about an artist's working methods when laboratory investigation is combined with documentary and historical evidence. All of a sudden a group of drawings makes sense, or one can relate studies to a hitherto unsuspected composition, which may or may not have been executed.

Surely there are more secrets to be discovered in sources as varied as popular culture, political and cultural history, literature, letters, reminiscences, in the laboratory, and, of course, in the works themselves. Using methods the authors have employed here will undoubtedly reveal much more about the artist and his work. The subject of Picasso will never be a closed book.

There are a number of individuals who have made invaluable suggestions and contributions to the catalogue, and in particular to the chronology: Jeffrey Weiss, Mark Rosenthal, Tam Curry Bryfogle, Elizabeth Cowling, Luanne McKinnon, and Sydney Resendez. For recently published documentation concerning the dating of Picasso's and Casagemas' travels (1900–1901) to Paris and Málaga, I am indebted to María Teresa Ocaña's chronology in *Picasso i els 4 Gats* (Museu Picasso, Barcelona, 1995).

Marilyn McCully
London

Notes to the Reader

Dimensions are given in centimeters followed by inches in parentheses; height precedes width.

Sources cited in more than one essay have been spelled out in full in a bibliography at the back of the book, with short references used in the text throughout (author surname and date; or city of exhibition and date). Otherwise, sources are given in full on the first citation and in short form subsequently.

Reference numbers to works by Picasso have been abbreviated as follows:

D. Pierre Daix and Georges Boudaille, *Picasso: The Blue and Rose Periods* (Greenwich, CT, 1967).

M.P. Musée Picasso, Paris

MPB Museu Picasso, Barcelona

Spies Werner Spies, Picasso: *Das plastische Werk* (Stuttgart, 1983).

Z. Christian Zervos, *Pablo Picasso*, 33 vols. (Paris, 1932–1978).

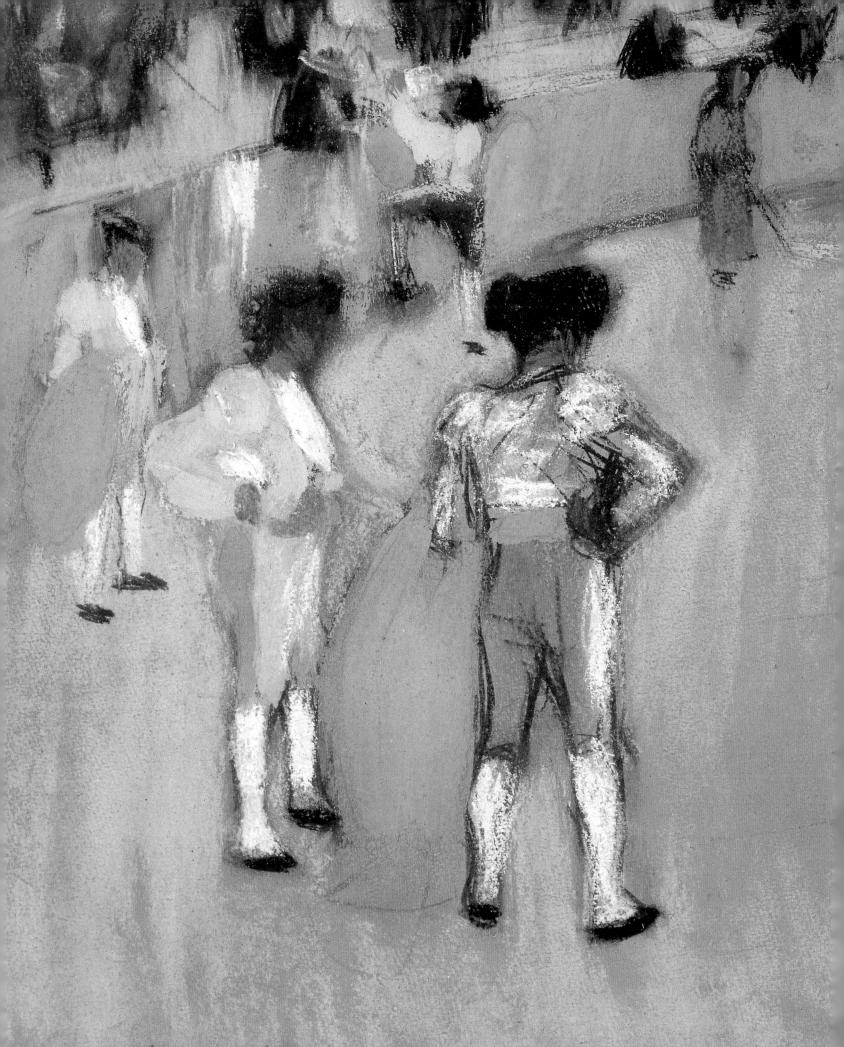

Chronology

Marilyn McCully

Detail, cat. 33

1. Pablo, age four, photograph by F. Martin, private collection

2. Pablo, age seven, with sister Lola, Musée Picasso, Paris

3. José Ruiz Blasco, c. 1878, Musée Picasso, Paris

1881

On 25 October Pablo Diego José Francisco de Paula Juan Nepomuceno María de los Remedios Crispín Crispiniano Santísima Trinidad was born to José Ruiz Blasco and María Picasso López in Málaga, Spain, at 36 Plaza de Riego.

He was called Pablo Ruiz Picasso, but by 1901 he had dropped his father's surname in favor of his mother's. Although he later joked that he chose the name Picasso because it had a double 's' like "Poussin," his choice was probably influenced by the fact that "Picasso," a name of Italian origin, sounded more distinguished than the common Spanish name "Ruiz."

Two sisters were born later: Lola (Dolores) in 1884, Conchita (Concepción) in 1887. The family moved to a larger apartment at 32 Plaza de Riego.

Picasso's father, don José (1838–1913), was the eighth of eleven children. As a young man, he was known for his Andalusian *sal* (salt)—that is, the clever way he told stories and jokes—and was thought among his cronies to look like

an Englishman because of his height, slim build, clear eyes, and fair complexion (fig. 3). A gypsy once said about him that he looked like an ex-voto made of wax and dirtied by flies. Although he had few professional ambitions, he studied art at a time when Málaga was enjoying something of an artistic renaissance, with the appointment of Valencian artists Bernardo Ferrándiz (1835–1885) and Antonio Muñoz Degrain (1840–1924) to the local academy. After the death of his father in 1876 and his brother Canon Pablo in 1879, don José looked after his unmarried sisters as well as his wife María (they had married in 1880). He took up two positions in Málaga: instructor of drawing at the Escuela de Bellas Artes (San Telmo), and conservator of the Museo Municipal.

María Picasso López (1855–1938) grew up in quite different circumstances from her husband. María's mother, whose in-laws considered her lower class, had been deserted by her husband, a mysterious character who is said to have studied in England as a youth and to have gone off to Cuba, where he died of yellow fever. His widow

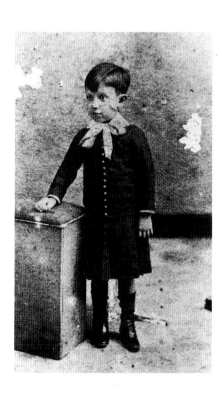
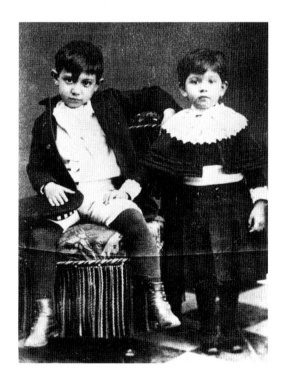
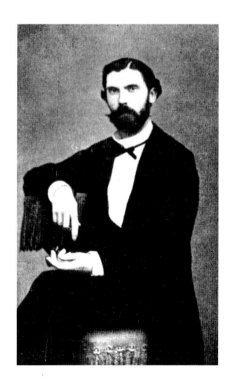

brought up their six daughters, and María grew up a strong, if somewhat unconventional and lively personality and was physically—short and dark—the model for her son (fig. 4).

"In Picasso's memory, his father, his mother, and his maternal grandmother are forever fixed. On holidays, his father took him to bullfights in Málaga; his grandmother told him weird stories, which he would repeat, sometimes, as if he had just invented them himself; and from his mother, who taught him 'not to say anything about anybody or anything,' the boy learned to keep quiet when the occasion warranted. His father's inclinations were an open image of those he himself carried within, and as he matured, this treasure, accumulated in the silence that he had learned to keep, emerged as line and color." (Sabartès 1949, 11)

1881–1891

As a child, Pablo attended elementary school in Málaga; and under his father's guidance he began to draw and make paper cut-outs. His earliest known drawings depict pigeons (his father kept pigeons and preferred them as a subject for his own paintings), bullfights, and a full-length figure of Hercules (see fig. 5; and fig. 1 in Staller essay).

"When I was a child, my mother said to me, 'If you become a soldier you'll be a general. If you become a monk you'll end up as the Pope.' Instead, I became a painter and wound up as Picasso." (Picasso, quoted in Françoise Gilot, with Carlton Lake, *Life with Picasso* [New York, 1964], 60)

1891–1894

In 1891 Picasso's father accepted a better position as professor at the Instituto da Guarda in La Coruña. The family resided at 24 Payo Gómez, several blocks from the school and near the ocean. Throughout the whole time Picasso's family lived in Galicia, however, his father was

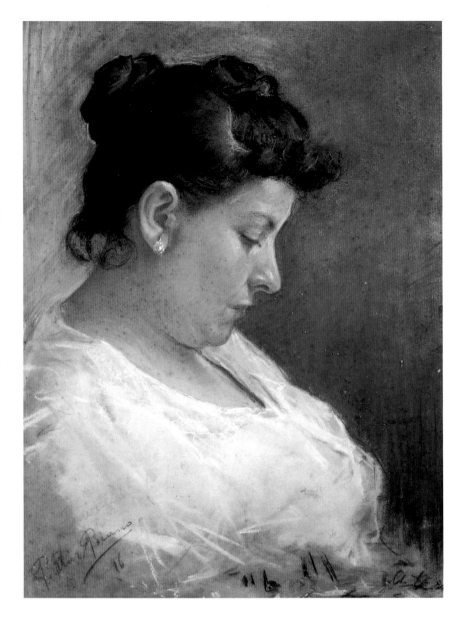

restless and unhappy. He could not acclimatize himself to the wind and rain of northwestern Spain, nor did he feel at ease among the Galicians. For him life in La Coruña was a kind of exile from his native Andalusia. His son, on the other hand, entered into school and social activities with enormous enthusiasm.

Pablo officially enrolled in the Instituto da Guarda in 1892, studying drawing (generally from plaster casts) with his father and with the

4. Picasso, *Doña María (The Artist's Mother)*, Barcelona, 1896, pastel on paper, 49.8 x 39 (19 5/8 x 15 3/8), Museu Picasso, Barcelona

5. Picasso, *Bullfight; Pigeons*, Málaga, c. 1890, pencil on paper, 13.5 x 20.2 (5 1/4 x 8), Museu Picasso, Barcelona

6. Picasso, *Portrait of Ramón Pérez Costales,* La Coruña, 1895, oil on canvas, 52 x 37 (20½ x 14½), Heirs of the artist

La Coruña sculptor and painter Isidoro Brocos (1841–1914); Brocos also instructed him on an informal basis in watercolor techniques.

Picasso boasted many years later that when he was at school in La Coruña: "For being a bad student I was banished to the 'calaboose'—a bare cell with whitewashed walls and a bench to sit on. I liked it there, because I took along a sketch pad and drew incessantly. . . . I could have stayed there forever drawing without stopping." (Interview with Picasso, in Antonio D. Olano, "Los Cuatro Años de Picasso en La Coruña," *Picasso e a Coruña* [La Coruña, 1982], 7)

At his father's suggestion, Picasso produced several handwritten newssheets imitating popular illustrated journals: *Asul [sic] y Blanco* ("Blue and White," the colors of the Galician flag; see cat. 3), of which the first of four issues is dated 8 October 1893; and *La Coruña* (see cat. 4) and *Torre de Hercules,* done in 1894. In them Pablo recorded news about life in La Coruña for the family back in Málaga.

Picasso's first dated oils—mainly portraits of family and friends—were painted in 1894–1895. Picasso's father arranged for a model for *Girl with Bare Feet* (cat. 5) as a Christmas present. Picasso later recalled: "The poor children in our neighborhood always went barefoot, and this little girl had her feet covered with chilblains." (Vallentin 1957, 20)

Ramón Pérez Costales (1832–1911) acted as a protector for the Ruiz Picasso family in La Coruña. The Galician doctor and celebrated Republican politician had first met don José in Málaga and helped the family settle in Galicia. It was young Pablo, however, who enjoyed a measure of artistic success there rather than his father. Pérez Costales' French wife is said to have helped Pablo with language lessons, and the doctor himself became the boy's earliest patron, commissioning paintings and sponsoring his first exhibition.

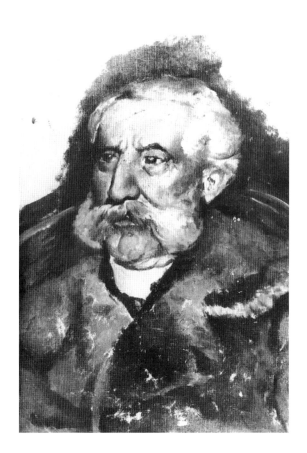

1895

In January Picasso's sister Conchita became ill with diphtheria. As her doctor, Pérez Costales sent off an urgent request to Paris for medicine, but it arrived twenty-four hours too late to save the child's life. Although the parents were consumed with grief after her death, Picasso worked with great energy in the next months, exhibiting twice in storefront windows on the fashionable Calle Real: in February two studies of heads, and in March the *Beggar in a Cap* (fig. 7). A reviewer for *La Voz de Galicia* (21 February) predicted that "if he continues in this [courageous and mature] manner, there is no doubt that he has days of glory and a brilliant future ahead of him."

Picasso said later in life that he preferred the paintings he did under his father's supervision in La Coruña to the work he would do at art

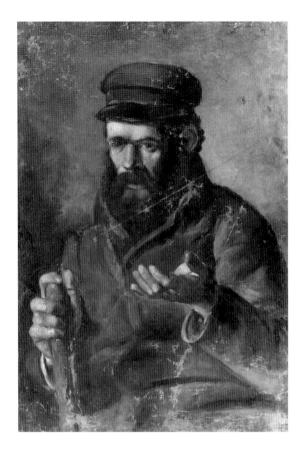

school in Barcelona. The artist kept several of the La Coruña canvases—including *Portrait of Ramón Pérez Costales, Beggar in a Cap, Girl with Bare Feet,* and *Portrait of a Bearded Man* (cat. 6)—in his personal collection until his death.

"I remember at the School of Fine Arts they made us write in a notebook—'One must learn to paint' and to repeat it several times. I did it, but in reverse. I wrote 'One must not learn to paint. One must not learn to paint. One must not learn to paint.'" (Olano 1982, 7)

As secretary of the Instituto da Guarda, Picasso's father became embroiled in art school politics. When the opportunity came up in the spring of 1895 to swap positions with a native Galician who was teaching at the art school in Barcelona, don José was willing to accept a lower-ranking job in order to leave La Coruña. He wrote the last entry in the school register by his son's name: "Pasha from Rif."

During the summer the family returned to Málaga, passing through Madrid, where Pablo visited the Prado for the first time and made studies of a court dwarf and a jester after paintings by Velázquez.

In Málaga the family stayed with Pablo's rich uncle, who was chief medical officer at the port, where he had a house at 97 Calle Cortina del Muelle. Dr. Salvador Ruiz Blasco (1844–1908) represented the authority, prestige, and upper-class ambition (when he married a second time, it was into a wealthy Málaga family) that his brother, Pablo's father, lacked. Salvador was interested in the arts; his first wife had been the daughter of a Granada sculptor, and they had had two daughters. But he regarded Pablo as a kind of son and heir and took a special interest in his abilities as a painter, with an eye to securing a future for him in the Spanish art establishment. During the summer Salvador arranged for an old fisherman, Salmerón, to model for the boy (cat. 7).

In September, with financial assistance from Pablo's uncle Salvador, the family traveled by boat to Barcelona. Their first residence was at 4 Carrer Llauder, near the waterfront and close to the art school, where don José assumed his new post. Some months later they moved around the corner to 3 Carrer de Cristina.

Pablo easily passed the entrance exam for the art school (known as La Llotja, as it is situated in the old stock exchange). There he met Manuel Pallarès (1876–1974), who remained a friend for life. They shared a small studio at 4 Carrer de la Plata.

Pallarès later recalled: "[Picasso] was way ahead of the other students, who were all five or six years older. Although he paid no apparent attention to what the professors were saying, he instantly grasped what he was taught. . . . He was well aware of his superiority, but never showed it. He often seemed melancholy, as if he had just thought of something sad. . . . At fifteen he neither looked nor acted like a boy his age. He was very mature." (Pierre Cabanne, *Picasso: His Life and Work,* trans. Harold J. Salemson [New York, 1977], 33)

7. Picasso, *Beggar in a Cap,* La Coruña, 1895, oil on canvas, 72 x 50 (28 ⅜ x 19 ⅝), Musée Picasso, Paris

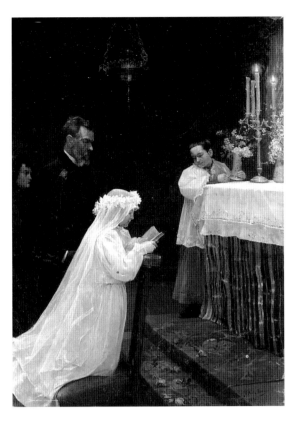

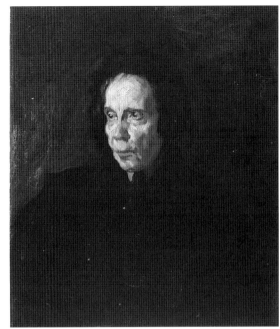

8. Picasso, *First Communion*, Barcelona, 1896, oil on canvas, 166 x 118 (65 3/8 x 46 1/2), Museu Picasso, Barcelona

9. Picasso, *Portrait of Aunt Pepa*, Málaga, summer 1896, oil on canvas, 57.5 x 50.5 (22 5/8 x 19 7/8), Museu Picasso, Barcelona

1896

In order to promote his son as an up-and-coming Málaga painter, don José arranged for Pablo to work on a canvas in the studio of the established Andalusian artist José Ramón Garnelo (don José's colleague at La Llotja from 1895 to 1899). The subject was undoubtedly dictated by the father; first communions and altar boys were typical of the "School of Málaga." Picasso's *First Communion* (fig. 8) was exhibited at the Exposición de Bellas Artes y Industrias Artísticas in Barcelona in April (family legend holds that it commemorated Lola's first communion). The critic Miquel i Badía wrote in *Diario de Barcelona* (25 May 1896) that *First Communion* represented "the work of a novice in which one perceives sensibility in the principal figures. Certain areas are painted with strength."

Picasso's father also used Andalusian connections to win his fifteen-year-old son a commission to copy two altarpieces by Murillo for a convent in Barcelona (these were presumably destroyed during the Setmana Tràgica in 1909, when convents were burned). Picasso later told Apollinaire: "The idea bored me, so I copied them up to a point, then rearranged things according to my own ideas. Considering my age, I must admit feeling very satisfied." (Richardson 1991, 73)

Picasso's family moved to an apartment at 3 Carrer de la Mercè, still close to La Llotja, which would be a permanent home for Pablo whenever he was in Barcelona until he settled in France eight years later.

The family returned to Málaga for the summer and once again stayed with Salvador. After considerable urging on the part of his uncle, Pablo painted a portrait of his pious and reclusive aunt Pepa (fig. 9), who was equally reluctant to pose. Picasso's sister Lola later recalled: "[Aunt Pepa] was very old and a little crazy, and we knew she wasn't going to live much longer. She was always difficult, and we couldn't persuade her to pose, but we wanted something to remember her by. Then one day, when for once she was in an agreeable mood, Pablo thought that it was the right moment. He went to her house with his paints and worked so quietly that she hardly noticed what was going on. The portrait was finished in an hour. She died a few days later." [Ed. note: In fact she died in 1900.] (Rosamond Bernier, "48 Paseo de Gracia," *L'Oeil* 4 [15 April 1955], 7)

Back in Barcelona in the autumn, Picasso resumed his studies at La Llotja. Although the courses offered him little more than he had encountered in La Coruña, he thrived on the aca-

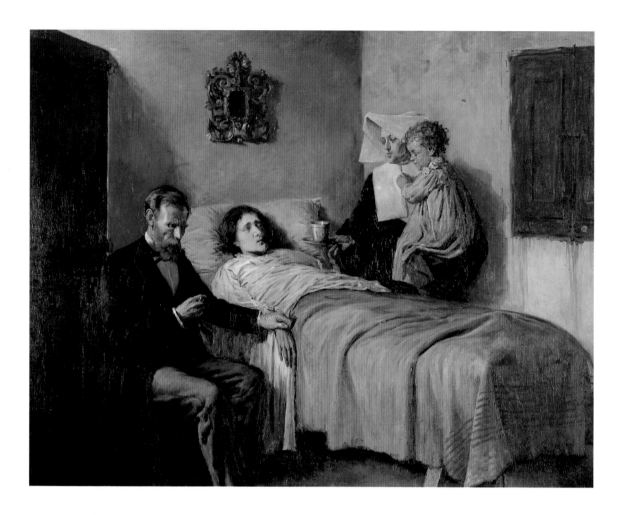

demic insistence on the practice of drawing. In the evenings he began to frequent the gathering places of young artists and writers, notably the Eden Concert, where he met the de Soto brothers, Angel (1882–1938) and Mateu (1881–1939). The lively fin-de-siècle atmosphere of the Catalan capital gave Picasso his first taste of contemporary, international artistic currents.

At the Sala Parés gallery in November an exhibition was held of foreign posters, engravings, lithographs, and other printed ephemera; artists represented included Puvis de Chavannes, Chéret, Dudley Hardy, Grasset, Bradley, Hassall, Forain, Steinlen, Toulouse-Lautrec, Toorop, and Mucha.

1897

In the spring *Science and Charity* (fig. 10), the large allegorical painting for which don José served as the model for the doctor, was exhibited and won an honorable mention at the Exposición General de Bellas Artes in Madrid. Once again Picasso's father had dictated the subject and prepared the canvas, which was worked on in Picasso's little studio on Carrer de la Plata.

A Madrid critic wrote: "I am sorry to laugh callously at such grief, but I cannot help it, for surely the doctor is feeling the pulse of a glove." (McCully 1981, 21)

Afterward *Science and Charity* was exhibited at the Exposición Provincial de Málaga, where it was awarded a gold medal. The family returned to Málaga for the summer; and when the exhibition closed, the painting was given to Picasso's uncle Salvador, who probably recognized the dignified doctor (with his brother as a stand-in) as a portrait-reference to himself. To celebrate the boy's artistic triumph, the Málaga painter Martínez de la Vega (1846–1905) ceremoniously baptized him as an artist by pouring champagne over his head. In his family's eyes Pablo was at age sixteen still on course to become a distinguished academic artist. While Barcelona had opened Pablo's eyes to other possibilities, his father and uncle now insisted that he was ready to leave the provinces and study at the royal academy in the capital. Picasso later remembered that family members pooled their financial resources to send him to Madrid as if they were buying shares in his future.

10. Picasso, *Science and Charity*, Barcelona, 1897, oil on canvas, 197 x 249.5 (77 ½ x 98 ¼), Museu Picasso, Barcelona

P.R.P.

11. Picasso, *Bernareggi Copying in the Prado,* Madrid, 1898, brown crayon on sketchbook page, 19.5 x 12 (7 5/8 x 4 3/4), Museu Picasso, Barcelona

In October Picasso entered the Academia Real de San Fernando in Madrid, where he took courses with cronies of don José, including Moreno Carbonero and Muñoz Degrain, who to the boy's dismay kept an eye on him and reported his progress back to his father. Picasso lived in a poor section of Madrid, at 5 Calle de San Pedro Mártir, and soon lost interest in classes, preferring to sketch in cafés, on the street, and in the Prado. He also went to Toledo, where he admired El Greco.

Fellow art student Francisco de Bernareggi (c. 1880–1959) recalled: "One day in the Prado Picasso and I were copying El Greco. The people around us were scandalized and called us *modernistes.* . . . We sent our copies to our professor in Barcelona (Picasso's father) . . . [who] responded severely: 'You're taking the wrong road.' That was in 1897, at a time Greco was

considered a danger." (Diego F. Pro, *Conversaciones con Bernareggi* [Tucuman, 1949], 21)

On 3 November Picasso wrote fellow Llotja classmate Joaquim Bas i Gich about life in Madrid, especially noting works of interest in the Prado: "The Museum is beautiful. Velázquez first class; some magnificent heads by El Greco; as for Murillo, to my mind not all his pictures carry conviction. There is a very fine *Mater Dolorosa* by Titian; Van Dik [*sic*] has some portraits and a really terrific *Taking of Christ.* Rubens has a painting (*The Fiery Serpent*) that is a prodigy; and then there are some very good little paintings of drunkards by Teniers. I can't remember anything more now." (Richardson 1991, 92)

He went on to describe a drawing he intended to submit for publication: "I am going to do a drawing for you to submit to *Barcelona Cómica,* if they buy it, you'll have a good laugh. *Modernista* it will have to be, as that is what the magazine is all about. Neither Nonell nor the Young Mystic, nor Pichot, nor anybody else has ever done anything half so shocking as my drawing is going to be. You'll see. . . . "

Picasso's boast was apparently never realized; his first published (and very conventional) drawing of a woman doing her shopping appeared in *L'Esquella de la Torratxa* in December 1898.

1898

In the spring Picasso contracted scarlet fever; his sister Lola was sent to care for him in Madrid until he was well enough to return home. After a short stay in Barcelona he accepted an invitation to his friend Pallarès' family home in Horta de Sant Joan on the border of Catalonia and Aragon, where he could recuperate in the mountains. Over the next seven or eight months Picasso learned to speak Catalan, to live in the open (he and Pallarès would camp and paint out of doors for weeks at a time), and to work in

the countryside. He later remarked: "All that I know, I learned in Pallarès' village." (Sabartès 1949, 43)

During this period the defeat of the Spanish in war with Cuba and the Philippines provoked political and social turmoil back at home. The country was flooded with returning veterans, many of them wounded, for whom the government made little or no provision. Picasso and Pallarès became aware of this when they went to the market town of Gandesa and were appalled to see the wretched state of these men, barefoot and in rags.

1899

On 17 January Picasso and Pallarès were in Horta for the annual festival of Saint Anthony, which included an enactment in costume of the Temptation of Saint Anthony. A painting based on his experiences in Horta, *Un Patio de una casa de Aragón* (now lost), was exhibited in the spring at the Exposición Nacional de Bellas Artes in Madrid, where it was awarded an honorable mention.

In February Picasso returned to Barcelona to live with his family, but no longer as a student. He gave up any intention of returning to Madrid to continue formal studies and instead embarked on a career as a graphic artist, earning some money by contributing drawings to journals and producing printed ephemera. He was taken up as something of a prodigy among his friends; and as a Catalan-speaking Andalusian, the seventeen-year-old was accepted as a talented outsider. He first worked in a studio belonging to former classmates, the Cardona brothers—Joan (1877–1957), an illustrator, and his sculptor-brother Josep (1878–1923) (cats. 17, 26)—above the family's corset factory on Escudillers Blancs. Picasso also used the studios of the de Soto brothers and of Ramon Pichot (1871–1925). For several years—and some for much longer—almost all of Picasso's closest friends

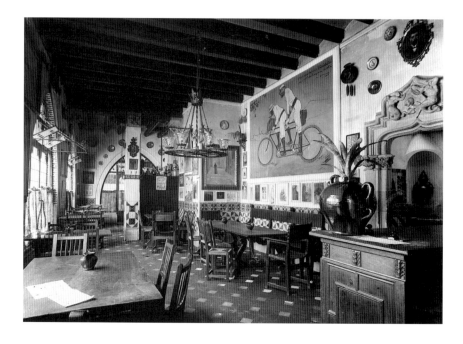

were members of the circle he met at the tavern Els Quatre Gats, including the melancholy writer and artist Carles Casagemas (1880–1901) (cats. 19, 67–70), with whom he was inseparable for most of the year 1900; and Jaime Sabartès (1882–1968) (cats. 29, 30; fig. 6 in Weiss essay), an aspiring poet and writer in the Quatre Gats circle, who would in the late 1930s become Picasso's loyal secretary, a post he kept until the end of his life. Some of Picasso's other friends were Ricard Canals, Enric Casanovas, Emili Fontbona, Antoni Gelabert, Juli González, Xavier Gosé, Sebastià Junyent, Carles and Sebastià Junyer Vidal (cat. 91), Manolo (Manuel Martínez Hugué) (cat. 111), Eduard Marquina, Alfons Maseres, Joaquim Mir, Rafael Nogueres, Isidre Nonell, Ricard Opisso, Ramon and Jacint Reventós, Josep Rocarol (cat. 28), Francisco de Asís Soler, Eveli Torent (cat. 24), Joan Vidal Ventosa, as well as the older generation of artists who founded Els Quatre Gats.

The tavern Els Quatre Gats (fig. 12) was inspired by Le Chat Noir in Montmartre, and its proprietor, Pere Romeu (c. 1862–1908), modeled himself on the notorious cabaret owner, Aristide

12. Interior of Els Quatre Gats, Barcelona, c. 1899, photograph by Mas

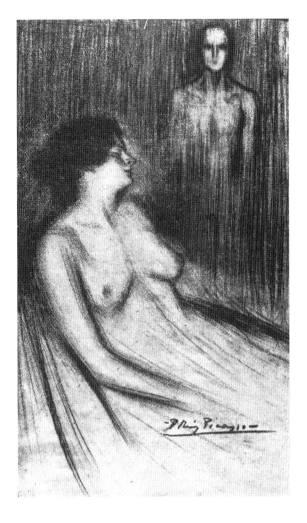

13. Picasso, *The Call of the Virgins*, Barcelona, published in *Joventut*, 12 July 1900

Quatre Gats were exponents of the movement's international aspirations. Turning to models in French, English, and northern European art and literature, the *modernistes* sought inspiration in literary and artistic symbolism as well as in the widely influential art nouveau movement in graphic design and architecture. The English arts and crafts movement found its greatest admirer in Alexandre Riquer (1856–1920), who went to London in 1894, where he was impressed by the work of Edward Burne-Jones and especially by the activities of William Morris. The workshop he set up in Barcelona was based on Morris' principles. Riquer's journal *Joventut*, to which Picasso contributed several illustrations (see fig. 13; and fig. 3 in Lubar essay), was modeled on the English illustrated magazine *The Studio*. Riquer was a member of the Cercle Artístic de Sant Lluc, which represented the conservative and essentially Catholic wing of the *modernistes*. The architect Antoni Gaudí (1852–1926), who was one of the founding members of the Cercle, was regarded by Picasso and his friends as something of a joke.

An obsession with Nietzsche and anarchism characterized the political sympathies of many of the young clientele of Els Quatre Gats. Although Picasso himself never pledged any allegiance to these causes, there are resonances in his work of the social awareness of fellow artists such as Isidre Nonell (1873–1911), Ricard Canals (1876–1931), and Joaquim Mir (1873–1940), who, with the writer Juli Vallmitjana (1873–1937), loosely formed a group called Colla de Sant Martí (named for a poor, suburban area of Barcelona).

In the summer Picasso and Casagemas traveled to Málaga, where Picasso exhibited three paintings at the Exposición Regional de Bellas Artes organized by the Liceo arts club: *Un Patio de una casa de Aragón* (on their way they may have retrieved this canvas from the Exposición General in Madrid, which closed on 10 June), *Last*

Bruant, for whom he had once worked in Paris. After its opening in 1897 Els Quatre Gats soon became a popular bohemian meeting place in Barcelona for Catalan artists and writers, who were dubbed *decadentes* or *modernistes* in the press. A principal member and primary influence was Santiago Rusiñol (1861–1931), who, along with Miquel Utrillo (1862–1934) and Ramon Casas (1866–1932), had experienced the world of Montmartre firsthand in the 1880s and 1890s. In addition to offering a cheap restaurant and bar, the tavern hosted exhibitions, puppet shows, and other activities; the journal *Quatre Gats* was also produced there, followed by *Pèl & Ploma*, which was edited by Utrillo with Casas as artistic director.

Romeu commissioned Picasso to design menus, leaflets, and other advertisements for Els Quatre Gats, including a mixed-media poster for a puppet play called "Dramas Criollos" (cat. 31).

Catalan *modernisme* was the predominant literary and artistic movement in Barcelona at the turn of the century, and the writers, dramatists, graphic artists, and painters who gathered at Els

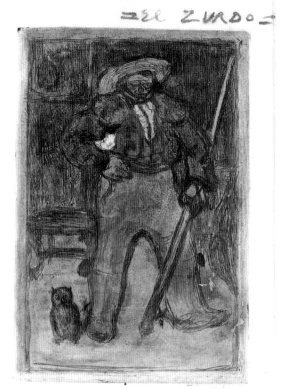

Rites (undoubtedly *Last Moments*, described below), and an unidentified portrait (possibly the *Portrait of Josep Cardona* [cat. 17]).

1900

Early in the year Casagemas and Picasso took a studio together at 17 Riera Sant Joan; both entered the Carnival poster competition and prepared solo exhibitions for Els Quatre Gats. Picasso worked intensively to finish many portraits of his friends for his show (between 50 and 150—reports vary), which opened in February. He also exhibited three paintings, including *Last Moments* (painted over with *La Vie* in 1903 [cat. 93]), which he had first shown the previous summer in Málaga; it would later be selected to hang in the Spanish pavilion at the Exposition Universelle in Paris in the spring. The typically fin-de-siècle subject of this painting was described in a review of the Quatre Gats show, which faults the artist for lack of originality:

". . . a young priest standing with a prayer book in his hand, looking at a woman on her deathbed. The light of a lamp radiates weakly and is reflected in patches on the white bedspread over the dying woman. The rest of the canvas is in shadow, which dissolves the figures into indecisive silhouettes. There are qualities in this work, painted with a natural ease that we appreciate; qualities that we hope will reach maturity the day when Señor Ruiz Picasso frees himself of prejudice and brings his work richer experience and study than he shows today, when he reaches the age when one dares all and produces typically personal works." (attributed to Manuel Rodríguez Codolá, *La Vanguardia,* 3 February 1900)

Another reviewer suggested that the influence of Barcelona *modernisme* detracted from the work: "One cannot deny that Señor Picasso has talent and feeling for art; he proves this in three oils which appear in the exhibition, in which he demonstrates intuition and knowledge of the expressive potential of color; but in contrast to this, the exhibition reveals in the painter, as in many others who have preceded him and are madly in love with the *modernista* school, a lamentable confusion of artistic sensibility and a mistaken concept of art. . . . In the collection of pencil portraits, which forms part of the exhibition, several stand out for the confidence of drawing, but it is only necessary to glance at them as a whole to recognize that this is a gallery of melancholy, taciturn, and bored characters that produces in the spectator an impression of sadness and compassion for their unsympathetic portrayal." (Sebastià Trullol i Plana, *Diario de Barcelona,* 7 February 1900)

In April Picasso submitted poster designs to competitions sponsored by Fiter y Planas (Barcelona lace manufacturers) and the Caja de Previsión y Socorro savings bank.

In a second solo exhibition at Els Quatre Gats in July Picasso presented four bullfight pastels. His first engraving, *El Zurdo* (fig. 14), was executed around this time with the assistance of Ricard Canals. (In years to come Picasso would seldom bother to reverse features in his prints—which explains the left-handed picador in this work—especially signatures and dates.)

14. Picasso, *El Zurdo,* Barcelona, 1899–1900, etching, 11.8 x 8 (4 ⅝ x 3 ⅛), private collection

Picasso was eager to see his painting *Last Moments* hung at the Exposition Universelle in Paris, so he and Casagemas traveled there, leaving at the end of September. A notice appeared in *Catalunya artística* (27 September) to the effect that "the noteworthy artists Ruiz Picasso and Casagemas, who have been named artistic correspondents for this journal, planned to depart yesterday [for Paris]." On their arrival in the French capital, Picasso and Casagemas made contact with Catalan artists already in residence there and managed to take over the studio of Isidre Nonell (who was returning to Barcelona) at 49 rue Gabrielle in Montmartre. Pallarès joined them on 23 or 24 October. Three women moved in: Odette (Louise Lenoir), who took up with Picasso; Antoinette (later Fornerod), who was paired up with Pallarès; and Germaine Gargallo (also known as Laure Florentin), who became involved with Casagemas and later married Ramon Pichot. (Pichot's symbolist canvases of the turn of the century influenced the young Salvador Dalí, who knew the Pichot family when he was a child in Cadaqués.)

On 25 October Casagemas and Picasso sent a letter to their friend Ramon Reventós (1881–1924) back in Barcelona (embellished with Picasso's drawings): "We have already started work and have a model. Tomorrow we are going to light the stove and work furiously, for we're already thinking about the paintings we're planning to send to the next Salon. Also . . . to exhibitions in Barcelona and Madrid. . . . So long as there is daylight . . . we stay in the studio painting and drawing." Casagemas went on to describe café life, asserting that Romeu would be "crazy not to come here and open up [a tavern]. . . . The Boulevard de Clichy is full of crazy places like Le Néant, Le Ciel, L'Enfer, La Fin du Monde, Les 4 z'Arts, Le Cabaret des Arts, Le Cabaret de Bruant, and a lot more that have no charm but make lots of money. A Quatre Gats here would be a gold mine. . . . Pere would

be appreciated and not at the mercy of the milling throng as he is in Barcelona. . . ." (McCully 1981, 27–28)

On 11 November Picasso and Casagemas again wrote to Reventós: "We've decided that we've been getting up too late and eating at improper hours and that everything was beginning to go wrong. On top of this . . . Odette was starting to become raucous because of [her] good habit of getting drunk every night. So we have arrived at the conclusion that neither [the women] nor we will go to bed later than midnight, and every day we'll finish lunch by one. After lunch we'll dedicate ourselves to our paintings and they'll do women's work—that is, sew, clean up, kiss us, and let themselves be 'fondled.' Well, this is a kind of Eden or dirty Arcadia. . . ." (McCully 1981, 31)

In addition to seeing his own work at the Exposition Universelle (hung too high, according to one reviewer), Picasso made a point of visiting the paintings section in the last weeks of the fair. Other special features included the Palace of Electricity; the Tour du Monde, with dioramas and plaster reproductions from Africa, South America, and Asia; demonstrations of x-rays, wireless telegraphy, and synchronized sound with movies; and performances by the "Japanese Bernhardt," Sada Yacco, and the celebrated veil dancer Loïe Fuller (Picasso did a drawing of Sada Yacco in the following year).

Picasso, Casagemas, and Pallarès also made the rounds of the cabarets, theaters, dance halls, and brothels (although Casagemas reportedly waited outside the brothels); and Picasso responded to the liberated atmosphere of Paris in several paintings, including *Moulin de la Galette* (cat. 40). He reported to Reventós (in the letter cited above) that he was finishing the canvas and that it was to be sold [through Berthe Weill for 250 francs to Arthur Huc, publisher of the newspaper *La Dépêche de Toulouse*].

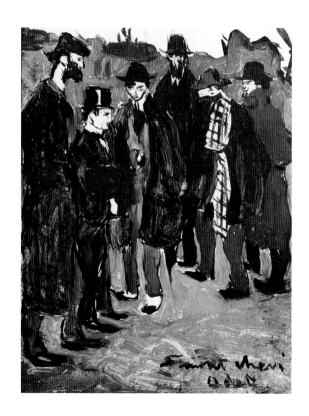

Picasso signed a contract with the dealer Pere Mañach (b. 1870), who agreed to pay him 150 francs per month for his work and to represent him in Paris. Mañach supplied paintings and drawings to several dealers, including Berthe Weill, who had a small gallery at 25 Rue Victor-Massé. Weill, in addition to taking three of Picasso's bullfight pastels and arranging the sale of the *Moulin de la Galette*, sold Olivier Sainsère a painting of a child in white. Picasso later recalled that Sainsère, a conseiller d'Etat, provided a measure of protection against the police, who suspected virtually all young Spaniards of anarchism (Daix and Boudaille 1967, 159). At Mañach's urging, the Spanish consul Emmanuel Virenque bought *The Blue Dancer* out of the artist's studio.

Pere Mañach was the son of a safe-and-lock manufacturer in Barcelona and as a young man had set himself up in Paris as a dealer in modern Spanish art. Although the French police suspected him of anarchist affiliation (because of

his friendship with known anarchist writers Jaume Brossa [1875–1919] and Pompeu Gener [1848–1920]), Mañach's politics were those of the "fashionable anarchism" that characterized the progressive philosophy of so many of his fellow Catalan businessmen.

On 29 December *La Publicidad* ran an article requesting amnesty for deserters from Cuba and the Philippines. Among the signers of the "Manifiesto de la colonia española en Paris" were Casagemas, Pallarès, Cardona, and Picasso.

Picasso's companion Casagemas was as depressed by Paris as Picasso was invigorated by it. His attempt at a love affair with Germaine was disastrous. In December Picasso and Casagemas returned to spend the holidays first in Barcelona and then with Picasso's relatives in Málaga.

1901

Arriving in Málaga on New Year's Day, Picasso and Casagemas behaved and dressed so outrageously that they were not allowed to stay in Picasso's uncle Salvador's house. Instead they took a room at the Tres Naciones on Calle de Casas Quemadas. Apart from a few drawings, Picasso produced little work during the month they spent there. This would be the last time Picasso returned to the city of his birth, and the last time he would see Casagemas.

On 28 January Picasso departed for Madrid and Casagemas returned by steamer to Barcelona. Casagemas wrote the Reventós brothers: "Picasso took off for Madrid this morning. I plan to be in Barcelona for as little time as possible, and if the ship gets there early, I'll go directly to the train station. If by chance I arrive in the evening or at night, I'll go to the Gats." (Ocaña, *Picasso i els 4 Gats*, 1995, 157–158)

After spending a few days in a pension on the Calle Caballero de Gracia, Picasso signed a one-year lease on a studio at 28 Calle Zurbano in

15. Picasso, *Group of Catalans in Montmartre: Pichot, Mañach, Casagemas, Brossa, Picasso, and Gener*, Paris, 1900, oil on paper, inscribed to "Odet," 23 x 17 (9 x 6 ⅝), Barnes Foundation, Merion, PA

16. Picasso, *Pío Baroja,* Madrid, published in *Arte Joven,* 1 June 1901

17. Picasso, *Head of Casagemas,* Madrid, published in *Catalunya artística,* 28 February 1901

Madrid. He and a friend from Els Quatre Gats, the writer Francisco de Asís Soler (c. 1880–1903), coedited a new art and literary journal called *Arte Joven*; five issues appeared beginning in March.

"Ruiz Picasso, who recently arrived in Madrid, has not slept for a moment, and has been studying, running around, painting, and sketching in all the streets and alleys of the land of the *chulos*. The principal fruit of his activity which has seen the light of day in Madrid is a new periodical, supported by good friends, *Arte Joven*. It has had a good start, particularly on the graphic side." (*Pèl & Ploma,* 15 March 1901)

Although Picasso never warmed to the Madrileños, his work on *Arte Joven* brought him into contact with some of the writers of the Generation of '98, notably Pío Baroja (1872–1956) and Miguel de Unamuno (1864–1936), whose books

and articles dealt with the reevaluation of Spanish life in the aftermath of the war with Cuba.

In February Picasso learned that Casagemas had returned to Paris, where his failure with Germaine drove him to suicide. Casagemas shot himself in front of a group of friends at the Hippodrome restaurant in Montmartre. Picasso's portrait drawing of his friend appeared with an obituary by Eduard Marquina in *Catalunya artística,* 28 February (fig. 17).

Picasso expressed his dismay at this turn of events in a letter (written in April) requesting assistance from Miquel Utrillo at *Pèl & Ploma*: "Friend Utrillo—I'm writing to ask you a favor. We're doing a magazine and we want to dedicate almost all of the second issue to [Santiago] Rusiñol. If it is not too much trouble and you would like to, could you send us some of the gardens that you reproduced [in *Pèl & Ploma,*

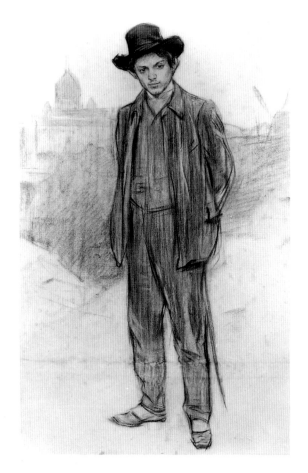

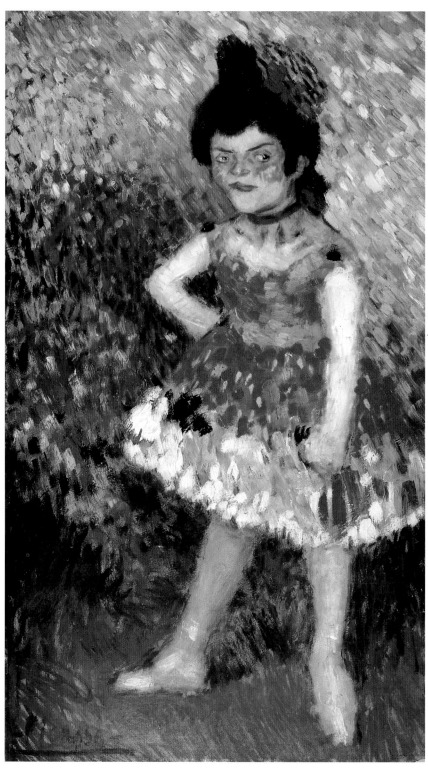

7 April 1900]. Needless to say, we will recipro-
cate. Write to us immediately giving us an
answer about what you decide. . . . You must
know about poor Carlos. You can imagine
the shock this has given me. . . ." (McCully
1981, 32)

Shortly afterward Picasso decided to leave
Madrid and *Arte Joven* and go back to Paris.
Although he had just submitted his painting
known as *Lady in Blue* (cat. 48) to the Exposi-
ción General de Bellas Artes, he left the canvas
behind. (With Picasso gone, Soler abandoned
Arte Joven and worked on another journal
La Música ilustrada. He died in an accident
in Santa Cruz de Tenerife two years later.)

In May Picasso stopped briefly in Barcelona,
where an exhibition of his pastels was being or-

18. Ramon Casas, *Picasso in Montmartre*, published in *Pèl & Ploma*, June 1901

19. Picasso, *Dwarf Dancer*, Madrid, 1901, oil on canvas, 102 x 60 (40 ⅛ x 23 ⅝), Museu Picasso, Barcelona

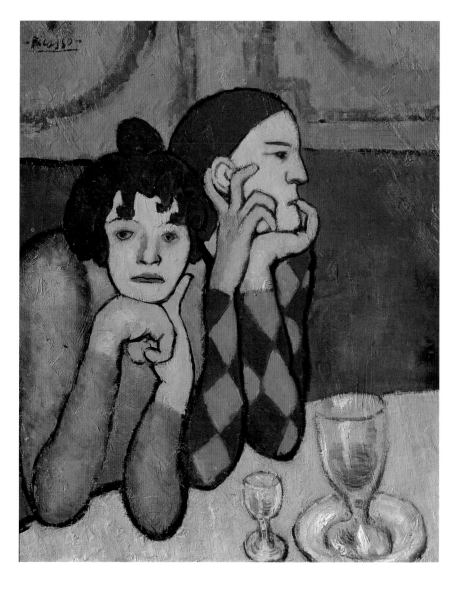

20. Picasso, *Harlequin and His Companion*, Paris, 1901, oil on canvas, 73 x 60 (28 ¾ x 23 ⅝), Pushkin State Museum of Fine Arts, Moscow

ganized at the Sala Parés gallery (June); a biographical article about him by Utrillo appeared in *Pèl & Ploma* at the time of the show with a portrait drawing by Casas (fig. 18).

Late in May Picasso traveled with a friend called Jaume Andreu Bonsons to Paris (see cat. 50), where, along with Mañach, he moved into Casagemas' studio at 130 ter Boulevard de Clichy and began immediate preparation for the exhibition that Mañach had organized of his work at Ambroise Vollard's gallery at 6 Rue Laffitte. Picasso exhibited some sixty-four paintings and drawings—many of which were done in only three weeks—alongside works by the Basque painter Francisco Iturrino (1864–1924). Gustave Coquiot (1865–1926) was enlisted to write a preface for the catalogue.

Picasso later recalled that "the canvases [at the Vollard show] were not presented as they usually are today, with plenty of space and in a single line, but on top of one another almost

to the ceiling and unframed, while some were not even on stretchers but in large folders, at the mercy of any collector or visitor." (Palau 1985, 257)

Félicien Fagus (*nom de plume* of the poet Georges Faillet [1872–1933]) reviewed the show in *La Revue blanche* (15 July 1901): "[Picasso] is the painter, utterly and beautifully the painter; he has the power of divining the essence of things. . . . Like all pure painters he adores color for its own sake. . . . he is enamored of all subjects, and every subject is his. . . . Picasso's surge forward has not yet left him the leisure to forge a personal style; his personality is embodied in this hastiness, this youthful impetuous spontaneity. . . . The danger lies in this very impetuosity, which could easily lead to facile virtuosity and easy success. . . . That would be profoundly regrettable since we are in the presence of such brilliant virility. . . ."

Fagus commended several works, including *Les Blondes Chevelures*, the picture Picasso gave him as a token of his gratitude for this review. This canvas recalls a composition by Gauguin of three girls dancing. Picasso also did portraits of fellow exhibitor Iturrino and of the show's sponsors (Coquiot, Vollard, and Mañach); he also gave a painting to the critic Pere Coll, who reviewed the show for a Barcelona journal: "Picasso is very young . . . and at his age I doubt if there are many who have done what he has. He has very great qualities but also great defects. The portraits of his companion Iturrino and one of another friend, Mañach, and a self-portrait are done with great courage and great confidence, indicating the genius of the painter. . . . " (Pere Coll, *La Veu de Catalunya*, 10 July 1901)

The Vollard show represented Picasso's first financial success. More than half the works were sold, and among the buyers was "Madame K. Kollwitz, artiste peintre à Berlin," who acquired *La Bête*.

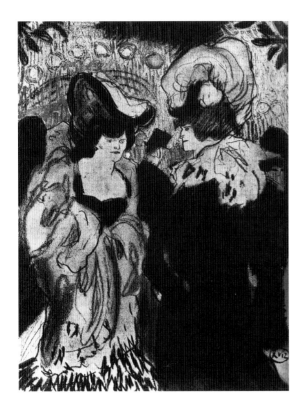

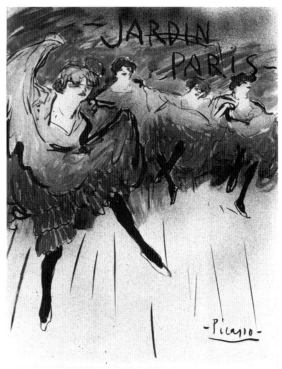

Picasso wrote in July to his friend Joan Vidal Ventosa (1880–1937) in Barcelona: "My exhibition in Paris has had some success. Almost all the papers have treated it favorably, which is something. . . . " (McCully 1981, 35)

Mañach introduced Picasso to the poet Max Jacob (1876–1944), who remained a close friend throughout life. Jacob later recalled: "As soon as he had arrived in Paris, [Picasso] had an exhibition at Vollard's, which was a veritable success. He was accused of imitating Steinlen, Lautrec, Vuillard, Van Gogh, etc., but everyone recognized that he had a fire, a real brilliance, a painter's eye. I was an art critic at that time; I expressed my admiration and I received an invitation from a certain M. Mañach, who spoke French and who managed all the affairs of this eighteen-year-old boy. . . . I went to see them . . . [and] I spent a day looking at piles and piles of paintings! He was making one or two each day or night, and selling them for 150 francs on the Rue Laffitte." (McCully 1981, 37)

Picasso also did illustrations for Paris journals (including *Frou Frou* and *Gil Blas*), using the name "Ruiz" (see fig. 21); he later turned down a regular job at *L'Assiette au beurre*.

Josep Oller (1839–1922), the Catalan proprietor of the Moulin Rouge and the Jardin de Paris, commissioned Picasso to do a poster for his dance hall (fig. 22), though his design was never printed.

In October five works (three from the Vollard show) were shown at the Salon Witcomb, Exposición de Pintura de Arte Catalan, in Buenos Aires.

In the autumn Picasso began to paint almost exclusively in shades of blue; as he later remarked, contemplating the death of Casagemas triggered this change in palette. Several paintings done at this time commemorate his friend's death, including three death's-heads, several groups of faceless mourners, and an evocation of the *Burial of Casagemas* (cats. 67–70). In this last

21. Picasso (signed Ruiz), *Two Women*, Paris, published in *Gil Blas*, 25 July 1902

22. Picasso, *Jardin [de] Paris*, design for a poster, Paris, 1901, brush and ink with watercolor, 64.8 x 49.5 (25 ½ x 19 ½), The Metropolitan Museum of Art, New York

composition the division of space into an earthly realm below and a heavenly realm occupying the space above recalls works by El Greco, notably the *Burial of Count Orgaz*. In Picasso's evocation, however, the upper realm is occupied by women, children, and prostitutes rather than welcoming angels. One nude bids farewell to Casagemas, who departs on horseback.

The subjects of syphilitic whores and maternities that have come to be identified with the Blue period were inspired by visits made at this time to the Saint-Lazare women's prison in Paris.

1902

Picasso broke his contract with Mañach and moved out of the apartment they shared; he returned in January to Barcelona, where he worked in the studio of Angel de Soto and another aspiring artist, Josep Rocarol (1882–1961), at 10 Carrer Nou de la Rambla. Again Picasso regularly joined his friends at Els Quatre Gats. In an advertisement he drew for the tavern (cat. 34), he placed himself (bearded) in front of the main table (the oversized gothic arch of the Puig i Cadafalch building is seen at the back); behind him from left to right: Romeu (the proprietor), Rocarol, the sculptor Fontbona, Angel de Soto, and standing, Jaime Sabartès.

During the next few months Picasso worked on a series of crouching street women and other scenes of alienation, including *Two Women at a Bar* (cat. 83). The artist is said to have contracted a venereal disease around this time. It is known that he made a gift of *Woman and Child by the Sea* (cat. 82) to his friend and doctor Josep Fontbona, presumably in exchange for medical attention. The doctor's brother Emili (1879–1938) also offered Picasso the opportunity to work in his sculpture studio. Picasso's earliest sculptures—including a seated woman, a picador (cats. 84, 95), and a blind singer — suggest the prevailing influence of Rodin, especially in the expressive treatment of surfaces.

In Paris Mañach arranged for works by Picasso and another artist, Louis Bernard-Lemaire to be shown at Berthe Weill's gallery (1–15 April). Adrien Farge wrote the preface to the catalogue: "Picasso is all nerve, all verve, all impetuosity. With vehement brush strokes, thrown on the canvas with great rapidity to keep pace with the flight of his conception, he builds brilliant, solid works, which delight the eyes of those taken with dazzling painting in colors that are sometimes crudely brutal, sometimes rare and knowing. . . . Then there is a *Clown* in glittering yellows and a fanciful *Pierrot*, both of which show Picasso's facility in capturing attitudes, while a brilliant, clamorous *Quatorze Julliet* combines the exaggerated movement and intensity of the popular festival in the gaudiest of colors." (Daix and Boudaille 1967, 334)

In response to Weill's show, Félicien Fagus discussed Picasso's work in an article in *La Revue blanche* (1 September 1902) about Spanish artists working in Paris (most of whom were represented by Mañach).

Picasso's reputation as a portraitist grew steadily during the Blue period. Not only did he paint and draw many of his Quatre Gats friends, notably Sabartès, Juli González, the de Soto brothers, and Sebastià Junyer Vidal, he also received several commissions. These included a portrait of Pere Romeu's wife Corina (cat. 80), portraits of the tailor (and minor patron) Benet Soler and his wife and family (1903), and the Catalan businessman Lluís Vilaró (1904).

Picasso worked earnestly in Barcelona, although those around him displayed little understanding of his work. In a letter to Max Jacob, he described his work in progress on *Two Sisters* (fig. 23): "My dear Max, it's a long time since I've written to you. It's not that I've forgotten you, but I'm working very hard. That's why I haven't written to you at all. . . . I'm showing what I'm doing to the '*artistas*' here, but they think there

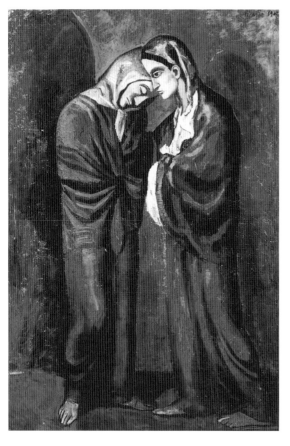

is too much soul and no form. It's very funny. You know how to talk to people like that; but they write very bad books and they paint idiotic pictures. That's life. That's how it is. [Emili] Fontbona is working very hard, but he's getting nowhere. I want to do a picture of this drawing I'm sending you. It's a picture of a St-Lazare whore and a nun. . . ." (McCully 1981, 38)

In the autumn an exhibition presented more than 1,800 works of ancient and medieval Catalan art at the Palau de Belles Arts in Barcelona. Picasso had the opportunity to study not only paintings by El Greco (including a *Saint John the Baptist* that would help inspire *La Vie*) but also primitive Catalan romanesque frescoes (fig. 24), which awakened an abiding interest in ancient Spanish art.

Before Picasso's twenty-first birthday in October his uncle Salvador bought him out of the draft for military service.

Several drawings by Picasso appeared in *El Liberal*, the newspaper directed by the Junyer Vidal brothers: Sebastià (1879–1966)—who became a close friend—and Carles (1881–1962), both of whom became minor dealers in works by the artist later in life. One of these drawings featured the Catalan feast of the Mercè (Our Lady of Ransom), showing the typical *gegants*, processional papier-maché giants, and a typical Blue period mother with two children in the foreground (see fig. 8 in Lubar essay).

In October Picasso returned to Paris in the company of the sculptor Juli González (1876–1942) and Josep Rocarol. Again Picasso made contact with the Catalan colony resident in the French capital. González and his brothers and sisters, who had trained as traditional iron craftsmen in Barcelona, had already moved to Paris, where Joan and Juli had established themselves as artists (the sisters later opened a dress shop in

23. Picasso, *Two Sisters*, Barcelona, 1902, oil on panel, 152 x 100 (59⅞ x 39⅜), The State Hermitage Museum, St. Petersburg

24. *The Visitation*, detail from an altar-front from Lluça, fourteenth century, 34 x 35.9 (13⅜ x 14⅛), Museu Episcopal, Vich

Montparnasse, where they sold buttons and accessories designed by Juli). Their home on the Avenue du Maine in Montparnasse was open to visiting friends from Barcelona. (Picasso would stay there briefly in 1904, at which time he worked with Joan González on the engraving of *The Frugal Repast* [cats. 104, 105].)

Life was difficult for Picasso that winter—he later claimed to have burned drawings to keep warm—and he moved several times, staying at the Hôtel Maroc and finally sharing Max Jacob's small apartment at 87 Boulevard Voltaire. Picasso remembered this episode nostalgically in a letter written the following year: "My dear old Max, I think about the room on the Boulevard Voltaire and the omelettes, the beans, the brie, and the fried potatoes. But I also think about those days of misery and that's very sad. . . . " (McCully 1981, 41)

In November Berthe Weill included works by Picasso in a group show at her gallery. The catalogue included an essay by Thilda Harlor (*nom de plume* of Jeanne-Fernande Perrot) in which she emphasized the freedom and indefatigable approach reflected in his work: "We see three studies of women, like cameos showing painful reality, dedicated to misery, loneliness, and exhaustion. A fierce light surrounds these creatures. There is a violent play of light and shade above and around them. One woman in particular personifies despair, isolation amid the unfeeling consolations of nature; she is seated on the sand, bent over at the waist, too desperately exhausted even to sob; and she apparently wishes to know nothing of the treacherous call of the ocean. . . . How different is the small sketch of a naked woman looking for something, suggested only by a clear, pure outline!" (Palau 1985, 515)

Charles Morice, who reviewed the show and gave Picasso a copy of Gauguin's *Noa Noa* when they met, wrote: "Picasso is someone who

painted before learning to read, someone whose destiny is to express by means of his brush everything in existence. One might say a young god out to do over the world. But he is a dark, unsmiling god. The hundreds of faces that he paints grimace—never grin. . . . What drawing! A crouching nude is little short of a miracle. What composition! A man and woman in a music hall, turning away from the stage in the background, where a dancer performs in a blaze of light, is as disturbing and provocative as one of the *Fleurs du mal*. People of indeterminate sex, 'mundane demons' with woebegone eyes, heads bowed, brows dark with desperation or thoughts of crime. . . . " (*Mercure de France*, December 1902)

Among the artist's new friends was the Basque potter Paco Durrio (1868–1940), also represented by Weill and a collector of Gauguin. Picasso signed a drawing "Paul Picasso" to commemorate his admiration for Gauguin.

1903
In January Picasso moved back to Barcelona to the studio he had formerly occupied with Casagemas and now shared with Angel de Soto, with whom he visited Barcelona brothels. A series of erotic drawings done on trade cards (from the Junyer Vidal brothers' shop) and caricature-like portraits of the de Soto brothers, Nonell, and Sebastià Junyer Vidal date from this period (cat. 91).

Picasso painted his most celebrated Blue period compositions during the next fifteen months. For the work known as *La Vie* (cat. 93) he painted over his earlier canvas *Last Moments*, which had been returned from the Exposition Universelle and was stored in the studio. Early drawings for *La Vie* suggest that his first idea was to represent himself at the left, with a bearded man (identified in one sketch as the sculptor Fontbona) entering from the right. As the painting progressed, Picasso changed

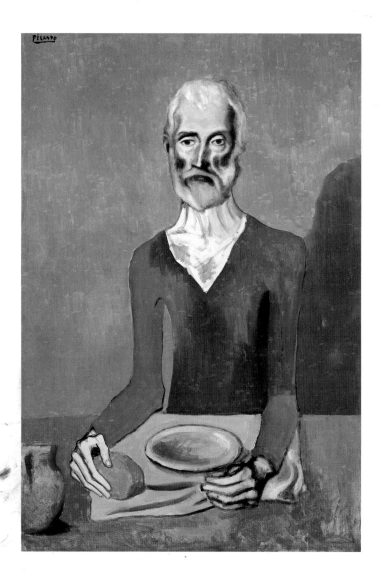

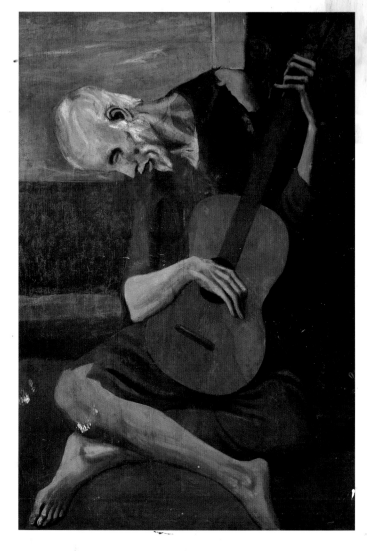

this right-hand figure to a typically Blue period mother and child and repainted the faces of the couple at the left with portraits of Casagemas and Germaine Gargallo (with whom Picasso had had an affair after the death of his friend). The straightforward scene of the artist's studio (with canvases stacked against the wall behind the principal figures) is thus transformed into a symbolic painting about life and death, with its highly charged personal references to Picasso's dead friend and the woman who triggered his suicide (in addition to the previous composition about dying, *Last Moments,* lurking beneath the surface).

A report of the sale of *La Vie* appeared in *El Liberal* on 4 June 1903: "Pablo Ruiz Picasso, the well-known Spanish artist who has had so many triumphs in Paris, has recently sold one of his latest works, for a respectable price, to the Parisian collector M. Jean Saint-Gaudens. This belongs to the new series that the brilliant Spanish artist has produced recently and to which we will devote ourselves soon with the attention it deserves. . . . The painting Jean Saint-Gaudens has acquired is entitled *La Vida* [*La Vie*] and is one of those works that, even considering it apart from the rest, can establish the reputation and name of an artist. The subject is, besides,

25. Picasso, *The Ascetic,* Barcelona, 1903, oil on canvas, 130 x 97 (51 ⅛ x 38 ⅛), The Barnes Foundation, Merion, PA

26. Picasso, *The Old Guitarist,* Barcelona, 1903, oil on panel, 122.9 x 82.6 (48 ⅜ x 32 ½), The Art Institute of Chicago, Helen Birch Bartlett Memorial Collection

interesting and suggestive, and the work of the artist is of such strength and intensity that one can say for certain that it is one of the few truly solid works that has been created in Spain for some time."

Other Blue period works evoking the beggar/ philosophers, maternities, and procuresses of the golden age of Spanish painting include *Blind Man's Meal, La Celestina* (cats. 94, 100), *The Ascetic,* and *The Old Guitarist* (figs. 25, 26).

In July the tavern Els Quatre Gats closed; the premises were subsequently occupied by the conservative Cercle Artístic de Sant Lluc.

Picasso became annoyed with de Soto's laziness and moved into the sculpture studio of Pablo Gargallo (1881–1934), who was in Paris at 28 Carrer del Comerç (facing Nonell's studio). For the five years that he had been living and working as an artist, Picasso had followed the pattern of most Barcelona artists, spending several months a year in Paris and returning to Catalonia (usually for the summer). It was becoming clear to him, however, that if he wanted to establish his reputation beyond the Spanish borders, he would have to reside permanently in France.

1904

In the spring Carles Junyer Vidal published a long article, "Picasso y su obra" in *El Liberal* (24 March 1904), in which he announced that Picasso intended to return to the French capital. Two weeks later (11 and 12 April) the same paper reported that "The artists Messrs. Sebastià Junyer Vidal and Pablo Ruiz Picasso are leaving on today's express for Paris, where they propose to hold an exhibition of their latest works."

Picasso stayed for a short time with the Gonzàlez brothers in Montparnasse before he and Junyer Vidal took over Paco Durrio's studio at 13 Rue Ravignan. The building was called the Bateau Lavoir because it looked like a Seine washing barge (perched on a hill in Montmartre; see fig. 27) and also because the floorboards in the old, ramshackle hallways creaked like a boat. Among his neighbors were the Catalan artist Ricard Canals and his Italian wife Benedetta. Picasso was asked to be godfather to Benedetta's son Octavi (fig. 29). (Junyer Vidal

27. Front of the Bateau Lavoir at 13 Rue Ravignan in Montmartre

28. Picasso, 1904, Musée Picasso, Paris

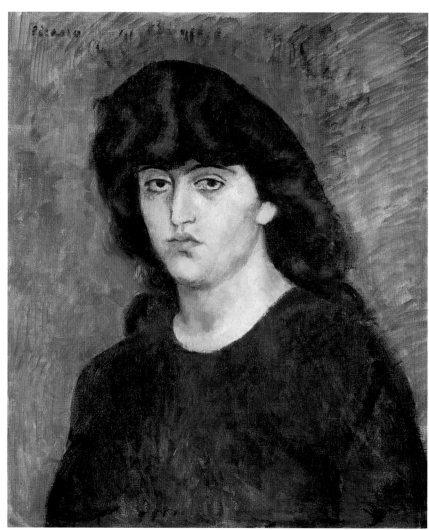

returned to Catalonia in the summer, leaving the studio at the Bateau Lavoir to Picasso.)

During these years Picasso's circle of friends widened, and he became especially close to the poets Guillaume Apollinaire (1880–1918) and André Salmon (1881–1969). Salmon later recalled a visit to the artist's studio and the Blue period works he saw for the first time: "A petrol lamp was burning on a table carved in bourgeois taste with Second Empire moldings, which [Picasso] had bought at a junk shop. There was no question of electricity or even gas at 13 [Rue Ravignan]. The petrol lamp gave out little light. In order to paint and to display his canvases, a candle was necessary—that guttering candle which Picasso held up high in front of me when he gave me a human introduction to the super-human world of these starving people, these cripples and mothers with no milk, the super-real world of *bleue Misère*." (Salmon 1955, 170)

Among the many other artists, writers, actors, and musicians whom Picasso met while he lived at the Bateau Lavoir (he left in 1909) were Déo-dat de Séverac, Frank Burty Haviland, Ricardo Viñes, Edgard Varèse, Erik Satie, Pierre Mac-Orlan, Maurice Raynal, Kees Van Dongen, Otto Van Rees, André Derain, Maurice Vlaminck, Alice Gèry (later Derain), Maurice Princet, Juan Gris, Amedeo Modigliani, Harry Baur, Charles Dullin, Henri and Suzanne Bloch (of whom he did a memorable portrait; see fig. 30), Marcelle Lapré, and Georges Braque (in 1907).

Once Picasso settled in Montmartre, his palette and subject matter began to change, which later prompted Coquiot to call this new phase

29. Picasso, *Octavi Canals*, Paris, 1904, pen and sepia ink on paper, 21 x 13.3 (8 ¼ x 5 ¼), private collection

30. Picasso, *Portrait of Suzanne Bloch*, Paris, 1904, oil on canvas, 65 x 54 (25 ⅝ x 21 ¼), Museu de Arte de São Paulo Assis Chateaubriand

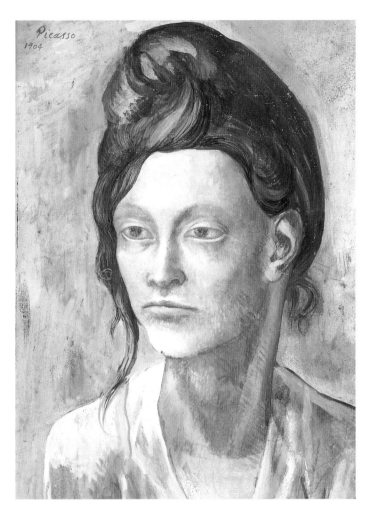

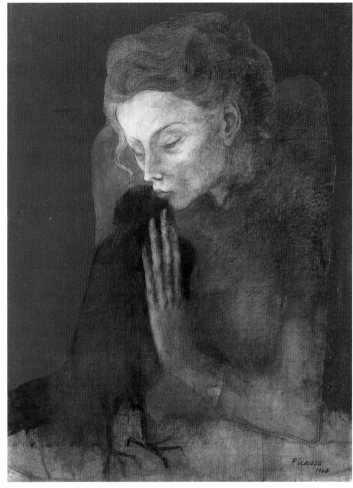

31. Picasso, *Woman with a Helmet of Hair*, Paris, 1904, gouache on board, 41.6 x 29.9 (16⅜ x 11¾), The Art Institute of Chicago, Bequest of Kate L. Brewster

32. Picasso, *Woman with a Raven*, Paris, 1904, charcoal, pastel, and watercolor on paper, 64.8 x 49.5 (25½ x 19½), The Toledo Museum of Art, Gift of Edward Drummond Libbey

33. Fernande Olivier and Benedetta Canals in the Canals' studio at the Bateau Lavoir, 1904, private collection

the Rose or Pink period. Major works include *Woman with Helmet of Hair, Woman with a Raven* (figs. 31, 32), *Woman Ironing, Woman in a Chemise (Madeleine), Young Acrobat on a Ball, Boy with a Pipe* (cats. 106, 112, 125, 138).

Soon after moving to the Bateau Lavoir Picasso met Fernande Olivier (1881–1966), an artist's model and great friend of Benedetta Canals (fig. 33). Known among Picasso's circle as "la belle Fernande," she was the artist's first real love and became a principal inspiration in his work until 1910; she and Picasso broke up definitively in the spring of 1912.

In July Gustave Coquiot commissioned Picasso to design the book jacket for his play (with Jean Lorrain), *Hôtel de l'Ouest* (fig. 34). He also supplied the artist with canvases and paints for some unidentified "portraits." (On a previous visit to Paris in 1902 Coquiot had asked Picasso to do drawings of entertainers for an album the writer had intended to publish. Picasso produced several of these, including a portrait of Jane Avril, but the album never appeared.)

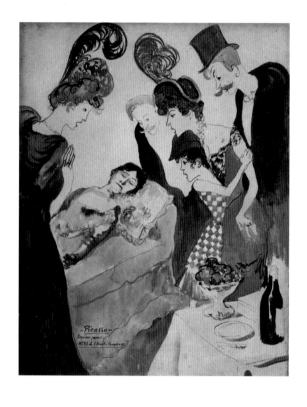

Picasso exhibited for the last time at Berthe Weill's gallery in a group show in October. Maurice Le Sieutre wrote the catalogue preface: "[Picasso] is a good image maker. A fine enameler, if one may express it that way. In his pastels, one finds sharp tones . . . left intentionally as a result of chemical oxidation. Their line is elegant, outlining the splashes of pinks and particularly blues that represent flowers, draperies, dresses, [and] the shawls of lively Spanish women. . . ." (Daix and Boudaille 1967, 238)

Picasso always enjoyed the company of his Spanish friends, many of whom had also settled in Paris. One of his favorites was the sculptor Manolo (1872–1945), who was associated with the emerging *Ecole romane,* principally French writers who had rejected literary symbolism in favor of classical ideals. Under the influence of Maillol, sculptors who were drawn to this movement responded by turning away from the expressive gestures and surfaces of Rodin; instead they looked to their roots in ancient Mediterranean tradition for inspiration.

At the end of the year Picasso worked on *The Actor* (see fig. 35; and fig. 6 in Read essay) and began his huge *Family of Saltimbanques* (cat. 137). Although the artist claimed to have little interest in the stage or opera, he was enthusiastic about the fringe theaters and cabarets of Montmartre, and several struggling actors numbered among his friends. Most of all he enjoyed the clowns and assorted traveling comedians he met at the bars near the Cirque Médrano. The marginalized performer became an alter ego for the artist in his work.

1905

Picasso was quite poor at this time. In February the critic Charles Morice came to his rescue and sponsored an exhibition of Picasso's saltimbanques (alongside works by two other artists, Gérardin and Trachsel) at the Galeries Serrurier on the Boulevard Haussmann (see fig. 37), for which he wrote the catalogue preface.

Picasso wrote his friend Jacint Reventós (1883–1968) in Barcelona: "It's such a terrible waste

34. Picasso, book jacket design for *Hôtel de l'Ouest, Chambre 22,* Paris, 1904, watercolor and crayon on paper, 55 x 44 (21 ⅝ x 17 ⅜), private collection

35. Picasso, drawing for *The Actor* with heads of Fernande, Paris, late 1904, pencil on paper, 47 x 31.5 (18 ½ x 12 ⅜), The Metropolitan Museum of Art, New York

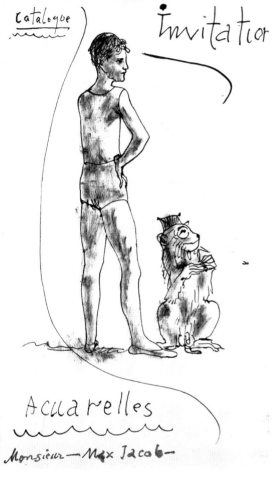

36. Picasso, *Two Acrobats with a Dog*, Paris, 1905, gouache on cardboard, 105.4 x 74.9 (41 ½ x 29 ½), The Museum of Modern Art, New York, Gift of Mr. and Mrs. William A. M. Burden

37. Picasso, *Young Acrobat with a Monkey* (personal invitation to Max Jacob for exhibition), Paris, 1905, pen, wash, and watercolor on paper, 21.7 x 12.5 (8 ½ x 4 ⅞), private collection

of time, scrounging the last peseta to pay for the studio or a restaurant. . . . Anyway I continue working and in a few days I'm going to have a small exhibition. God willing, people will like it and I'll sell everything I'm showing. . . ." (McCully 1981, 51)

Picasso showed thirty paintings and gouaches, plus three engravings and an album of drawings. Although his work was discussed in the press, he probably sold little. This would be Picasso's last Paris exhibition during the early period.

Apollinaire wrote two reviews, including the following: "The harlequins go in splendid rags, while the painting is gathering, warming, or whitening its colors to express the strength and duration of the passions, while thé lines, de-

limited by the tight curves, intersect or flow impetuously. . . . More than all the poets, sculptors, and the other painters, this Spaniard scathes us like a sudden chill. His meditations are laid bare in the silence. He comes from afar, from the opulence of composition and brutal decoration of the Spaniards of the seventeenth century." (*La Plume*, 15 May 1905)

The principal meeting places for Picasso's circle outside the Bateau Lavoir studio were various cheap restaurants, cafés, and cabarets, including Le Zut and Le Lapin Agile (fig. 39). Picasso did a self-portrait as a harlequin for the walls of Le Lapin Agile, with Germaine Gargallo beside him as Colombine (see fig. 7 in Weiss essay). At this popular Montmartre gathering place Picasso met Wilhelm Uhde (1874–1947), the German art

enthusiast (and first husband of Sonia Terk, later Delaunay) who had recently bought *Le Tub (The Blue Room)* (cat. 71). Thereafter Uhde occasionally dealt in works by the artist (giving him a show in Montparnasse in 1910).

One evening in the spring, after leaving the Cirque Médrano with Max Jacob, Picasso decided to model a head of his friend in clay. As he worked over the next day or two, the artist added the cap and bells of a jester, transforming his friend metaphorically into a member of his personal troupe of performer/saltimbanques (cat. 129).

Picasso's circle included a number of Dutch artists and writers, including the journalist Tom Schilperoort (1882–1930), the potter Jean van Dongen (1883–1970) (brother of the painter Kees and later an assistant to Aristide Maillol), and several artists who lived at the Bateau Lavoir: Kees and Guus van Dongen, Adya Dutilh and Otto van Rees. Van Rees later reminisced: "[Picasso] may have been a wonderfully gifted and imaginative artist, but he was always out for his own ends. All of us were poor as church mice and helped each other with loans of materials or food or small sums of money. Picasso was the only one who never paid anybody back." (Richardson 1991, 376)

Early in the summer of 1905 Picasso traveled to north Holland, where he spent some six weeks in Schoorl and Schoorldam at the invitation of Schilperoort. According to Picasso: "Schilperoort came into some money; he inherited 10,000 francs. He'd made up his mind to go to his village in Holland. I didn't have any money. A little, at least, was needed to make the trip. Max Jacob didn't have any more than I did. He went to the concierge and returned with 20 francs. I had a satchel . . . and had put my paints in, but the brushes wouldn't go. So I broke them in half and was on my way." (Daix and Boudaille 1967, 274)

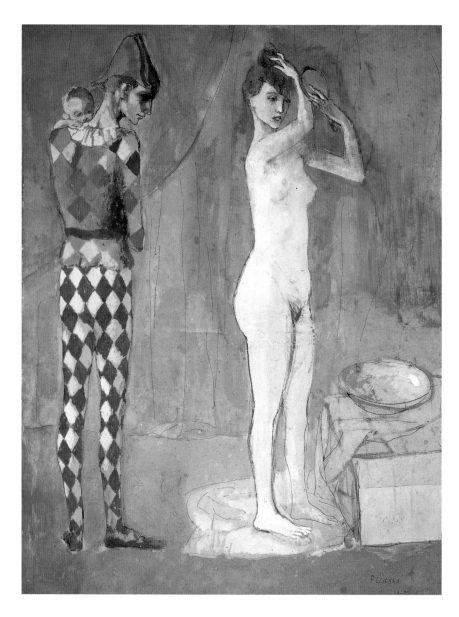

38. Picasso, *Harlequin's Family*, Paris, 1905, gouache, pen, and collage on cardboard, 60.6 x 45.2 (23 ⅞ x 17 ¾), private collection, Monaco

39. Interior of the Lapin Agile, with the owner, Frédé, playing his guitar, c. 1905

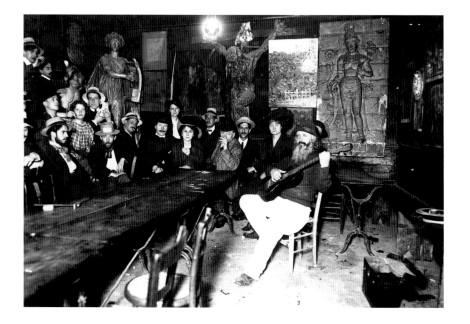

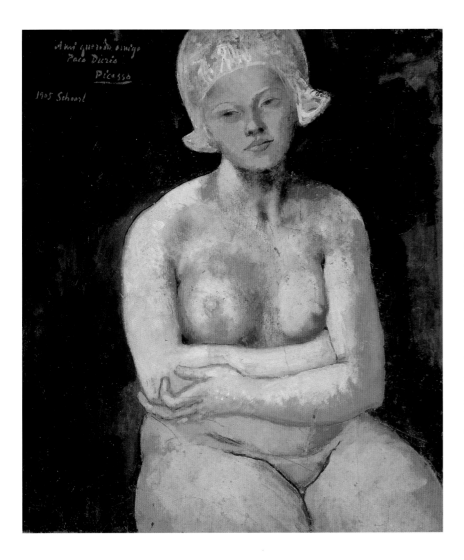

40. Picasso, *La Belle Hollandaise*, Schoorldam, 1905, gouache, oil, and blue chalk on cardboard, 77 x 66.3 (30⅛ x 26⅛), Queensland Art Gallery, Brisbane

In his sketchbooks Picasso recorded visits to Alkmaar and Hoorn, but not to Amsterdam. He continued working out compositional ideas and color schemes for the *Family of Saltimbanques* canvas he had left behind in Montmartre; the great expanses of sand dunes near Schoorl may have influenced the empty landscape setting in the final composition. In the room Picasso rented alongside the North Holland canal he worked on three large gouaches: *Three Dutch Girls* (cat. 134), *Nude with Dutch Bonnet,* and *La Belle Hollandaise* (fig. 40). The villagers were said to have been shocked that a local girl (probably Dieuwertje de Geus, the daughter of the postman and Picasso's landlady) agreed to pose naked for him. The hefty Dutch body type provided a sharp contrast to the waifs of Montmartre. For depicting the large, fleshy "Belle Hollandaise" Picasso experimented with sculptural effects by mixing glue and gouache to build up the actual surface. He later gave this Gauguinesque painting to his friend and fellow Gauguin admirer Durrio.

Within weeks of Picasso's return to Paris, Fernande Olivier moved into his studio. In the beginning of their relationship each was ecstatically happy with the other, and the paintings and drawings Picasso did of her over the next months celebrate both her beauty and their personal closeness (cat. 110). In spite of the squalor of the Bateau Lavoir, their studio became an even more popular gathering place, with impromptu dinners, poetry readings, and even drug sessions becoming regular features.

Picasso resumed work on the large *Family of Saltimbanques* canvas, probably intending to exhibit it in the autumn, but he abandoned the idea. Although André Salmon once claimed that the strongman standing next to the Picasso/harlequin figure (at the left) was supposed to represent Apollinaire, he was actually an itinerant performer called El Tío Pepe. The model for the girl with the basket of flowers was a local Montmartre child.

Picasso made a habit of visiting the small dealers' galleries, and he and Fernande regularly attended the popular vernissages of the official salons. The 1905 Salon d'Automne featured works by Maillol (notably *La Mediterranée*), Le Douanier Rousseau, the celebrated room devoted to Matisse and the artists who became known as the fauves, and a retrospective of works by Ingres. Picasso painted *Woman with a Fan* (cat. 140), in part as a response to Ingres (an artist to whom he would return for inspiration in 1914).

The Americans Gertrude (1874–1946) and Leo Stein (1872–1947) had set up residence at 27 Rue de Fleurus in Paris and with their inheritance were beginning to amass an extraordinary collection of art. Shortly after acquiring Matisse's *Woman with a Hat,* they bought Picasso's *Harlequin's Family with an Ape* (cat. 122).

According to Leo Stein: "I dropped in at [the dealer] Sagot's to talk about Picasso; he had a

picture by him, which I bought. The ape looked at the child so lovingly that Sagot was sure this scene was derived from life, but I knew more about apes than Sagot did and was sure that no such baboon-like creature belonged in such a scene. Picasso told me later that the ape was his invention, and it was a proof that he was more talented as a painter than as a naturalist." (Leo Stein, *Appreciation: Painting, Poetry, and Prose* [New York, 1947], 169)

1906

Gertrude Stein (fig. 41) became a great friend and patron of Picasso's; and the salon she held at her home attracted a wide range of artists, writers, and foreigners interested in the arts. She encouraged a number of her American friends, including Etta (1870–1949) and Claribel Cone (1864–1929) of Baltimore to buy drawings and paintings by Picasso and Matisse: "Etta Cone found the Picassos appalling but romantic. She was taken there by Gertrude Stein whenever the Picasso finances got beyond everybody and was made to buy a hundred francs' worth of drawings. After all a hundred francs in those days was twenty dollars. She was quite willing to indulge in this romantic charity." (Stein 1961, 52)

Picasso met Henri Matisse (1869–1954) around the time of the spring Salon des Indépendants; their friendship would last a lifetime. They visited each other's studios (in 1907 they exchanged paintings) and responded to their respective work in progress—even if it merely represented a challenge to go one better. Gertrude Stein encouraged their rivalry at her salon; her brother Michael and his wife Sarah became Matisse's leading patrons.

During the early months of 1906 Picasso no longer painted harlequins (he had ended the previous year with a *Death of Harlequin* [cat. 141]), preferring horseback riders and youths who occupied arcadian landscapes in the spirit of both Gauguin and Puvis de Chavannes (whose

work was featured at the Indépendants). Picasso planned a large *Watering Place* composition; although it was unrealized (apart from the studies [see cat. 142]), he painted the related *Boy Leading a Horse* (cat. 145).

Picasso also worked on the *Portrait of Gertrude Stein* (cat. 168). In the *Autobiography of Alice B. Toklas* Alice recalled that Gertrude sat some ninety times: "Fernande offered to read LaFontaine's stories aloud to amuse Gertrude Stein. . . . She took her pose, Picasso sat very tight on his chair and very close to his canvas and on a very small palette which was of a uniform brown grey color, mixed some more brown grey and the painting began." (Stein 1961, 46–47)

Picasso's preoccupation with classicizing subjects and forms, as well as with a renewal of interest in modeling, led him to study antiquities, including recent finds of Iberian art from Cerro de los Santos (in Andalusia) at the Louvre.

41. Gertrude Stein, c. 1901, Beinecke Rare Book and Manuscript Library, Yale University

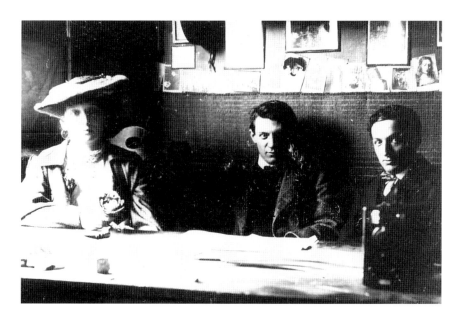

42. Fernande, Picasso, and Ramon Reventós in Barcelona, May 1906, photograph by Vidal Ventosa

The Italian painter and writer Ardengo Soffici later recalled: "[Picasso] would go from museum to museum nourishing himself on good old and modern painting, and since I used to do the same thing, it wasn't unusual for us to run into each other in the impressionist room at the Luxembourg or in the Louvre. There Picasso always returned to the ground-floor rooms, where he would pace around and around like a hound in search of game between the rooms of Egyptian and Phoenician antiquities—among the sphinxes, basalt idols and papyri, and the sarcophagi painted in vivid colors." (Ardengo Soffici, *Ricordi di vita artistica e letteraria* [Florence, 1942], 365–366)

Picasso put aside the portrait of Gertrude Stein after working on it for three months. Stein wrote: "Spring was coming and the sittings were coming to an end. All of a sudden . . . Picasso painted out the whole head. I can't see you any longer when I look, he said irritably. And so the picture was left like that." (Stein 1961, 53)

In April the dealer Vollard visited Picasso's studio and bought virtually all the artist's recent work, except for the *Family of Saltimbanques.* (Although Picasso finally agreed to a contract with Daniel-Henry Kahnweiler in 1912, Vollard,

who never offered the artist a contract, would continue to buy his work throughout the early period.) With the 2,000 gold francs Picasso received, he took Fernande with him to Spain, first to Barcelona and then to Gósol. She later recalled: "The Picasso I saw in Spain was completely different from the Paris Picasso: he was gay, less wild, more brilliant and lively and able to interest himself in things in a calmer, more balanced fashion; at ease in fact. He radiated happiness and his normal character and attitudes were transformed." (Olivier 1965, 93, 95)

Picasso and Fernande arrived in Barcelona on 21 May and spent approximately two weeks there visiting family and friends (including Ricard and Benedetta Canals, Pablo Gargallo, the de Soto brothers, Ramon Reventós [fig. 42]). On 23 May the artist wrote the sculptor Enric Casanovas (1882–1948), who was planning either to accompany or to visit them in Gósol: "Would you like to come tomorrow in the evening to the [Hôtel] Continental so that we can arrange all the details of the journey?" (Richardson 1991, 434)

At this moment life with Fernande was idyllic. Picasso introduced her to his family in Barcelona as his *novia*, although she was never in a position to marry him (she had never divorced her husband, Paul Percheron). In Gósol the beauty of the surroundings and the clear air and calm suited them both—apart from the villagers, the only outsider seems to have been a Catalan musician (Carles Vidiella), who transported his piano up into the Pyrenees on muleback. Picasso was particularly fond of the old innkeeper and former smuggler Josep Fontdevila (1821–1910), with whom he went into the hills to hunt and to collect materials for carving.

On 27 June Picasso wrote his friend Casanovas, who was still planning to join them: "Tell me a few days before you come so that I can answer you, because I may want you to bring some

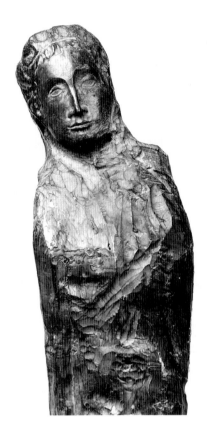

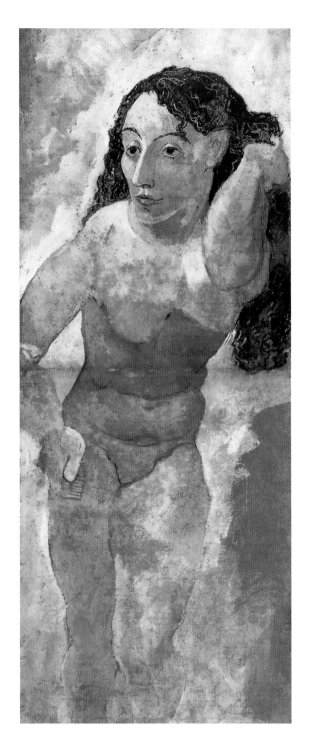

chisels to work the wood [that the villagers had brought him]." (Richardson 1991, 442–444)

Although the sculptor never made the visit, Picasso wrote Casanovas again in July: ". . . I want you to buy or send me by mail a roll of twenty sheets of *papier Ingres* and as quickly as you can, because I have finished the small stock of paper I bought in Barcelona. . . . Could you send me in the same package two or three small chisels to work in wood?" (Richardson 1991, 444). Picasso worked on several woodblocks and a few sculptures, including a boxwood figure, the so-called *Bois de Gósol* (fig. 43).

In Gósol Picasso was inspired both by the presence of Fernande and by some of the villagers, including Fontdevila, who agreed to pose (see cats. 164–166). The generally reddish, clay-colored palette of the Gósol paintings reflects a preoccupation with modeling and a turning back to his archaic, Mediterranean artistic roots.

Picasso worked enthusiastically, and the huge number of works he produced included figure paintings and drawings, a series of still lifes, and several landscapes (see cats. 148–166).

Picasso and Fernande were present for several village festivals, including Saint John's Eve (Midsummer's Day); and on 20 July the feast of Santa Margarida, the patron saint of Gósol. Picasso's sketchbooks record the dancing couples.

Fear of typhoid forced the couple to leave for Paris. On 13 August Picasso wrote Casanovas to forget about the various errands he and Fernande had requested him to undertake on their

43. Picasso, *Bois de Gósol* (detail), Gósol, 1906, carved boxwood, height: 77 (30¼), Musée Picasso, Paris

44. Picasso, *Woman Combing Her Hair*, Paris, 1906, india ink and watercolor on paper, 139 x 57 (54¾ x 22⅜), Musée de l'Orangerie, Paris, Jean Walter and Paul Guillaume Collection

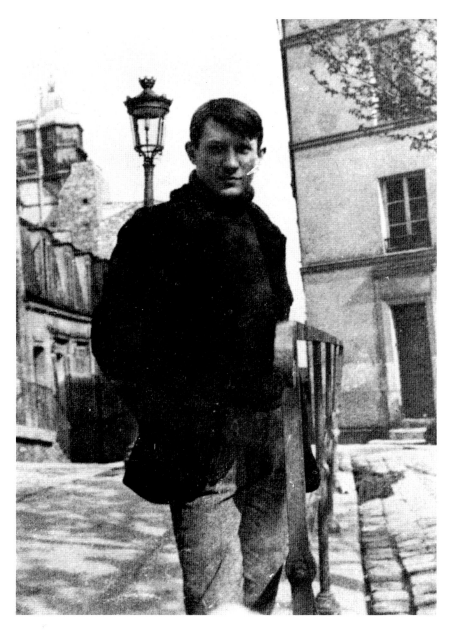

On Picasso's return to the Bateau Lavoir, he wrote Leo Stein (17 August) about the large composition known as *The Blind Flower Seller* (Barnes Foundation, Merion, PA), which he had begun in Gósol and for which he included a drawing. The subject was likely inspired by something Picasso had seen at a village festival: "I have received your letter and the money. Thanks. I worked at Gósol and am working here. I will show you and talk to you about all that when I see you. Each day is more difficult. . . . I am in the course of doing a man with a little girl. They are carrying some flowers in a basket. Beside them are two oxen and some wheat." (Richardson 1991, 455)

Picasso also set about finishing the *Portrait of Gertrude Stein*: "Everybody thinks she is not at all like her portrait," Picasso said, "but never mind, in the end she will manage to look just like it." (Roland Penrose, *Picasso: His Life and Work* [London, 1981], 118)

The artist embarked on various works, including *Nude Combing Her Hair* (fig. 44) and two-figure compositions culminating in *Two Nudes* (cat. 177). He also worked on ceramic sculptures in Paco Durrio's studio, including a *Bust of Josep Fontdevila* and *Fernande Combing Her Hair* (both later cast in bronze; see cats. 166, 171–172). Picasso's experiments in stoneware under Durrio's instruction were inspired by ceramics by Gauguin they saw (probably together) at the artist's retrospective at the 1906 Salon d'Automne.

At the end of the year Picasso stopped painting, choosing to fill sketchbooks with studies for a major figure composition that would become *Les Demoiselles d'Avignon*, the work that would confirm him as a revolutionary innovator of modern art. The twenty-five-year-old artist was no longer the hopeful heir to the "School of Málaga" but had assumed his position as a modern master on the world stage.

45. Picasso on the Place Ravignan, 1904, Musée Picasso, Paris

behalf: "within a few days we are going to Paris by Puigcerdà and will take the train to Aix [*sic*, Ax] and from there to Toulouse. I never received the paper and I think it must have been lost. When you write you can tell me what I owe you and I'll send [the money]. . . . I'll write you from Paris and would appreciate it if you wouldn't tell anyone that I'm returning there. . . . Hugs from your friend Pau [Catalan for Pablo]." (Richardson 1991, 451)

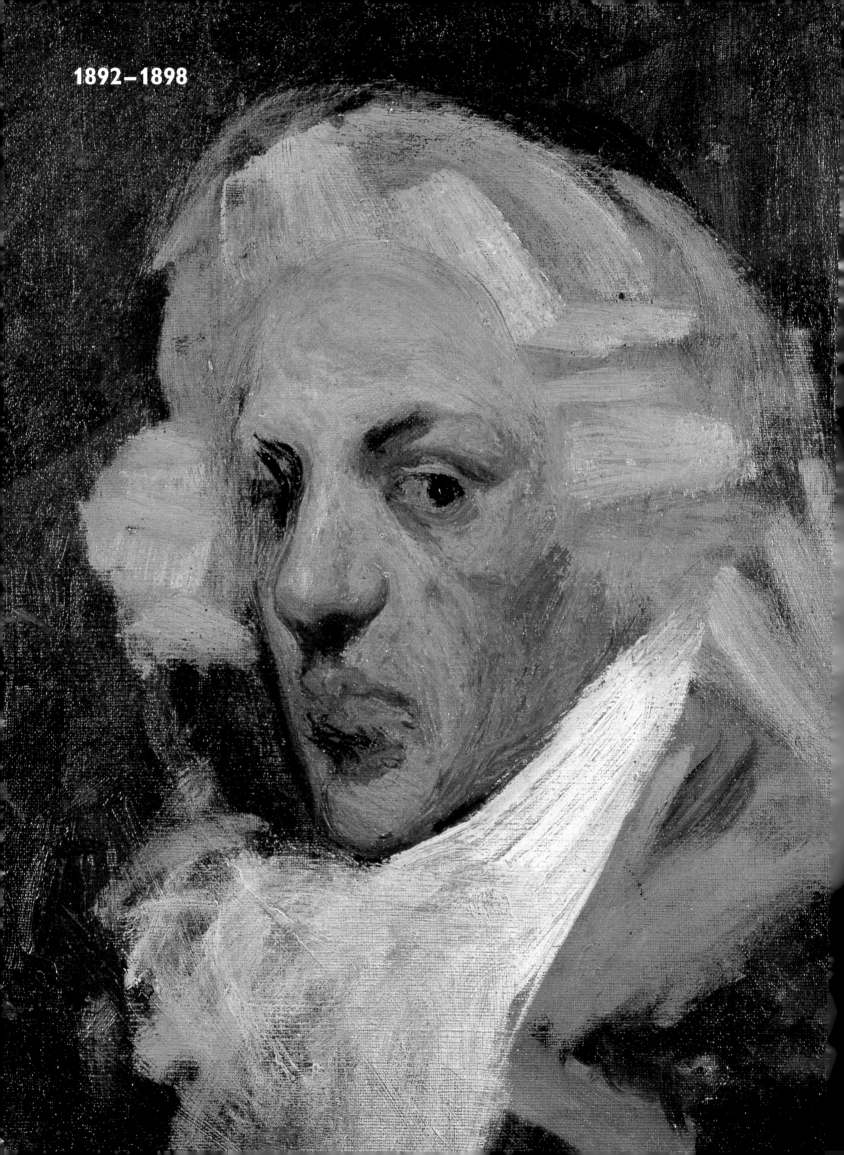

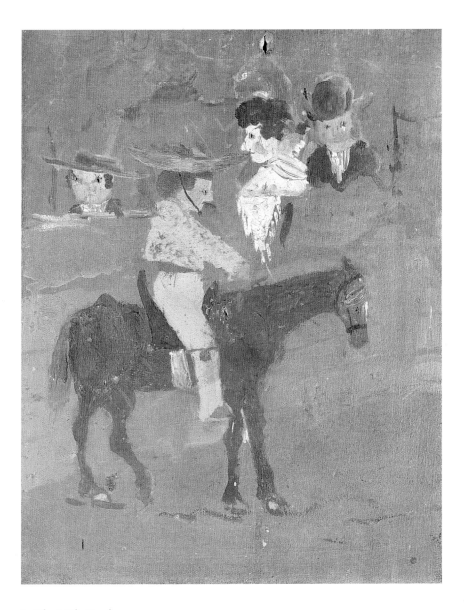

1. *The Little Picador,*
Málaga, 1892, oil on
panel, 24 x 19 (9 ⅜ x
7 ½), private collection

Detail, cat. 12

2. *Study of a Torso, after a Plaster Cast,* La Coruña, 1893–1894, charcoal on paper, 49 x 31.5 (19 ¼ x 12 ⅜), Musée Picasso, Paris

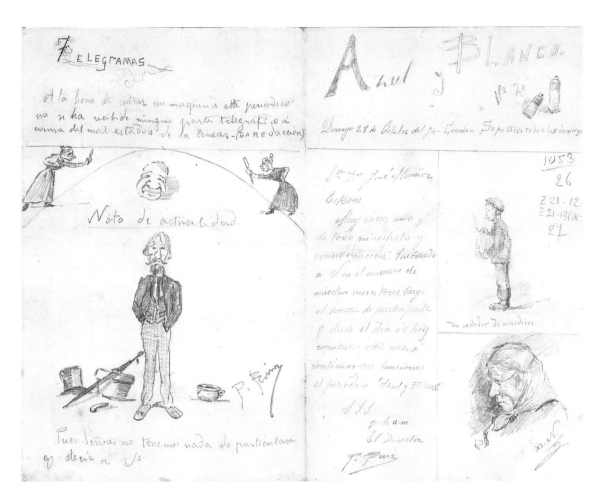

3. *Azul y Blanco*,
La Coruña, 1894, pencil
on paper, 20.5 x 26.5
(8 1/8 x 10 3/8), Musée
Picasso, Paris
Boston only

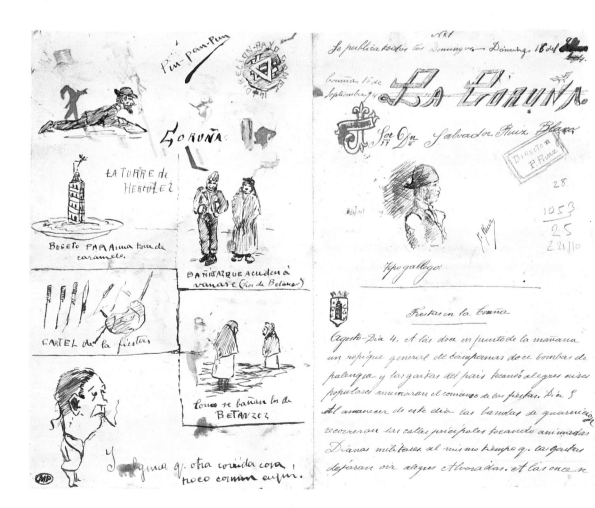

4. *La Coruña*, La
Coruña, 1894, ink and
pencil on paper, 21 x 26
(8 1/4 x 10 1/4), Musée
Picasso, Paris
Washington only

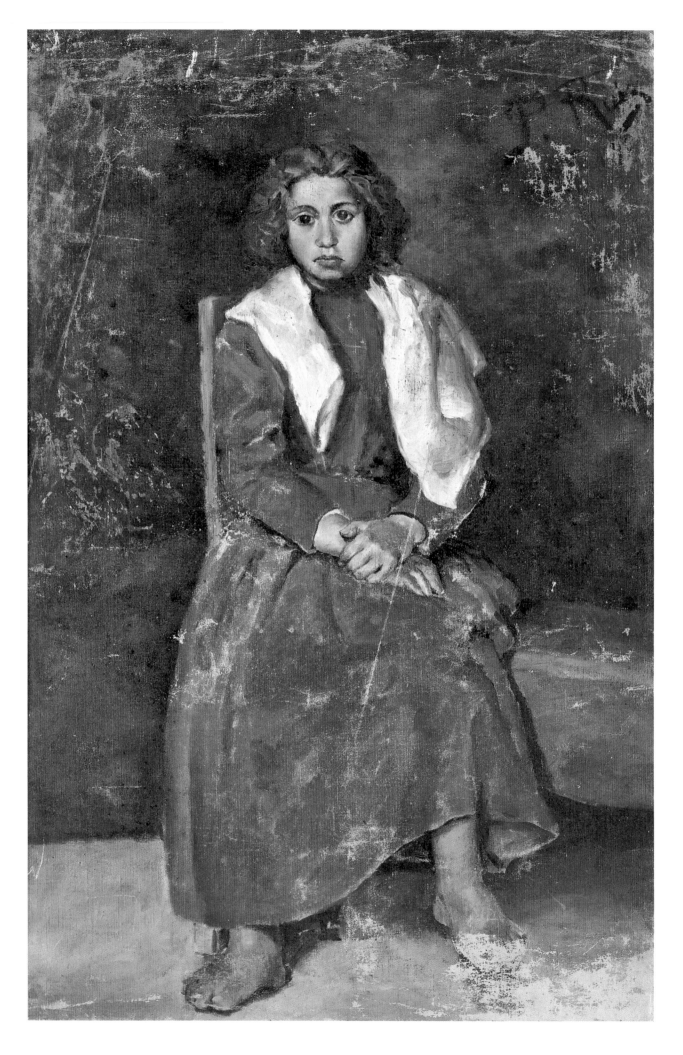

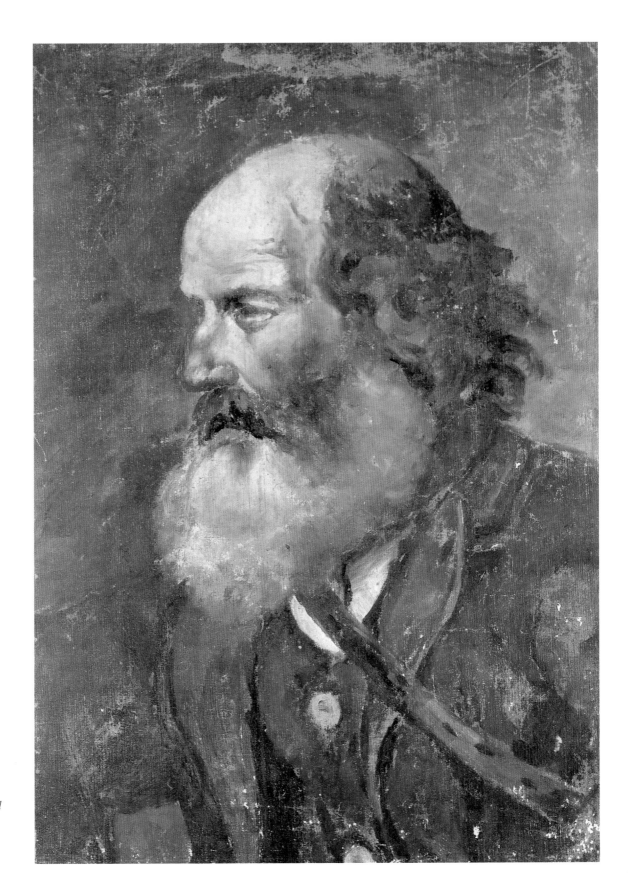

5. *Girl with Bare Feet*, La Coruña, early 1895, oil on canvas, 75 x 50 (29 ½ x 19 ⅝), Musée Picasso, Paris

6. *Portrait of a Bearded Man*, La Coruña, 1895, oil on canvas, 57 x 42 (22 ⅜ x 16 ½), private collection

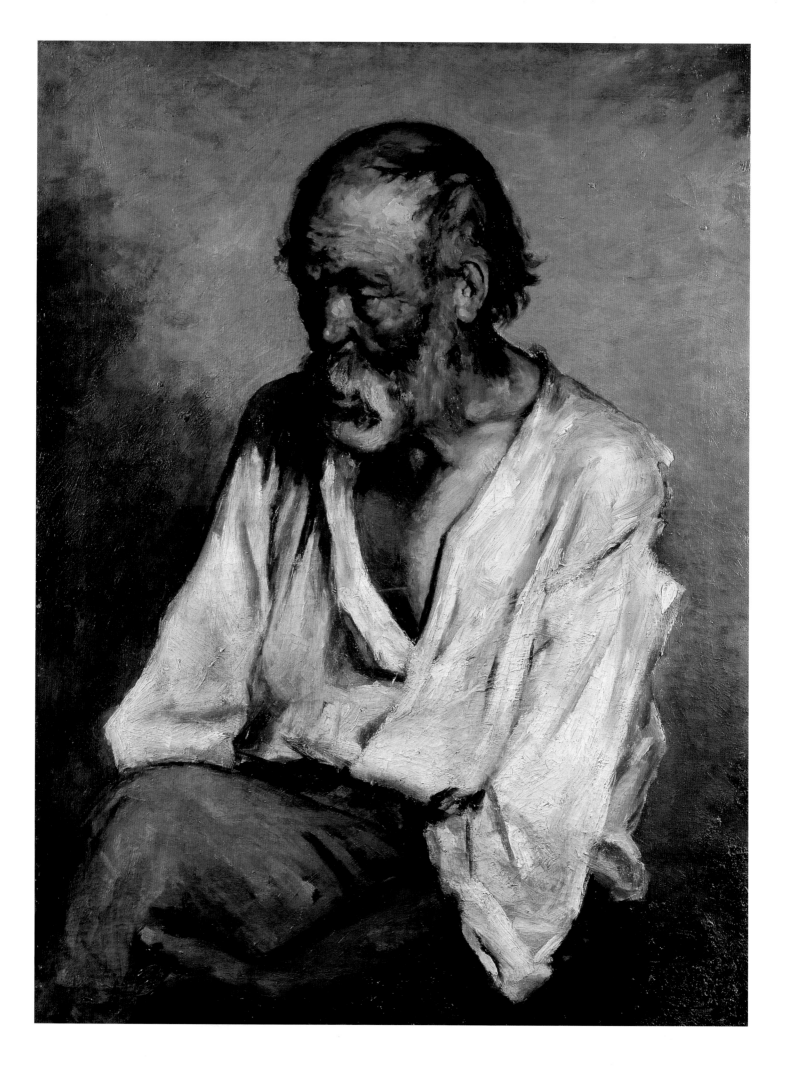

7. *The Old Fisherman (Salmerón)*, Málaga, summer 1895, oil on canvas, 83 x 62 (32⅝ x 24⅜), Museu de Montserrat, Barcelona
Washington only

8. *Male Nude*, Barcelona, 1896, charcoal and conté crayon on paper, 60 x 47.4 (23⅝ x 18⅝), Museu Picasso, Barcelona

9. *Academic Nude*,
Málaga, 1895–1897, oil
on canvas, 82 x 61 (32 ¼
x 24), Museu Picasso,
Barcelona

10. *Seascape with Houses
in Foreground*, Málaga,
summer 1896, oil on
canvas, 23.5 x 29.4 (9 ¼
x 11 ⅝), Museu Picasso,
Barcelona

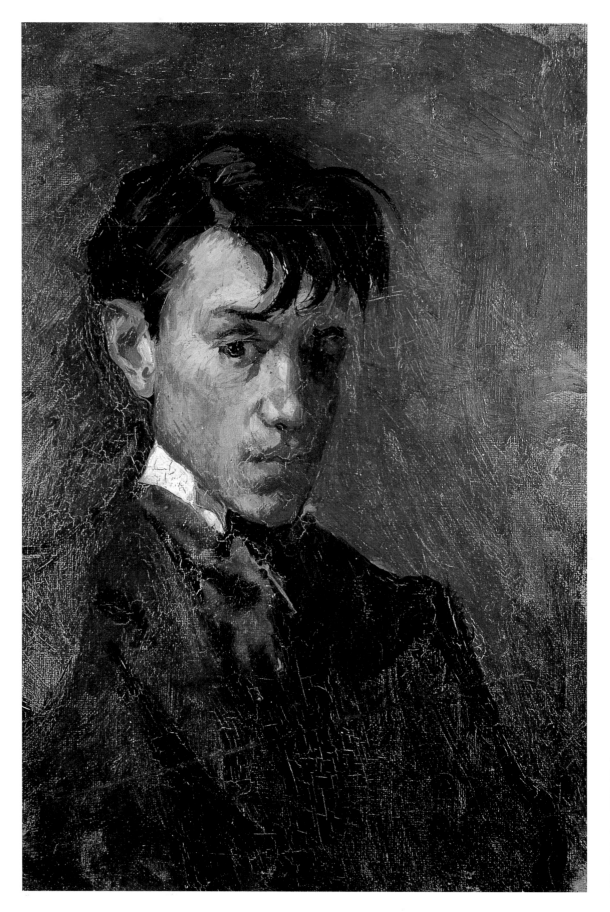

11. *Self-Portrait*, Barcelona, 1896, oil on canvas, 32.7 x 23.6 (12 7/8 x 9 1/4), Museu Picasso, Barcelona

12. *Self-Portrait in a Wig*, Barcelona or Madrid, c. 1897, oil on canvas, 55.8 x 46 (22 x 18 1/8), Museu Picasso, Barcelona

13. *Portrait of a Woman*,
Barcelona or Madrid,
c. 1897, colored pencil
and charcoal on paper,
20.7 x 15.5 (8 ⅛ x 6 ⅛),
private collection, cour-
tesy Galerie Berès, Paris
Boston only

14. *Shed with Carriages
and Barrels,* Horta de
Ebro, 1898, oil on canvas,
31.2 x 47.5 (12¼ x 18¾),
Museu Picasso, Barcelona

Gods of Art: Picasso's Academic Education and Its Legacy

Natasha Staller

In 1890 when he was nine years old and living in the provinces of Andalusia, Picasso drew *Hercules* (fig. 1), his first signed and dated work—very possibly, in his eyes, his first masterpiece. This heroic if still human-looking male nude, this demigod, brandishes his mythological attribute and demonstrates Picasso's skill and his daring: to capture a figure in *contrapposto,* with arm and legs foreshortened; to conquer a difficult subject and style and claim his image with a signature flourish. In effect it is a proper academic drawing, as though Picasso already were enrolled in formal classes, an impossibility at his age. It is a repository of dreams. It offers a tantalizing glimpse of how he first conceived of art, first imagined ideal bodies, first fantasized an artist's path to glory. Every one of these conceptions was institutionally driven: learned first from his father, then from other professors who taught at and were defined by Spanish academic

institutions. This is the academic crucible where Picasso began. Many lessons he would reject. Others he would subvert. While some crucial lessons he would remember forever.

Spanish Academies, at the Center and Periphery

The first Spanish academy, La Academia de San Fernando, was founded in Madrid in 1752 by an absolutist monarch on an absolutist model for the most exalted of reasons. It would give glory to God as well as to his representative on earth—who would realize, like the French kings, that "les arts du dessin" were an ultimate treasure and most potent propagandistic tool. By training artists at home instead of relying on those who were foreign born, the academy would stop the flood of pesetas beyond Spain's borders and counteract the lure of other centers that might tempt Spaniards to study elsewhere.[1] Once founded, the new royal academy's propagandistic cachet was enhanced by its new home: La Casa de la Panadería, a royal residence.[2]

Although a statute initially barred the creation of other academies within Spain, a cascade of other schools was founded, radiating outward from the capital, under the thumb of Madrid's authority. Royal decrees dictated the specific status of individual schools (that is, whether they were of the first or second rank) and also a shared curriculum—including additions over time of courses such as *colorido* (painting) and landscape.

Many of the same plaster casts—of the Apollo Belvedere, Parthenon figures, and other consensual masterpieces like Michelangelo's *Dying Slave*—lorded over hallways and classrooms of academies from Cadiz to Málaga, La Coruña to Barcelona, to be studied and copied with reverence and love (fig. 2). The academy's neoclassical orientation, whose visual models persisted through the time Picasso was in school, began when Antonio Raphael Mengs was brought in as the San Fernando's director

Detail, plate 9

1. Picasso, *Hercules,* Málaga, 1890, pencil on paper, 49.6 x 32 (19 ½ x 12 ⅝), Museu Picasso, Barcelona

in 1761. As an apostle of Winckelmann and convert to his faith in antiquity, Mengs believed Winckelmann's paradoxical dictum that "the only way for us to become great, or, if that be possible, inimitable, is to imitate the ancients," and shared his Platonic conviction that "the masterpieces of Greek art" embodied "not only nature at its most beautiful, but also something beyond nature, namely, certain ideal forms of beauty."[3] Velázquez, Mengs conceded, was Spain's greatest painter, a master of *clarobscuro,* the virtuosic handling of light and shading, as well as aerial perspective.[4] Yet Velázquez' deficiently unidealized style damned him to the lowly fifth level of Mengs' artistic hierarchy. "El estilo sublime," the sublime style, "the apex of beauty, had never been produced in the entire history of Spanish art."[5]

After Mengs' directorship, the tenets of neoclassicism were attacked from within the academy itself, as nationalistic pride in the Spanish school returned with a vengeance. Academicians began to paint in a range of more naturalistic styles, many inspired by French painters like Meissonier.[6] Yet the casts and two-dimensional images of canonical classical statues continued to be copied decades later when Picasso was in school. (Plates of many of these sculptures as well as canonical paintings from the Prado and other European museums had been shipped out of Madrid to regional academies.)[7]

By the time of Picasso's childhood Spanish academic education was rigidly intertwined with a prescribed career trajectory (a path available only to men; women could take only limited *cursos para señoritas*).[8] If a student did very well, he would get honor grades; he could then compete for scholarships to Paris or Rome, where he would learn to make the large history paintings that would put him in the strongest position to take one of the three medals at a national exhibition; then and only then could he become a professor at a Spanish academy. (A law to this effect was passed the year before

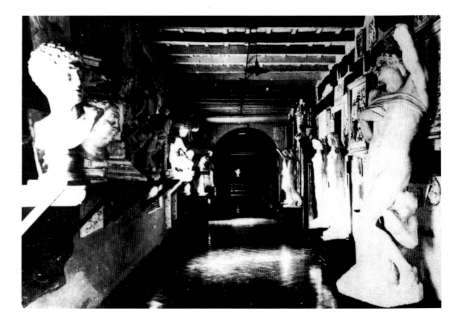

2. Halls of the Academia de San Telmo, Málaga, Archivo del Museo de Málaga

Picasso was born.)[9] If he continued to distinguish himself, he could aspire to the heights, to teach at the Academia de San Fernando, where, since Francisco Pacheco's battles for the cause, he could literally enter the nobility.[10]

The Epistemology of the *Cartilla*

Picasso learned from a curriculum that had been studied with minor variations by thousands of students before him. This curriculum, which remained remarkably constant, drew on practices and treatises harking back to Leonardo, Zuccaro, and Dürer, as well as Spaniards who learned from them, such as Pacheco, Juan de Arfe, and Antonio Palomino. A student progressed from copying two-dimensional images, often of classical statues, Winckelmann's gods; to copying from *yesos* (plaster casts) of the statues themselves; finally to drawing the model, *del natural,* from life. Students worked, as Palomino described it, from the part to the whole: from an eye, to a series of eyes, noses, and ears from different points of view; from a profile, to a whole face, to an entire body.[11]

Cartillas or drawing manuals, often dating from generations before, were kept around, with pages tattered or missing. They overflowed

3. José García Hidalgo
de Quintana, *Ojos y ar-
ranque de nariz, mirada
dolorida,* in *Principios
para estudiar . . .*
(Madrid, 1693), pl. 10

with page after page of perspective schemes, sometimes juxtaposed to figures set in that same position; and of objects or geometric shapes—globes, cones, or cubes—seen from different angles, often *en escorzo,* or foreshortened.[12] Pages displayed eyes or arms or noses jostling each other, with different shapes, expressions, or slightly altered views (fig. 3). Pages bristled with body parts or entire figures overlaid with a grid, as a method of analysis and a means of transferring the image to a larger surface.[13] Pages presented models in different postures, each subsumed inside a geometric form; or outlined faces or figures, with geometrical forms subsumed inside them (as when a face is composed of three or four circles), revealing the tension between Platonic universals and specific naturalistic individual inflections.[14] Pages showed statues, embodied canonical ideals of different cultures such as Greece and Egypt, human taxonomies to be measured, calibrated, proportions codified.[15] Pages depicted skeletons (often in animated poses) or figures revealing stripped bare net-

works of muscles or veins.[16] Pages included ornamental and architectural forms, some geometrical, some organic.[17] By copying such images, one would master shapes and qualities of lines; one would internalize a vocabulary to imagine and reproduce the world—a series of schemata, an arsenal of possibilities, which could be endlessly transmuted and recombined.[18]

The *cartillas* offered a key to master technique and conquer mimesis, the representation of the phenomenal world. Shading and modeling loomed as challenges. Many *cartillas,* such as those by Charles Bargue, which Picasso would copy, juxtaposed an outline drawing (sometimes a schematic sketch, called a *mise en trait*) with a modeled version of the same thing, whether shaded with cross-hatching (which evoked engraving, the preferred technique until the early nineteenth century), or with stumped (smudged) shapes of shadow.[19]

Certain pages in *cartillas*—of baroque ceiling decoration or rococo ornament—registered changes in artistic styles over time (that is, styles practiced after academic education was completed). While most *cartillas* were populated by uniformly idealized heroic beings, in José de Ribera's seventeenth-century *cartilla,* pages of hairy warted faces defiantly elbowed pages with classically beautiful ones.[20] Despite these changing additions, basic educational principles remained. Even years after Mengs, after romanticism finally came to Spain, an insistence that *dibujo* (drawing) was the cornerstone of art continued to dominate all academic instruction. When students arrived at a more advanced stage, they drew increasingly from life: drawing male models posed as statues, reveling in the bodies and the patterns that they made, reveling in their increasing virtuosity.

Although the institutional models as well as the basic curriculum were grounded in earlier examples from France and Italy, profound differences existed between those countries and Spain. Although Spain's academic education, like

theirs, still was steeped in the classical tradition, that tradition did not resonate to the same degree in Spain as in France or Italy, because the Roman Empire's dominion of Spain was ruptured by the centuries' long occupation by the Moors.[21] Although Spain's academic education, like theirs, still was predicated on close study of the nude, there was markedly less comfort for that subject in Spain than in France or Italy. (King Carlos III, after all, had ordered Mengs to burn pictures in the royal collections, the Titians, Rubenses, and so on that revealed what he considered to be excessive nudity, a demand Mengs happily circumvented.) No live models posed at San Fernando until over thirty years after its founding.[22] Even late into the nineteenth century feeble arguments were tendered as to why nude models would not be available for men, to say nothing of women, to study. In semi-tropical Málaga the practice of using live nude models was repeatedly stopped because, it was argued, there simply was no money for extra heat to keep them from shivering.[23] Perhaps most explosive, Spain's academic system—like the Colbertian centralized system in France, on which it depended—was based on the absolute hegemony of Madrid. But Málaga, where Picasso was born, and La Coruña and Barcelona, where he lived and studied, each had a highly developed regional identity—in Catalonia to the point of viewing itself as a separate nation. In all these places many distrusted or even violently hated the center, hated what they understood to be the political and economic exploitation by Madrid.[24]

The exalted rhetoric of the center also collided with the economic and cultural vicissitudes of provincial reality at places like Málaga's Academia de San Telmo, where Picasso's father studied and later taught. In starkest contrast to pronouncements of Madrid's San Fernando, the founders of San Telmo harbored no illusions that Málaga could produce a great artist. Its mission was social and economic: to enable its largely adult, already working, nonpaying student body to become better locksmiths, bricklayers, ceramicists, better silversmiths, watchmakers, commercial lithographers, better ironworkers and woodcarvers, better military and civil engineers.[25] When Bernardo Ferrándiz came to Málaga in 1868 to begin the proper teaching of courses in painting, he saluted the school's goal of "social regeneration" but recognized that a Malagueño's only hope of becoming accomplished was to win a scholarship to study elsewhere.[26] Ferrándiz' most accomplished students, like Moreno Carbonero, studied in Madrid, Paris, or Rome; and entered national competitions with history paintings, like Carbonero's tepid *Conversion of the Duke of Gandía.*[27] They won prizes and returned to Málaga, creating the so-called School of Málaga, catalyzing for the first time a sense that the provincial city had a viable artistic scene. In the 1880s, after Picasso had been born, academic professors like Antonio Galbién continued to argue, in print, that it simply *was not possible* to become a serious artist if one stayed in Málaga at that school.[28] Even for those artists who went off to be trained elsewhere, the artistic results were so meager, the horizon of ambition extraordinarily low.

Pablo's Teachers

Picasso's first teacher was his father, José Ruiz Blasco, who studied at Málaga's Academia de San Telmo before Ferrándiz had arrived with his improved methods of painting instruction. Ruiz Blasco never earned a single honor grade, nor won a prize fellowship to study abroad, yet was named assistant professor in the class of "Dibujo lineal y adorno" (1875).[29] It was made plain at the time that his appointment had nothing to do with artistic gifts: rather than hiring "eminent artists," it was argued, the San Telmo should fill vacant places with "more modest artists, who are natives of Málaga and sons of this school . . . in order to establish these

4. José Ruiz Blasco, *The Pigeon Loft*, 1878, oil on canvas, 102 x 147 (40⅛ x 57⅞), Ayuntamiento de Málaga

modest places as a prize for young artists."[30] Ruiz Blasco's other appointment, as restorer at the Museo Municipal, came through family connections. A consummate company man, Ruiz Blasco's vision of how one could make an artistic career depended entirely on institutions and on the patronage within them.

Although he taught from *cartillas* with classical images, Ruiz Blasco followed the standard academic practice of painting in a different mode for his own work, and followed the Malagan practice of painting genre scenes. Primarily he painted pigeons. At once earnest and stolid, they are set within a strong structuring geometry that controls and stills them: a series of horizontals and verticals, perhaps set against the oblique grid of a terra-cotta tiled floor, which in turn plays off the few curves of a shelter's opening, the slow ellipse of a vessel's top, or the rounded pigeons themselves (fig. 4). Malagan artists often structured their works with simple underlying gridlike geometries, such as Leoncio Talavera's *Cenachero* and Luis Grarite's *Muleteer,* both of 1877, with their odd-angled repeating shapes of doors and windows, some with iron grid-patterned bars. In his capacity at the museum Ruiz Blasco meticulously copied works in

the collection by Malagueños like Talavera and Grarite, who were more respected and younger than he—obliterating any trace of himself, any sense of individual style or sensibility. This practice intersected with a veritable culture of copying, one far removed from Winckelmann's lofty aims, a cottage industry of artists who replicated, often as closely as possible, their own pleasant if anodyne works to answer the demands of a burgeoning bourgeois market.[31]

Because Ruiz Blasco failed to win a medal at a national exhibition and lost the senior position at San Telmo to Antonio Muñoz Degrain, he and his family were forced to relocate in 1891 to La Coruña. There he took a position at the Instituto da Guarda, obtained through connections, and formally became his ten-year-old son's teacher.[32] Because the region was so poor, there was pressure, as in Málaga, to conceive of the school primarily as an instrument of social regeneration, a place for citizens to learn practical skills. (At the end of Ruiz Blasco's tenure there, the faculty divided between advocates of this applied orientation and those, like Ruiz Blasco, who wanted to stress "pure arts." The applied camp won.)[33] Ruiz Blasco taught "Ornamental Drawing," "Figure and Ornamental Drawing," and "Figure Drawing, *yeso,*" all of which his son took.[34]

Picasso also studied with Isidoro Brocos, whom he remembered as "an exceptional teacher."[35] Brocos—a sculptor, ardent son of Galicia, and one of its few leading artists—embraced the classical tradition in a way Picasso's father never did.[36] Brocos trained at the local academy (which preceded the Instituto da Guarda), won chances to study in Paris and travel to Rome, won third prize at the National Exhibition at Madrid in 1878 for his *Last Moments of Herod*—but only a bronze medal at a local exhibition, perhaps because, to many in Galicia, classical styles and subjects smacked of Madrid's abusive power. Shortly thereafter he became an auxiliary, then a full professor of

sculpture in La Coruña. Although he continued to sculpt works like *Ero* in a classical vein (1884), what were most beloved were his genre studies of local folk and customs, more naturalistic in style, picturesque in tenor, like *Village Tailor* (1878).

Pablo's Pantheon

Picasso's academic education became his conduit to giants. With an often lush technique that owes something to Brocos' drawings,[37] Picasso copied images of a litany of heroes, gods, and godlike fragments made by a multitude of godlike artists—such as the massive muscled Belvedere Torso (1892–1893) and the *Theseus* from the Parthenon (1893–1894), Winckelmann's ideal of "a noble simplicity and quiet grandeur" incarnate.[38] In La Coruña he copied many of these from Charles Bargue's *Cours de dessin*, which consisted of collections of oversized lithographs and was a latest *cartilla* of choice in France and England. Many of Bargue's subjects "after plaster casts" were explicitly labeled, trumpeting the name of the glorious god in question.[39] When the adolescent Picasso copied plate 56 from Bargue, which was simply identified as "Antique torso," he or perhaps a teacher reverentially inscribed "a Hercules by Phidias" (cat. 2).

Thousands of students before Picasso had slogged through many of the same exercises, copying from many of the same *cartillas*, copying two-dimensional images, as he had done with his first *Hercules* (fig. 1), and, as he had done, making pentimenti corrections.[40] Thousands like Picasso had explored a full array of academic artistic practices—juxtaposing different views of a single body part, such as a left eye (fig. 5); drawing a stylized acanthus flower, a subject specially singled out in the curriculum (1892–1893); making a schematic sketch of a profile head beside a more modeled version of the same thing (1892–1893). Thousands had filled sketchbook pages with a cornucopia of

5. Picasso, *Two Views of a Left Eye*, La Coruña, 1892–1893, conté crayon, 23.7 x 31.5 (9¼ x 12⅜), Heirs of the artist

possible subjects and compositions, often taken from life or their imaginations, as in Picasso's sheet of quick jottings inscribed "boceto para decorar un techo," a sketch for ceiling decorations (1894).[41] Thousands had struggled over many years' time, as he did, to master mimesis and master technique.

But if thousands copied the same images, many of Picasso's copies, such as those after plaster casts, are worlds apart from workmanlike, diligent, rote—even if technically accomplished—drawings by others in the French or Spanish academic track. Many, such as a languorous leg veiled by softly smoldering shadow, are mysterious, compelling, sensual, seemingly alive.[42] Albert Boime has suggestively compared the academic act of copying in France to sympathetic magic, where by copying the other, one takes on attributes of the other, one becomes the other. This association would have had great power for one as superstitious as Picasso, who came from a place where many believed in oracular possession.[43] His copies—such as one of a foot with its bizarre flange of toes—often look magical, ominous or weird in their shadows, as if softly lit from within or strafed from without by blinding light (fig. 6). They throb and pulsate, charged by a sense of wonder. Even in his

6. Picasso, *Foot*, La Coruña, 1894, charcoal and conté crayon on paper, 33.2 x 49.7 (13 ⅛ x 19 ½), Museu Picasso, Barcelona

7. Picasso, *Pantheon*, La Coruña, 1894–1895, pen and ink on paper, 13 x 20.7 (5 ⅛ x 8 ⅛), Museu Picasso, Barcelona

relatively close copies after Bargue, Picasso made subtle but often pungent changes—drawing, for example, a greater range of lines, some straighter, harsher, more powerful, others more febrile, more energized, some shadows inkier, more clotted, some silhouettes sharper, the whole less harmonious, more urgent. Some of the strangeness and apparent problems in these works came initially in part from the Bargue plates he copied, such as the awkward juxtaposed parcels of muscles in the Belvedere Torso, or the heightened arbitrary shadows and raw highlights on a fragment Picasso attributed to Phidias (cat. 2). Such exercises provided Picasso with an entry into classicism, which he would explore at different moments of his life, and with the conviction that the human figure was a fundamental subject of art, a belief he would hold all his life.[44] Picasso kept an extraordinarily large number of these early academic copies, his trophies of mastery, his fetishes, his talismans— kept them with him until the day he died.

At the same time he was copying figures from the Parthenon and painting works outside of class in more immediate naturalistic modes[45]—Picasso sketched, with pen and ink, *his* pantheon (fig. 7). Pablo's pantheon, perhaps inadvertently, resonates humorously with de-

cades-old arguments within the academy: that reclaimed the glories of Spanish painting and national tradition, and raised hosannas to Veláz-quez, no longer a fifth-class citizen to Mengs' classical gods and his "sublime style." In Pablo's pantheon the classical elements, though still present, are summarily indicated: a Greek temple, with its pediment and columned row, is pushed backward; the Venus de Milo, also shunted off to the side, almost a bookend, shown from an unimposing side view, stands slightly inclined, almost deferential. Center stage, portrayed with more vivid detail and verve, a more beautiful goddess, perhaps his first schoolboy crush, Angeles Méndez Gil, plays a lyre,[46] as a cherub shoots her with an arrow, while other jubilant putti and birds air-dance in attendance to Picasso's current, clearly named, Spanish gods: Cervantes (holding a book identi-fied as *Don Quijote*) and the Spanish artistic god of gods, Velázquez.

When Picasso moved with his family to Bar-celona and came to the academy known as La

Llotja in 1895 (his father exchanged positions with a professor there), he came for the first time to a national art school of the highest rank-ing, where the so-called "pure arts" were em-phatically privileged.[47] On the way to Barcelona, the family stopped at the Prado, where Picasso was finally able to immerse himself in real paint-ings instead of pallid reproductions of Spain's *siglo de oro* giants, and where he followed a hallowed Spanish academic practice of making quick copies after heads by Velázquez in his sketchbook.[48] While his tenderly drawn copy after Velázquez' *Niño de Vallecas* involved subtle changes, Picasso transformed *Calaba-cillas*' visage into something haunting, almost menacing, when he turned his left eye into an eery, huge, dark pool.[49]

At La Llotja, Picasso continued to draw from casts and copy images of the classical canon: from the Parthenon, a horseman and reclining figure with his eloquent flowing contour (1895); the Laocöon, with its tangle of bodies and surg-ing snakes, sketched faintly, perhaps as a com-

8. Picasso, *Male Nude*, Barcelona, c. 1896, pen and conté crayon on paper, 25 x 20.4 (9⅞ x 8), Museu Picasso, Barcelona

9. Picasso, *Nude Study of José Román*, Málaga, 1895, charcoal and conté crayon on paper, 43.5 x 47.4 (17⅛ x 18⅝), Museu Picasso, Barcelona

mon academic practice, from memory (1895–1896); as well as sketches, some schematic, some more finished, of that archetype of female beauty, the Venus de Milo (1895–1896).[50] (We associate prodigious memory with Picasso, but memory training was an important part of academic education.)[51] And he copied *yesos* of less famous but still heroic statues (1895–1896), as well as a poignant decidedly unidealized Roman head. He engaged in other standard academic practices too: drawing a figure almost swallowed up by voluminous draperies (1895), and a jaunty skeleton with carefully annotated bones (1895–1897).[52]

Because Picasso had entered advanced classes, he now was able to draw and paint more extensively from life, from models whose expressive and physiognomic specificity he intensely captured: a figure whose raised arm seems splayed, like a *cartilla* (fig. 8), a fellow lost in thought, his genitals elided (fig. 9). (This and the related practice of whiting over genitals in earlier Spanish academic studies were dictated, one assumes, by modesty.)[53] Other life studies included stylized touches, like the emphatic shape of a shoulder below a distinctive, partly revealed profile (cat. 9).[54] His nascent mastery is thrilling to witness—his increasing sense of grasping the body in a single fluid rhythm, an explicit academic goal, and his increasing command of a subtle range of values, especially the middle range of beautifully modulated pearly grays so prized in academic teaching (cat. 8). Such achievements involved real struggle; even at this stage, in some of Picasso's works a shoulder may seem undeveloped, an arm awkwardly attached, even atrophied.[55]

Pablo's "Theorem of Optics"

Another facet of academic training was the study of geometry and perspective, which loomed large in the San Fernando's curriculum, almost from the moment it was founded. But as romantic ideas came to be adopted in Spain, as

elsewhere in Europe, some artists began to rebel against this discipline as a system of calcified rules and regulations that destroyed spontaneous expression, as they denied an individual's sensibility or will. One critique was levied from within by Goya, who had impeccable academic credentials and was even appointed director of painting at the San Fernando itself. In his "Diplomatorio a la Real Academia de San Fernando" of 14 October 1792 he rejected the oppressive, obligatory emphasis on geometry and perspective as means "to conquer difficulties in drawing," insisting: "no hay reglas en la Pintura," there are no rules in painting.[56] Decade upon decade of such attacks continued. While *cartillas* still abounded with their perspective schemes and drawings of geometrical forms in space, and while artists like Picasso's father still made use of them in their finished works, the study of geometry and perspective, for many, became increasingly marginalized.

But Picasso was fascinated. That is not to say he would have understood the mathematical disquisitions in perspective treatises. He relished his tales of truancy from school and his problems with nonartistic subjects, describing how he turned his letters and numbers into the animals they resembled, turned them into play, into something that was wondrous and meaningful for him. Although a course in arithmetic and geometry was offered in Málaga's academy, he was too young to take it; he took no such course in La Coruña or in Barcelona. But from childhood on, he delighted in the visual properties and ludic potential of geometrical shapes and perspective schemes (intrigued perhaps in part because they were as mysterious to him as math). As apparent non sequiturs, he drew a tiny cube and a geometric solid off to the far right border of his first *Hercules* (fig. 1), a flurry of geometrical shapes in his textbook pages.

On a sheet of quick sketches he wrote "Teorema de las Lentes" (Theorem of Optics), including a grid-covered cube and a receding series

of cubes in perspective (1894). The same year he drew a foreshortened pigeon, peppers, and globes (1894); soon after, he made scores of perspective studies, sometimes on their own (1895–1897), sometimes next to heads or objects in that same foreshortened angle (fig. 10). On the verso of a panel painting of a flat disc of moon over a rooftop, he sketched a series of circumferences, marked A–B, A–C–B, and so on (c. 1896). Many of these are working sketches, tried and true schemata that still are taught today: used to plot spatial recessions or determine possible shapes of a foreshortened globe.

He sought out subjects with strong geometrical components, some presented in a relatively straightforward manner, such as a *Seascape with Houses in the Foreground* (1896) with its series of overlapping rectangles, some of architecture, some of light.[57]

Sometimes, even from early on, he manipulated perspective schemes and geometric shapes for unexpected expressive ends—for example, depicting a balconied window with an emphatic grid, but then covering it with a billow of curtain, rendering it opaque, mute, mysterious (fig. 11). This sense of enchantment with geometry

10. Picasso, *The Artist's Mother and Perspective Studies*, Barcelona, 1895, pencil on paper, 12 x 8.2 (4 ¾ x 3 ¼), Museu Picasso, Barcelona

11. Picasso, *Window with Interior Curtain*, Barcelona, 1899, oil on panel, 21.8 x 13.7 (8 ½ x 5 ⅜), Museu Picasso, Barcelona

and perspectival cues would continue in works like *Roofs of Barcelona* (1903) and *The Reservoir* (1909) and beyond.[58]

Judgment

With an eye to entering exhibitions, Picasso painted two conventionally ambitious works, both large in scale, both supervised by his father and his Andalusian teacher at La Llotja, José Garnelo Alda. *First Communion* of 1896 was exhibited in the Tercera Exposición de Bellas Artes é Industrias Artísticas in Barcelona; *Science and Charity* of 1897 won a *mención honorífica* at the Exposición General de Bellas Artes in Madrid (where Muñoz Degrain was a judge) and a gold medal in the Exposición Provincial of Málaga (see figs. 8 and 10 in Chronology). But Picasso was growing bored with the academy, impatient with its vision.

In a drawing from that period (fig. 12), Picasso depicted his father, seated, with a bevy of his pigeons below, sketched with greater

animation than his father ever could achieve. Surrounding don José, a barrage of words apparently written in his own hand referred to the system of honor grades in which he so fervently believed.[59] Above and to each side thundered the judgments "suspenso, suspenso, suspenso," failure, failure, failure. Farther out, as though beyond his grasp, again and again, sounded "sobresaliente," "sobresaliente," the highest examination grade, which he had never earned, but which he and others had awarded his son from the very beginning.

After Picasso won his gold medal, his father and other family members scraped together the money to send him to the Academia de San Fernando in Madrid. But when he arrived, he was to be taught not by exalted artists, but by two old cronies of his father, Muñoz Degrain (for the elementary section of landscape) and Moreno Carbonero (for drawing from classical models and draperies).[60]

Two letters. As late as 1897, while he was rebelling against the San Fernando, cutting classes, displeasing Muñoz Degrain (who tattled to his parents), and while he caustically was criticizing certain academic techniques, Picasso still thought of drawing as foundational and of academies (at least Parisian academies) as the preeminent training ground for artists. In his letter of 3 November 1897 to his former classmate Joaquim Bas he wrote:

> Sr Moreno Carbonero told me the other night in the life class, which he teaches, that the figure I was doing was very good in proportions and drawing, but that I ought to *draw with straight lines,* as that was better. . . . He means you *should construct a kind of box around the figure.* It seems impossible that anyone should say such stupidities. But there's no doubt about the fact that, however far from one's way of thought, he certainly knows more and doesn't draw badly. And I'll tell you why he's the one who draws the best, because

he went to Paris and went to several acade-
mies. Make no mistake, here in Spain we are
not as stupid as we have always demonstrated,
we are just very badly educated. . . .[61] *(empha-
sis added)*

Picasso's father wrote from Madrid to his wife
on 14 March 1899:

I'm happy that Pablo is working, and above all
that he's not cutting classes, which to me is
fundamental. . . . Pablo knows that there will
be an exhibition and I forgot to tell you that
the first three medals pay 2000 pesetas; today
Antonio Muñoz [Degrain] was at home and I
spoke to him about this and he promised to do
everything he could. I showed him the draw-
ings, which he liked a lot, although he told me
that last year [Pablo] made no progress at all.
But that's all past. I told him that Pablo would
make a drawing of the painting, and that he
would send it to me. . . . When he's working
on the picture, he should not forget that it
must be very realistic [*muy verista*].[62]

Exhibitions, prizes, money, cronyism, restrictive
styles. Pablo never finished the picture and never
entered the exhibition.

The drawings to which Ruiz Blasco referred
were not done at La Llotja. After Picasso left
Madrid and returned to Barcelona, he continued
to draw from life, but at an art club, the Cercle
Artístic. Although some of his figure studies are
relatively straightforward, drawn in a sinuously
contoured *modernista* style, others use the
academic practice of drawing from life as scaf-
folding for new explorations: an occasion to
manipulate shadows in bizarre ways, spiking
small sharp triangles under an arm or breast,[63]
or weaving a shadow shape into an enveloping
cocoon (fig. 13).

Perhaps because he initially believed in it,
later to humor his father and his uncle Salvador,
who had supported him, Picasso played the in-

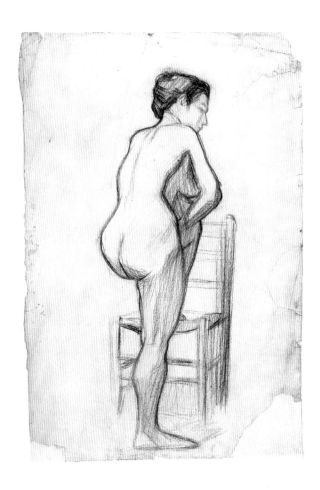

13. Picasso, *Female Nude*, 1899, Barcelona, charcoal and conté crayon on paper, 48.5 x 34.5 (19 ⅛ x 13 ⅝), Museu Picasso, Barcelona

stitution game at the outset of his career: earning
honor grades, entering exhibitions, winning
prizes, painting in the styles and subjects they
valued. All his life, he valued certain lessons he
learned from his academic training, particularly
drawing from life. But soon he stopped compet-
ing for prizes. Beyond repudiating much of the
art they privileged, he refused to put himself at
the mercy of institutions or let institutions define
him. He ultimately became an entrepreneur who
found his own dealers and patrons. If they dis-
approved of the direction he was taking, he jetti-
soned them rather than be deflected from
his path.

Cubism as (Academic) Anti-Language

At a ferociously subversive moment, while he
was crystallizing *Les Demoiselles d'Avignon*
(1907) and while he was intensely involved with
African sculptures—even arguing that they were

14. Picasso, *Proportion Study* for *Les Demoiselles d'Avignon,* Paris, April–May 1907, ink on tracing paper, 31 x 12.6 (12 ¼ x 5), Musée Picasso, Paris

15. Picasso, *Man with a Guitar in an Armchair,* Céret, spring–summer 1913, pencil on quadrilaterally ruled paper, 13.5 x 8.5 (5 ¼ x 3 ⅜), Musée Picasso, Paris

"more beautiful" than the Venus de Milo[64]—Picasso still was thinking in academic terms. He looked back to the *cartilla* tropes of his childhood, drawing a proportion study razored through by numbered horizontal lines (fig. 14), which invoked a slew of anthropometric studies, including those by Dürer; and drawing a figure that more explicitly recalled Dürer, if rendered more schematically, more iconically, which played with the tension between representational forms and subsuming geometrical forms as it challenged and negated European canons.[65]

Cubism itself bristles as an anti-language, characterized by Peter Burke and others as a language set against the conventional code "as the expression of a sub-culture [in this case Picasso and Braque's avant-garde position] in conscious opposition to a dominant culture and its institutions."[66] Perhaps as a distant memory—and as

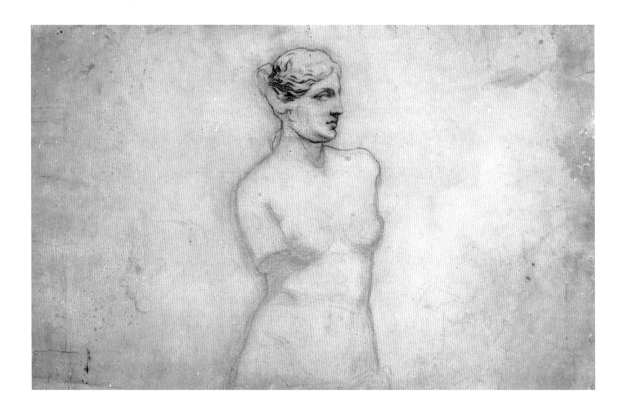

one facet, among many, in the invention of the cubist style—Picasso used vestiges and strategies of his academic training to attack the values of that training and to attack the institutions themselves. If Goya had criticized the academic study of geometry and perspective with the declaration "There are no rules in painting," Picasso appropriated hallowed academic strategies to break the academy's rules.

The academy taught him to master mimesis by copying juxtaposed body parts, often askew or at different angles, by superimposing grids on heads or whole figures, by learning to draw elements as *escorzos* or foreshortened, by making schematic diagrams, by mastering a range of shading and modeling, especially middle tones, and by recognizing the tension between geometrical and naturalistically rendered forms. (Almost certainly, at least in retrospect, Picasso would have recognized the potentially subversive, inherently strange, even funny qualities of the *cartillas* from which he learned.) In *Man*

with Pipe of 1912, Picasso comically plays with all these elements in a manner that would have been horrific sacrilege to Spanish academicians. Some works, like *The Reservoir* (1909), apparently conflate geometry and representational referents. Other cubist works, like *Man with a Guitar* (fig. 15) on a notebook page with machine-made grids, read like black-humored puns on the idea of a grid-measured body or on Carbonero's "stupid" demands that one "draw with straight lines" and "construct a kind of box around the figure."

Where the academy taught Picasso to select from Nature's most beautiful treasures, to correct and perfect them to attain the eternal ideal, he and Braque pasted on newsprint, bits of rope, the fugitive detritus of the vulgar world around them, in their aggressively anti-Beautiful, anti-artistic cubist collages. Where the academy taught him perspective, inspired him with his "theory of optics," and enabled him to represent a regularized, controlled illusion of the phenom-

16. Picasso, *Venus de Milo*, Barcelona, 1895–1896, conté crayon on paper, 30.7 x 47.8 (12 ⅛ x 18 ⅞), Museu Picasso, Barcelona

enal world, he used the perspective cues he learned to confound any coherent spatial illusion—adding teasing bits of foreshortening, obliquity, and shading, but setting them against each other, overlapping or dematerializing them. Where the academy taught him, after laboring for years, to reproduce the human figure and render values and shadow in order to create convincing modeling of forms in space, in certain so-called analytic cubist works he obliterated the figure and untethered shading from any representational reference, to sing out as disembodied halftones, as if painted through a veil of memory.

To Become a God

Between 1895 and 1896 Picasso sketched the Venus de Milo in several guises, some almost heartbreakingly beautiful, with exquisite features and lovingly caressed contours (fig. 16).

By 1907 when he painted *Les Demoiselles d'Avignon*[67]—which he painted on fine canvas and relined as an intended masterpiece—he no longer hoped to emulate academic painters like Muñoz Degrain, a false god. He could no longer defer to his father, a fallen god. He rejected their institutions. He repudiated their career trajectory. He revolted against their ideals of beauty. He despised their images. He smashed their idols. But in large measure from his academic education, he conquered mimesis—which he sometimes would choose to subvert. He became, with struggle, a dazzling virtuoso—which he often would choose to deny. He imbibed an ideal of titanic ambition, a goal of greatness, a dream of entering the pantheon, his redefined pantheon, to become a god, himself a god, a god of art.

Notes

To the memory of Arnaldo Momigliano
ciertamente ferozmente aun aprende

All translations, unless noted, are my own.

1. Claude Bédat, *L'Académie des Beaux-Arts de Madrid, 1744–1808* (Toulouse, 1974), 3–5. On the San Fernando see also José Caveda, *Memorias para la historia de la Real Academia de San Fernando y las bellas artes en España . . .*, 2 vols. (Madrid, 1867); Francisco Calvo Serraller, "Las Academias artísticas en España," epilogue to Nikolaus Pevsner, *Las Academias de arte* (Madrid, 1940; reprinted 1982), 209–239; and R. A. San Fernando, *Renovación, crisis, continuismo. La Real Academia de San Fernando en 1792* (Madrid, 1992).

2. Bédat 1974, 75.

3. Johann Joachim Winckelmann, *Gedanken über die Nachahmung der griechischen Werke in der Malerie und Bildhauerkunst* [1755], bilingual ed., trans. Elfriede Heyer and Roger C. Norton (La Salle, 1987), 4–7.

4. Mengs, "Carta de Don Antonio Rafael Mengs á Don Antonio Ponz," in *Obras, publicadas por don Josep Nicolás de Azara,* 2nd ed. (Madrid, 1797), 210; also 213 on *clarobscuro.*

5. Andrés Ubeda de los Cobos, "Nacionalismo y pintura a finales del siglo XVIII: El Descubrimiento del barroco," unpublished paper presented at College Art Association, Boston, 1996, 6. Earlier Spanish theorists also revered what Rodrigo Caro called "sacred antiquity," see Jonathan Brown, *Images and Ideas in Seventeenth-Century Spanish Painting* (Princeton, 1978), 37.

6. On Spanish debts to Meissonier see Carlos Reyero, *Paris y la crisis de la pintura española, 1799–1889* (Madrid, 1993).

7. On the pan-European phenomenon of academic institutions see Nikolaus Pevsner, *Academies of Art, Past and Present* (Cambridge, 1940).

8. On nineteenth-century Spanish women artists, their education, exhibitions, and critical reception see Estrella de Diego, *La Mujer y la pintura del XIX español (Cuatrocientas olvidadas y algunas más)* (Madrid, 1987), which includes artists that trained in Paris, like Margarita Arosa, who painted a rare female nude, *La Baigneuse* (1887).

9. Royal decree of 13 February 1880; María de los Angeles Pazos Bernal, "En El Umbral de Picasso: José Ruiz Blasco," *Picasso y Málaga* (Madrid, 1981), 14, 34.

10. Pevsner, *Academies of Art,* 1940, 187.

11. Antonio Palomino de Castro y Velasco, *El Museo pictórico y escala óptica,* vol. 2 (Madrid, 1715), chap. 1.

12. For a detailed discussion and multiple plates see Palomino 1715, vol. 1, chap. 2, and vol. 2, chap. 8. On pattern books and drawing manuals see E. H. Gombrich, *Art and Illusion: A Study in the Psychology of Pictorial Representation* (Princeton, 1960), 146–178; L. J. van Peteghem, *Histoire de l'enseignement du dessin* (Brussels, 1868); and Wolfgang Kemp, " *. . . einen wahrhaft bildenden Zeichenunterricht überall einzuführen" . . .* (Frankfurt am Main, 1979). On early Italian, French, and Spanish *cartillas* see also Juan José Gómez Molina et al., *Fortuny-Picasso y los modelos académicos de enseñanza* (Valladolid, 1989), which briefly characterizes Picasso's academic works in terms of their "clumsiness" and "impotence" explained by his "incredulity" and "resistance" to the academic project (p. 14).

13. On the process of transferring with grids see Winckelmann [1755] 1987 ed., 45; and also D.I.S.O. y A.F., *Curso completo teórico práctico de diseño y pintura* (Barcelona, 1837), 80. Among the profusion of other gridded figures see plates in Matías Irala, *Método sucinto i compendioso de cinco simetrías . . .* (Madrid, 1730); and Pedro de la Garza Dalbono, *Método teórico-práctico del dibujo de la figura humana* (Madrid, 1863).

14. Gombrich 1960, 150–172. On the legacy of Platonism see Erwin Panofsky, *"Idea." Ein Beitrag zur Begriffsgeschichte der älteren Kunsttheorie,* 2nd rev. ed. (Berlin, 1960). On geometric forms subsumed within naturalistic forms, as well as the reverse, and examples of different views of body parts see plates in José García Hidalgo de Quintana, *Principios para estudiar el nobilísimo y real arte de la pintura con todo, y partes del cuerpo humano, siguiendo la mejor escuela y simetría . . .* (Madrid, 1693).

15. See Winckelmann, *Proportions des plus belles figures de l'antiquité . . . ,* (Paris, 1798), trans. M. Huber, illustrated by F. A. David, which includes measured images of the Laocöon, the Venus de Medici, an Egyptian Terme, and many others, as does Gerard Audran's *Les Proportions du corps humains* (Paris, 1801). Even the library of Málaga's San Telmo had many books on proportion, more than forty published in Paris alone, as well as treatises of Dürer, Leonardo, and Palomino. See María de los Angeles Pazos Bernal, *La Academia de Bellas Artes de Málaga en el siglo XIX* (Málaga, 1987), 217–224; and Francisco Palomo Díaz, *Historia social de los pintores del siglo XIX en Málaga* (Málaga, 1985), 106. On successive ideal canons, their attendant theories, and iconological charge see Erwin Panofsky, "The History of the Theory of Human Proportions as a Reflection of the History of Styles," *Meaning in the Visual Arts* (Garden City, NJ), 55–107.

16. See plates in Palomino 1715, vol. 2; and José López Enguidanos, *Cartilla de principios de dibuxo según los mejores originales . . .* (Madrid, 1797).

17. See plates in Antonio Galbién y Meseguer, *Tratado de dibujo práctico geométrico y lineal* (Málaga, 1879).

18. Gombrich 1960, 146–178.

19. For an analysis of modeling techniques and artistic training in France, see Albert Boime, *The Academy and French Painting in the Nineteenth Century* (London, 1971); and Albert Boime, "The Teaching Reforms of 1863 and the Origins of Modernism in France," *The Art Quarterly* 1 (1977), 1–39.

20. José de Ribera, *Cartilla para aprender a dibuxar sacada por las obras de José de Ribera llamado (bulgarmente) el Españoleto* (Madrid, n.d).

21. On Picasso as part of an ongoing "counterclassical" Spanish tradition from El Greco to Velázquez to Goya see Brown 1996.

22. Caveda 1867, 1, 293.

23. Teresa Sauret Guerrero, "El Siglo XIX en la pintura malagueña" (Ph.D. diss., Universidad de Málaga, 1987), 66–67.

24. On Catalan regional hatred of Madrid, played out in many cultural domains, which transcended class and even left/right political affiliation see Kaplan 1992.

25. On the Academia de San Telmo and its pedagogical program see Bernardo Ferrándiz y Bádenes, *Memoria Exposición dirigida a las excmas. corporaciones provincial y municipal de Málaga* (Málaga, 1878); Antonio Galbién, *Breve Reseña de la escuela de bellas artes de Málaga* (Málaga, 1886); Peña Hinojosa, "La Real Academia de Bellas Artes de S. Telmo de Málaga," *Gibralfaro* (Málaga, 1958), 77–89, n. 8; Pazos Bernal 1987; Palomo Díaz 1985; for the fullest discussion of Málaga's painters see Sauret 1987.

26. Ferrándiz 1878, 11.

27. Carbonero's *Conversion of the Duke of Gandía* was bought by the State and won first prize at the National Exhibition in 1884 (Sauret 1987, 710). On Moreno Carbonero see also Real Academia de Bellas Artes de San Telmo, *Moreno Carbonero. Homenaje al glorioso maestro* (Málaga, 1943).

28. Galbién 1886, 24.

29. For fullest account of Ruiz Blasco's career see Pazos Bernal 1981, 7–35.

30. Actas de la Academia, 1879; quoted in Pazos Bernal 1981, 13.

31. Sauret 1987, 111.

32. On Muñoz Degrain see also Santiago Rodríguez García, *Antonio Muñoz Degrain* (Valencia, 1966).

33. Fernando Pereira and José Sousa, "La Carrera artística de Isidoro Brocos," in *Isidoro Brocos* [exh. cat., Caixa Galicia] (La Coruña, 1989), 47.

34. Archival documents collected, unpaginated, at the end of Angel Padin, *Los Cinco Años coruñeses de Pablo Ruiz Picasso* (La Coruña, 1991). Picasso was awarded "sobresaliente" for each class, with an extra "honorable mention" for the first. Other classes offered included Brocos' "Drawing from the Antique" and "Modeling and Casting of Figures and Adornment," and Navarro's "Drawing of Landscape."

35. Quoted in Richardson 1991, 45.

36. On Brocos see also M. Murguía, "*Los Ultimos Momentos de Herodes.* Estatua en yeso de D. I. Brocos," *La Ilustración gallega y asturiana,* 20 March 1879, 88; R. Balsa de la Vega, *Artistas y críticos españoles. Siluetas de pintores, escultores, y críticos* (Barcelona, 1891), 161–169; and Pereira and Sousa 1989, 30–51.

37. For example, two academic studies of female nudes from the back, charcoal on paper, one signed "Isidoro Mª Brocos 1872," the other undated (Colección Caixa Galicia).

38. Winckelmann [1755] 1987 ed., 33.

39. Picasso copied images from Bargue's *Cours de dessin . . .* (Paris, 1868) and Bargue's *Exercices au fusain* (Paris, 1871). On different examples of Picasso's copies after Bargue, noted as straightforward acts, see Irving Lavin, "Picasso's Lithograph(s) 'The Bull(s)' and the History of Art in Reverse," in *Past-Present, Essays on Historicism in Art from Donatello to Picasso* (Berkeley, 1993), which views the increasingly simplified forms of these 1945 lithographs as a conscious "unlearning" of his education. On the continuity of fundamental attitudes toward structure and meaning, and on Picasso's willed use of practices associated with childhood in otherwise sophisticated works—ultimately as a means of attacking the mimetic values he had mastered—see my "Early Picasso and the Origins of Cubism," *Arts Magazine* 61, no. 1 (September 1986).

40. On the verso of his early *Hercules* (fig. 1), Picasso copied or perhaps traced neat rows of architectural elements—again, standard academic exercises (MPB 110.842R). On Picasso's recollection of copying a Hercules, presumably a two-dimensional image, "dans le couloir," see Hélène Parmelin, *Picasso dit . . .* (Paris, 1966), 86. On Picasso's academic education, including material on examinations, prizes, and so on, see also Richardson 1991; Josep Palau i Fabre, *Picasso en Cataluña* (Barcelona, 1966); Palau 1985; and Palau's *Picasso: Academic/Anti-Academic (1895–1900)* (New York, 1996), all of which chronicle Picasso's increasing technical mastery and all of which view Picasso's academic experience as stifling, something happily escaped. Susan Mayer, "Ancient Mediterranean Sources in the Works of Picasso 1892–1937" (Ph.D. diss., New York University, 1980), 26, views Picasso's early study of classical statues as the beginning of an ongoing *engagement* with the classical tradition, which sparked an "admira-

tion for Classical beauty . . . [that] remained with him throughout his career."

41. Acanthus flower (MPB 110.859); study of old man's profile (Heirs of the artist, Z.VI.10; copied after the central figures, in the original one over the other, in Bargue 1868, pl. 3). "Sketch to decorate a ceiling" (MPB 111.16R).

42. *Leg*, 1893–1894, Heirs of the artist (Z.VI.8).

43. Boime 1971, 123–124.

44. On the enduring importance of the classically valued human figure for Picasso see Phoebe Pool, "Picasso's Neoclassicism: First Period, 1905–1906," *Apollo* 81 (February 1965), 122–127.

45. Musée Picasso, Paris.

46. On Angeles Méndez Gil see Palau 1985, 68; and Richardson 1991, 55.

47. On La Llotja see also César Martinell, *La Escuela de la Lonja en la vida artística barcelonesa* (Barcelona, 1951).

48. On academic copies after Velázquez see Sauret 1987, 66.

49. MPB 111.172R and MPB 111.170R. See also Javier Herrera, "El Joven Picasso en el Museo del Prado," *Boletín del Museo del Prado* 15 (1994), 61–62.

50. Parthenon horseman (MPB 110.694R); reclining figure (MPB 110.886); Laocöon (MPB 110.876R); Venus de Milo (MPB 111.174R, 110.392, and 110.856).

51. Even at Málaga's San Telmo, Ferrándiz' pedagogical reforms were explicitly linked to a new emphasis on memory training where, to stimulate creativity, students would draw an object from memory several days after they had copied it. See Palomino Díaz 1985, 35–36, which quotes extensively from Ferrándiz' unpublished "Memoria" of 1869.

52. See MPB 110.877; Roman head (MPB 110.889; undated); figure in drapery (MPB 110.600R); and skeleton (MPB 110.551).

53. For example, see Fortuny's "academy" and unattributed images in Molina et al. 1989, 22, 23, 24, and 37, none of which are discussed in these terms.

54. MPB 110.147.

55. On *demi-teintes* see Boime 1971, 28. See, for example, a problematic Picasso of 1896 (MPB 110.056).

56. "para vencer dificultades en el dibujo." Document conserved at the Archive of the San Fernando, Leg. 1–18, n. 4; published in Jutta Held, "Goyas Akademiekritik," *Münchner Jahrbuch der Bildenden Kunst* 17, ser. 3 (1966), 214. See also Manuel Ruiz Ortega, "La enseñanza oficial del dibujo," in Molina et al. 1989,

221–223. On this document and Goya's reformist stance see also Andres Ubeda, "De Antonio Rafael Mengs a Francisco de Goya," in San Fernando 1992; and Janis A. Tomlinson, *Goya in the Twilight of the Enlightenment* (New Haven, 1992). Contrast with Mengs 1797, 391.

57. Geometrical shapes on textbook page (MPB 110.927, p. 97); "Teorema de las Lentes" (MPB 110.862R); pigeon, peppers, and globes (MPB 110.864R). Picasso had been drawing elements in perspective since 1890, the year he first began to sign his work, when he drew, like his father, a pigeon-cote cube in perspective (MPB 110.867). Perspective studies from 1895 (MPB 111.138R and MPB 111.142R); from 1896–1897 (MPB 111.116 and MPB 111.116R). Circumferences (MPB 110.130R). *Seascape with Houses in Foreground* (cat. 10).

58. MPB 110.020 and private collection, New York.

59. Palau 1966, 34.

60. Enrique Lafuente Ferrari, "Picasso, al trasluz de Málaga," *Papeles de son armadans* (Palma de Mallorca, 1960), 44–45. On the application Picasso falsely labeled himself "a pupil of Muñoz Degrain," presumably with his blessing (see Richardson 1991, 85).

61. Letter published, translated, and analyzed in Xavier de Salas, *Burlington Magazine* 102, no. 692 (November 1960), 482–484 (translation slightly altered).

62. MPB 110.290 and MPB 1110.290R.

63. MPB 110.594.

64. Francis Carco, *De Montmartre au Quartier Latin* (Paris, 1927), 36: "C'est pluss bô!"

65. On this connection as a celebration of African over European canons see Werner Spies, "Picasso und Zeine Zeit," in Spies, ed., *Pablo Picasso: Eine Ausstellung zum hundertsten Geburtstag* (Munich, 1981), 28–29. Picasso's sketches also may have invoked the dying Jarry, who loved Dürer's work; on Jarry and Dürer see Roger Shattuck, *The Banquet Years* (New York, 1955; rev. ed. 1968), 196, 245. For other views on the proportion studies see Yves-Alain Bois: "the purging of such almost academic procedures was a necessary step toward achieving the disruptive character of the *Demoiselles*" ("Painting as Trauma," *Art in America* 76, no. 6 [June 1988], 140). David Lomas argues for a "shared mentality common to both Picasso's art and [contemporary] physical anthropology," an "ideological agreement" where "the audacious departure from a classical canon of the body in *Les Demoiselles d'Avignon* relies on and brings into play what were, in effect, highly denigratory stereotypes of cultural otherness" ("A Canon of Deformity: *Les Demoiselles d'Avignon* and Physical Anthropology," *Art History* 16, no. 3 [September 1993], 426–427).
In "Sur le 'Cubisme' et la peinture," *Temps présent* (Paris), 2 April 1913, 332–333, Charles Lacoste, a con-

temporary critic of cubist painting who painted in a late impressionist mode, suggested that cubist painters in their works, "returned" to the fundamentals of their academic training: "On sait que l'ABC du dessin enseigné par les professeurs officiels à inscrire l'objet que l'on veut reproduire dans une figure géométrique élémentaire telle que triangle, parallélogramme, pentagone, etc., cela en vue de ne pas se perdre dans le détail et d'établir de prime abord les grandes lignes et les directions principales de son dessin; l'élève apprend ainsi à voir par masses. Il s'ensuite que la première esquisse d'un tableau se compose de quelques polygones assemblés diversement et qui sont la forme simplifiée des arbres, montagnes, fabriques, figures, dont l'oeil peu ainsi juger plus aisément l'ensemble."

66. Peter Burke, "Languages and Anti-Languages in Early Modern Italy," *History Workshop,* no. 11, spring 1981, 24–32. For "anti-languages" in visual as well as verbal domains see my "Babel: Hermetic Languages, Universal Languages and Anti-Languages in Fin de Siècle Parisian Culture," *Art Bulletin* 76, no. 2 (June, 1994), 331–354. "Babel" and this essay are expanded in my forthcoming *A Sum of Destructions: Picasso's Cultures and the Origins of Cubism.*

67. See fig. 2 of Werth essay in this volume.

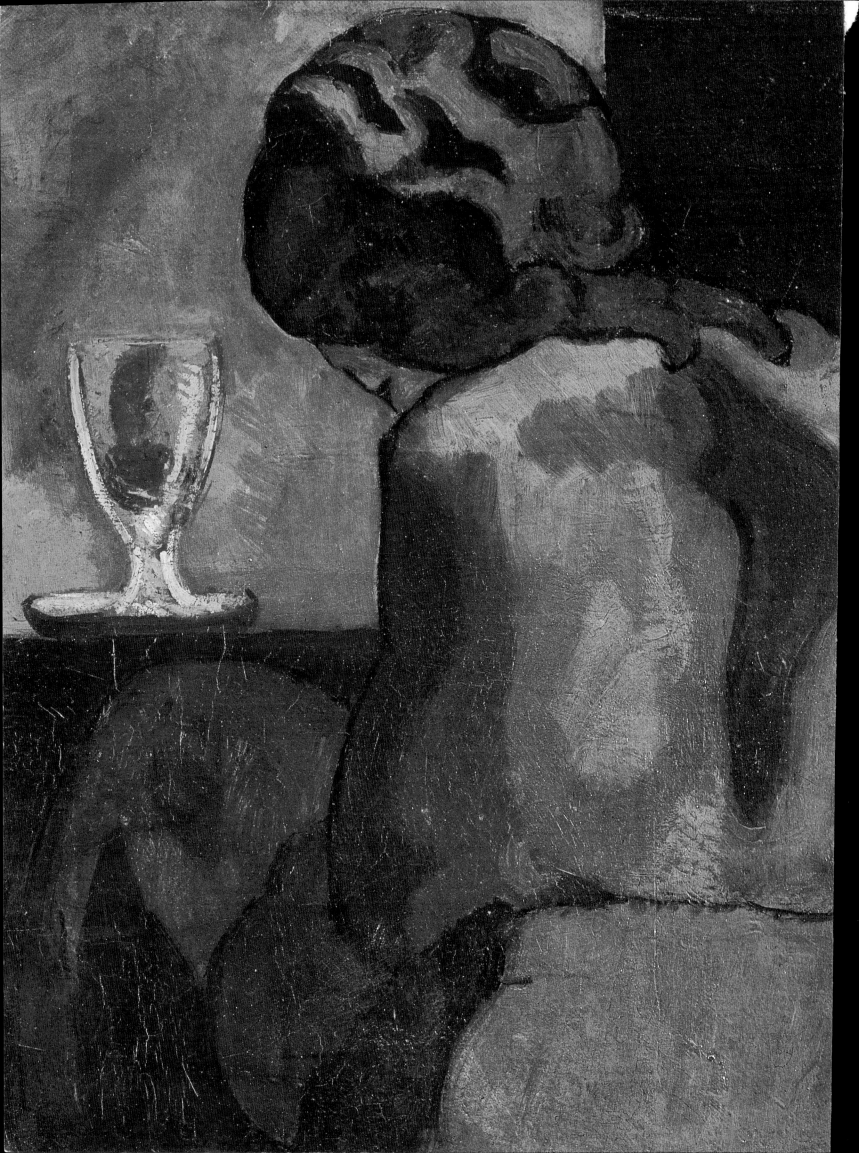

"Barcelona Blues"

Robert S. Lubar

February 1900. Picasso's *Portrait of Sabartès ("Poeta Decadente")* (cat. 30) takes its place in the symbolic "gallery of bohemians"[1] the young artist has conceived for the theme of his first solo exhibition, at Els Quatre Gats café in Barcelona (cats. 24–29). With time this motley cast of characters acquires the historical patina of a distinguished generation, but in 1900 these individuals are for the most part little-known figures who are trying to carve a niche for themselves in the provincial and traditionalist world of Catalan arts and letters. Following the illustrious examples of artists Santiago Rusiñol and Ramon Casas, who are likewise portrayed in Picasso's gallery, these young bohemians continue the project of Catalan cultural nationalism that their more established peers have initiated.

Sabartès hardly seems a likely candidate to participate in such a lofty enterprise. More ectoplasm than flesh in this portrait, the poet floats in a sea of lavender mist and murky silhouettes, a latter-day prophet who announces an obscure religion of the senses. Ostensibly lampooning his friend's artistic pretenses and cultural affectations, Picasso in effect underscores the public's perception of the bohemian artist as a neurasthenic aesthete who refuses the mundane demands of the material world in the pursuit of his craft. Picasso's decadent poet is a cliché, a stock character who strikes a contrived posture of social alienation. His negation of bourgeois society from the ivory tower of art rings hollow.

Picasso envisioned the bohemian artist of his day as a tragicomic figure. In a drawing of 1899–1900 (see fig. 4 in Cate essay) he represents a typical *modernista* as a lanky aesthete with long hair, mustache, and goatee, dressed in a dark smock and sporting an extravagant *cravate*. In related sketches of "decadents" and bohemians, individual details of the costume vary, but the overall effect of studied elegance and effete worldliness remains the same. In contrast, a slightly later drawing strikes a decidedly pessimistic note (cat. 46). Published in the short-

lived literary review *Arte Joven,* the scene depicts the artist (second from right) and a group of friends at an informal gathering. Judging by the ideological orientation of the journal, whose commitment to social reform and cultural regeneration was expressed in the form of a frontal attack on the Spanish establishment, the future for these young bohemians was as dismal as the barren, wintry landscape they inhabit in the drawing. Indeed between the affected alienation of Picasso's stereotypical *modernista* and the social marginalization of the young artist whose call for the spiritual and material regeneration of the nation falls on deaf ears, the agonistic sacrifice of this generation emerges with the force of contradiction. Aesthetic retreat, refusal, and negation, Picasso suggests paradoxically, are the terms of engagement for the avant-garde artist in bourgeois society. The images of indigent families and outcasts that culminate in such masterpieces of the artist's Blue period as *Tragedy* and *Blind Man's Meal* (cats. 92, 94) are, I will argue, attempts to fill those terms with new social meaning and to inscribe them within a critical cultural practice.

On 4 November 1894 the celebrated Catalan painter, critic, and dramatist Santiago Rusiñol delivered a speech before an august assembly of artists, writers, white-collar professionals, and intellectuals. The occasion was the celebration of a cultural festival in the coastal village of Sitges, an hour south of Barcelona, and the installation in Rusiñol's house-museum of two portraits reputedly painted by El Greco. The so-called *festes modernistes* had been initiated two years earlier. Within a broad process of historical and social transformation, Rusiñol and other progressive thinkers of his generation sought to awaken Catalonia from its provincial torpor and forge a national culture of modernity in their homeland. From the start, however, the *modernista* artist found himself in conflict with his own class, the

industrial bourgeoisie, whose economic aspirations he expressed, but whose cultural parochialism and social conservatism he deplored.[2] Proposing the religion of art as a corrective to the instrumental mentality of bourgeois reason, Rusiñol argued that cultural and social regeneration must proceed in tandem with spiritual renewal.[3] The procession of the works by El Greco through the streets of Sitges symbolically announced the role art would play as a secular religion in the reawakening of the Catalan national spirit.

Picasso also identified with El Greco. If Rusiñol imagined the painter as a heroic individualist and a precursor of modern art, however, Picasso was drawn to El Greco's status as the quintessential outsider artist.[4] Not only was Picasso younger, and from a considerably more modest social background, than either Rusiñol or Casas, his Andalusian origins set him apart from his Catalan friends. Just as El Greco had come to define the Spanish national tradition

through the objectifying distance of cultural difference, Picasso viewed the momentous changes in Catalan political and social life with a critical eye. In a drawing of c. 1899 (fig. 1) Picasso declared himself to be the artist's legitimate heir, inscribing the words "Yo el Greco" beside a stylized head. The formal affinities of this and other drawings in El Greco's style with Picasso's caricatures of *modernista* painters from the same period are telling, as El Greco's outsider status is invoked in relation to both the marginalized bohemian artist (filtered through Picasso's own experience of cultural difference) *and* the decadent aesthete in pursuit of art for art's sake. In effect these figures represent two sides of the same coin, although Picasso remains ambivalent about their exchangeability. If Rusiñol invoked the secular religion of painting and poetry in 1894 as a panacea for the excessive materialism of his day, eight years later Picasso imagined a more active role for the socially engaged artist. In a sardonic drawing of September 1902 (fig. 2)

1. Picasso, *"Yo el Greco,"* Barcelona, c. 1899, pen and ink on paper, 31.5 x 21.8 (12 ⅜ x 8 ½), Museu Picasso, Barcelona

2. Picasso, *"Muy importante,"* Barcelona, September 1902, pen and ink on paper, 13.5 x 21.2 (5 ¼ x 8 ⅜), Museu Picasso, Barcelona

3. Picasso, *Ser o No Ser*, Barcelona, published in *Joventut*, 16 August 1900

a solitary figure delivers a latter-day "sermon on the mount" to an impoverished family. "I speak to you of *very important* things—of God, of Art," the preacher announces, to which one of the unfortunates pithily responds, "Yes—Yes—but my children *are hungry.*"

The artist's position in bourgeois society and the nature of his commitment to social reform were hotly debated issues in fin-de-siècle Barcelona and Madrid.[5] In the wake of the disastrous Spanish-American War and the corresponding loss of Cuba, the Philippines, and Puerto Rico as colonial possessions and export markets, Spain experienced a collective crisis of conscience. Demands for educational, social, and political reform by Spanish writers of the so-called Generation of '98 and the gradual transformation of Catalan nationalism from a cultural movement into a political force necessitated new solutions to age-old problems, from the organization of the Spanish state itself to what was euphemistically called the "social question." Against this backdrop of ideological crisis and social change, Picasso and his colleagues emphasized the creative force that youth would exert in the spiritual and moral regeneration of the nation.[6]

Numerous authors have discussed the Nietzschean aspects of this vitalist conception of culture. Advertisements for the Spanish translation of Nietzsche's *Birth of Tragedy* appeared throughout *Arte Joven*, while the Catalan critic Pompeu Gener (whom Picasso included in his gallery of bohemians) regularly contributed commentaries on the German philosopher's writings to the Catalan journal *Joventut*.[7] In a text proclaiming "the modern oligarchy of the intellect,"[8] Gener insisted on the natural authority of the intellectual elite to engage in a triumphant *tabula rasa* of the past in order to lead the blind masses forward. For Picasso's generation the Nietzschean superman symbolized heroic individualism and the struggle of youth against an anachronistic and historicized culture, a theme the artist economically expressed in an illustration to a poem by Joan Oliva Bridgman, published in *Joventut* (fig. 3).[9]

Critics have attempted to read into this and related images of Picasso's formative years a discrete political program linked to the anarchist movement in Spain.[10] Patricia Leighten has been most vocal in insisting that "Picasso intended his work to be seen as political art. His themes accumulate subjects of specific concern to the anarchist milieu of which he was a member, and his treatment of them expresses a sympathy with the *marginación social* and represents much

more than solipsistic projection."[11] For Leighten the Nietzschean rhetoric of destruction through which Picasso and his contemporaries expressed their contempt for bourgeois society "could be metaphorically expressed in their art" as social criticism, "without actually requiring them to live out its injunctions literally."[12]

Leaving aside for the moment the complex questions of philosophical anarchism as an ethico-cultural posture shared by a wide sector of the Spanish intellectual community and political activism as a concrete means to an end in direct contact with the worker's movement,[13] the nature of Picasso's relation to dominant ideologies is at issue here. On this point Leighten effects a closure on the historical object of her study, stating in her introduction, "My efforts to retrieve a lost political context for [Picasso's] early career have nothing to do with analyses of market forces and patronage, nor with an attempt to offer a theory of Picasso's relations to ruling-class (or other) ideologies. . . . My study is not Picasso as an object of historical forces (though surely the subject needs attention), but Picasso as a self-conscious agent in history, aspiring to master, manipulate, and direct what he perceived to be his 'historical' material, granting all its problems of contradiction, inconsistency, and ambivalence."[14]

Leighten's refusal to consider the broader implications of Picasso's "political" position results in a distorted reading of his early work. Most important, she fails to take into account exactly how intellectual anarchism in Barcelona was set in relation to the changing course of Catalan cultural and political nationalism in the period between 1888 and 1906, for the internal "contradictions" to which Leighten alludes are, precisely, Picasso's "historical material." Thus the radical essayist Jaume Brossa, who contributed theoretical articles sympathetic to the anarchist cause to publications like *Ciencia social,* remained committed to what Joan-Lluís Marfany has called "the cultural catalanization of the

working-class movement"[15] and to the formation of a revolutionary Catalan left. For Brossa and other progressive thinkers of his generation the national question was intimately tied to the social question, although the working class itself remained largely on the margins of this process. This disparity gave rise to an inherently unstable and contradictory situation that witnessed periodic eruptions of violence, labor unrest, and a vicious cycle of repression by the central government in Madrid. The broad outlines of this tense moment in Catalan history can be traced through the work of the artists who lived it.

The 1890s are today remembered as a decade of political strife and terrorist activity in Barcelona. At the Our Lady of Ransom Day celebrations on 24 September 1893 a young anarchist named Paulino Pallás tossed two bombs at a military procession led by General Arsejio Martínez Campos, the civil governor of Catalonia, wounding the general and killing or maiming several of his officers. Six weeks later, in an act of reprisal for the public execution of Pallás by garroting on 6 October 1893, Santiago Salvador French threw two bombs into the orchestra pit of the Liceu opera house during a performance of Rossini's "William Tell," leaving twenty-two dead and thirty-five wounded. The central government responded by suspending constitutional guarantees, effectively giving the police a free hand to pursue suspected anarchists and anarchist sympathizers.

Two years later another anarchist attack with broad international repercussions rocked Barcelona. On 7 June 1896, as observants in the annual Corpus Christi procession entered the medieval church of Santa Maria del Mar, a bomb exploded, killing six innocent bystanders—including two children—and wounding forty-two others. The government again reacted by imposing martial law, and the police, whom many historians believe planned the attack as

an excuse to clamp down on the workers' movement,[16] arrested some four hundred suspected anarchists, labor organizers, and leftist intellectuals. When word got out that confessions had been extracted under torture, the subsequent Montjuïc trials (named for the fortress where the accused were held) made front-page headlines throughout the world.

Both Santiago Rusiñol and Ramon Casas recorded these deeply traumatic events. Rusiñol attended the trial of Salvador French and other "anarchists" indicted in the Liceu bombing. In four sketches containing twenty-seven portrait heads of the accused (fig. 4),[17] he imagined a gallery of criminal types, carefully numbering his "specimens" for future identification. The taxonomical structure of the drawings and the brutal empiricism with which the individual heads are rendered hardly suggest a sympathetic response by Rusiñol to the persecution of innocent victims; rather, they enforced current views on social deviance, particularly César Lombroso's theories of criminal behavior.

More ambiguous, though no less problematic, are two paintings by Casas: *Garrote vil* (fig. 5), which depicts the execution of Paulino Pallás; and a broad view of the *Corpus Christi Procession Leaving the Church of Santa Maria del Mar* (fig. 6). As Temma Kaplan has argued, these paintings should be seen in relation to expiation rituals through which the Barcelona public vented its fears, outrage, and, in the case of the Corpus Christi bombings, collective mourning for the innocent victims.[18] As with Rusiñol's heads of anarchists, Casas' painting inspires little sympathy for the condemned man, who disappears in the middle ground among officials and penitents.[19] Indeed the real subject of the painting is public spectacle.[20] It represents what the critic Raimon Caselles aptly described as "a heterogeneous civilization in one of its most disconcerting and indefinable moments . . . in which all the antagonisms and contradictions are contained: justice and ferocity, work and

public entertainment, gallows and workshops. . . . A brutal and shameful reality!"[21] That the painting was exhibited as Santiago Salvador French awaited trial for the Liceu bombings only added to its sensationalist appeal.

Casas' *Corpus Christi Procession Leaving the Church of Santa Maria del Mar* is even more reticent. Exhibited in Barcelona's IV Exposición de Bellas Artes é Industrias Artísticas, the painting received critical accolades precisely because the artist appealed to a vague ideal of public solidarity. Characteristically, Casas depicts not the decisive moment of terror as the last celebrants enter Santa Maria del Mar, but a prior moment in the historical narrative as the procession leaves the church, if in fact we are correct in inferring a reference to the events of June 1896. The meaning of Casas' painting is almost entirely driven by context. In the absence of a specific historical referent, it reads like an open text on which a range of ideas about civic pride and collective experience are inscribed. The subject of the painting is a call to the Barcelona public to join in the project of Catalan national reconstruction across economic and political lines.

Given the presence of deep divisions in the Catalan social façade, Casas' message in these paintings is idealistic, if not subtly coercive. His position represents a typical response by liberal intellectuals of his generation to the unresolved question of class conflict in Barcelona. Invoking a shared ideal of national unity and social order, Casas in effect plays the bourgeois trump card of social reform.

The period immediately following these traumatic events was one of relative calm in Barcelona. The cycle of violence and political terror that had plagued the Catalan capital in the earlier part of the decade came to a halt, owing in part to police repression of anarchist groups, the weakened state of the central government following the Spanish-American War, the promise

of social legislation, the advent of republican Catalanism, and the rise of syndicalism and the strategies of the general strike.[22] In reality, however, this was a period of incubation for a new wave of violence that would erupt in 1902 as tensions continued to fester beneath the surface of a society in transition.

The Montjuïc trials effectively silenced a large sector of radical intellectuals sympathetic to the anarchist cause. Public opinion was decidedly not in favor of extremist politics, even when exercised in the realm of ideas. The writer Pere Coromines had been prosecuted, and Jaume Brossa and his colleague Alexandre Cortada went into exile in Paris. Moreover, the organized working-class movement, which had been eclipsed by individualist anarchism in the 1890s, had entered a period of gradual decline and collapse.[23]

The following assessment of the situation is taken from the pages of *Ciencia social*, an anarchist journal: ". . . how is it possible that a generation of Spanish workers that has given proof of its vitality over the course of the last twenty-five years can find itself plunged into [a state of] stagnation like that which currently subordinates it? Crisis, misery, pain. We can summarize our social state with these three words."[24]

Picasso's colleagues in Madrid and Barcelona experienced the full effects of these changes. Azorín (José Martínez Ruiz), in his 1899 treatise *La Sociología criminal*, examined crime in bourgeois society as a condition of social injustice and oppression. A member of the Generation of '98, the radical writer also contributed critical texts to *Arte Joven*. But as Lily Litvak has observed,[25] the final paragraphs of Azorín's book suggest that the author had become disillusioned with the possibility of revolutionary action. The text ends on a note of extreme pessimism that is as characteristic of the Generation of '98 as is the commitment to reform its members professed:

7. Joaquim Mir, *La Catedral de los pobres,* 1898, oil on canvas, 184 x 247 (72 ⅜ x 97 ¼), private collection, Barcelona

Nothing is eternal; everything is mutable. . . . Matter follows its ceaseless evolution toward the infinite, changing, transforming itself, dying in order to be reborn in new forms. Man is not exempt from universal destruction. Just as the fauna of earlier times has come to an end, so too will man, and no traces of his genius, of his movements, of his monuments, of his civilizations will remain. . . .

And when the Earth is deserted, revolving in profound darkness through the immensity of space, to what end will our labors, our struggles, our enthusiasm, our hatred have served us?

Surely, this sense of impotence and social collapse also pervades fin-de-siècle painting in Spain. The words "crisis, misery, pain" might well be used to describe specific canvases of Picasso's Blue period (cats. 92–94), or Joaquim Mir's *La Catedral de los pobres* (fig. 7), in which an indigent family begs for alms on the grounds of Antoni Gaudí's Temple of the Holy Family. As with Casas' *Corpus Christi Procession,* Mir's

painting concerns the broad effects of poverty and suffering, but it falls far short as a partisan statement. The title of the painting was in fact suggested by a comment from the future bishop of Vic, the conservative cleric Josep Torras i Bages, who, observing Mir at work on the canvas, exclaimed, "This looks like the poor man's cathedral!"[26] Indeed it is precisely the *in*articulateness of these and related images that sheds light on Picasso's silent, self-absorbed, and marginalized figures of the Blue period as ciphers of withdrawal and containment rather than as exalted expressions of social engagement. With the collapse of a revolutionary left linked to the workers' movement, the radical Catalan intelligentsia would increasingly play its political card through the organ of republican nationalism, conceiving of its intellectual revolt primarily as an ethical and moral project of regeneration within the world of ideas. The rules of engagement had dramatically changed.

There is considerable evidence of an ideological crisis within Picasso's circle. Among the short stories the writer Francisco de Asís Soler published in *Luz* and *Arte Joven,* two in particular point to the collapse of ideological politics. In "The Monopolists" Soler describes two mass gatherings:[27] a revolutionary meeting of workers who have been laid-off, and a banquet attended by their capitalist bosses, who cynically celebrate the economic rewards they have reaped by mechanizing their factories. When the angry mob arrives at the banquet hall shouting "death to the rich," the industrialists, initially alarmed, take comfort in the knowledge that the police will soon arrive to suppress the mutiny. Although Soler's sympathy clearly lies with the urban proletariat, he maintains an unmistakable air of contempt for the specter of a bloodthirsty, uncontrollable mob. An even more cynical tone is struck in Soler's "Propagandist," which first appeared in *Luz* and was later reprinted in *Arte Joven.*[28] The story concerns an

industrialist who approaches a labor organizer with the proposition that he organize a general strike to ruin a competitor. The propagandist agrees to betray his principles for the sum of 5,000 pesetas in addition to the costs involved in calling a mass meeting. A brilliant orator, the unscrupulous character manipulates his followers (the majority of whom are in no position to strike and forego desperately needed wages), who not only agree to the strike but contribute to the costs of the meeting that the industrialist had secretly agreed to pay. In this parable of greed, in which opportunism crosses political lines, the rank and file are deceived by their party bosses. Mass social movements, Soler suggests, are not exempt from corruption.

Although this attitude clearly draws on the rhetoric of individualist anarchism, it hardly functions as an adequate assessment of social and economic oppression. In the wake of the Montjuïc trials and the rise of the republican, Catalan left, the politics of social action had been coopted and entirely transformed by the liberal bourgeoisie. As an ominous reminder of Barcelona's recent, violent past, the image of Montjuïc loomed large over Picasso's generation, at once a symbol of failed hopes and new expectations. The anarchist credo, which continued to find an audience among bohemian artists and writers, would now play a role as the voice of pure negation.

The image of Montjuïc makes an appearance in Picasso's art at this time, pointing us in the direction of these momentous changes. The fortress towers over the city of Barcelona in the background of a drawing Picasso made to commemorate the Our Lady of Ransom Day festivities of 1902, which lasted from 23 September until 5 October (fig. 8). Published on the front page of the newspaper *El Liberal* to mark the final day of the celebrations, the drawing depicts a crowd of men, women, and children of different classes peacefully watching the traditional procession of giant papier-mâché effigies

8. *Festa de la Mercè (Our Lady of Ransom),* Barcelona, published in *El Liberal,* 5 October 1902

through the streets of the city. Although the representation of a poor woman with two children in the foreground appears to be an image of social marginalization, Picasso actually advances a politically neutral message about popular consensus and cooperation.[29]

Picasso's position is telling, given recent events that had again threatened the unity of Catalan political and cultural nationalism. A general strike had erupted in Barcelona that shut down factories and businesses and effectively paralyzed the city from 17 to 24 February 1902—a response to widespread unemployment, the growing use of unskilled, migrant labor to run Barcelona's industrial complex, and demands by metalworkers for a reduction of the working day to nine hours and the right to unionize. Barricades were erected in the streets of Barcelona and fighting broke out. Characteristically, the civil governor responded by declaring a state of war and calling on the dreaded civil guard to restore order. When the insurrection failed, the human tally of the week's violence included scores of wounded and between sixty and one hundred dead, most of whom, as Kaplan notes, were members of the working class.[30]

Ramon Casas' response to these shattering events was to retitle a fictional scene of urban conflict he had painted in 1899, from *The Charge* (fig. 9) to *Barcelona 1902.* In executing

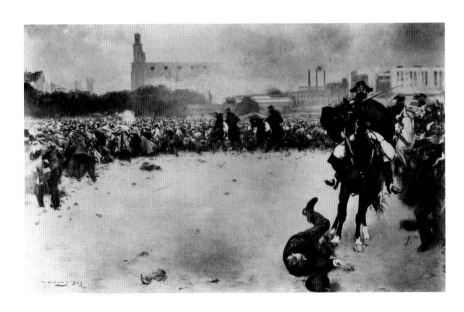

9. Ramon Casas, *Barcelona 1902 (The Charge)*, 1899, oil on canvas, 298 x 470.5 (117 ¼ x 185 ¼), Museu d'art modern, Olot

. . . [the Barcelona] that has provided work for the laborer, money for commerce and industry, and culture for the masses. Democratic above all else, Barcelona has on this occasion preferred to crown itself before celebrating a foreign coronation.[32]

With its pointed references to the strikes earlier that year, and the coming of age of King Alfonso XIII, the text reads like a litany of republican clichés: the defense of Catalan national interests and an appeal to a vague ideal of social harmony and class collaboration (work for all and a shared mass culture). The extent to which this ideal precluded a more penetrating level of social criticism is the very crux of Picasso's response to the plight of the urban poor, a response that was circumscribed by individualist anarchist rhetoric in the cultural sphere and republican ideology in the political arena.

Catalanism itself represented a divided political field. With electoral victories in 1901 by the conservative Lliga regionalista at the national and municipal levels, the editors of *Joventut* championed the cause of a leftist, federal, and popular republicanism. Still, as Marfany has insisted, the class compromise of these bourgeois intellectuals remained firmly intact. Characterizing republican Catalanism as "the left of this more or less civilized right,"[33] Marfany convincingly argues that the Catalan left advanced the cause of reform within a wider process of bourgeois self-determination, *not* in relation to the radical transformation of the means of production. Describing the essential differences between conservative and republican Catalanism, Marfany asserts:

this large, very public set piece, Casas sought to capitalize on the brutality of state-sanctioned violence as a declaration of Catalan opposition to the central government. But as a statement of partisan solidarity with the striking workers— the hapless victim in the foreground is antiheroic—Casas' painting is decidedly ambiguous. So too is Picasso's more informal drawing for *El Liberal,* which actually performed a didactic function in relation to an accompanying editorial:[31]

> The people have been the real protagonists of the festival! They have passed through the noisy and adorned streets without provoking any scandals, without giving in to drunkenness, containing their recreation within the just limits of well-tested decorum.
>
> And some faint-hearted spirits maintain that this great people can only live under the lash! . . . And they said that Barcelona, due to the unruliness of its people, did not deserve to exercise freely its constitutional rights! . . . Worries and lies!
>
> This is Barcelona in its fullest sense: the great Barcelona, the Barcelona of democracy, the Barcelona of the festivals that are ending

> The "social question" would be automatically resolved with the resolution of the national question. The only differences were of a strictly secondary order: a genuine compassion for the suffering of the working class . . . and a general and rather abstract sympathy for its

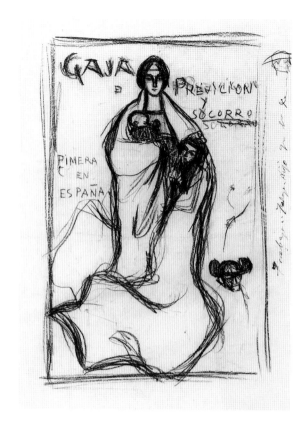

cause; and a vision of the solution to the problem the day following the great liberation of the nation, not in the form of absolute equality and the abolition of class, but rather in terms of a utopian, close [working] relationship among the classes: "a superior level of civilization in which certain unjust differences are erased and a certain balance of equivalencies is established proportional to the needs and the conditions of every person."[34]

The final quotation in Marfany's text is taken from an article by Picasso's friend Sebastià Junyent, published in *Joventut* in 1903.[35] Arguing that it was in the best interests of industrial and rural labor to participate in the Catalan national project, Junyent skillfully exercised the politics of bourgeois hegemony. Throughout the pages of *Joventut*[36] the "social question" was variously framed as a rejection of ideological politics (particularly socialism),[37] a return to the fraternal spirit of Christian morality,[38] and an appeal to an organic Catalan libertarian tradition.[39] When the illusion of national unity could no longer be maintained, as the general strike of 1902 clearly demonstrated, the editors of the journal characteristically proposed "sensible" reformist solutions to diffuse the potentially explosive force of anarcho-syndicalism and socialism alike,[40] among them an initiative to establish a retirement annuity fund for workers.[41]

Picasso was implicated in this process. In 1900 he executed a series of drawings announcing a social security fund sponsored not by the state but by a private insurance agency, the Compañia Española de Seguros (fig. 10). Although Picasso produced these sketches to earn much-needed cash—the final drawing was entered in a poster competition to advertise the fund—his image of a mother shielding her children in a long, flowing cloak reads more like an allegory of liberal beneficence than a political declaration of outrage against poverty and social injustice.[42]

In a similar vein, Picasso's images of prostitutes, beggars, and indigent families represent universal social types set in generalized landscapes rather than specific individuals. Here it should be noted that Picasso's work is in fact at odds with much anarchist imagery of his day, which, even in its more allegorical modes, generally underscored the connections between marginalization and the economic and political structures of bourgeois society.[43] Leighten has insisted that Picasso's paintings depict "actual types abundant in the streets of Barcelona . . . [and] represent political statements as much as symbolic representations,"[44] but the historical evidence points in other directions. When Picasso exhibited recent work in Paris in 1902, the author of the catalogue described the show in the following terms:

> We see three studies of women, like cameos showing painful reality, dedicated to misery, loneliness, and exhaustion. A fierce light surrounds these creatures. There is a violent play of light and shade above and around them. One in particular personifies despair, isolation amid the unfeeling consolation of nature; she is seated on the sand, bent over at the waist, too desperately exhausted even to sob; and she apparently wishes to know nothing of the treacherous call of the ocean.[45]

10. Picasso, poster design for "Caja de Previsión y Socorro," Barcelona, 1900, conté pencil and pen on paper, 32.2 x 22.5 (12 5/8 x 8 7/8), Museu Picasso, Barcelona

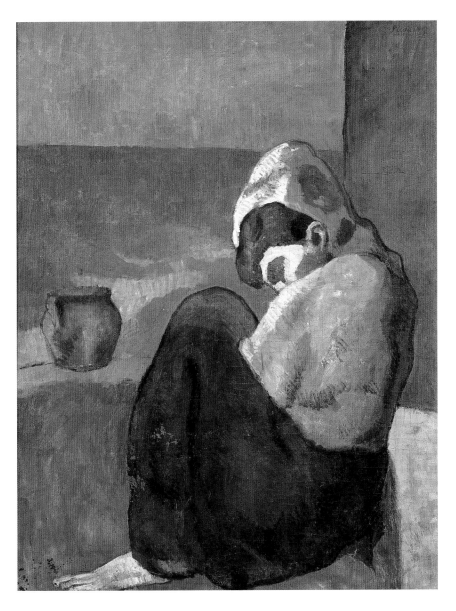

11. Picasso, *Crouching Woman*, Barcelona, 1902, oil on canvas, 88 x 69.5 (34 ⅝ x 27 ⅜), Staatsgalerie Stuttgart

Paying close attention to the artist's *Crouching Woman* (fig. 11), which Picasso inscribed on the verso with the title "Mother and Child, Grieving,"[46] the essayist underscored the passive, self-absorbed state of Picasso's figures. Other commentators went further, refusing to differentiate among the young painter's subjects.[47] Describing Picasso as a Baudelairian painter of modern life, Gustave Coquiot flatly listed "workers and so on" among the subjects represented in Picasso's exhibition at the Galerie Vollard in 1901.[48] Three years later Picasso's friend Carles Junyer Vidal would describe the artist's work as the expression of psychic rather than social turmoil: "The objects he draws . . . externalize the consequences of the psychological temperament, and every variety of the bilious, lymphatic, nervous, or sanguine humor. But all of this is not identified by external details at all,

but by the psychological tension of situations and things."[49]

These commentaries do not support the view that Picasso's imagery is implicated in a radical social project. This is not to depoliticize Picasso's paintings entirely, however—works of the Blue period are often dark, solemn, and deeply disturbing—but rather to insist on the precise nature of the political compromise they express. I have suggested that Picasso's work is implicated in a bourgeois politics of leftist republicanism that attempted to redress the social question within the framework of dominant class initiatives. In this light Picasso's self-reflexive figures are immobilized by the weight of their own inertia, oppressed members of the "passive class"[50] whose voice of protest has been effectively silenced. But they also express the artist's own refusal to be coopted by republican Catalanism. Self-absorbed and socially isolated, backs often turned to the viewer (see cat. 83),[51] these mute figures resist incorporation into the politics of bourgeois reform. Far more than metaphors for Picasso's own experience of marginalization as a bohemian artist, they are poignant signs of contradiction and withdrawal.

The work of Picasso's friend, Isidre Nonell, supports this reading of the artist's Blue period. It has frequently been remarked that Nonell championed the cause of the urban and rural poor, but the context in which much of his work initially appeared and the broader implications of his merciless realism have rarely been considered. Nonell's *Annunciation in the Slums* (fig. 12), depicting an angel appearing before a group of cretinous workers in a sinister industrial landscape, is a case in point. The drawing appeared in a special New Year's Day supplement published by *La Vanguardia* on 1 January 1897. Despite reproductions of other works containing socially engaged subject matter,[52] the tone of the supplement was decidedly conservative, to the extent that it supported the suspension of constitutional guarantees in Barcelona as a necessary

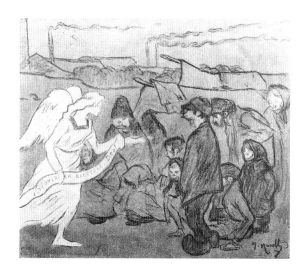

means to bring the "anarchists" reputedly responsible for the Corpus Christi bombing to justice.[53] Clearly, "political" art could be tolerated as long as it restricted its message to a generalized level of concern for human suffering.

In fact Nonell's contemporaries appear to have been divided over the social implications of his work. Although general consensus held that Nonell was a "cruel annotator of the misery that nature and society breeds,"[54] as one critic described an early series of paintings and drawings depicting villagers in the isolated town of Caldes de Boí (fig. 13), Nonell's work was also positioned within the venerable tradition of the grotesque and the stereotypical image of a "Black Spain."[55] Even Alfredo Opisso, who viewed Nonell's work as a declaration of conscience in his review of the artist's exhibition at Els Quatre Gats in December 1898, concluded that the Nonell "does little more than contribute facts, not solutions. . . ."[56] When Nonell exhibited paintings of gypsies four years later at the prestigious Sala Parés, Raimon Caselles was considerably less generous, commenting on "the condition of moral and physical ugliness that certain members of [the gypsy] race can have."[57] Indeed an unmistakable mixture of condescension and revulsion pervaded the critical reception of Nonell's work in Barcelona. In

Eugeni d'Ors' black tale of an angry mob of miserable creatures who turn on an artist—ostensibly Nonell—who has painted a portrait of their abjection, the author ironically comments on the enormous divide separating the artist from the social causes he champions. Venting their rage at the painter for having destroyed their illusion of happiness, the crowd in Ors' tale desecrates his flesh in a violent and bloody exorcism aimed at restoring their former state of blissful ignorance.[58] Even Miquel Utrillo, who interpreted Nonell's work in 1902 as an act of provocation directed at the bourgeois art market, could muster little more than a vague characterization of the artist's canvases as "painfully suggestive."[59]

"Suggestive," and for this very reason, tragic. It is the failure to articulate a clear social mes-

12. Isidre Nonell, *L'Anunciata (Annunciation in the Slums)*, c. 1892, published in *La Vanguardia*, 1 January 1897

13. Isidre Nonell, untitled drawing from the series "Cretins de Boí," 1896, conté crayon, color, and powder on paper, 46 x 31 (18⅛ x 12¼), private collection

14. Isidre Nonell, *Pair of Beggars,* 1898, "fried drawing," 27.5 x 27.5 (10⅞ x 10⅞), private collection, Barcelona

sage that is the real tragedy of Nonell's generation. A drawing of an elderly couple of beggars seated on a banquette (fig. 14)[60] is paradigmatic of the social paralysis that gripped Nonell, Picasso, and their friends. Hanging from the old man's neck is a placard with a text that is largely illegible except for the word "Ciego," or "blind." The sign clearly alludes to the poor creature's physical condition, like so many of the blind beggars and musicians who would appear in Picasso's *teatrum mundi* over the course of 1903 (see cat. 94, and fig. 26 in Chronology). But it can also be read as a signpost marking the conflicted social landscape that Nonell and his contemporaries inhabited. Nonell's drawing states what is largely implied in Picasso's work of the Blue period: the contradiction of a national culture that is produced by the same forces that turn a deaf ear and a blind eye to all but the most glaring manifestations of poverty; and the impossible position the bohemian artist must occupy in the empty space between social (in)action and (aesthetic) withdrawal. It is this condition that Picasso inscribes in the paintings that constitute the score of his Barcelona blues, a condition that, in its numbing contradiction and moral reticence, reveals a powerful social truth.

Notes

The title of this essay is adapted from Jaime Sabartès' *Picasso. Les Bleus de Barcelone* (Paris, 1963). I am grateful to Marilyn McCully for calling my attention to this reference. Unless otherwise indicated, all translations from the Catalan and Spanish are my own.

1. Richardson 1991, 145.

2. For a discussion see Joaquim Molas, "El Modernisme i les seves tensions," *Serra d'or* 12 [1970], 877–884, in his *Obra crítica*, vol. 1 (Barcelona, 1995), 241–250; and Joan-Lluís Marfany, *Aspectes del modernisme,* 2nd ed. (Barcelona, 1984), 22–23. For a typically ironic response to bourgeois cultural values see Santiago Rusiñol's "Tipos Barcelonins: El burgés," *Almanach de la Esquella de la Torratxa* (1899), 98–105.

3. ". . . a people who do not love their poets must live without color or song, spiritually and physically blind. He who walks the earth without adoring beauty is not worthy of receiving, nor does he have the right to receive, the light of day. . . ." Jaume [Santiago] Rusiñol, "Discurs," *Festa modernista del Cau Ferrat* (Barcelona, 1894), 14.

4. For a detailed discussion see my "Narrating the Nation: Picasso and the Myth of El Greco," in Brown 1996, 20–60.

5. See, for example, Ramón de Godoy y Solá, "Impresiones de arte. La Torre de marfíl y el arte por el arte," *Arte Joven* 2 (15 April 1901); and an interesting exchange of opinions between Domingo Martí i Juliá ("Erro," *Joventut* 43 [6 December 1900], 673–676) and Picasso's friend Sebastià Junyent ("L'Art á Catalunya," *Joventut* 60 [4 April 1901], 238–239).

6. Typical of this attitude is a line from the salutatory declaration of *Arte Joven* (10 March 1901), 2: "This journal is dedicated to you, young enthusiasts. It has been created for you, and hopes to be nourished by you."

7. See Pompeyus Gener, "El Cant a la Joventut de Zarathustra," *Joventut* 7 (29 March 1900), 100–102; and Pompeyus Gener, "Ara fa cent anys!" *Joventut* 23 (19 July 1900), 355–356.

8. Pompeyus Gener, "La Moderna Oligarquia del intel.lecte," *Joventut* 16 (31 May 1900), 241–242.

9. *Joventut* 27 (16 August 1900), 424.

10. See in particular Blunt and Pool 1962; Palau 1985; and Leighten 1989.

11. Leighten 1989, 38.

12. Leighten 1989, 15.

13. For a discussion see Rafael Núñez Florencio, *El Terrorismo anarquista, 1888–1909* (Madrid, 1983);

Marfany 1984, 22–27; and especially Jordi Castellanos, "Aspectes de les relacions entre intel.lectuals i anarquistes a Catalunya al segle XIX (A propòsit de Pere Coromines)," *Els Marges* 6 (February 1976), 7–28.

14. Leighten 1989, 10. For more on these "contradictions" and "inconsistencies" see my review of Leighten's book in *Art Bulletin* 72, no. 3 (September 1990), 505–510.

15. Marfany 1984, 26. See especially Brossa's 1892 essay "Viure del passat," reprinted in Joan-Lluís Marfany, ed., *Jaume Brossa: Regeneracionisme i modernisme* (Barcelona, 1969), 13–24.

16. For a discussion see Kaplan 1992, chap. 1.

17. Richardson 1991, 119, erroneously identifies the subject of these studies as *Anarchists Indicted in the Montjuïc Trials*, dating the drawing to 1896. For the correct attribution, see Isabel Coll Mirabent, *S[antiago] Rusiñol* (Sabadell, 1992), 120–125.

18. Kaplan 1992, 32–33.

19. As one journalist commented, "The death penalty receives no strong blows [in Casas' painting]. The artist offers us a colorful scene rather than a moving or loaded picture." See "La semana en Barcelona," *La Vanguardia* (25 March 1894), 1.

20. When *Garrote vil* was exhibited in Barcelona's prestigious Sala Parés in March 1894, it attracted huge crowds that judged the artist's accuracy of detail. To the extent that the painting was destined from the start to be an object of popular consumption, its function as a cultural commodity exists in marked symmetry to the spectacle that is recorded. See Carmen Belen Lord, "Point and Counterpoint: Ramon Casas in Paris and Barcelona, 1855–1908" (Ph.D. diss., University of Michigan, 1995), 173.

21. R[aimon] Casellas, "*Garrote vil*. Cuadro de Ramon Casas," *La Vanguardia* (24 March 1894), 4.

22. Nuñez 1983, 61–66.

23. Nuñez 1983, 67.

24. *Ciencia social* 1 (October 1895), 3 (December 1895), and 4 (January 1896); cited in Nuñez 1983, 66–67.

25. Lily Litvak, *España 1900. Modernismo, anarquismo, y fin de siglo* (Barcelona, 1990), 129–154.

26. Like Casas' *Corpus Christi Procession*, Mir's image was conceived as a public painting. At the IV Exposición de Bellas Artes é Industrias Artísticas in Barcelona, it was awarded a third prize medal. For a discussion see Enric Jardí, *Joaquín Mir*, 2nd ed. (Barcelona, 1989), 40–46.

27. F[rancisco] de A[sís] S[oler], "Los Acaparadores," *Luz* 4 (31 December 1897), 3–4.

28. F[rancisco] de A[sís] S[oler], "El Propagandista," *Luz* 5 (15 January 1898), 6–8; and *Arte Joven* 4 (1 June 1901), 3–4.

29. Kaplan 1992, 75, 77, astutely observes that this "sentimental personification of the laboring classes" served to "[neutralize] the power of the much more menacing anarcho-syndicalist movement in Barcelona. . . . She could pull on the heart strings, assuage the guilt of socially conscious artists and their audience, and yet not demand that they openly take sides."

30. Kaplan 1992, 67.

31. It is important to distinguish between the cultural status of the set piece painting and a drawing conceived for publication in a newspaper or journal. Although Picasso did not execute large-scale political paintings for exhibition, his drawing for *El Liberal* shares common social ground with the more public work of Casas and Mir.

32. "Barcelona Triunfante," *El Liberal* 540 (5 October 1902), 1.

33. Joan-Lluís Marfany, *La Cultura del catalanisme. El Nacionalisme català en els seus inicis* (Barcelona, 1995), 144.

34. Marfany 1995, 180.

35. Sebastià Junyent, "Cap al poble," *Joventut* 177 (2 July 1903), 433–435.

36. In addition to Sebastià Junyent and Pompeu Gener, Frederic Pujulà i Vallès regularly contributed texts to the journal. What is more, the editors of *Joventut* remained in close contact with the editors of *Arte Joven* (Picasso and Soler), as the following notice demonstrates: "We send our warm embrace to the editors of *Joventut* in Barcelona. *Arte Joven* has been welcomed there with enthusiasm. We are not obliged to anyone—we who have sufficient energy to scorn those who would cunningly try to make us fail in our project of regeneration—and we feel admiration for a journal that sustains ideals similar to our own and which knows how to follow its path despite the sneers of the ignorant and the tricks of the envious." See *Arte Joven* 1 (31 March 1901), 7.

37. Lluís Marsans, "La Qüestió social y 'l catalanisme," *Joventut* 28 (23 August 1900), 433–435.

38. Geroni Estrany, "Las Lluytas socials," *Joventut* 26 (9 August 1900), 401–404.

39. F[rederic] Pujulà y Vallès, "Als Socialistas é individualistas," *Joventut* 76 (25 July 1901), 500–501.

40. Trinitat Monegal, "Quelcom sobre las vagas," *Joventut* 102 (23 January 1902), 60–62.

41. "Caixa de pensions vitalicias y jubilació del obrer," *Joventut* 120 (29 May 1902), 358.

42. Leighten 1989, 25, describes the image as an "embodiment of . . . hoped-for state beneficence" but fails to recognize the full implications of the context in which the project was initiated.

43. For a discussion of Catalan anarchist imagery see Litvak 1990, 289–300.

44. Leighten 1989, 34.

45. Harlor, catalogue of works by Picasso, Pichot, Girieud, and Launay, at the Galerie Berthe Weill, Paris, 15 November–15 December 1902; as translated in Palau 1985, 515.

46. Palau 1985, 537, no. 730. The painting was exhibited under the title *Large Portrait of a Woman on the Shore*, no. 15 in the catalogue.

47. In addition to the marginal social types described above, a range of genre subjects was treated by Picasso, including nuns and priests with schoolchildren, wafer sellers, carters, fashionable people walking in the streets of Paris and Barcelona, and spectators crowding to watch an artist at work.

48. Gustave Coquiot, "La Vie artistique. Pablo Ruiz Picasso," *Le Journal* (17 June 1901).

49. Carlos Juñer Vidal, "Picasso y su obra," *El Liberal* (24 March 1904); as translated in Palau 1985, 515–516.

50. The phrase "passive class" is taken from a caption accompanying a reproduction of a drawing by Isidre Nonell in the January 1902 issue of the art journal *Pèl & Ploma*. Responding in the same issue to Nonell's "image of our poor brothers, who are practically at the lowest threshold of the human," Miquel Utrillo adopted a similarly patronizing attitude toward the artist's subjects. See Pinzell [Miquel Utrillo], "Nonell," *Pèl & Ploma* 84 (January 1902).

51. Palau 1985, 298, perceptively observes that "Picasso's figures, rather than being simply seen from behind, *turn their backs* on us. There is in them a kind of hostility to our world. Beyond the suffering or wretchedness of the faces painted before, these women seem to be telling us that they have nothing to do with us and that we may expect nothing from them. We have no right, therefore, to break in upon their privacy, their suffering, their feelings. We are excluded from any contemplation of such things. It is an essential episode in his theatre of blue."

52. Other reproductions included a drawing by Ricard Canals that depicted poor people going to Mass and a sketch entitled *Pascua de dolor* by Picasso's friend Ramon Pichot that showed a woman deep in contemplation beside a baby carriage. On the other hand, a more neutral *japoniste* drawing by Miquel Utrillo of a Parisian scene was also included.

53. "Since the sadly memorable date of 7 June Barcelona has been deprived of constitutional guarantees, which were necessary to suspend in order to facilitate the discovery of the authors of the savage attack. And indeed the year has not ended without their having to submit to the severe ruling of a war council, pending approval today by a higher authority." See "El Año en Barcelona," unsigned editorial, *La Vanguardia* (1 January 1897).

54. Unsigned review, "Salón de *La Vanguardia*. Dibujos de Nonell," *La Vanguardia* (25 October 1896). For an illuminating discussion of Nonell's painting in relation to the nineteenth-century tradition of caricature and the science of physiognomy see Maura Coughlin, "A Dirty Arcadia: Picasso, Social (In)difference, and the Blue Period," unpublished research paper, Institute of Fine Arts, New York University, May 1995.

55. Although Nonell's 1899 exhibition at Els Quatre Gats was not reviewed in the tavern's journal, Miquel Utrillo did comment on the recent publication of *España negra* (written by the Belgian symbolist poet Émile Verhaeren and illustrated by Darío de Regoyos) as the vision of "a Spain that is stale, primitive . . . dark, pessimistic, drowsy, distressing, weak, sick, and dying. . . ." See M[iquel] U[trillo], "Espanya negra," *Quatre Gats* 4 (2 March 1899).

56. A[lfredo] Opisso, "Arte y artistas catalanes," *La Vanguardia* (18 January 1899).

57. Raimon Casellas, "Isidre Nonell," *La Veu de Catalunya* (6 January 1902).

58. Eugeni d'Ors, "La fí de Isidro Nonell," *Pèl & Ploma* 82 (January 1902), 248–253.

59. Pinzell [Miquel Utrillo] 1902.

60. A related sketch of the male figure only appeared on the cover of *Quatre Gats* 4 (2 March 1899).

1899–1901

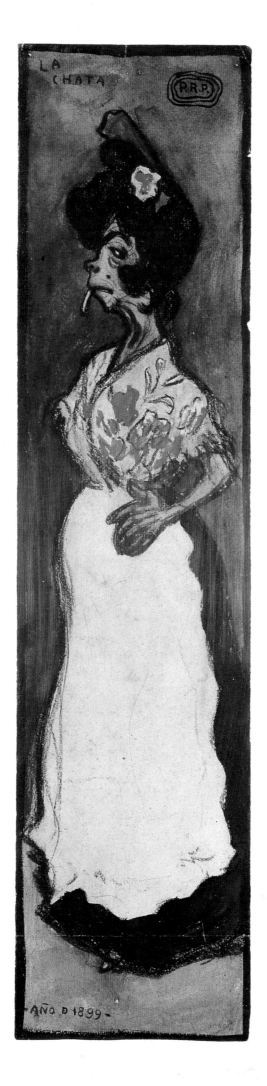

Detail, cat. 32

15. *La Chata*, Málaga, summer 1899, charcoal, watercolor, and gouache on paper, 31.6 x 7.6 (12 3/8 x 3), Museu Picasso, Barcelona

16. *Lola in a Spanish Dress*, Barcelona, 1899, oil on canvas, 46.7 x 37.5 (18 ⅜ x 14 ¾), The Cleveland Museum of Art, Gift of Mr. and Mrs. David S. Ingalls

17. *Portrait of Josep Cardona*, Barcelona, 1899, oil on canvas, 100 x 63 (39⅜ x 24¾), Collection Valentin, São Paulo

18. *Face in the Style of El Greco*, Barcelona, 1899, oil on canvas, 34.7 x 31.2 (13 ⅝ x 12 ¼), Museu Picasso, Barcelona

19. *Portrait of Casagemas*, Barcelona, 1899, oil on canvas, 55.8 x 46 (22 x 18 ⅛), Museu Picasso, Barcelona

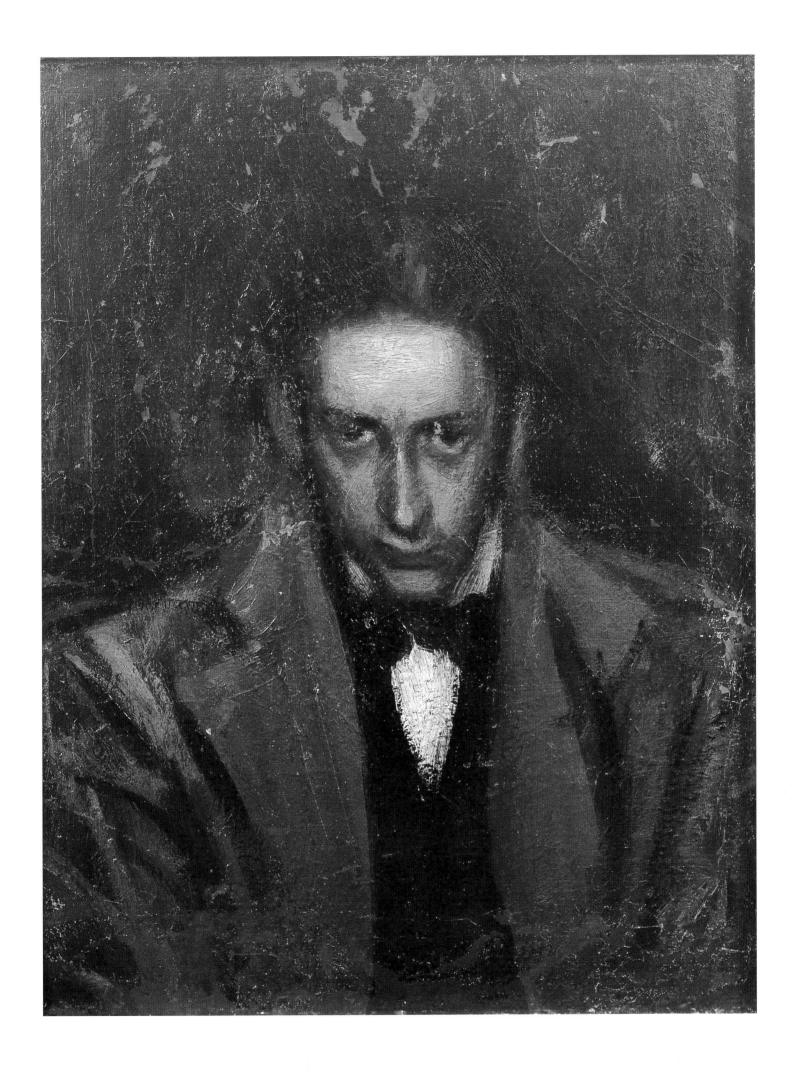

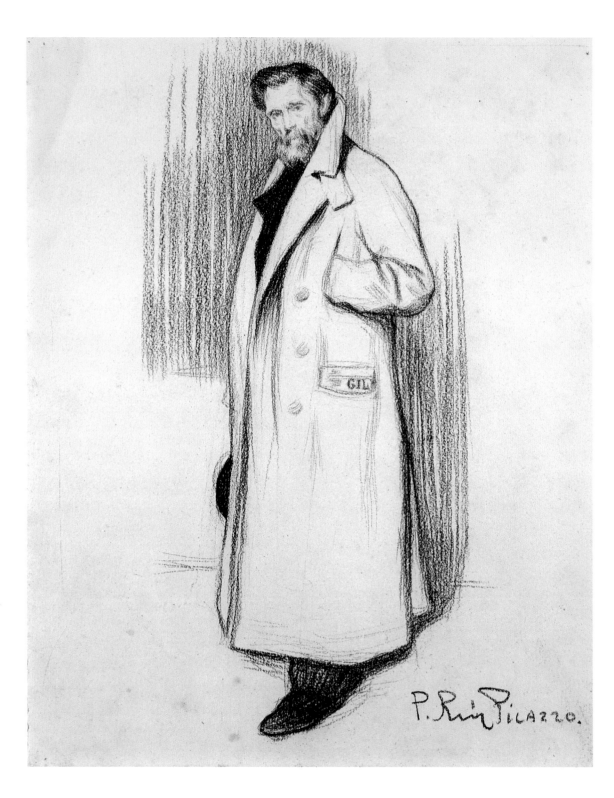

20. *Don José (The Artist's Father)*, Barcelona, 1899, crayon on paper, 30.5 x 24.7 (12 x 9¾), Museu Picasso, Barcelona

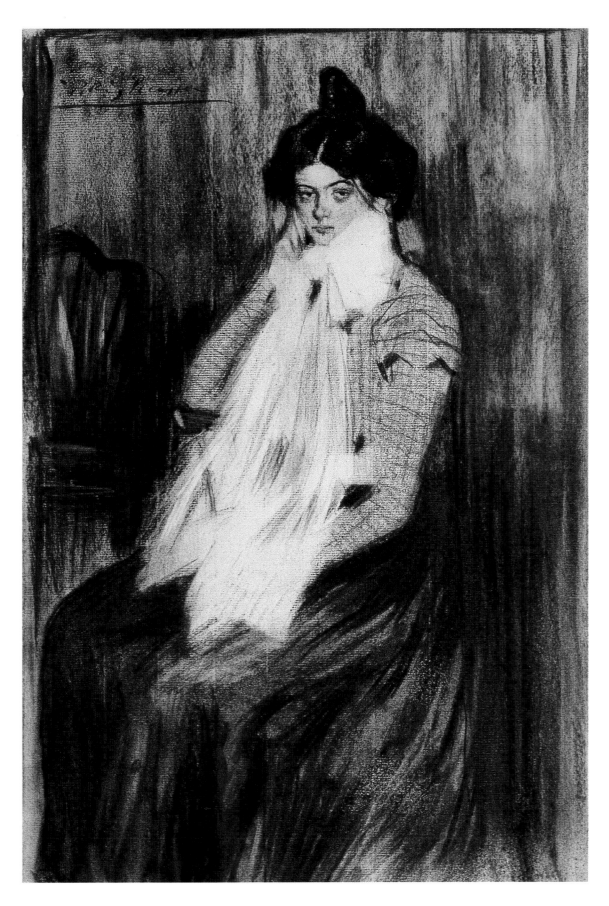

21. *Lola (The Artist's Sister)*, Barcelona, 1899–1900, charcoal and colored pencil on paper, 45 x 29.5 (17 ¾ x 11 ⅝), Museu Picasso, Barcelona

22. *Women Crossing a Plaza*, Barcelona, 1899–1900, black chalk on paper, 16.4 x 23 (6 ½ x 9), Museum of Fine Arts, Boston, Gift of Mrs. Charles Sumner Bird *Boston only*

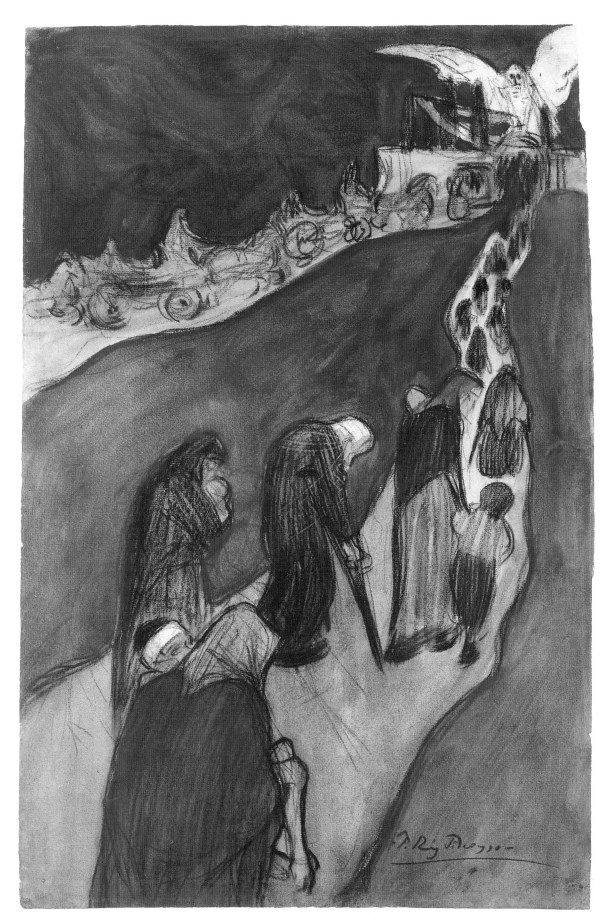

23. *The End of the Road*,
Barcelona, 1899–1900,
oil washes and conté
crayon on paper, 47.1 x
30.8 (18 ½ x 12 ⅛),
Solomon R. Guggenheim
Museum, New York,
Thannhauser Collection,
Bequest of Hilde
Thannhauser, 1991
Washington only

24. *Eveli Torent*, Barcelona, 1899–1900, charcoal on paper, 48.8 x 32.3 (19 1/4 x 12 3/4), The Detroit Institute of Arts, Founders Society Purchase, Dexter M. Ferry Jr. Fund
Boston only

25. *Joan Fonte*, Barcelona, 1899–1900, charcoal and oil-based wash on cream paper, 46.8 x 27.5 (18 3/8 x 10 7/8), Fogg Art Museum, Harvard University Art Museums, Bequest of Meta and Paul J. Sachs
Boston only

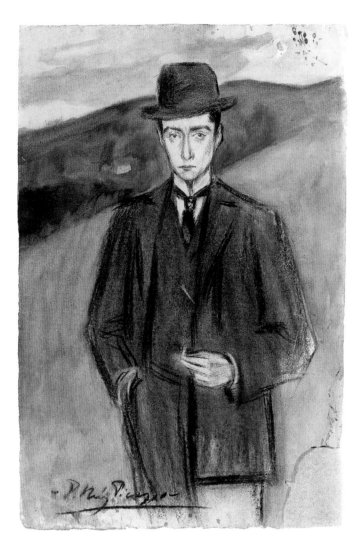

26. *Josep Cardona,*
Barcelona, 1899–1900,
conté crayon and oil
wash on paper, 51.8 x 36.5
(20⅜ x 14⅜), private
collection, Zurich
Boston only

27. *Unidentified Man,*
Barcelona, 1899–1900,
conté crayon and oil
wash on paper, 48.5 x 32
(19⅛ x 12⅝), private
collection, Zurich
Boston only

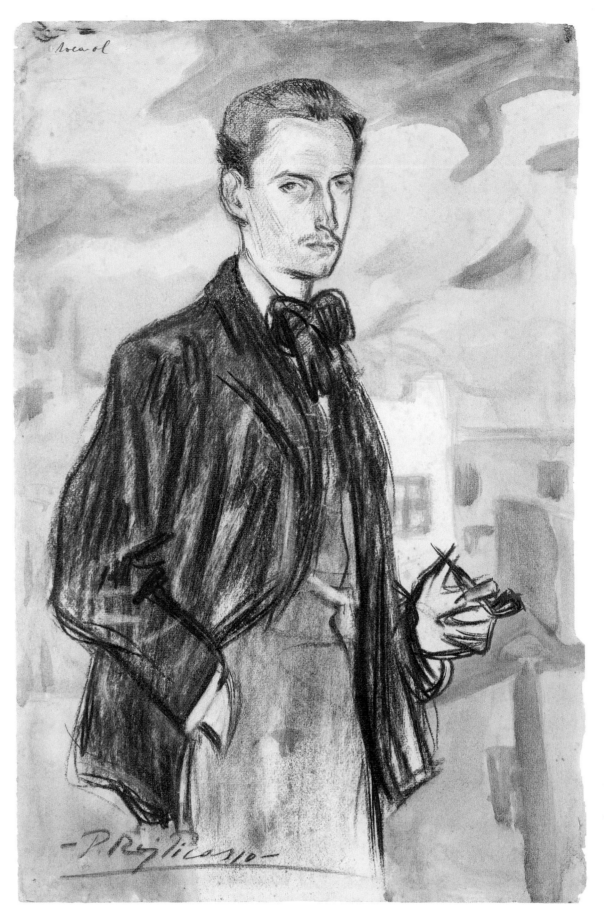

28. *Josep Rocarol*, Barcelona, 1899–1900, charcoal and oil-based wash on cream paper, 47 x 31 (18 ½ x 12 ¼), Fogg Art Museum, Harvard University Art Museums, Gift of Arthur Sachs *Boston only*

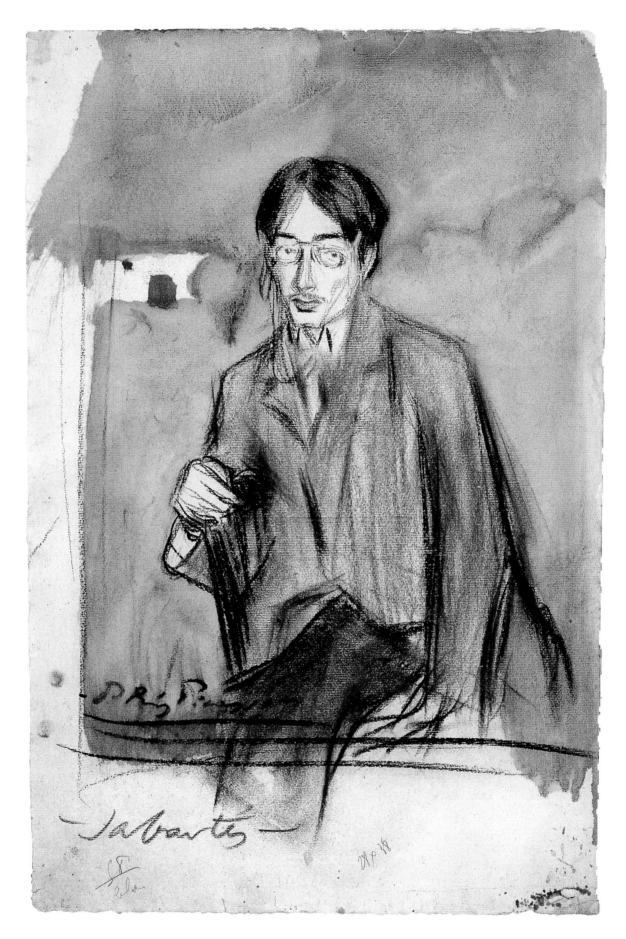

29. *Sabartès Seated*,
Barcelona, 1899–1900,
watercolor and charcoal
on paper, 48 x 32 (18⅞
x 12⅝), Museu Picasso,
Barcelona

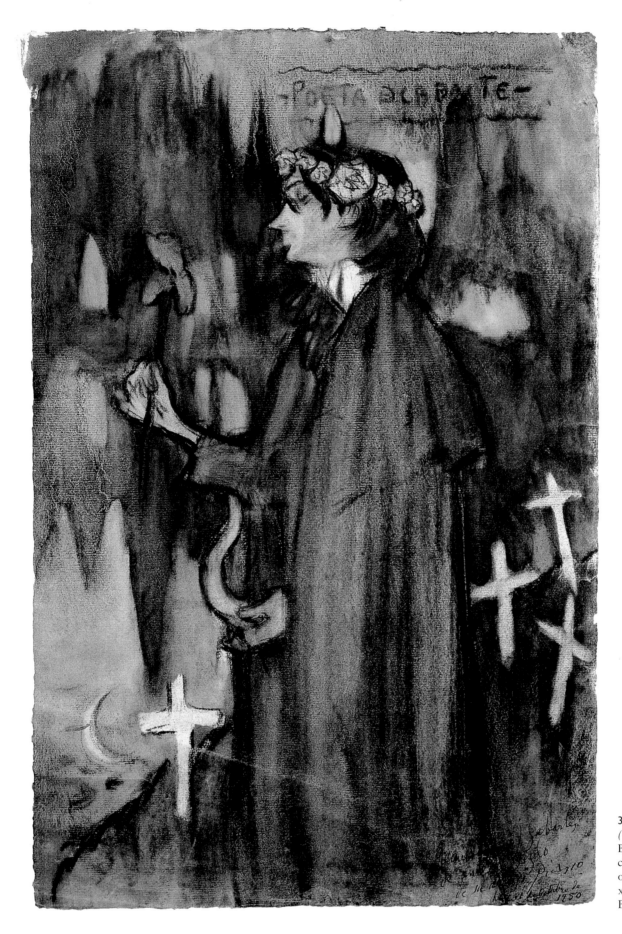

30. *Portrait of Sabartès ("Poeta Decadente"),* Barcelona, 1899–1900, charcoal and color wash on paper, 48 x 32 (18 7/8 x 12 5/8), Museu Picasso, Barcelona

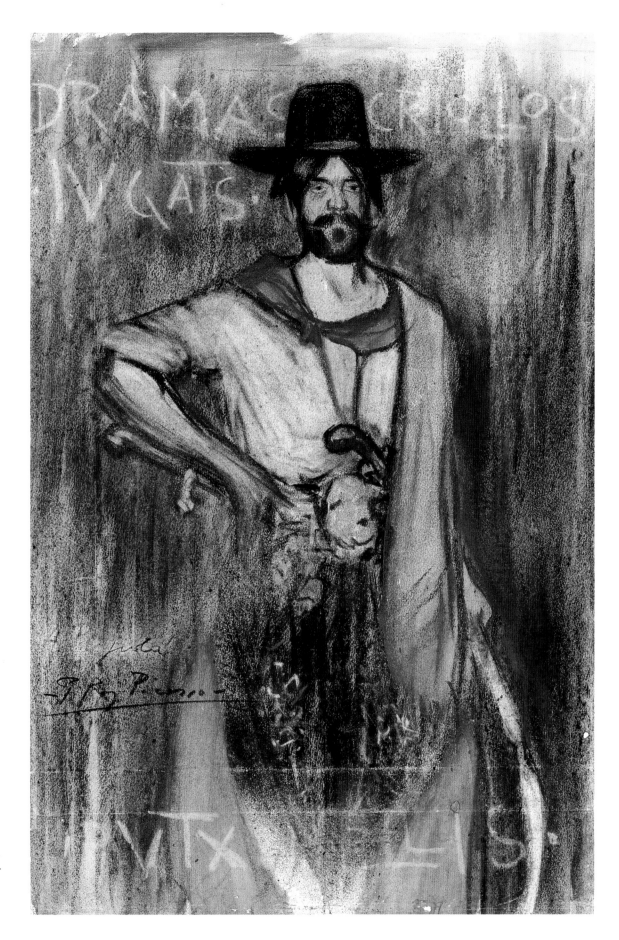

31. Poster design for "Dramas Criollos," Barcelona, 1900, charcoal and pastel on paper, 57.8 x 38.1 (22¾ x 15), Staatliche Museen zu Berlin, Kupferstichkabinett
Washington only

32. *Spanish Couple before an Inn*, Barcelona, summer 1900, pastel on paper, 40 x 50 (15 ¾ x 19 ⅝), Kawamura Memorial Museum of Art, Sakura

33. *Bullfight*, Barcelona,
summer 1900, pastel
and gouache on canvas,
45.8 x 65.6 (18 x 25⅞),
private collection

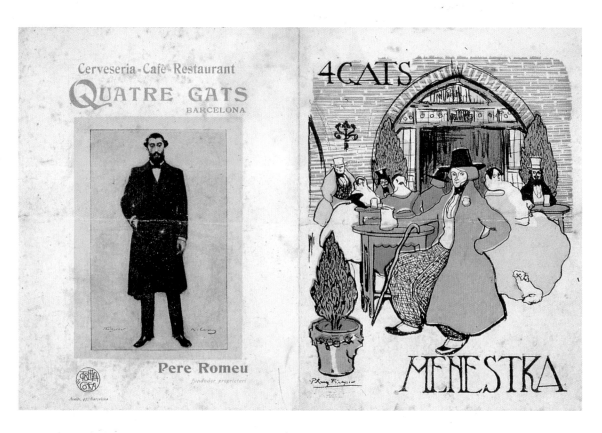

34. *Els Quatre Gats*, Barcelona, 1900, printed menu (with drawing of Romeu by Ramon Casas on back cover), 21.8 x 32.8 (8½ x 12⅞), Museu Picasso, Barcelona

35. *Before*, Barcelona, 1900, pencil and watercolor on paper, 26.7 x 15.7 (10½ x 6⅛), private collection, courtesy Yoshii Gallery, New York

36. *After*, Barcelona, 1900, pencil and watercolor on paper, 27 x 17.5 (10⅝ x 6⅞), private collection, courtesy Yoshii Gallery, New York

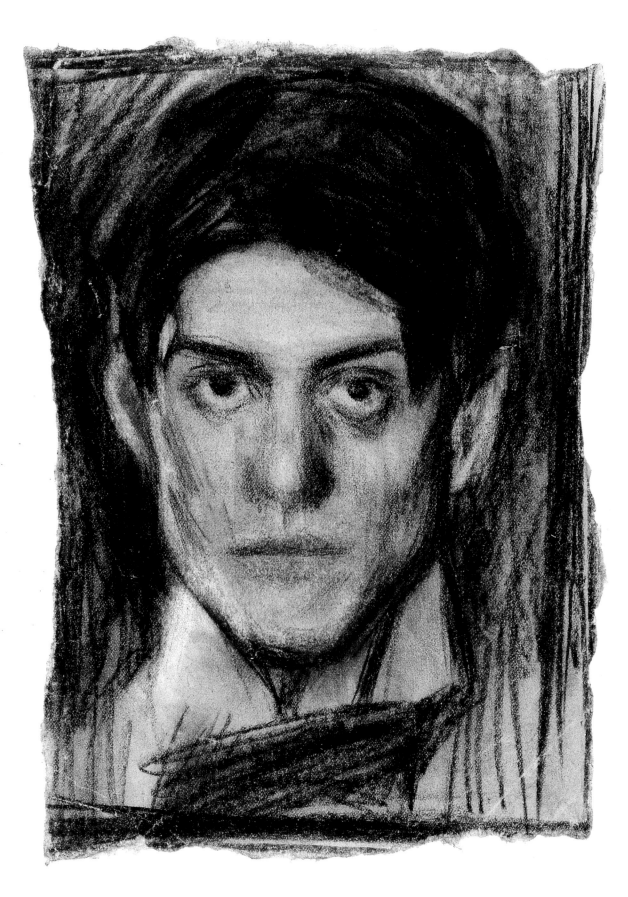

37. *Self-Portrait*, Barcelona, 1900, charcoal on paper, 22.5 x 16.5 (8⅞ x 6½), Museu Picasso, Barcelona

38. *Picasso and Pallarès Arriving in Paris,* Paris, autumn 1900, ink on paper, 8.8 x 11.1 (3 ½ x 4 ⅜), Museu Picasso, Barcelona

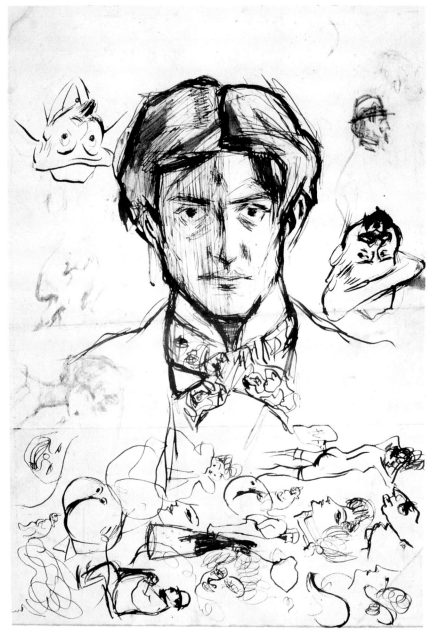

39. *Self-Portrait,* Barcelona or Paris, summer/autumn 1900, pen on paper, 32 x 22 (12 ⅝ x 8 ⅝), Museu Picasso, Barcelona

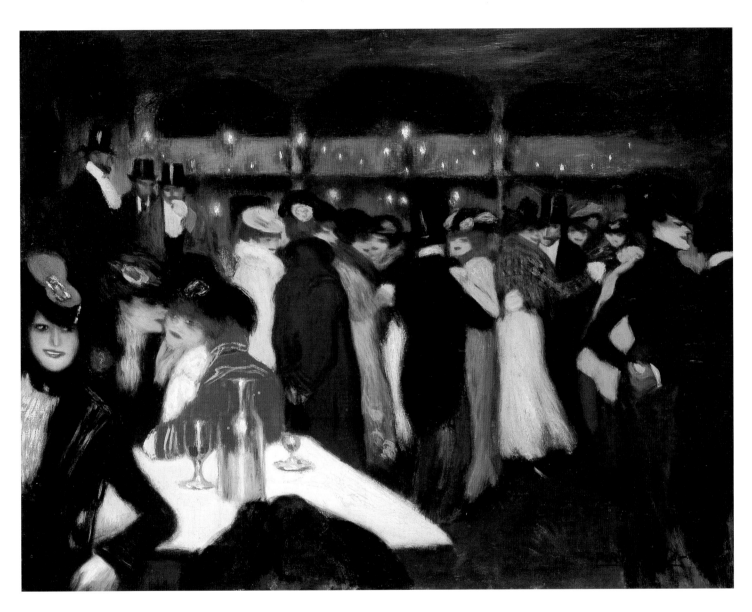

40. *Moulin de la Galette,*
Paris, autumn 1900, oil
on canvas, 88.2 x 115.5
(34 ¾ x 45 ½), Solomon
R. Guggenheim Museum,
New York, Thannhauser
Collection, Gift, Justin K.
Thannhauser, 1978

41. *The Embrace*, Paris,
autumn 1900, oil on
cardboard, 53 x 56
(20⅞ x 22), Pushkin
State Museum of Fine
Arts, Moscow

42. *Montmartre Street
Scene,* Paris, autumn
1900, oil on canvas, 47.6
x 66.7 (18 ¾ x 26 ¼),
San Francisco Museum
of Modern Art, Bequest
of Harriet Lane Levy

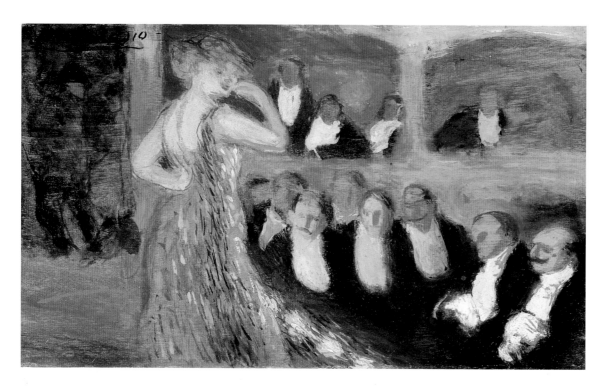

43. *Stuffed Shirts*, Paris, autumn 1900, oil on panel, 13.6 x 22.5 (5 ⅜ x 8 ⅞), Museum of Fine Arts, Boston, Gift of Julia Appleton Bird
Boston only

44. *Man in a Spanish Cloak*, Paris, autumn 1900, oil on canvas, 80.8 x 50 (31 ¾ x 19 ⅝), Von der Heydt-Museum, Wuppertal

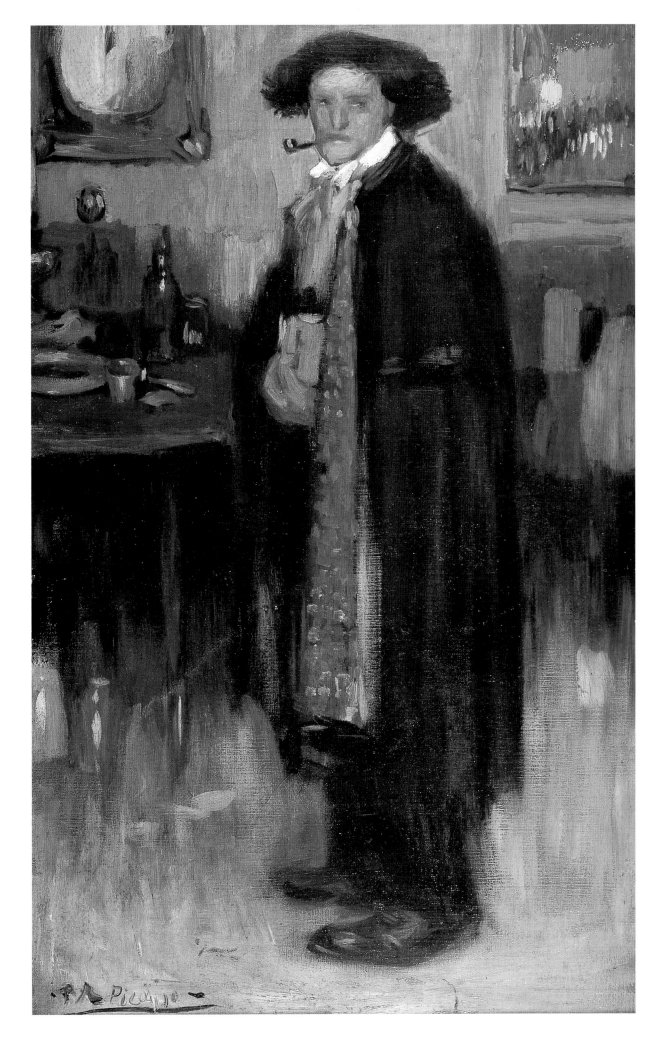

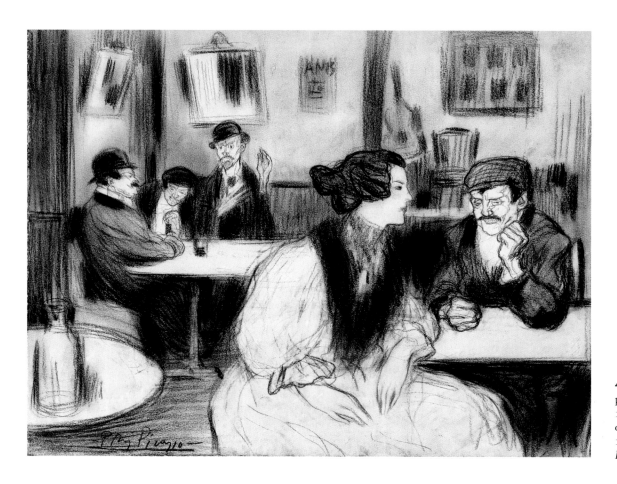

45. *Café Scene*, Madrid,
published in *Arte Joven*,
10 March 1901, charcoal
on paper, 30 x 42 (11 ¾ x
16 ½), private collection
Boston only

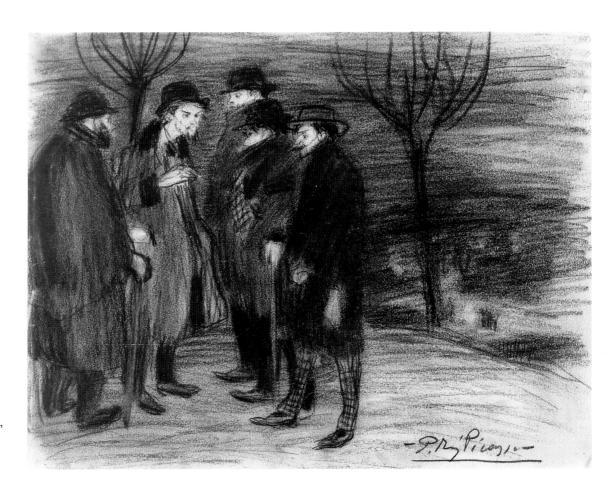

46. *Arte Joven Group,*
Madrid, published in
Arte Joven, 15 April 1901,
charcoal on paper, 23.5 x
30.5 (9 ¼ x 12), private
collection, Canada

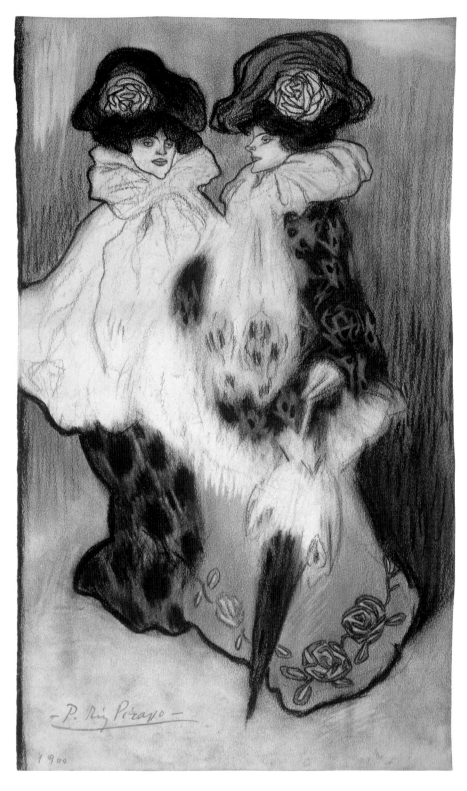

47. *Two Women*, Barce-
lona, 1900 (or Madrid,
1901), charcoal with
stumping and erasure
on paper, 41.4 x 24.5
(16 ¼ x 9 ⅝), Woodner
Collections, on deposit at
the National Gallery of
Art, Washington

48. *Lady in Blue*,
Madrid, 1901, oil on can-
vas, 113 x 101 (44 ½ x
39 ¾), Museo Nacional
Centro de Arte Reina
Sofía, Madrid

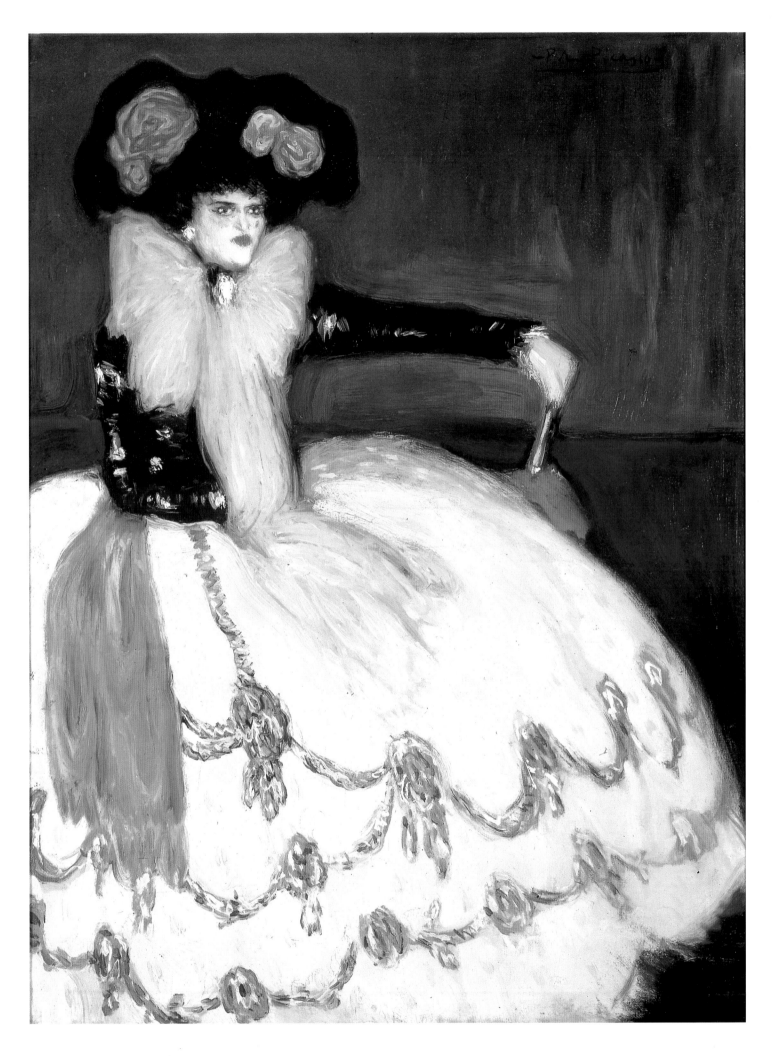

Fumism and Other Aspects of Parisian Modernism in Picasso's Early Drawings

Phillip Dennis Cate

By 1898 the young Picasso, already well-trained as a draftsman, was not satisfied with continuing in the artistic methods and techniques of the academic establishment. Rather, he took up the challenge of new styles and contemporary themes originating in Paris. In numerous self-portraits and figure studies executed in charcoal, crayon, or watercolor during the second half of 1898 in Horta de Ebro (fig. 1) and over the next two years in Barcelona, Picasso rejected the academic system of meticulously modeling the human form through subtle gradations of light and dark and created instead bold dark contours that rhythmically delineated musculature and separated the body into interlocking planes of black and white or color. He sacrificed three-dimensional illusion to emphasize the dynamic two-dimensional elements of the medium of drawing itself. Picasso's stark approach was not unique to the young Spaniard: the flat, linear style ultimately derives from the prints, posters, and designs for theater programs by graphic

artists in Paris, especially the Nabis—notably Félix Vallotton, Edouard Vuillard, and Pierre Bonnard. The most dramatic incorporation of Nabi pictorial elements by Picasso may be seen in his 1899 study for a Carnival poster (fig. 2), where, as in a c. 1891 decorative watercolor design by Vuillard for a Théâtre Libre program (fig. 3), Pierrot serves as the dominant compositional protagonist.

As with the humorous caricatural drawing of the Nabis and other fin-de-siècle Parisian journalist-artists, Picasso's graphic art, once freed from the discipline of academic art, took on a spontaneity and freshness in which the white of the paper actively participated in the composition and defined the image by intermingling with and complementing black dashes, scratches, or broad flat areas of charcoal, ink, or crayon. Equally direct are Picasso's quirky thumbnail ink portraits and sketches (see Z.VI.113), which might be highlighted with only dabs of watercolor. Although executed in Barcelona prior to the artist's first trip to Paris, his small black-and-white caricatures, often framed by margins of black ink, reflect the portrait vignettes by Vallotton and other members of the *Revue blanche* circle.

By the time Picasso first arrived in Paris in the fall of 1900, he was well acquainted with aspects of Parisian modernist styles and subjects. An earlier caricature he drew of himself entering Paris with his friend Manuel Pallarès (cat. 38) reveals that he was eager to explore firsthand the city that was host to that year's Exposition Universelle. His association during the previous year and a half in Barcelona with the tavern Els Quatre Gats brought him into close contact with Pere Romeu, the owner of the locale, and with the leaders of the eclectic *modernista* movement—Santiago Rusiñol, Ramon Casas, and Miquel Utrillo—who were also the prime movers of this lively nightspot. Picasso's sophisticated menu design for the cabaret (cat. 34) reflects clearly his interest in the abstraction of

Detail, cat. 39

1. Picasso, *The Artist Drawing,* Horta de Ebro, 1898, charcoal on paper, 33.1 x 23.4 (13 x 9⅛), Musée Picasso, Paris

133

the Nabis and in the then-current decorative international style of art nouveau poster design.

Rusiñol, Casas, and Utrillo, Picasso's mentors and compatriots, had lived in Montmartre off and on during the 1880s and 1890s. By exhibiting their own art in Spain and serving as Paris art correspondents for the journal *La Vanguardia,* these three artists became the direct links during the last decade of the century between the Parisian avant-garde and aspiring *modernistes* still in Spain. They experienced (or in the case of Utrillo and Romeu were active participants in) the lively cabaret environment of Montmartre, which was initiated in 1881 with the founding of the cabaret Le Chat Noir by Rodolphe Salis. Within a year Le Chat Noir attracted the membership of two overlapping groups of artists and writers—the Hydropathes (1878–1882) and the Incohérents (1882–1895)—as its artists-in-residence and its clientele.

The Hydropathes, organized and named by the poet Emile Goudeau, gathered in cafés on the Left Bank to recite poetry and read verse; the Incohérents, both artists and nonartists, were first brought together by the young writer Jules Lévy to exhibit their "art" in his one-room apartment for the sole purpose of rehabilitating "that glory of the nation known as French wit."[1] Members of these groups generally followed the creed of *fumisme* in both their art and life, espousing cynical or adolescent humor, parody, and satire.[2] Fostering these two antiserious art groups, Le Chat Noir soon emerged in the 1880s as the home of fumism and the center of avant-garde literary/artistic activity in Paris. As the catalyst for collaboration among artists, writers, and composers, Le Chat Noir was in fact the progenitor of the popular *cabarets artistiques* of fin-de-siècle Montmartre. Romeu, along with Rusiñol, Casas, and Utrillo, modeled Els Quatre Gats in Barcelona after Le Chat Noir, which significantly shaped Picasso's understanding of the Paris avant-garde.

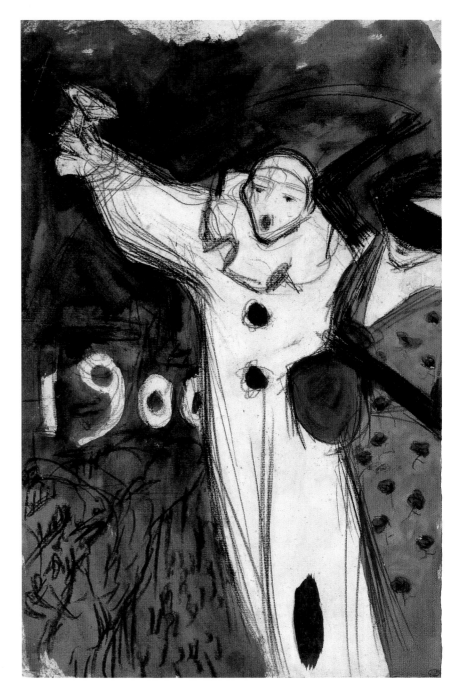

The young Picasso was receptive to the fumist spirit that dominated Montmartre's cabaret environment. It provided a means for the "moderns" to break from the past, from the "antiques," meaning the Greco-Roman tradition that defined academic standards in art and literature. As the Incohérent Henri Detouche stated in the 18 November 1882 issue of the weekly journal *Panurge,* "It seems to me that in front of Michelangelo's masterpiece, *Moses,* the true artist of today should say: 'I would like to do something else.'" Indeed this simple dictum underlay much fin-de-siècle aesthetics and inspired Picasso as well. The artists of Paris and in particular of Montmartre set the stage for

2. Picasso, poster design for Carnival, Barcelona, 1899, oil and black chalk on paper, 48.2 x 32 (19 x 12 5/8), Musée Picasso, Paris

3. Edouard Vuillard, *Pierrot*, program design for the Théâtre Libre, c. 1891, ink and watercolor on paper, 26.3 x 20.8 (10⅜ x 8⅛), private collection

Picasso's cubist challenge to traditional Western art.

Essential to the proliferation of the art and ideas of Parisian modernists, including the anti-serious groups of artists evolving in Paris in the last two decades of the century, was the development at the end of the 1870s of an economical, photomechanical, relief printing process, which permitted an artist's line drawings to be printed from a letterpress simultaneously with text. Photographic reproductions of drawings by the emerging avant-garde appeared in *L'Hydropathe* (1879–1881), *Le Chat noir* (1881–1895), *Le Courrier français* (1884—), and other new journals as well as in catalogues for the Incohérent exhibitions, books, cabaret and theater programs, menus, invitations, and even posters. The original drawings were displayed at Le Chat Noir and other cabarets or in exhibitions such as those organized by *Le Courrier français* atop the Eiffel Tower.

Years before the refinement of a practical, four-color photographic printing process in the

early twentieth century, color illustrations by artists were also available in the popular press. Black-and-white photorelief printed images could be enhanced with color by means of stencils, as was done with cover designs for Aristide Bruant's journal *Le Mirliton* by the popular socialist/anarchist artist Steinlen. Alternatively, relief plates for each primary color (red, yellow, and blue) could be made by craftsmen following an artist's watercolor, crayon, or pastel model and printed, one over another, on a sheet of paper, which would finally be printed with text and the photorelief black-and-white image of the artist's initial drawing. This system produced Steinlen's nearly 1,000 color illustrations in *Gil Blas illustré* as well as the more elaborately colored images in *Le Rire* by Steinlen, Vallotton, Henri de Toulouse-Lautrec, Jean-Louis Forain, and others in the 1890s. Thus drawings by vanguard Parisian artists of the day were readily available—both in black and white and in color—in prolifically illustrated journals and books that resulted from this newly developed industry of photomechanical printing, which inspired the young Picasso even before his first trip to Paris. Picasso himself experimented with these photographic printing processes, first in Barcelona for his Els Quatre Gats menu of 1899, and two years later in Madrid for *Arte Joven* and in Paris for *Gil Blas illustré* and *Frou Frou*.

Color lithography was another popular printing process based on drawing. Not traditionally considered an artistic medium, color lithography began to be preferred by progressive artists in the 1880s; Steinlen, Forain, Toulouse-Lautrec, and the Nabis fully exploited this artistic mass medium. Picasso must have owned a copy of Toulouse-Lautrec's 1895 lithographic poster *May Milton,* since it appears on the wall of his studio in his 1901 painting *Le Tub (The Blue Room)* (cat. 71).

By the 1880s and 1890s nonacademic artists were manipulating the two techniques of photomechanical printing and color lithography for

their own progressive aesthetic goals. Their artistic inroads into the world of mass media allowed artists much greater aesthetic flexibility in the realm of journal illustration and poster design and elevated the art of drawing in Picasso's generation to a level of independence and public visibility never known before.

Picasso's association with Els Quatre Gats led him to create numerous cabaret-related drawings, paintings, and of course his distinctive menu designs (cat. 34), all of which whetted his appetite for the Parisian cabaret art scene. When he first arrived in Paris in the fall of 1900, Le Chat Noir had been closed for three years, but the exuberant and liberating environment established by the innovative cabaret was still very much alive in Montmartre. Soon after moving into a studio on the rue Gabrielle in the heart of Montmartre, Picasso and his roommate Carles Casagemas wrote a letter to Ramon Reventós in Barcelona reporting their new situation: "The boulevard de Clichy is full of crazy places like Le Néant, Le Ciel, L'Enfer, La Fin du Monde, Les 4 z'Arts, Le Cabaret des Arts, Le Cabaret de Bruant, and a lot more that have no charm but make lots of money. . . ."[3]

The Quat'z'Arts (Les 4 z'Arts), founded by François Trombert in 1893, was the most "Chatnoiresque" cabaret in Montmartre by the end of the decade. It brought together artists, writers, poets, composers, and performers who had first found fame (or sanctuary) at Le Chat Noir—including artist/illustrator Adolphe Willette, artist/bohemian Marcellin Desboutin, singer Marcel Legay, musician Charles de Sivry, actress Louise France, and poet Emile Goudeau, who had organized the Hydropathes—as well as such artists, writers, and performers of the generation of the 1890s as Toulouse-Lautrec.[4] It is probably no coincidence that the name "Els Quatre Gats" is a hybrid of the names of the two most popular Parisian cabarets.

The Quat'z'Arts cabaret published its own illustrated journal, as had Le Chat Noir. *Les Quat'z'Arts* (1897–1898) operated with Goudeau as the chief editor, Trombert as its publisher, and Willette, Charles Léandre, Abel Truchet, Edouard Couturier, and Auguste Roedel as its primary illustrators. Yet a more important phenomenon at Quat'z'Arts with respect to the early drawing of Picasso was the cabaret's ephemeral wall journal, "Le Mur," which existed irregularly from September 1894 until around 1904–1905, when, coincidentally, Picasso finally established his residence in Montmartre.[5]

"Le Mur" never existed as a printed or published journal. Rather it was an ongoing but intermittent event or "happening" at the cabaret, usually but not exclusively in the fall of each year. The regular clientele of artists, writers, composers, and performers took turns serving as "editors" of "Le Mur," attaching to a wall of the Quat'z'Arts drawings, altered newspaper clippings, unpublished poems, multi-author stories, songs, music, puns, and parodies as well as early examples of collage, all of which contributed to that day's issue of the journal. These items were assiduously collected in scrapbooks and preserved, presumably by Trombert himself, but were only recently rediscovered.[6] They constitute an important link that had been missing between the anti-academic, nonserious art and antics of the Incohérents and members of Le Chat Noir circle of the 1880s and early 1890s and similar kinds of work by the new generation of artists and writers making their debut in Paris during the first two decades of the twentieth century, including Picasso, Guillaume Apollinaire, and Marcel Duchamp.

The anti-academic character of the Quat'z'-Arts cabaret must have held a particularly strong appeal for Picasso. The graphic art on the walls would have reinforced aesthetic predilections he had developed before arriving in Paris. For instance, his 1899 india ink and brush sketch of a bearded man with a bicycle (Z.VI.228) finds its technical and stylistic counterpart in Edmond

4. Picasso, *A Modernista,* 1899–1900, conté crayon on paper, 22 x 15.9 (8⅝ x 6¼), Museu Picasso, Barcelona

5. *Antique/Moderne,* parody of Victor Privas and Jehan Rictus, 1896, crayon on paper, 23 x 18 (9 x 7⅛), Jane Voorhees Zimmerli Art Museum, Rutgers, The State University of New Jersey. All works from this collection acquired with the Herbert D. and Ruth Schimmel Museum Library Fund

Lempereur's *Portrait of a Man* for "Le Mur." Picasso's *Modernista* of 1899–1900 finds a Parisian predecessor in the 1895–1896 parody for "Le Mur" of singer Victor Privas and the poet Jehan Rictus (Gabriel Randon) as *Antique/ Moderne* (figs. 4 and 5).

The drawings by Auguste Roedel set the tone for "Le Mur" from 1894 until his death in 1900.[7] Although a well-trained and competent draftsman and poster artist who excelled in the art of lithography, Roedel purposefully adopted

a style of childlike scribbles for many of his drawings for "Le Mur" and appropriated the same silly or macabre sense of humor found in illustrations by Adolphe Willette, Caran d'Ache, and others on the pages of *Le Chat noir* in the 1880s. Roedel's drawings and those by other "Murists" share with the Incohérents an interest in early adolescent sexual innuendo, scatology, and nasty insults. Before the 1880s this type of graffiti-like art was kept private, as a genre of drawing most often relegated to personal sketchbooks. Yet for Le Chat Noir and the Incohérent exhibitions artists created—and exhibited publicly—works that subverted academic standards in one manner or another. With "Le Mur," vulgar and crudely executed drawings became the norm for the clients of the Quat'z'Arts cabaret; and, probably not by coincidence, sexually explicit caricature became part of Picasso's own graphic idiom once he moved to Montmartre.

Exposition des quelques cons (Exhibition of Some Cunts) (fig. 6), a drawing undoubtedly done for Apollinaire, reveals Picasso's continued disregard of artistic and social decorum. Its comic-strip voice balloon, its blatant, graffiti-like style of line drawing, and its vulgar street slang within an art-related theme—in this case, visitors to an exhibition—find close counterparts in earlier work from "Le Mur" (fig. 7). For example, a series of graffiti-like scatological drawings in a "Le Mur" parody focused on Jehan Rictus, whose December 1895 performance at the Quat'z'Arts cabaret included a shocking excerpt from the poem "L'Hiver," in his *Les Soliloques du pauvre,* in which the first line reads, "Merd'! V' là l'hiver et ses dur'tés" (Shit! here's winter and its hardships).[8]

Once in Paris, Picasso would easily have become aware of Rictus and his startling performance through the sympathetic illustrations and prints for *Les Soliloques du pauvre* by Steinlen (1895, 1903) and by Picasso's compatriot Joaquim Sunyer (1897). The mannerist styles of

Steinlen and Sunyer are reflected in Picasso's own El Greco-inspired depictions of impoverished individuals, which culminate in 1904 with such works as the etching *Le Frugal Repas* (cats. 104, 105).

In Paris, Picasso experimented with the styles and themes of some of his favorite Parisian artists, including expressionistic renderings of lovers, young working girls, prostitutes, and street people of Montmartre by Steinlen; freely sketched portraits of prostitutes and clients in bordellos and bars by Forain and Toulouse-Lautrec; or images in several media of café-concert performers and cancan dancers also by Lautrec. Yet throughout the process of digesting and regurgitating these progressive styles and modernist subjects, Picasso maintained an affinity with the absurd drawings of "Le Mur."

Fin-de-siècle Montmartre artists and writers parodied various subjects but were most often

self-referential, representing specific places, events, and individuals within the confines of their own artist/writer community. The Incohérents addressed a quite broad but sophisticated audience in the 1880s with parodies of such universal icons as the Mona Lisa, the Venus de Milo, or seventeenth-century Flemish painter Anthony van Dyck and of such well-known figures as actress Sarah Bernhardt, theater critic Franscisque Sarcey, and artist Puvis de Chavannes. Although visual parodies in "Le Mur" might be directed at leading artists and writers of the day, such as Paul Gauguin, Odilon Redon, Emile Zola, Oscar Wilde, and Henri Ibsen, ironic barbs were more often reserved for specific personalities associated with the Quat'z'Arts, whose reputations were limited to the Montmartre cabaret community. Similarly, many of Picasso's early drawings (1900–1903) depicted individuals in his (at that time)

6. Picasso, *Exposition de quelques cons*, c. 1905, crayon, 25 x 16 (9⅞ x 6¼), Collection of Guillaume Apollinaire, sold at Hôtel Drouot on 25 June 1986, lot no. 140

7. *P. Daubry*, c. 1896, ink on paper, 20.9 x 13.1 (8¼ x 5⅛), Jane Voorhees Zimmerli Art Museum

8. Auguste Roedel, *Sécot, sa vie et son oeuvre, image d'Epinal*, 1894, watercolor, 22.5 x 18 (8⅞ x 7⅛), Jane Voorhees Zimmerli Art Museum

9. Picasso, *Histoire claire et simple de Max Jacob*, Paris, 13 January 1903, pen and ink, 19 x 28 (7½ x 11), Musée Picasso, Paris

relatively inconsequential circle of artists, friends, and models, and were done in the same vein as drawings for "Le Mur." Roedel invented a comic narrative watercolor for "Le Mur" that was a tongue-in-cheek description *à l'image d'Epinal* of the "Life and Work" of Gaston Sécot (fig. 8), a pianist at both Le Chat Noir and the Quat'z'Arts cabarets and an editor of "Le

Mur." Nearly ten years later Picasso created his own cartoon narrative, "The Clear and Simple Story of Max Jacob" (fig. 9). Each work pays mock homage to the subject/victim/friend/associate and includes an allegorical crowning of the honoree. An ink drawing for "Le Mur" of the cabaret performer Georges Brandimbourg as a "degenerate monkey" (fig. 10) finds its parallel in Picasso's 1903 *Simian Self-Portrait* (fig. 11).

These examples and others indicate that Picasso was aesthetically and psychologically aligned with the fumist spirit of Montmartre and suggest that he was also prepared to respond to the more radical sensibility of Alfred Jarry. Of all of the idiosyncratic personalities in Paris, it was Alfred Jarry whose bizarre genius and unconventional life and whose iconoclastic style and imagery in graphic arts provided the closest affinities for Picasso. On 9 and 10 December 1896 at the Théâtre de l'Oeuvre in Montmartre, Jarry's *Ubu Roi* was performed for the first time, opening with the pseudo-expletive "Merdre." Rictus of course had established the precedent for this kind of scurrilous public speech at the Quat'z'Arts cabaret almost exactly one year earlier. But more challenging to traditional theater than the invective were the outrageous costumes, the stage-set designs by members of the Nabis, and the Jarry-choreographed puppet-like movements of the actors, including comedic actress Louise France, who regularly served as "secretary" of "Le Mur," playing Mère Ubu. In fact *Ubu Roi* announced the advent of the theater of the absurd, making Jarry its founder.

The closest published literary counterpart to the witty parody of "Le Mur" is Jarry's even more far-reaching parodic text for two issues (1899 and 1901) of *Almanach du Père Ubu*, illustrated by Bonnard. In the 1899 almanac Jarry tackled one by one the entire modernist literary/artistic community of Paris, creating an extraordinary fin-de-siècle inventory of *tout Paris*. As with "Le Mur," Jarry's text requires extensive deciphering of long-forgotten

codes and personal references to be fully comprehended today. But the young Picasso's Els Quatre Gats associates would have made known to him the cryptic references to individuals, events, and schools of thought in the almanacs, which were made all the more immediate by Bonnard's eccentric illustrations.

In a sheet of quick sketches from 1905 Picasso included several studies of Ubu based on Jarry's woodcut portrait of the character, which first appeared in Paul Fort's *Le Livre d'art* of April–May 1896 along with the first fully published text of *Ubu Roi*. Jarry's childlike rendering of this morally repulsive antihero, with abbreviated facial features and a pear-shaped head planted squarely on a rotund torso, was abstracted further in Jarry's 1897 and 1898 lithographs, where Ubu and his equally dehumanized associates appear as paper cutouts.[9] Jarry's *Almanach du Père Ubu* of 1901 carried

the absurdity to its printed extreme, with seventy-nine lithographic illustrations by Bonnard in which artistic license was given free reign by the irrationality of Jarry's parodic narrative, to the extent that Bonnard's ridiculous image of Ubu's companion Athanor Le Fourneau, with his stovepipe, triangulated head (fig. 12), predicts Picasso's cubist distortions of the human figure some six years later.[10] Both of Jarry's *Almanach*s were published by the important impressionist/post-impressionist art dealer Ambroise Vollard, and it was Vollard who gave Picasso his first Paris exhibition in June 1901 and thus serendipitously brought him tangentially into contact with the circle of Jarry.

Jarry organized sixty-four puppet performances of a reduced version of *Ubu Roi* entitled *Ubu sur la butte* at the Quat'z'Arts cabaret in the fall of 1901. It was the last time he performed his revolutionary play either with

10. *Portrait of Brandimbourg [sic] as a Degenerate Monkey,* c. 1896, ink on paper, 21.2 x 13.4 (8 3/8 x 5 1/4), Jane Voorhees Zimmerli Art Museum

11. Picasso, *Simian Self-Portrait,* Paris, 1 January 1903, ink on paper, 11.8 x 10.7 (4 5/8 x 4 1/4), Museu Picasso, Barcelona. See also colorplate 88

12. Pierre Bonnard, *Ubu Colonial,* 1901, lithograph from *Almanach illustré du Pere Ubu,* Jane Voorhees Zimmerli Art Museum

puppets or live actors. Although Picasso never met Jarry, the former would surely have visited the popular Chatnoiresque cabaret, situated only two blocks from his studio on the boulevard de Clichy, to attend one of the many performances that fall of Jarry's fumist play *Ubu sur la butte.*[11]

A common characteristic of the graphic art of "Le Mur," Jarry, and Bonnard's lithographs for *Almanach du Père Ubu* is that all reveal an underlying commitment to the "incoherent" and the ludicrous. This quality shaped Picasso's early art in Paris. Ultimately the cutting edge in his precubist art was not his exploration of the styles of Toulouse-Lautrec and the Nabis or his Steinlenesque, humanistic approach to drawing in his Blue and Rose periods. These aesthetic exercises—abundantly demonstrated, and in a sense exorcised, at Picasso's 1901 exhibition at the Galerie Vollard—provided the foundation for his evolution as a young modernist. But it was the ludicrous, fumist side of his work—as manifested in his drawings, which reveal a kinship to the parodic humor and graffiti style of "Le Mur," to the eccentric graphic art of Alfred Jarry, and to Bonnard's images for *Almanach du Père Ubu*—that eventually gave Picasso the freedom and the expanded visual vocabulary to break most radically with academic traditions.

Notes

1. Jules Lévy, "L'Incohérence—son origine—son histoire—son avenir," in *Le Courrier français* (12 March 1885), 3–4. For a history of the Hydropathes and the Incohérents see my "The Spirit of Montmartre" and Daniel Grojnowski's "Hydropathes and Company," in *The Spirit of Montmartre: Cabarets, Humor, and the Avant-Garde,* ed. Phillip Dennis Cate and Mary Shaw (New Brunswick, 1996), 1–93, 95–105.

2. By 1880 *fumisme* referred to a way of life, an art form that rested on skepticism and humor, often morbid or macabre. *Fumisme* did not produce a quick laugh, nor was its intention always obvious. A *fumiste* had no social or humanitarian agenda; if anything a *fumiste* was politically incorrect, to adapt a modern term. *Fumistes* aspired to counteract the pomposity and hypocrisy they perceived in society.

3. Richardson 1991, 161.

4. Cate and Shaw 1996, 69–72.

5. For "Le Mur" see Anna Dull, "From Rabelais to the Avant-Garde: Wordplay and Parody in the Wall-Journal 'Le Mur,'" in Cate and Shaw 1996, 199–241.

6. The scrapbooks were acquired by the Jane Voorhees Zimmerli Art Museum at Rutgers in 1991.

7. Roedel also faked for "Le Mur" the work of other contemporary artists, creating wash drawings in the style of Vallotton, Henri Ibels, and Hermann-Paul and forging their signatures, for instance, and inventing comical parodies on the work of Redon and Gauguin. Other editors of "Le Mur" made comparable anonymous fakes of literary works and forged signatures of contemporary authors.

8. Jehan Rictus, *Les Soliloques du pauvre* (Paris, 1895), 1.

9. In 1897 Jarry created a lithographic program for the puppet performance of *Ubu Roi* at the Théâtre des Pantins and in 1898 three lithographic covers for the music to *Ubu Roi* for "Le Répertoire des Pantins," published by *Mercure de France.*

10. See my "Forums of the Absurd: Three Avant-Garde Lithographic Publications at the Turn of the Last Century," *The Tamarind Papers* 16 (1996), 27–35.

11. For Picasso's relationship to Jarry see Richardson 1991, 359–368.

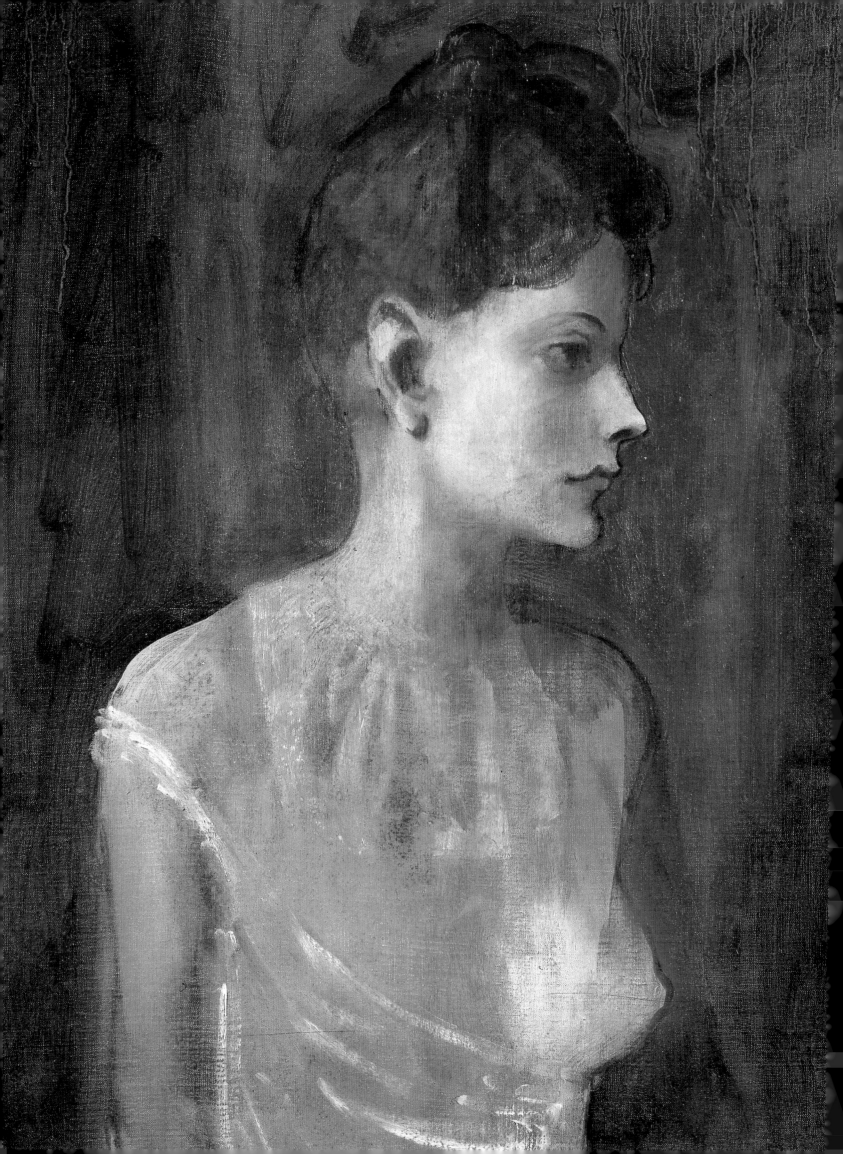

Gustave Coquiot and the Critical Origins of Picasso's "Blue" and "Rose" Periods

Robert J. Boardingham

Gertrude Stein wrote of Picasso in 1938: "needing to completely empty himself of everything he had, he emptied himself of the blue period, of the renewal of the Spanish spirit and that over he commenced painting what is now called the rose or harlequin period."[1] When considering Picasso's early work today, it is virtually impossible not to think of the stylistic terms "Blue" and "Rose" and the chronology they imply. The Blue period extends roughly from the late fall of 1901 to the middle of 1904, and the Rose period from the middle of 1904 into 1906. Although these terms leave many questions unanswered about the nature of the work done during that time, they have gained general acceptance as classifications since they were originally employed before World War I. The first piece of critical writing that introduced the notion of a sequence of styles to describe the development of Picasso's oeuvre leading up to cubism is an essay by Gustave Coquiot, published in 1914 in his book *Cubistes, futuristes, passéistes*.[2] Some

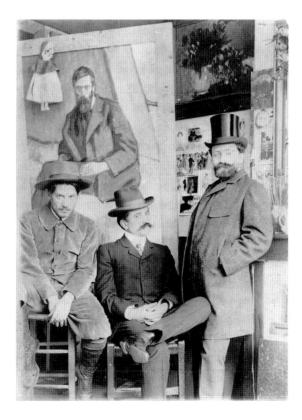

Detail, cat. 112

1. Picasso, Pere Mañach, and Torres Fuster in Boulevard de Clichy studio with Picasso's portrait of Iturrino in the background, 1901, Musée Picasso, Paris

of Coquiot's text had in fact appeared as early as 1901 at the time of Picasso's first commercial Paris exhibition.

Before his twentieth birthday Pablo Ruiz Picasso had already participated in two exhibitions in Paris. *Last Moments* (later painted over with *La Vie*) was included in the official Spanish pavilion of the 1900 Exposition Universelle. The next year more than sixty-five of his works were presented in an exhibition at the Galerie Vollard, alongside compositions by the Basque painter Francisco Iturrino.

Ambroise Vollard was well known as a dealer in works by Cézanne, Gauguin, and other leading French avant-garde artists, and his backing represented an audacious beginning for the young Picasso outside his native Spain. In his teens Picasso had exhibited in La Coruña, Málaga, Barcelona, and Madrid, winning prizes or honorable mentions, but the Vollard show was an extraordinary opportunity for an unknown foreigner who barely spoke French.[3] Henri Matisse, twelve years Picasso's senior, did not have his first show at Vollard's until 1904.

The Catalan Pere Mañach, Picasso's first dealer in Paris, organized the show at Vollard's, while journalist Gustave Coquiot handled the publicity, including the writing of the catalogue. Coquiot apparently gave titles to many of the paintings (not, however, the drawings), and it is now possible to identify most of the works in the exhibition from his list in the catalogue.[4] We know, for instance, that Picasso showed portraits of Mañach (cat. 59), Iturrino (seen in fig. 1 but later painted over on the back of *Young Acrobat on a Ball* [cat. 125]), and probably the other principal organizers of the show, Coquiot (see fig. 3) and Vollard, both of whom Picasso painted in 1901 (the catalogue lists simply "Portraits").

The catalogue preface, on which Coquiot drew for his 1914 text, was published at the time of the exhibition—ostensibly as criticism—in *Le Journal* on 17 June 1901.[5] Given Coquiot's

role in promoting the show, it is not surprising that his text is full of praise for the unknown painter. But it also includes some insights into the reception of Picasso's work in Paris at this early date. This very young Spanish painter was an "impetuous lover of contemporary life." Coquiot implied that for this reason Paris rather than Barcelona or Madrid was best suited to Picasso's ambitions, for it was "a city that offers a different spectacle every minute."[6]

Coquiot's 1901 text reveals serious limitations as a critical review. Although at least nine of Picasso's works shown at Vollard's had explicitly Spanish subjects, including three bullfights, Coquiot made no mention of this, even at a time when Hispagnolist subjects held a particular appeal for French audiences. Works by the older and established Basque artist Ignacio Zuloaga were highly popular, with his *Corrida de toros en Eibar* reproduced in *L'Art decoratif* a month before Picasso's show opened. Picasso shared the exhibition with another talented Spaniard, Iturrino, yet Coquiot did not mention either Picasso's Spanish identity or heritage. Nor did he discuss the multiplicity of Picasso's styles and subjects presented in the Vollard exhibition. *Boulevard de Clichy* (cat. 61) and *Spanish Church* (Bührle Collection, Zurich) not only offered a contrast in subject—modern life versus a romanticized view of a timeless Spain—they were rendered differently. The Paris street scene is loosely derived from French impressionism, whereas the *Spanish Church* is reminiscent of the compositions and tenebrous palette that typified *modernista* painting in Barcelona during the late nineteenth and early twentieth centuries. Coquiot, whose aim was to "sell" the young artist, made no attempt to situate Picasso's work within the context of contemporary painting or French criticism, with regard to the legacy of naturalism, impressionism, or symbolism in any of their manifestations.[7]

In 1914 Coquiot expanded and revised his essay on Picasso and added it to his anthology

of writings on contemporary artists, including two other Spaniards, Iturrino and Joaquim Sunyer, as well as French painters Othon Friesz, Henri Manguin, Albert Marquet, Henri Matisse, and André Derain. If Coquiot was reluctant to classify Picasso's work in 1901, he attempted to chart his "major exploits" in 1914.[8] In so doing, he again stressed Picasso's technical virtuosity and the importance of Paris to his development. With hindsight he classified the artist's work in the 1901 Vollard exhibition as reflecting the influence of Théophile Steinlen, whose work Picasso had known in both Barcelona and Paris at the turn of the century. Picasso's depictions of couples embracing (see cat. 41), for example, have a distinct precedent in works by Steinlen, such as *The Kiss* (fig. 2).[9]

Coquiot then identified works done after the Vollard exhibition as initiating Picasso's "Toulouse-Lautrec period." Yet the artist was undoubtedly drawn to the work of Toulouse-Lautrec on his first visit to Paris in 1900; his *Moulin de la Galette* (cat. 40), executed that fall,

2. Théophile Steinlen, *The Kiss,* 1895, charcoal and pastel on paper, 24.5 x 18 (9 ⅝ x 7 ⅛), Petit Palais, Geneva

3. Picasso, *Portrait of Gustave Coquiot*, Paris, 1901, oil on canvas, 100 x 80 (39 3/8 x 31 1/2), Musée national d'art moderne, Paris, Gift of Mrs. Gustave Coquiot, 1933. *Exhibited in Washington and Boston*

4. Henri de Toulouse-Lautrec, *Monsieur Delaporte au Jardin de Paris*, 1893, gouache on cardboard glued to panel, 76 x 70 (29 7/8 x 27 1/2), Glyptotek, Copenhagen

constitutes something of an homage in subject matter to the French master. At the same time, the manner in which the work was painted reflects a *modernista* aesthetic, and the fact that Barcelona artists before him, notably Ramon Casas and Santiago Rusiñol, had also painted the celebrated dance hall suggests that Picasso was following their examples by choosing this icon of recent French painting.[10] There is other visual evidence to suggest that Picasso was exploring the work of Toulouse-Lautrec in 1900 and 1901. Perhaps the most compelling example is his portrait of Coquiot (fig. 3), one of the largest pictures in the Vollard exhibition. The composition is strikingly similar to Toulouse-Lautrec's *Monsieur Delaporte au Jardin de Paris* (fig. 4) or *Maxime Dethomas* of 1896 (National Gallery of Art, Washington). Picasso's palette is shriller than Toulouse-Lautrec's and his line more incisive, but his composition depends on the older artist's portrait formulas.

According to Coquiot, the influence of Toulouse-Lautrec failed to engage Picasso for long,

and he returned to Spain where he created his "blue period" works. This is perhaps the first use of this term (or certainly one of the first). Coquiot, who was not favorably disposed to this stage in Picasso's development, attributed its character principally to the artist's return to his native country and to the influence of El Greco. That Picasso painted blue canvases as early as the late fall of 1901 while still living in the French capital—for instance, *Le Tub (The Blue Room)* (cat. 71) and *The Poet Sabartès (Le Bock)* (fig. 6 in Weiss essay)—went unremarked by Coquiot. Among precedents in contemporary French art for the predominant use of blue, Coquiot cited Puvis de Chavannes, but he excluded the Swiss artist Steinlen, who sometimes exploited blue for evocative effects, as in his color aquatint *Girl and Pimp* of 1898.

Coquiot moved on to cover the Rose period, distinguished, he claimed, by "exceptional portraits." Although he did not specify which portraits, they must have included those of the little-known model Madeleine (cats. 112, 113).

Coquiot provided scant description or explanation for the works of this period before going on to discuss the "triumph of cubism," a development in Picasso's inventiveness that implicitly diminished the body of work done before 1907, according to the author. Thus Coquiot's analysis is reductive and oversimplified. This brief essay, like the 1901 review, reveals Coquiot's somewhat dismissive opinion of Spanish art.

Picasso himself never attached any significance to labels given to his work, nor did he hold the paintings of the Blue period in especially high regard—"nothing but sentiment," he told John Richardson.[11] Despite his ambition and desire to succeed in Paris, Picasso seldom exhibited there prior to World War I—indeed he never participated in the Salon des Indépendants or the Salon d'Automne, the principal annual avant-garde exhibition venues. Perhaps if he had there would be a large body of contemporaneous criticism to trace his rapid growth as a young artist.[12] Lacking this, the texts of minor critics and journalists like Gustave Coquiot remain of value both for assessing and for documenting the origins of the critical response and classification of Picasso's work in the early years.

Translated from Gustave Coquiot's *Cubistes, futuristes, passéistes* (Paris, 1914)

PABLO PICASSO.—Or simply Picasso; otherwise known as leader of the cubists, and whose continual evolution is not at an end. His technical brilliance is quite extraordinary. He ignores everything, he absorbs it all, yet sticks to none of it. Take a look at his major exploits.

Very young, having arrived in Paris, he embarks on the Steinlen period. He paints the street, gardens, houses, urchins, the women of the town. He paints very quickly, at the rate of about ten pictures a day. Soon he has so many that in June 1901, his first public show is mounted at Vollard's. One has simply too much to choose from. It is a juvenile, miscellaneous

exhibition, with something for everyone. Girls, children, interiors, landscapes, café-concerts, Sundays at the races, dances, etc., etc.,—these are the *subjects* most portrayed. If one considers the *manner,* the lively, precocious style, one quickly realizes that Picasso wants to see everything and wants to convey everything. The days obviously aren't long enough for this impetuous lover of contemporary life. At this stage he creates harmonies of light colors, but he's rather frantic and impatient, and rises ready-armed each morning, on the alert and full of energy.

As I have said, this is his era of varied *subjects.* Here for example are some of his titles: *Toledo; Iris; The Mother; The Morphine Addict; Absinthe; The Moulin Rouge; Woman Drinking; Evening; The Square; Boulevard de Clichy; The Matador; Café-Concert; El Tango; Spanish Church; The Waterside; The Fair; Don Tancredo,* etc., etc. . . .

He gets tired of this plagiarism; and from Steinlen he moves on to Lautrec. Stacks more pictures of dancers, of girls, slapdash portraits done in bars and in foyers, remain from this second period. Anyhow, he's cunning, and so his clowns and harlequins from this time sometimes seem to derive from other painters. These figures are more "colorful" than significant.

But all this doesn't satisfy Picasso. He returns to us after a trip to Spain, laden with portraits that are barbaric, and if truth be told, very odd. This doesn't last either. He is still chasing originality, and while he is suddenly so smitten with El Greco that he hangs photographs of the Master's incredible paintings all around his bedroom, he breaks new ground with the "blue period." Works of that time are now much sought after by collectors. At another point, Picasso imitated Puvis de Chavannes. I know collectors of that period too, but I have to admit, the blue period has the edge. It is the skeletal period of famished couples, transfixed before a glass of absinthe. In those days Picasso was living in the Place Ravignan.

Then comes the "rose period" [*periode rouge*] and we are graced with some exceptional portraits. Picasso is still finding himself. His virtuosity allows him to do so, and what's more, to tackle any problem. Painting is a game to him. He keeps on attempting the impossible, and he goes down each and every road.

This is how he comes across an African sculpture, and with a leap, he throws himself into tribal painting. Squares, cubes, triangles are revealed to him by this strange African sculpture. He knows nothing about geometry; but more so even than Pascal himself, he grasps it entirely by contemplating this "Griot" [story teller] that chance has thrown in his path. Next day—and with what a splash!—he launches the "African period" [*periode nègre*].

Members of the art world, dumbfounded and amazed, shake themselves and question each other. Can this be genius or is it a hoax? And then the brutal blow falls. Picasso scarcely leaves them time to get their bearings, and he throws "cubism," the child of primitive art, in their faces.

Well, I need not recount the triumph of cubism. It is by now familiar to all. There is even a whole retinue of followers to escort Picasso. Copied in Germany, but nonetheless comfortably rewarded by the people of Munich, by Berliners and others, Picasso now contemplates a total transformation of cubism. This he has already begun with the pasting of actual fragments of objects: newspaper, fabric, hair, nail-clippings, etc., etc.—And it may well be— so skillful is Picasso!—that for a long time yet he will have no potential imitators in the art of sticking assorted items onto canvas or paper; in the art of presenting, in a word, "showpieces."

Notes

I am grateful to Sydney Resendez for her assistance in preparing this brief essay.

1. Gertrude Stein, *Picasso* (London, 1938), 7.

2. I am grateful to Marilyn McCully for drawing this text to my attention.

3. See Richardson 1991, 193–207.

4. See Daix and Boudaille 1967; and Palau 1985.

5. For the text of this review see McCully 1981, 32–34. For a consideration of the developing artist-dealer-critic nexus see Robert Jensen, *Marketing Modernism in Fin-de-Siècle Europe* (Princeton, 1994).

6. McCully 1981, 32, 33.

7. For a survey of critical trends around 1900, see Michael Marlais, *Conservative Echoes in Fin-de-Siècle Parisian Art Criticism* (University Park, PA, 1992).

8. Translation by Christine Baker.

9. Blunt and Pool 1962, figs. 85–89.

10. See, for example, the paintings by Casas or Rusiñol reproduced in Michael Raeburn, ed., *Homage to Barcelona* (London, 1985), 156, 157.

11. Conveyed to me by Marilyn McCully.

12. Several early reviews, which have gone unnoticed by scholars, have been kindly brought to my attention by Dr. Roger Benjamin, University of Melbourne: E. M. Sedeyn, "Exposition de M. F. Iturrino et P. R. Picasso," *La Critique* 7, no. 155 (5 August 1901), 114; anonymous, "Exposition Girieud, Pichot, Picasso, Launay," *La Chronique des arts* 44, no. 37 (29 November 1902), 294–295; Roger Marx, "A La Galerie Weill," *La Chronique des arts* 46, no. 34 (5 November 1904), 297; Louis Vauxcelles, "Exposition Raoul Dufy, Picasso, Girieud, et Clary-Baroux," *Gil Blas* (9 November 1904), n.p.; Louis Vauxcelles, "Exposition Trachel, Gérardin, et Picasso," *Gil Blas* (3 April 1905), n.p.

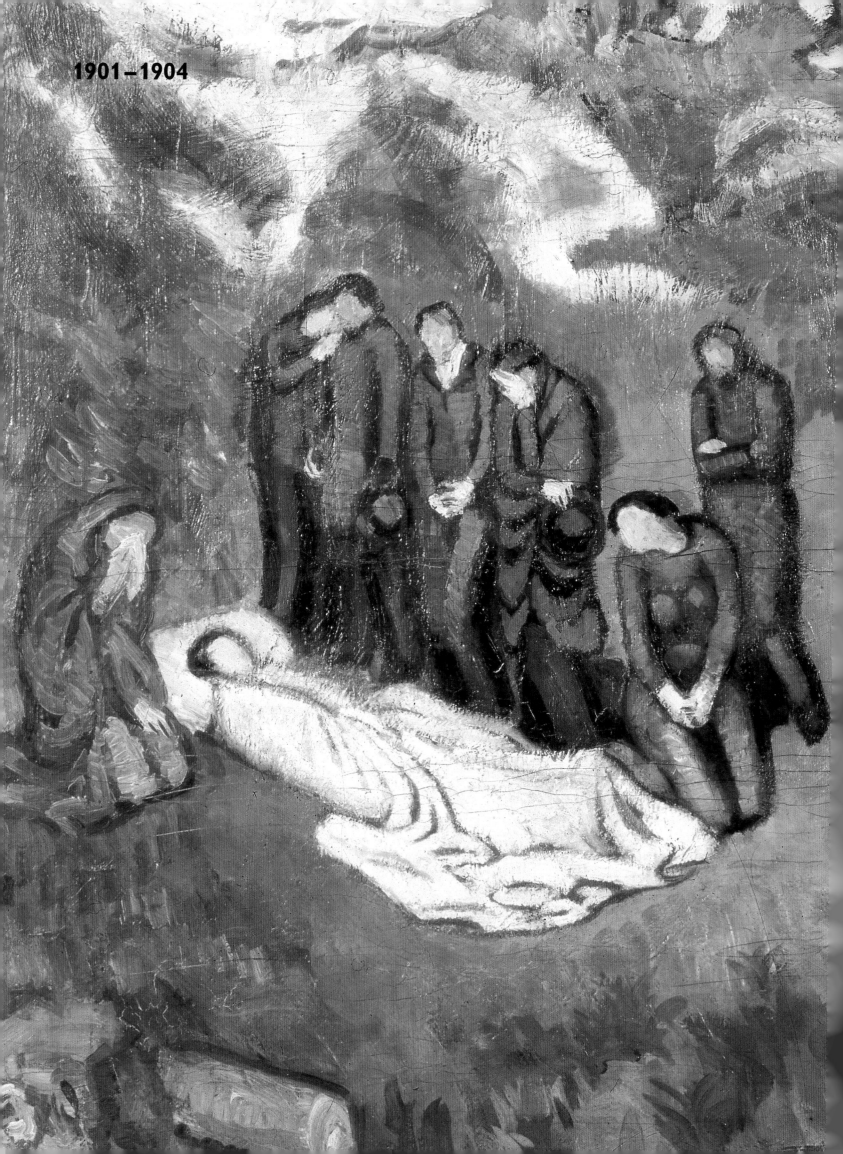

1901—1904

49. *Self-Portrait in Front of the Moulin Rouge,* Paris, May 1901, ink and crayon on paper, 18 x 11.5 (7 ⅛ x 4 ½), private collection

Detail, cat. 70

50. *Self-Portrait with Jaume Andreu Bonsons,* Paris, May 1901, crayon on paper, 31 x 37 (12 ¼ x 14 ½), private collection, London

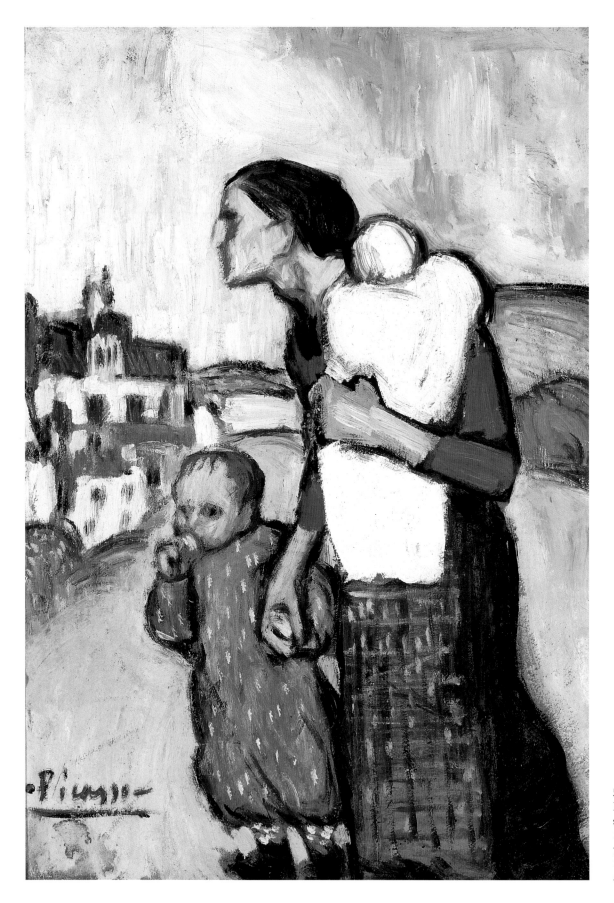

51. *Mother and Child*,
Barcelona or Paris, late
spring or early summer
1901, oil on cardboard,
74.4 x 50.4 (29 ¼ x
19 ⅞), The Saint Louis
Art Museum

52. *Blue Roofs*, Paris,
early summer 1901, oil
on cardboard, 40 x 57.5
(15 ³/₄ x 22 ⁵/₈), Ashmo-
lean Museum, Oxford
Boston only

53. *On the Upper Deck*,
Paris, early summer 1901,
oil on canvas, 49.2 x 64.2
(19 ⅜ x 25 ¼), The Art
Institute of Chicago, Mr.
and Mrs. L. L. Coburn
Memorial Collection

54. *The Absinthe Drinker*, Paris, early summer 1901, oil on cardboard, 65.5 x 51 (25 ¾ x 20 ⅛), Mrs. Melville Wakeman Hall *Washington only*

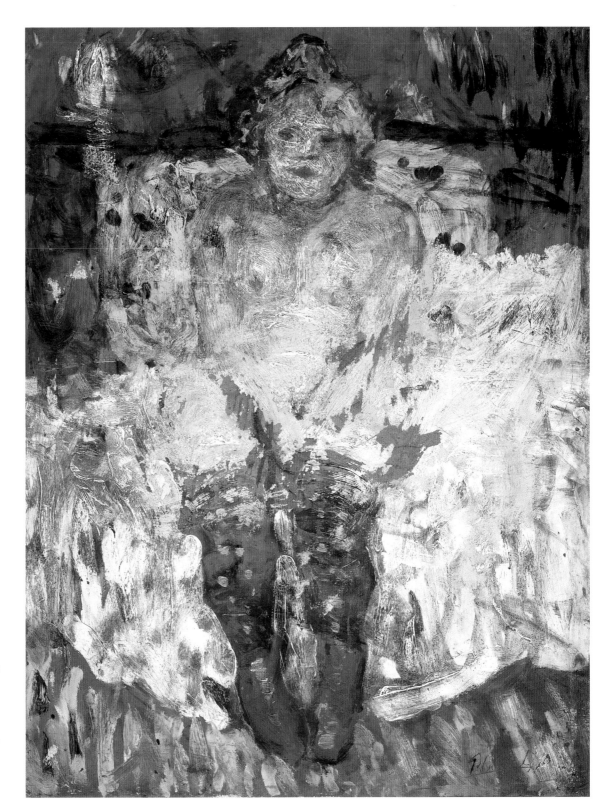

55. *Le Divan japonais*,
Paris, early summer
1901, oil on cardboard
mounted on panel, 69.9 x
53 (27 ½ x 21), private
collection

56. *Woman in Stockings,*
Paris, early summer 1901,
oil on cardboard, 65 x
48.3 (25 ⅝ x 19), private
collection
Boston only

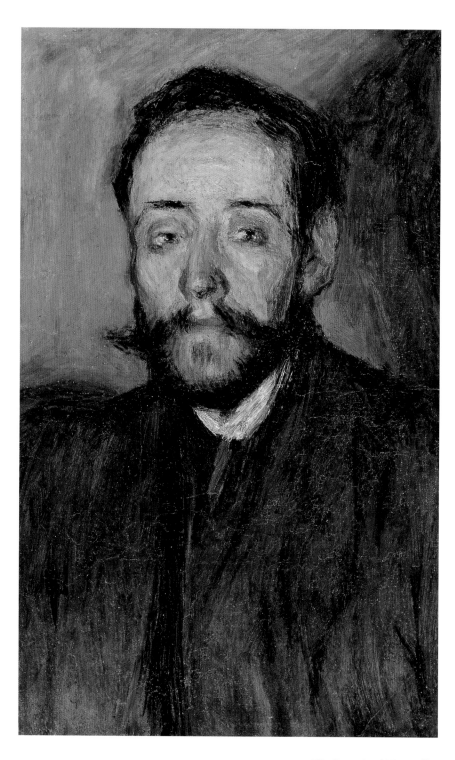

57. *Portrait of Minguell*,
Paris, early summer 1901,
oil on cardboard, 52 x 32
(20½ x 12⅝), private
collection

58. *Still Life,* Paris, early
summer 1901, oil on
canvas, 60 x 80.5 (23 ⅝
x 31 ⅝), Museu Picasso,
Barcelona
Boston only

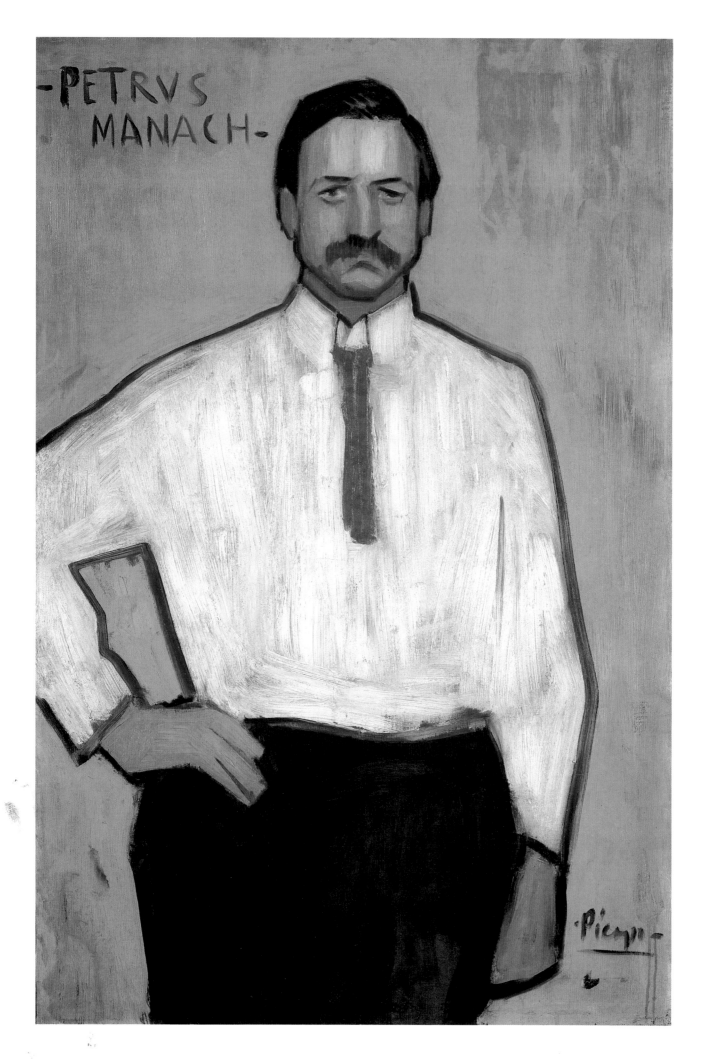

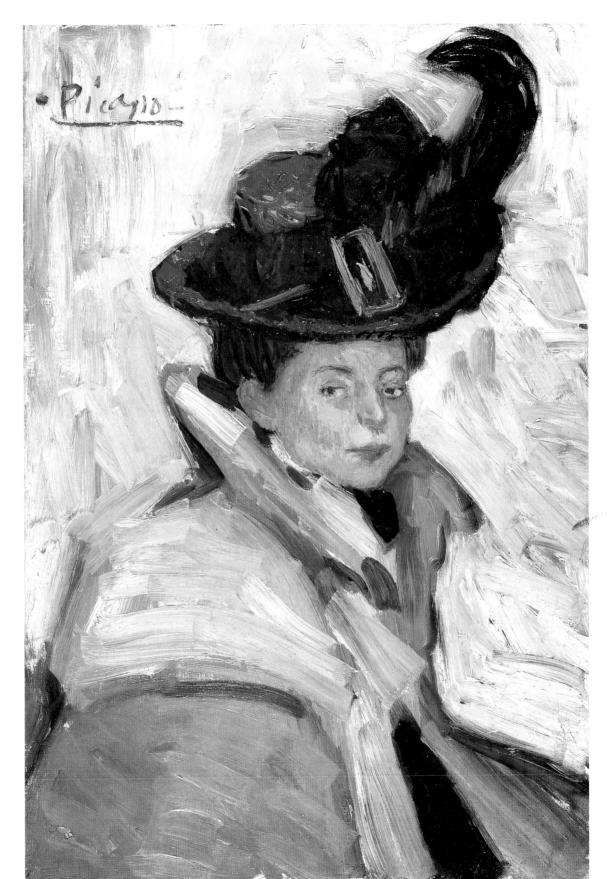

59. *Portrait of Pere Mañach*, Paris, early summer 1901, oil on canvas, 105.5 x 70.2 (41 ½ x 27), National Gallery of Art, Washington, Chester Dale Collection
Washington only

60. *Woman with a Cape (Jeanne)*, Paris, early summer 1901, oil on canvas, 73 x 50.2 (28 ¾ x 19 ¾), The Cleveland Museum of Art, Bequest of Leonard C. Hanna Jr.

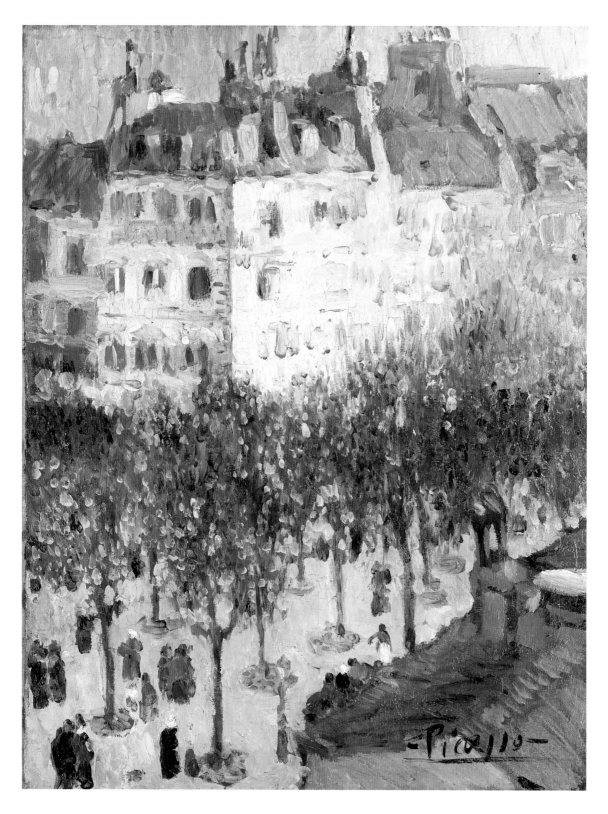

61. *Boulevard de Clichy,* Paris, early summer 1901, oil on canvas, 61.5 x 46.5 (24 ¼ x 18 ¼), Maspro Denkoh Museum, courtesy of Christie's

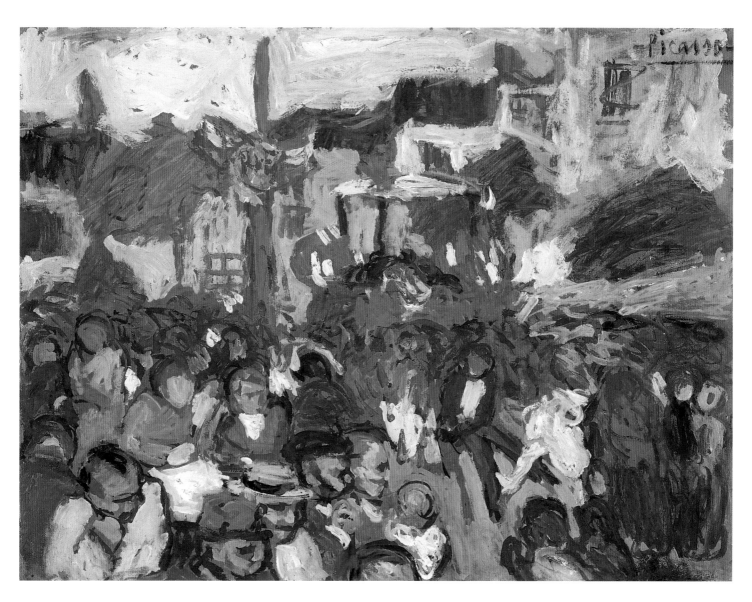

62. *Fourteenth of July,*
Paris, July 1901, oil on
cardboard mounted
on canvas, 48.3 x 62.8
(19 x 24 ¾), Solomon R.
Guggenheim Museum,
New York, Thannhauser
Collection, Gift, Justin K.
Thannhauser, 1978

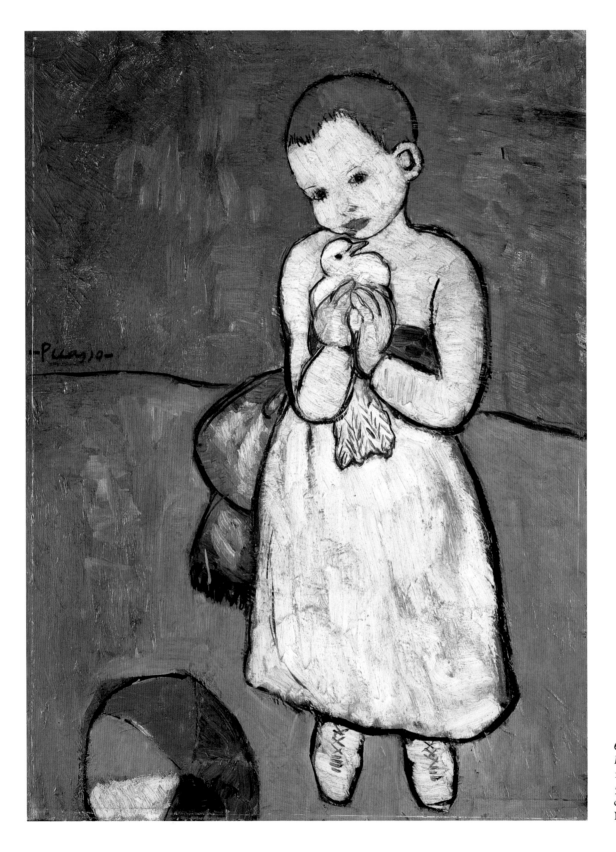

63. *Child Holding a Dove*, Paris, summer 1901, oil on canvas, 73 x 54 (28 ¾ x 21 ¼), private collection, on loan to the National Gallery, London

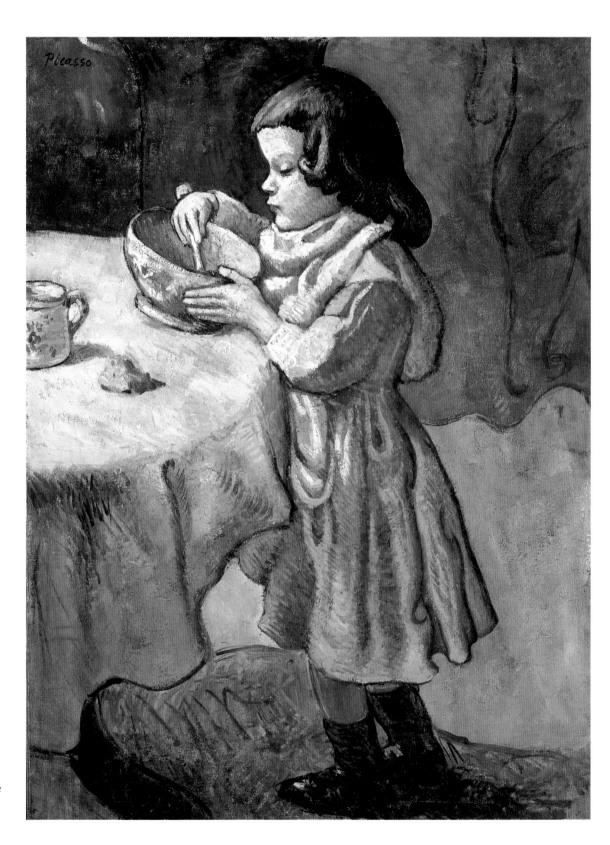

64. *The Greedy Child*,
Paris, summer/autumn
1901, oil on canvas, 92.8
x 68.3 (36½ x 26⅞),
National Gallery of Art,
Washington, Chester Dale
Collection
Washington only

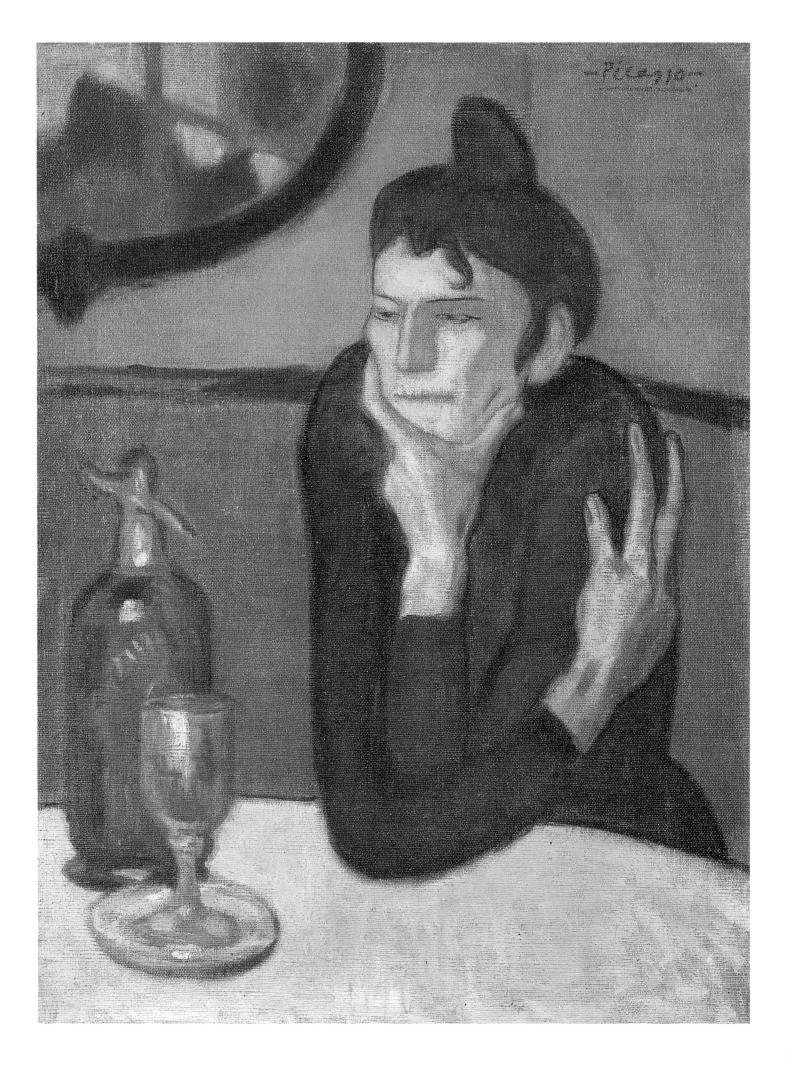

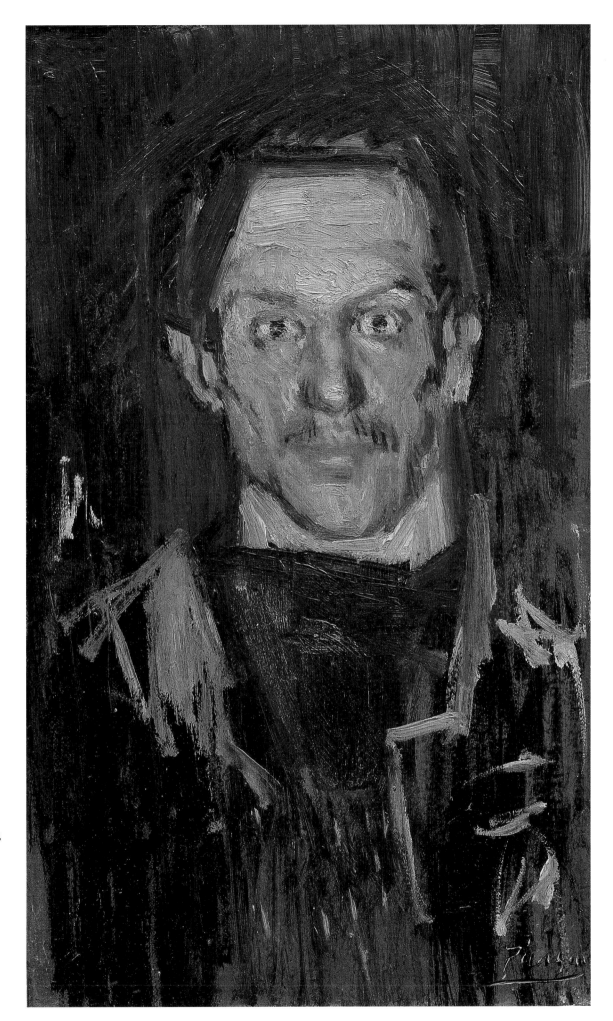

65. *The Absinthe Drinker,* Paris, summer/autumn 1901, oil on canvas, 73 x 54 (28 ¾ x 21 ¼), The State Hermitage Museum, St. Petersburg

66. *Self-Portrait,* Paris, summer/autumn 1901, oil on cardboard, 51.5 x 31.7 (20 ¼ x 12 ½), Mrs. John Hay Whitney *Washington only*

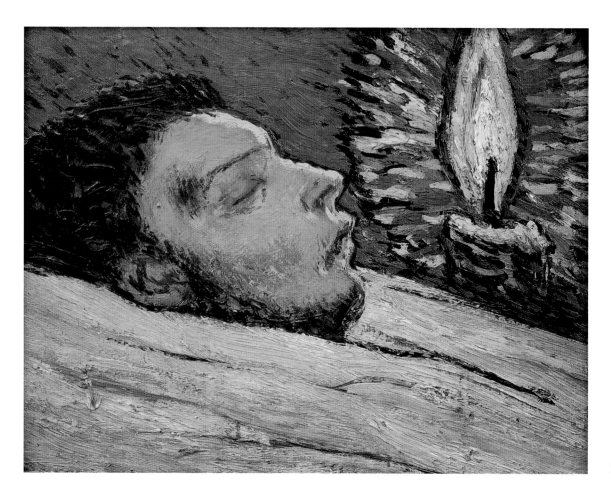

67. *Head of the Dead Casagemas*, Paris, autumn 1901, oil on panel, 27 x 35 (10⅝ x 13¾), Musée Picasso, Paris

68. *Casagemas in His Coffin*, Paris, autumn 1901, oil on cardboard, 72.5 x 57.8 (28½ x 22¾), private collection, Switzerland
Washington only

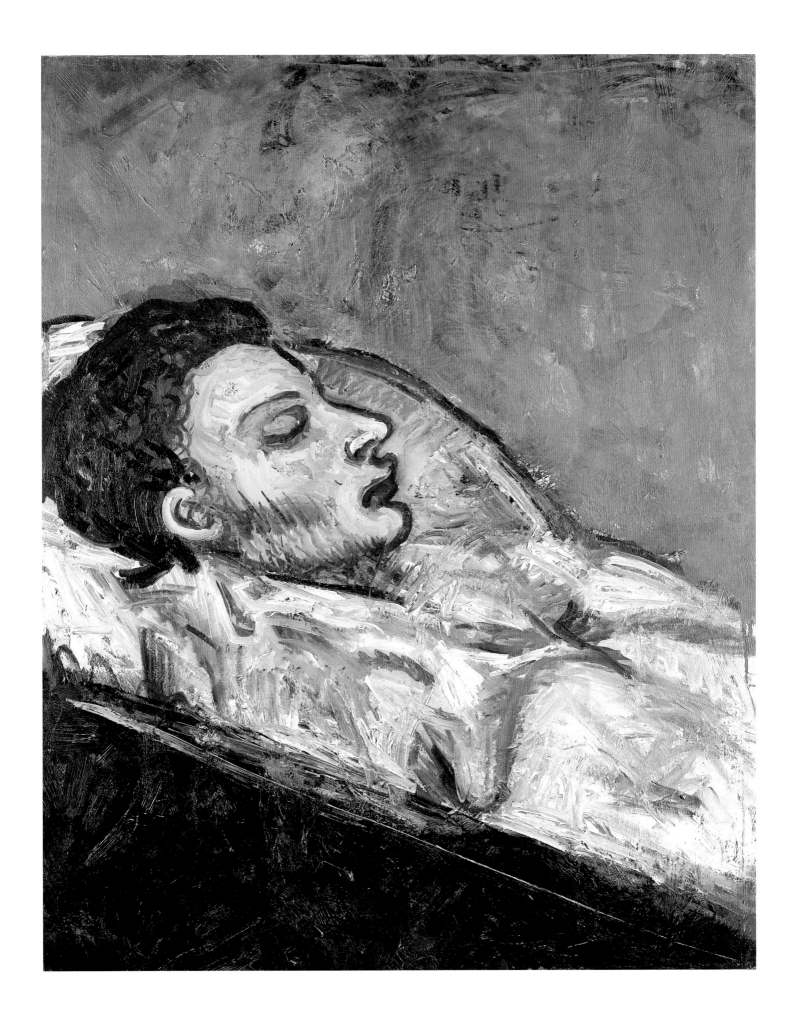

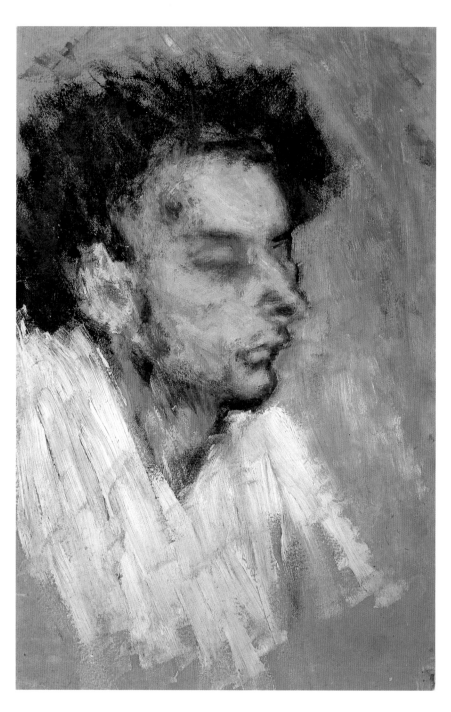

69. *Head of the Dead Casagemas,* Paris, autumn 1901, oil on cardboard, 52 x 34 (20½ x 13⅜), private collection

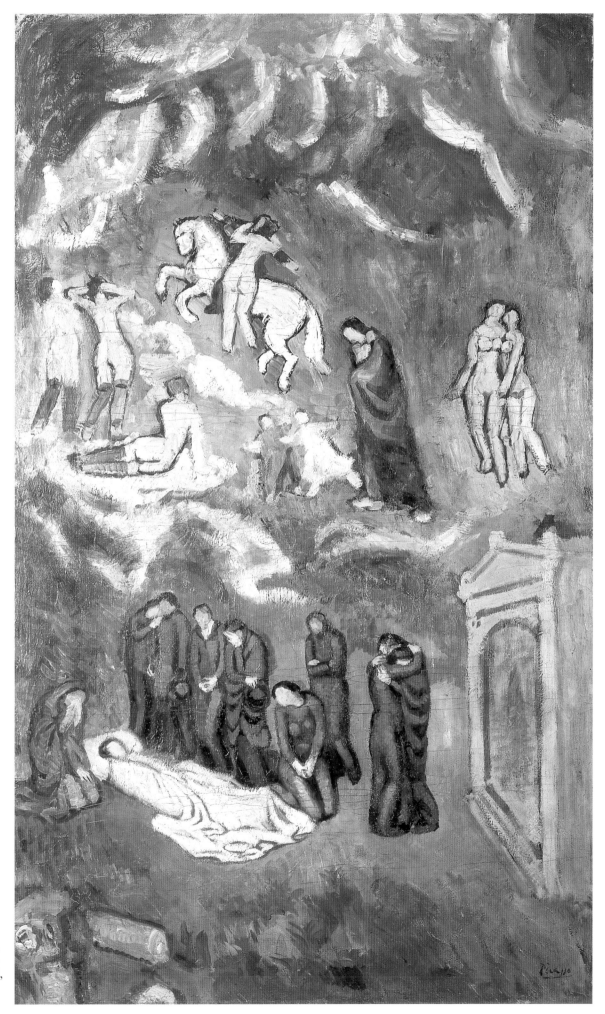

70. *The Burial of Casa-gemas (Evocation),* Paris, autumn 1901, oil on canvas, 150 x 90 (59 x 35 ³⁄₈), Musée d'Art Moderne de la Ville de Paris

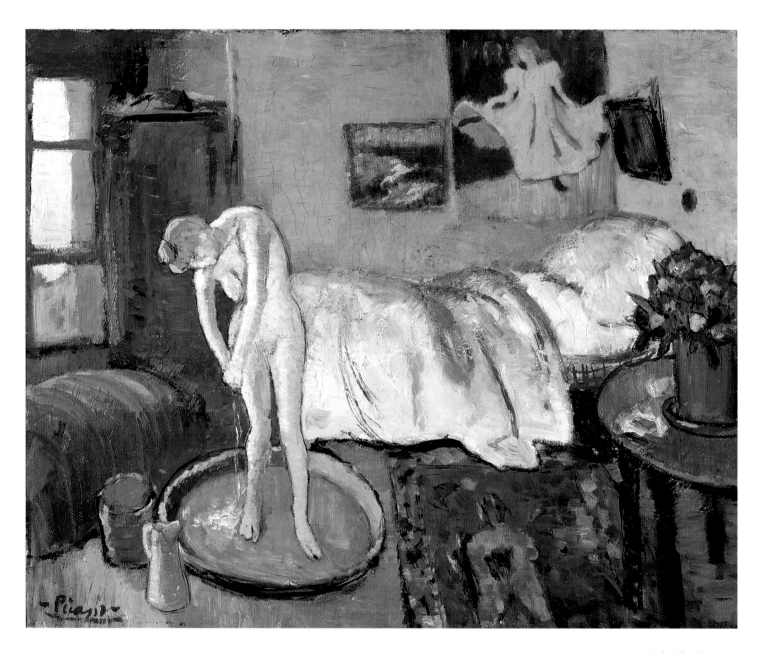

71. *Le Tub (The Blue
Room)*, Paris, autumn
1901, oil on canvas,
50.4 x 61.5 (19 ⅞ x 24 ¼),
The Phillips Collection,
Washington, D.C.

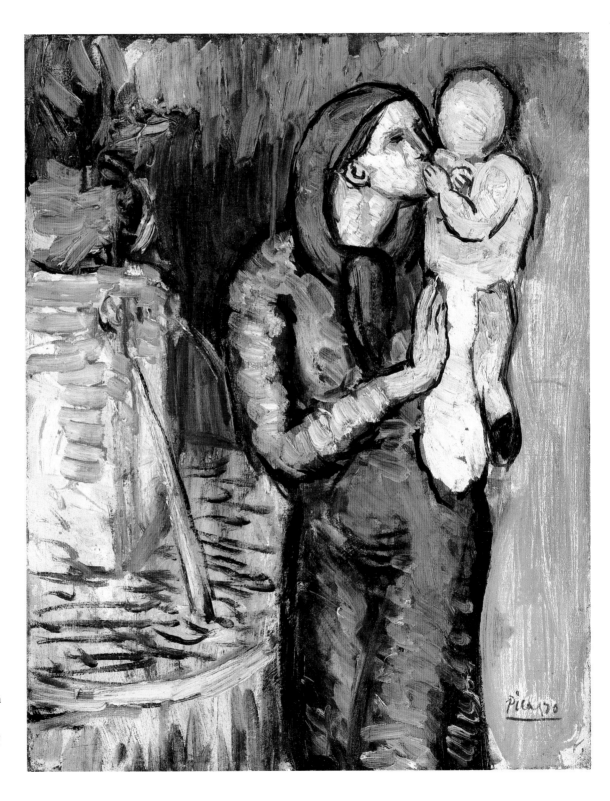

72. *Mother and Child by a Fountain,* Paris, autumn 1901, oil on canvas, 40.6 x 32.4 (16 x 12¾), The Metropolitan Museum of Art, Bequest of Scofield Thayer, 1982

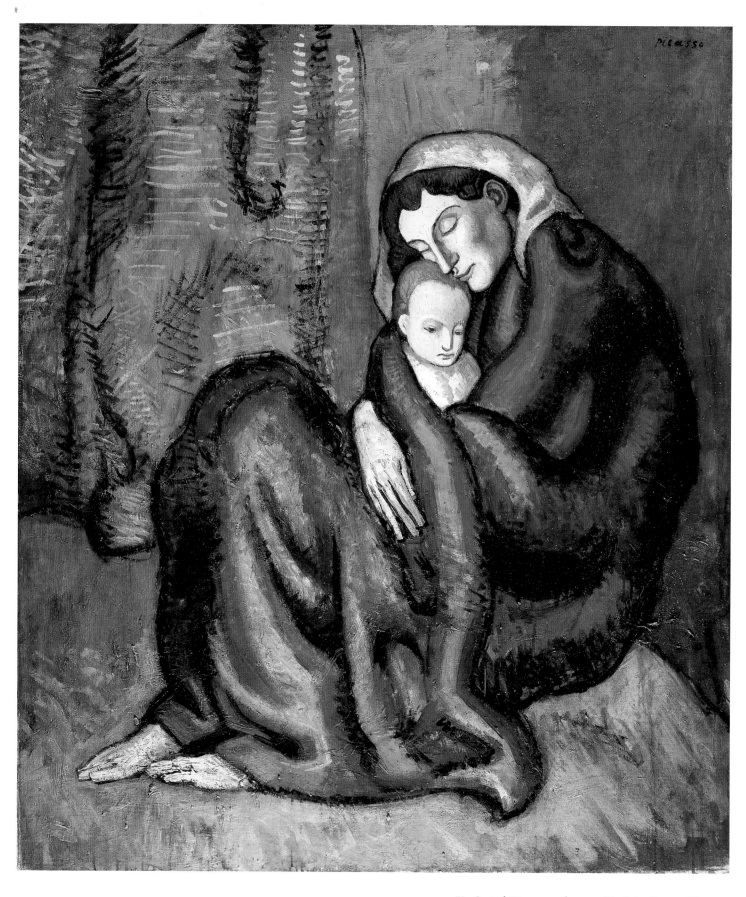

73. *Seated Woman and Child,* Paris, autumn 1901, oil on canvas, 112.3 x 97.5 (44 ¼ x 38 ⅜), Fogg Art Museum, Harvard University Art Museums, Bequest from the Collection of Maurice Wertheim, Class of 1906
Boston only

74. *Saint-Lazare Woman by Moonlight,* Paris, autumn 1901, oil on canvas, 100 x 69.2 (39 ⅜ x 27 ¼), The Detroit Institute of Arts, Bequest of Robert H. Tannahill

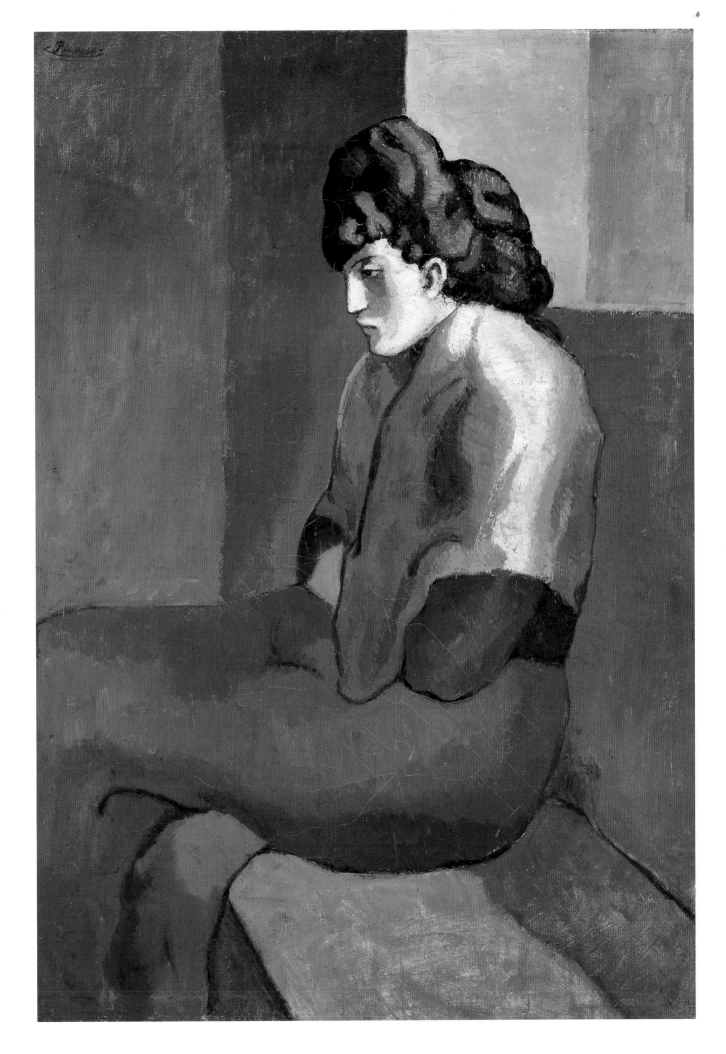

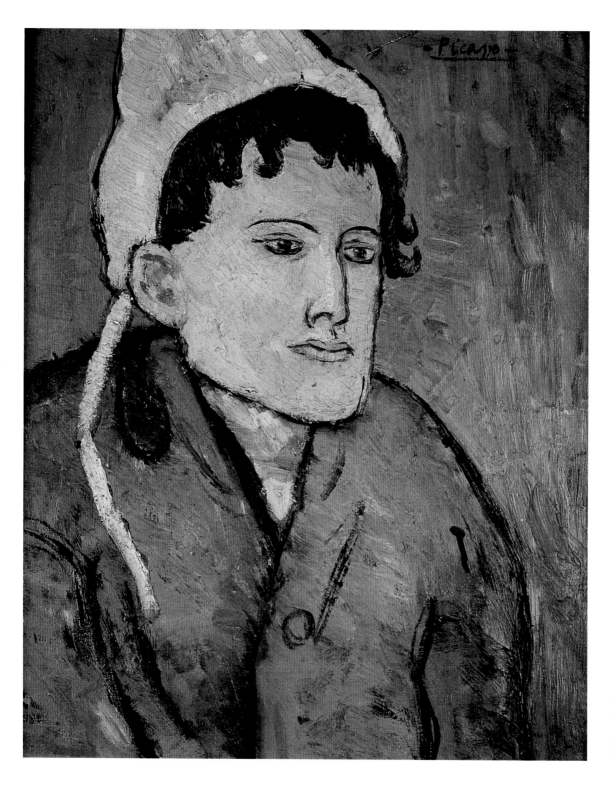

75. *Woman with a Cap,*
Paris, autumn 1901,
oil on canvas, 41.3 x 33
(16¼ x 13), Museu
Picasso, Barcelona

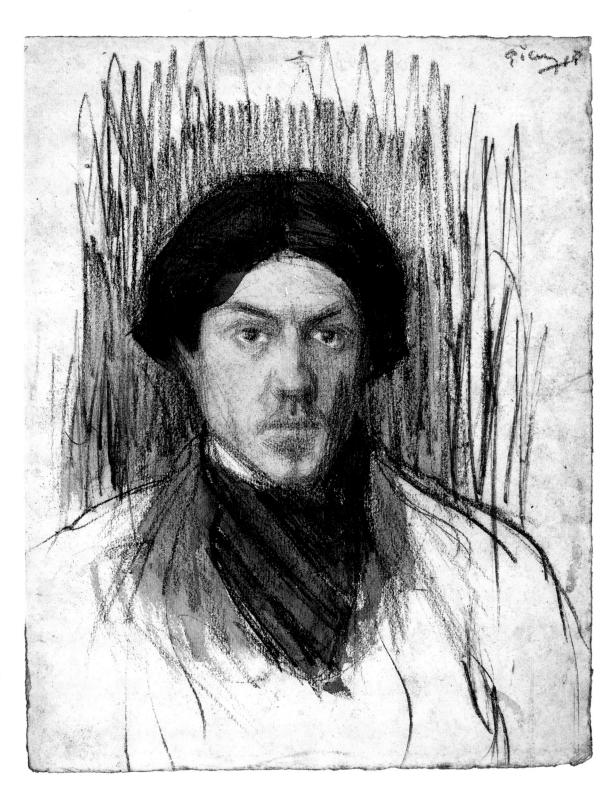

76. *Self-Portrait*, Paris,
end 1901/beginning 1902,
crayon with color washes
on paper, 30.4 x 23.8
(12 x 9 ⅜), National
Gallery of Art, Washing-
ton, Ailsa Mellon Bruce
Collection
Washington only

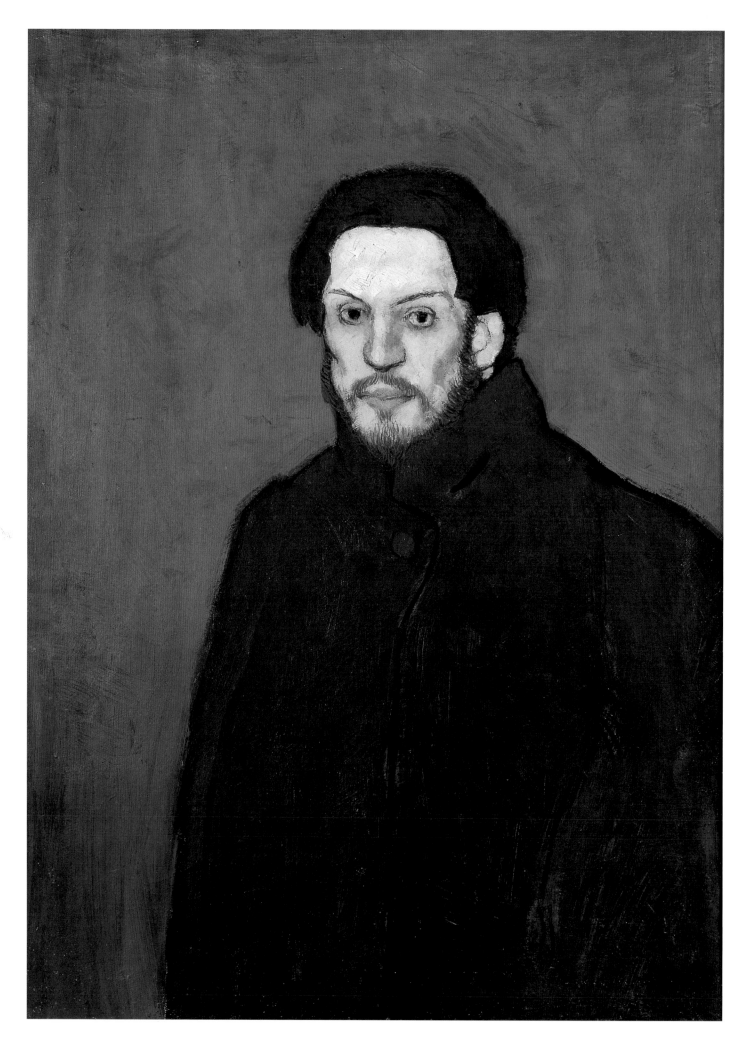

77. *Self-Portrait,* Paris, end 1901, oil on canvas, 81 x 60 (31 ⅞ x 23 ⅝), Musée Picasso, Paris

78. *Two Sisters,* Barcelona, 1902, pencil on paper, 61.4 x 46.4 (24 ⅛ x 18 ¼), private collection

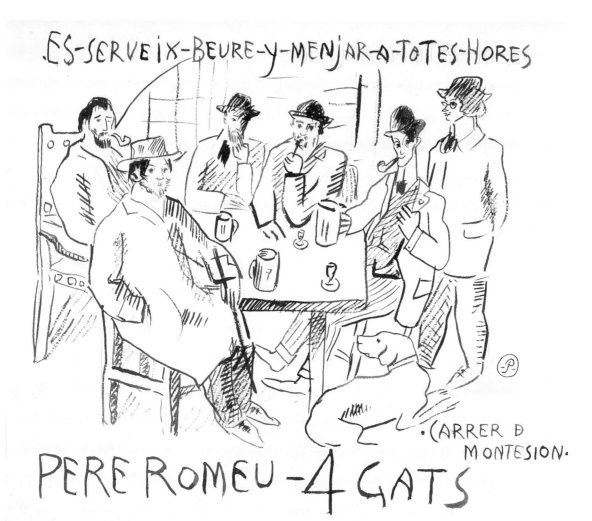

79. *Pere Romeu—4 Gats*, Barcelona, 1902, ink on paper, 31 x 34 (12 ¼ x 13 ³⁄₈), private collection, Canada

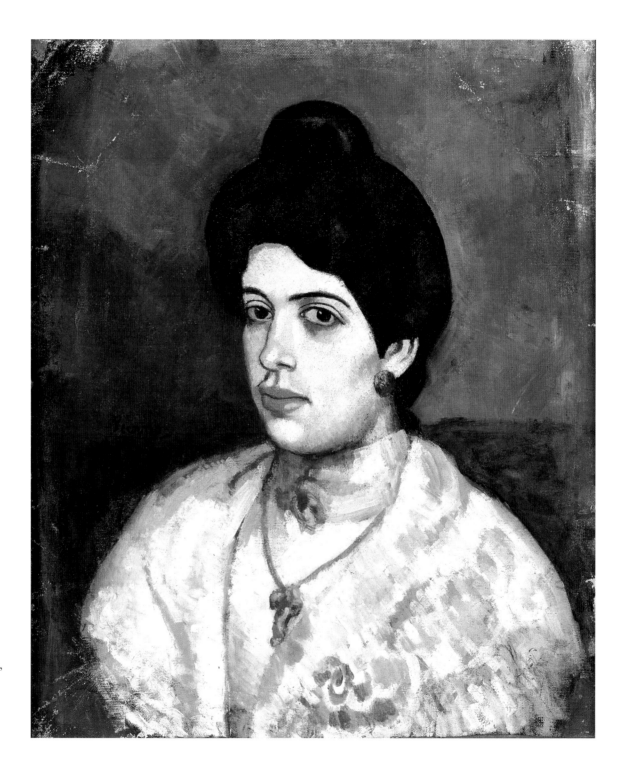

80. *Portrait of Corina Romeu*, Barcelona, 1902, oil on canvas, 60 x 50 (23 ⅝ x 19 ⅝), Dation Picasso, assigned to Musée d'art moderne, Céret

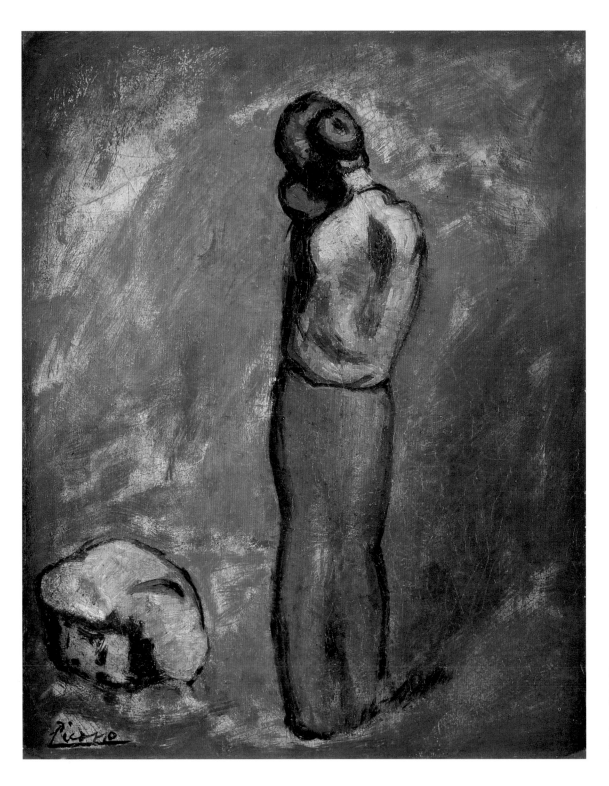

81. *Mother and Child*,
Barcelona, 1902, oil on
canvas, 40.7 x 33 (16 x
13), Scottish National
Gallery of Modern Art,
Edinburgh
Boston only

82. *Woman and Child by
the Sea*, Barcelona, 1902,
oil on canvas, 81.5 x 60
(32 x 23 ⅝), private
collection, Japan

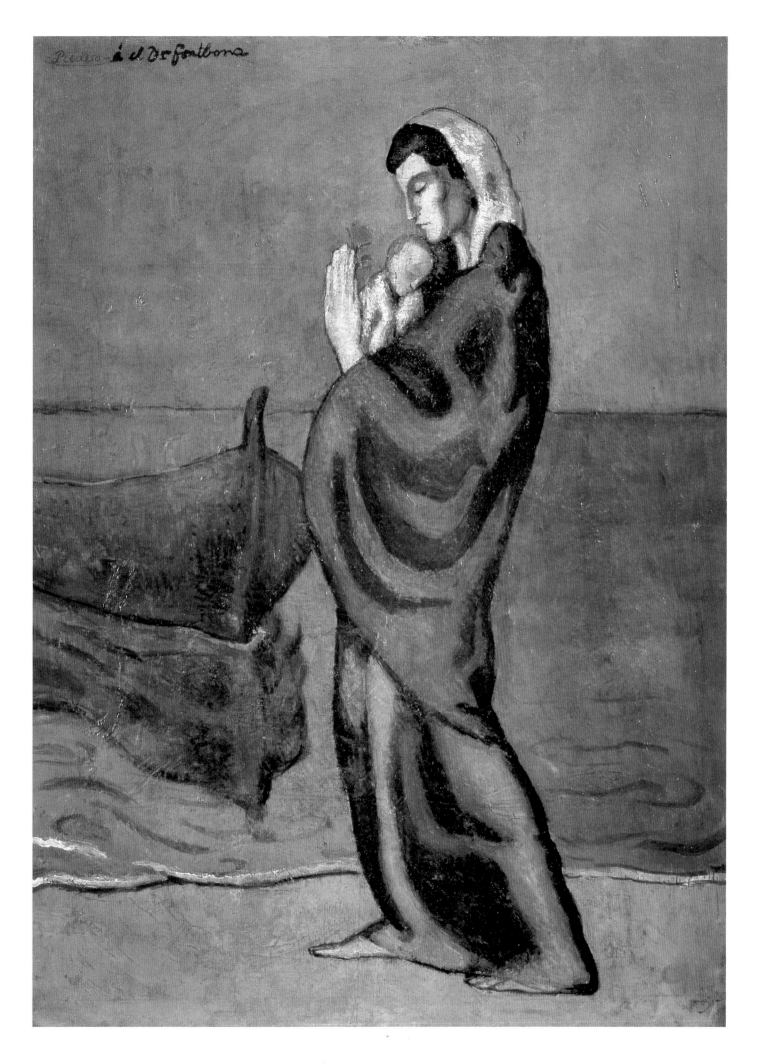

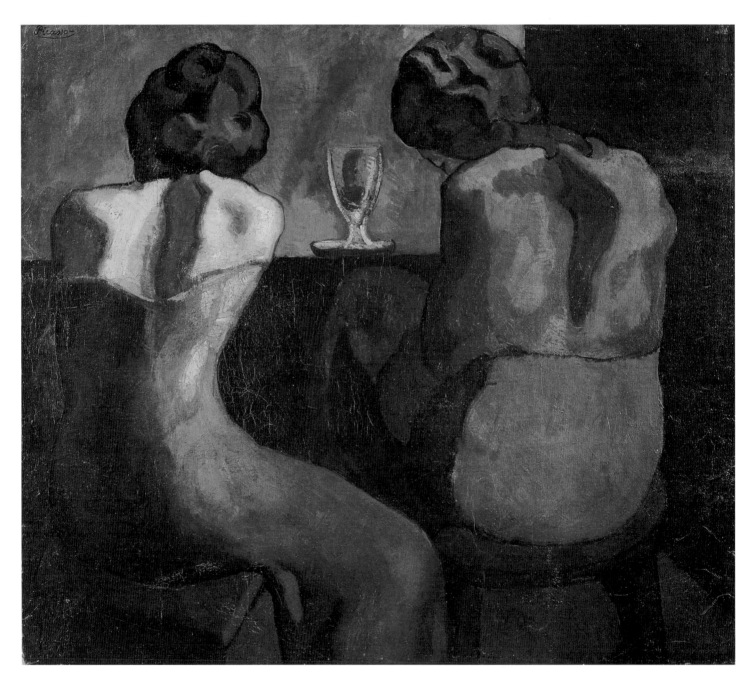

83. *Two Women at a Bar*,
Barcelona, 1902, oil on
canvas, 80 x 91.5 (31 ½ x
36), Hiroshima Museum
of Art

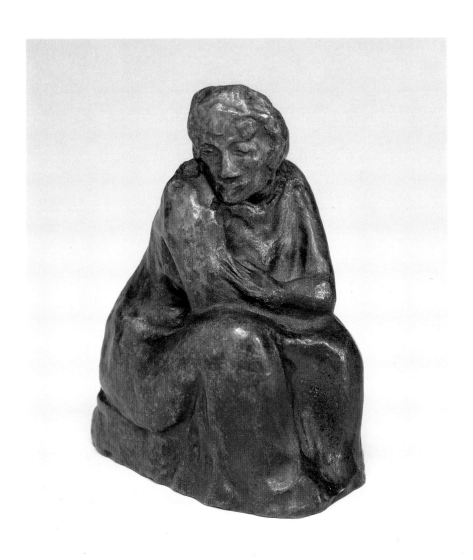

84. *Seated Woman,*
Barcelona, 1902, bronze,
14 x 7.6 x 7 (5 ½ x 3 x
2 ¾), The Fine Arts Mu-
seums of San Francisco,
Memorial Gift from
Dr. T. Edward and
Tullah Hanley, Bradford,
Pennsylvania

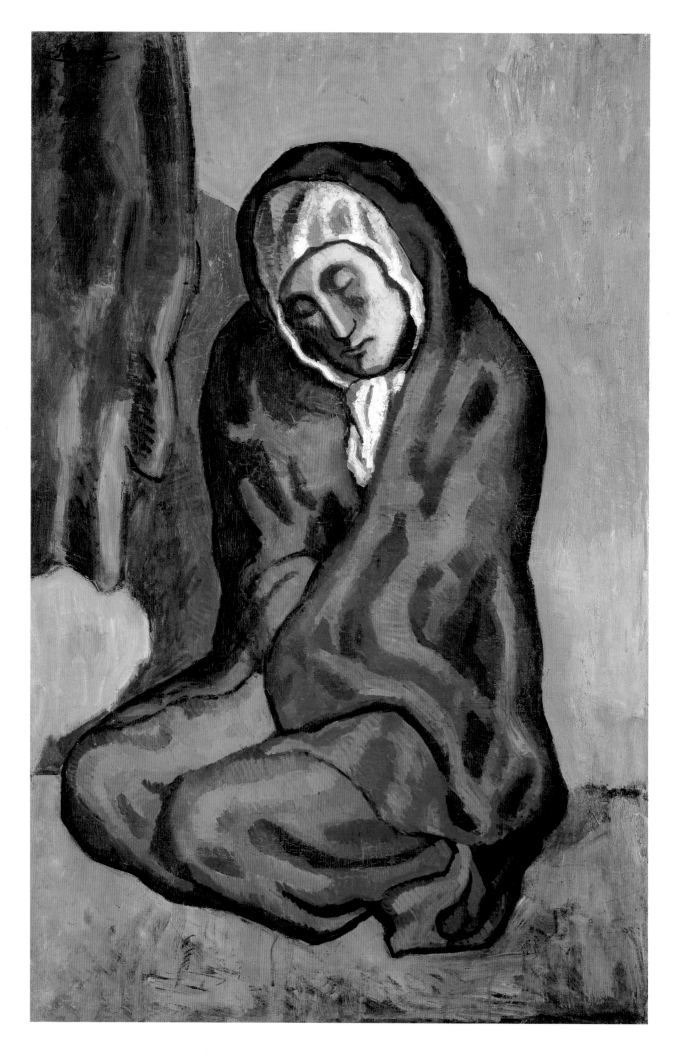

184

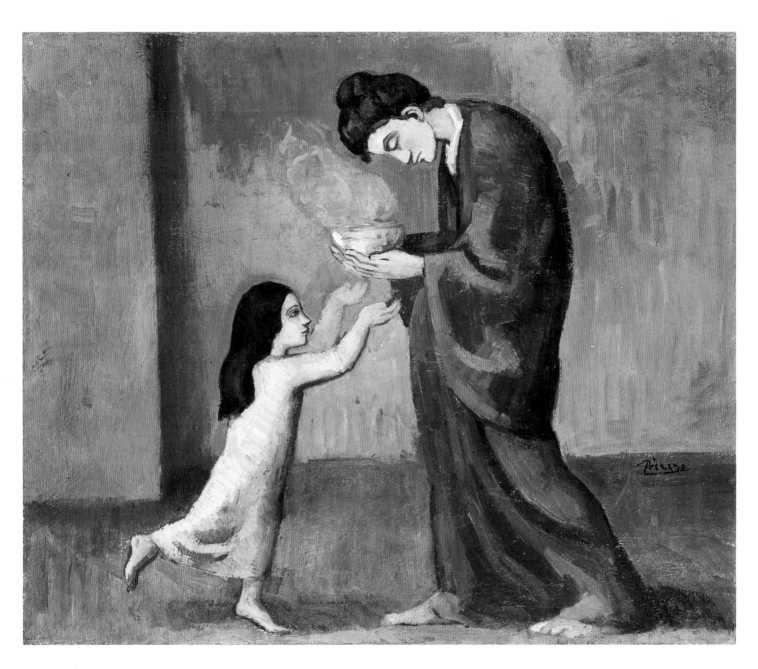

85. *Crouching Woman*,
Barcelona, 1902, oil on
canvas, 100.3 x 66 (39 ½
x 26), Collection Art Gal-
lery of Ontario, Toronto,
Anonymous Gift, 1963

86. *La Soupe*, Paris, win-
ter 1902, oil on canvas,
38.5 x 46 (15 ⅛ x 18 ⅛),
Collection Art Gallery of
Ontario, Toronto, Gift
of Margaret Dunlap
Crang, 1983

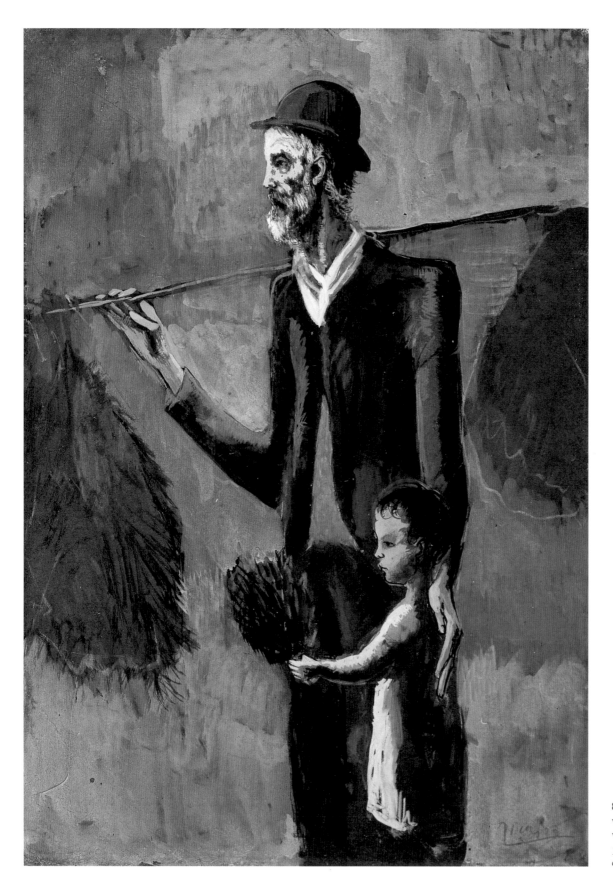

87. *Mistletoe Seller*, Paris,
winter 1902, gouache and
watercolor on paper, 55 x
38 (21 ⅝ x 15), private
collection

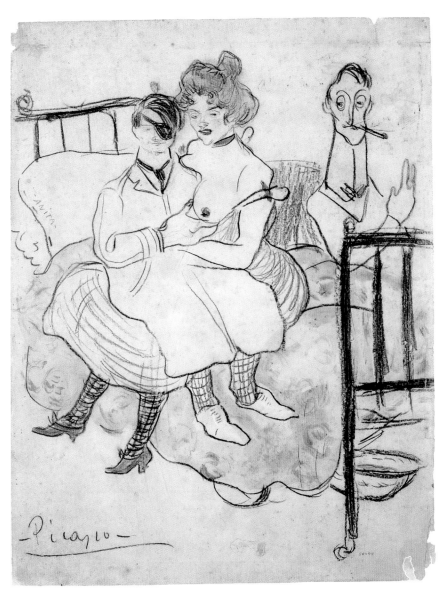

88. *Simian Self-Portrait*,
Paris, 1 January 1903,
ink on paper, 11.8 x 10.7
(4⅝ x 4¼), Museu
Picasso, Barcelona

89. *Mateu and Angel de
Soto, with Anita,* Barce-
lona, 1903, conté crayon,
colored pencil, and water-
color on paper, 31 x 23.7
(12¼ x 9¼), Museu
Picasso, Barcelona

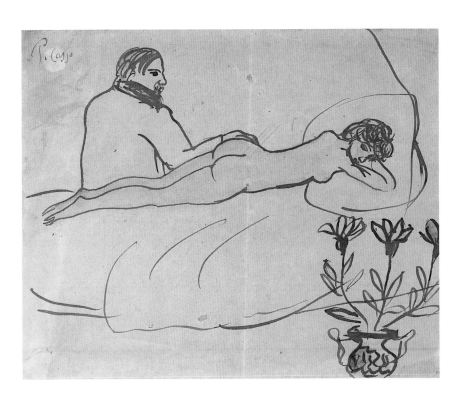

90. *Self-Portrait with
Reclining Nude,* Barce-
lona, 1902–1903, ink
and watercolor on paper,
17.6 x 23.3 (6⅞ x 9⅛),
Museu Picasso, Barcelona

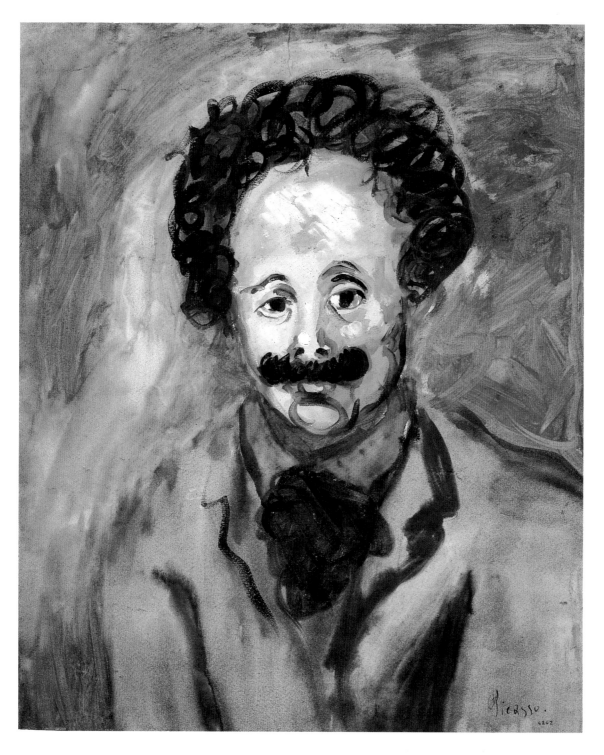

91. *Portrait of Sebastià Junyer Vidal*, Barcelona, 1903, oil on paper, 56 x 46 (22 x 18 1/8), Museu Picasso, Barcelona

92. *Tragedy*, Barcelona, 1903, oil on panel, 105.4 x 69 (41 1/2 x 27 1/8), National Gallery of Art, Washington, Chester Dale Collection
Washington only

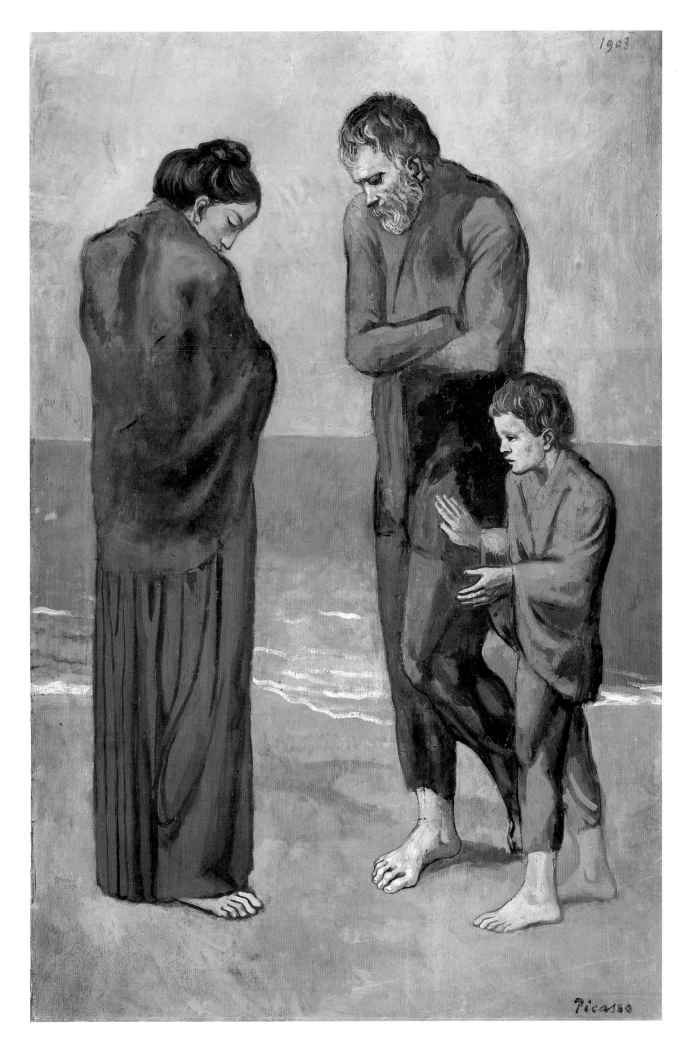

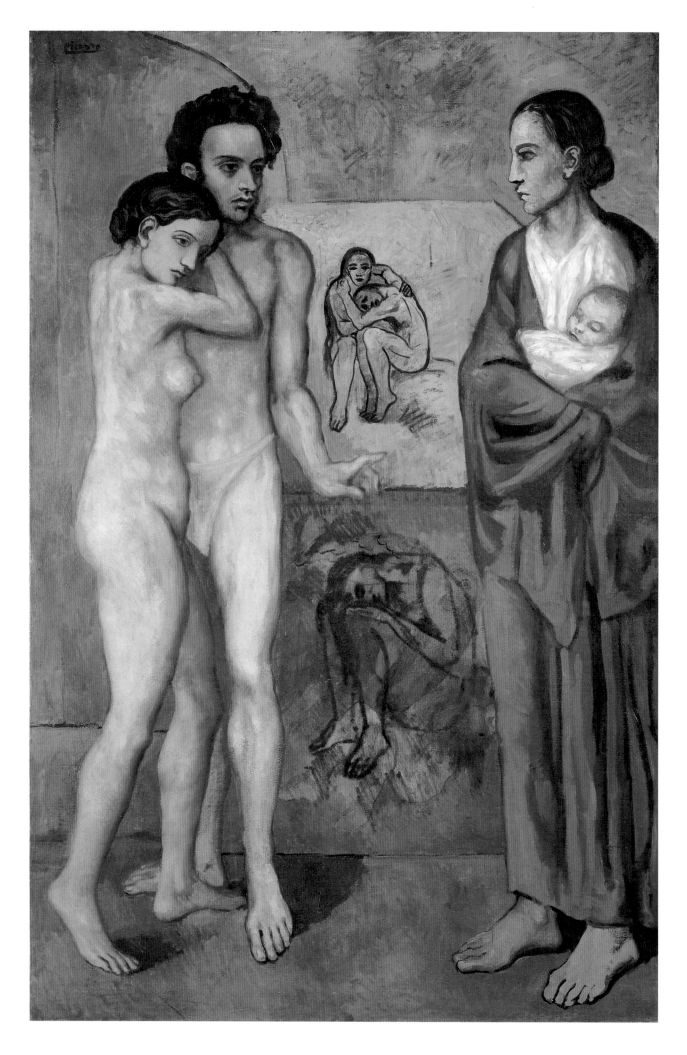

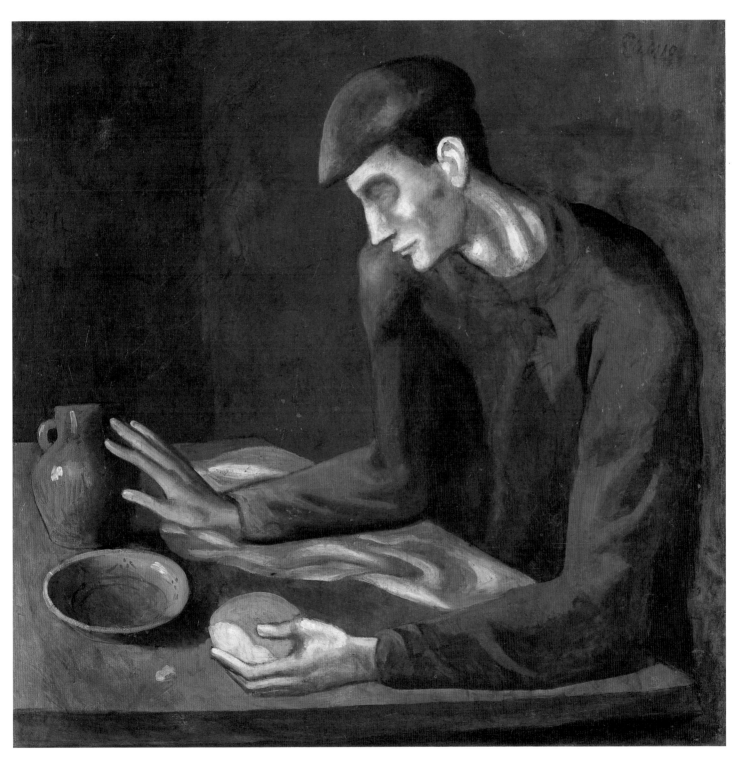

93. *La Vie*, Barcelona, 1903, oil on canvas, 197 x 127.3 (77 ½ x 50 ⅛), The Cleveland Museum of Art, Gift of the Hanna Fund

94. *Blind Man's Meal*, Barcelona, late summer 1903, oil on canvas, 95.3 x 94.6 (37 ½ x 37 ¼), The Metropolitan Museum of Art, Purchase, Mr. and Mrs. Ira Haupt Gift, 1950

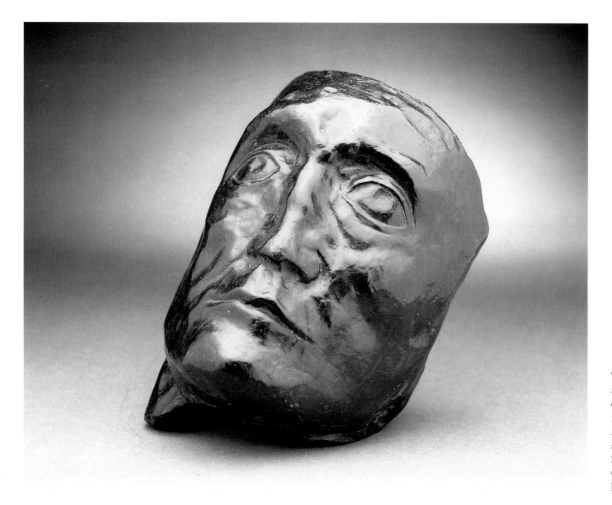

95. *Mask of a Picador with a Broken Nose*, Barcelona, 1903, bronze, 19.5 x 14.7 x 11.5 (7¾ x 5⅞ x 4½), Hirshhorn Museum and Sculpture Garden, Smithsonian Institution, Gift of Joseph H. Hirshhorn, 1966

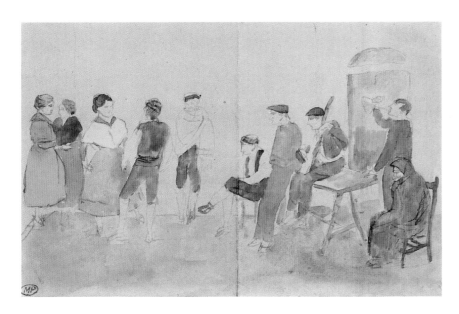

96. *Practicing the Jota,*
Barcelona or Tiana, sum-
mer 1903, watercolor,
ink, and gouache on
paper, 13 x 21 (5 ⅛ x
8 ¼), Musée Picasso, Paris
Boston only

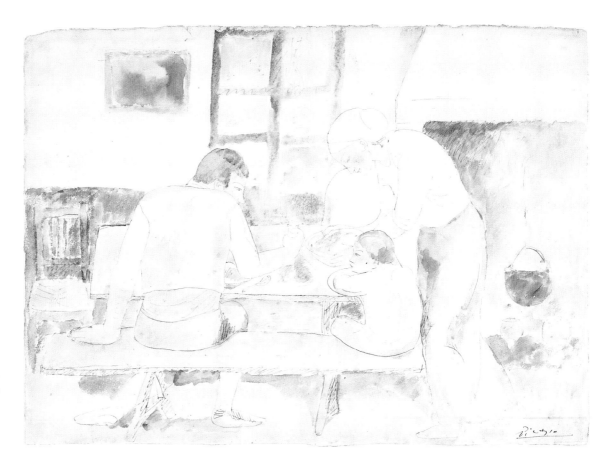

97. *Family at Supper,*
Barcelona or Tiana, sum-
mer 1903, pen and ink
with watercolor on paper,
32.7 x 44.5 (12 ⅞ x 17 ½),
Albright-Knox Art
Gallery, Buffalo, New
York, Room of Contem-
porary Art Fund, 1941

98. *Picasso Painting Carlota Valdivia,* Barcelona, 1904, conté pencil and colored pencil on paper, 26.7 x 20.6 (10 ½ x 8 ⅛), private collection
Boston only

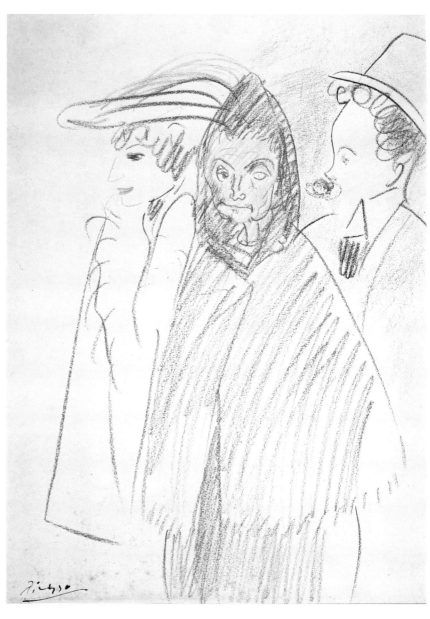

99. *Sketch for "La Celestina,"* Barcelona, 1904, crayon and charcoal on paper, 38 x 27.3 (15 x 10 ¾), Mrs. Alex Lewyt

100. *La Celestina,* Barcelona, 1904, oil on canvas, 70 x 56 (27 ½ x 22), Musée Picasso, Paris

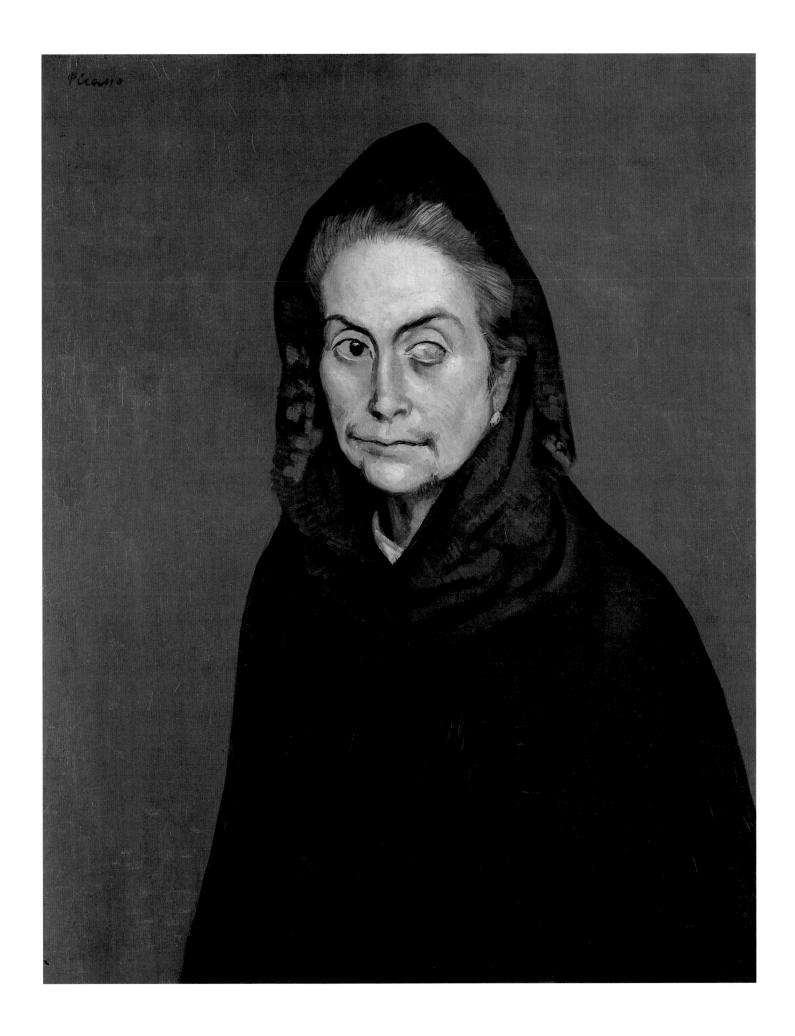

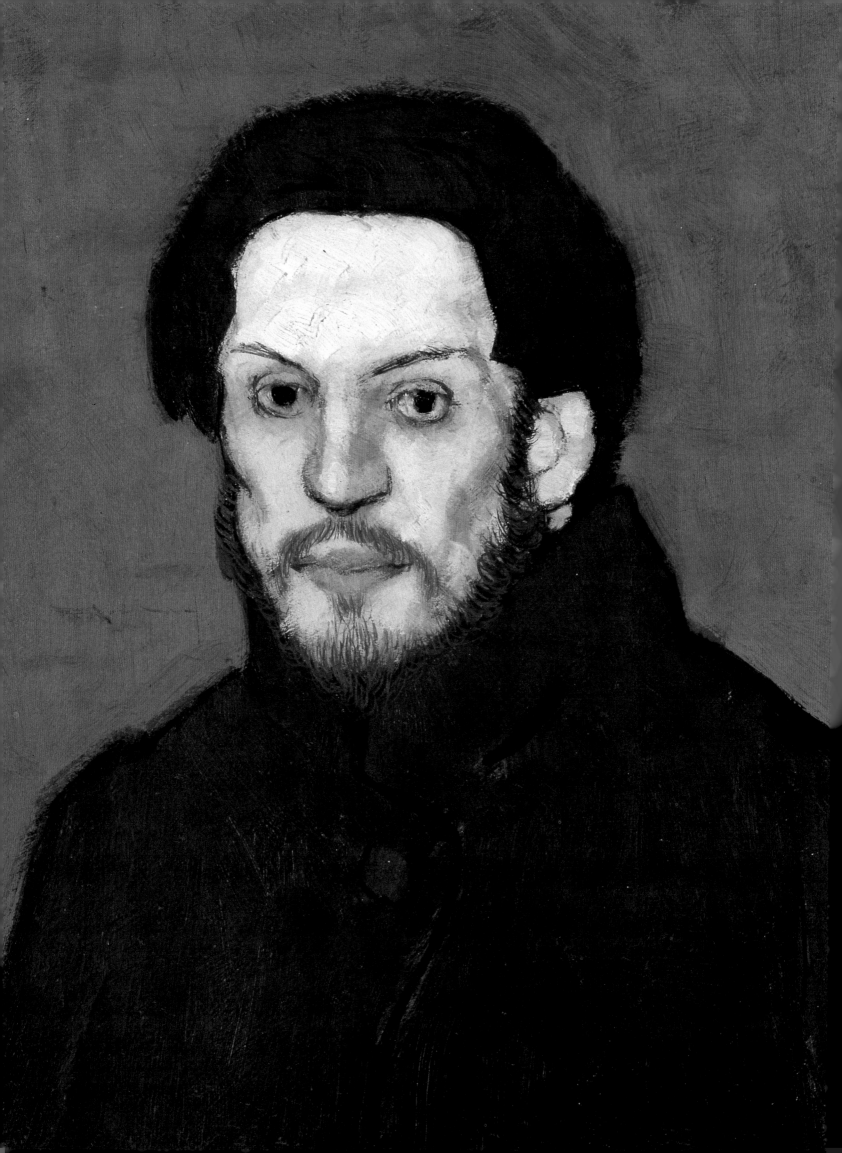

Bohemian Nostalgia: Picasso in Villon's Paris

Jeffrey Weiss

In the winter of 1904–1905 Marcel Schwob, an eminent young *littérateur,* presented a series of lectures on the fifteenth-century French poet François Villon for the Ecole des Hautes Etudes at the Paris Sorbonne. Since about 1890 Schwob had been conducting pioneering research into the biographical and social context of Villon's work. The course announcement reads:

> La Société et la Poésie au XV[c] siècle.
> La Société parisiennse de 1430 à 1480:
> Explication et commentaire du *Grand Testament* de François Villon.

Classes would meet on Thursday afternoons at 4:00. In fact Schwob, who was revered among members of the symbolist generation, died in a fever before completing the term, having delivered lectures from November to February. According to the class inscription, the names of those in attendance included Max Jacob, André Salmon, and Picasso.[1]

Some years later Salmon, a poet and chronicler of Picasso's Paris, wrote with pensive nostalgia about Schwob's lectures. Describing the class, he recalled fifteen students in a tiny room,

among whom only five or six faithful devotees were passionate enough to attend regularly. This group, Salmon remarked, thought of themselves as a small "aristocratie villoniste." Schwob, visibly weakened by the illness to which he would soon succumb, lectured somewhat hesitantly, rallying with sudden vigor to recite a *ballade en jargon,* from the poems that Villon composed using underworld argot, or to recount a fifteenth-century murder on the rue Saint-Jacques (where the Sorbonne is located)—"the same rue Saint-Jacques on which several of us actually lived at the time!"[2] Schwob's weakened state inadvertently contributed an element of dark romance to the proceedings; Salmon referred to the lectures as having been "marked by the sign of death."[3] At home, taking up his old edition of Villon, Salmon felt as if he were reading "master François" for the first time. Later, in his memoirs, he recalled following the class with nocturnal walks along the rue Saint-Jacques (fig. 1), during which he and his companions would recite Villon's *ballades* among themselves.[4]

It remains impossible to say for certain that Picasso actually attended Schwob's lectures on Villon. Apparently no record exists beyond the roll. Picasso's notorious antipathy for literary exegesis would have left him ill-disposed toward Schwob's learned ruminations, and his barely serviceable French would have been inadequate to the task. Yet Villon was a mythic presence in bohemian Paris at the turn of the century, a street tough whose verse, variously sentimental, satiric, and crudely profane, constituted a first-person account of criminal conspiracy, imprisonment, and life on the run. His name saturates souvenirs of the epoch in which he seems to haunt virtually every street coinhabited by poets, indigents, and thugs. Indeed, in the bohemian literary imagination Villon is so pervasive that his legacy is generally taken for granted. Given the specific character of Villon's work, however, Salmon's allusion to members of the Picasso circle as a small band of *villonistes*[5]—a reference

Detail, cat. 77

1. Atget, *Rue Saint-Jacques,* c. 1903, Bibliothèque Nationale de France, Paris

that has been overlooked in literature on the artist—is provocative. Whether or not Picasso attended the entire lecture series in the winter of 1904–1905, the Sorbonne episode reflects on the nature of his bohemian voice. Bohemianism prevails throughout his Blue and Rose period work, offering a comprehensive access to his oeuvre. Associations with Villon suggest that this indispensable element might also be understood, somewhat unexpectedly, as a medieval strain, with special reference to the modern milieu of medieval Paris.

Picasso spent 1901 to 1905 primarily in Paris and Barcelona, and his art from that period is essentially urban. While denizens of the city populate his work, however, the city itself can be difficult to find. Settings include the garret, the brothel, and the café-bar, each of which— represented only by a minimum of descriptive detail—is often interchangeable with the next. Instead, the milieu is characterized by its inhabitants. For the most part Picasso has chosen to represent figures that occupy the socioeconomic margin, a realm that was appropriately portrayed in French using terms of exclusion: the *bas-fonds,*[6] the *zone,* and the *terrain vague.* By 1900 this fragmented subculture possessed a well-defined identity. It had already been catalogued in 1852 by Karl Marx, whose list includes a virtual register of Blue and Rose period subjects: vagabonds, swindlers, mountebanks, pickpockets, tricksters, gamblers, brothel keepers, literati, organ-grinders, ragpickers, and beggars, a "disintegrated mass thrown hither and thither, which the French term *la bohème.*"[7] With respect to Picasso, only friends and lovers are missing from this inventory (along with the satirical presence of the bourgeoisie), a significant factor that defines the phenomenon of bohemianism, of adapting oneself to, rather than being a native member of, *la bohème.* Marx disparages the population of outsiders as a nonproductive and unstable one, existing apart from the dynamics of class struggle; they were

in fact the object of broad resentment and fear throughout the nineteenth century. By contrast, Picasso identified himself and his circle with the citizens of bohemia, requiring them to occupy a protean world of his invention, one in which the artist was his own chief protagonist.

As discussed recently by Jerrold Seigel, bohemianism is an ambiguous form of social identity that emerged in mid-nineteenth-century France, where it was shaped by the dual rise of an urban underclass and an upwardly mobile bourgeoisie.[8] Bohemianism falls between these two realms; it addresses the indigence of the true social outcast as pathetic yet empowering, and it finds marginality to be distinguished by—even to sanction—a contempt for conventionalism and authority. The adoptive bohemian community involved a youthful apprentice and student class (such as the bourgeois defectors in Henri Murger's play of 1849, *Scènes de la vie de Bohème*), a membership that prominently includes artists and writers. Not all bohemians, however, emerge from within the confines of the bourgeoisie. Bohemianism constitutes a broad constellation of strategies and means through which the creative temperament establishes itself as an individual one operating on the margin of social norms—eccentricity, provocation, political insurgence, moral dissent, and a cultivated indifference to sordidness and squalor. In general, and often from material necessity, these imply a close rapport with the impoverished outcast's condition of social alienation, although the figure of the outcast himself could be assimilated into the self-conscious bohemian class. Ironically, of course, the bohemian's social and aesthetic nonconformism became a norm of its own over time.

Most of the subjects that occupy Picasso's art of the Blue and Rose periods correspond to the theme of bohemian identity. Although some differences in iconography occur between France and Spain, they are eclipsed, in the context of the bohemian theme, by the regular recurrence

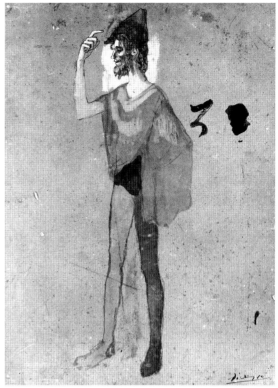

2. Picasso, *Madman,* Barcelona, 1904, water-color on paper, 85 x 35 (33 ½ x 13 ¾), Museu Picasso, Barcelona

3. Picasso, *The Saltim-banque,* Paris, 1905, gouache and ink on card-board, 62 x 47 (24 ⅜ x 18 ½), private collection, courtesy Galerie Beyeler, Basel. See also colorplate 120

of certain motifs. Several categories of indigents and *misérables* populate the shadowy pockets of Blue period space, alternating between the general and the particular; by representing acquaintances and members of his circle, Picasso mythologized his own life as a creature of this milieu. Indeed in his blue *Self-Portrait* of 1901 (cat. 77), executed in Paris, the artist character-izes himself as just that—starved and remorse-ful, with an admonishing stare ("about poor me I want to speak," Villon wrote in the *Grand Tes-tament*). The Blue period had already been her-alded by deathbed images of Carles Casagemas following his *suicide passionnel* by gunshot at a Montmartre restaurant in 1901; these portrayals culminate with the darkly burlesque *Burial of*

Casagemas (Evocation) (cat. 70), in which Casa-gemas' soul can be seen approaching heaven in the attentive company of low-class whores. Picasso's images of prostitution during this time have been traced to his experience of visiting Saint-Lazare, a women's prison for syphilitic prostitutes in Montmartre, in the summer of 1901.[9] Although the inmates, many of whom he depicted as young mothers, could originally be recognized by the white bonnets the prison required them to wear, in Picasso's subsequent work the prison clothing gave way to a hood and cloak in generalized representations such as the *Saint-Lazare Woman by Moonlight* (cat. 74). By contrast, personal experience reemerges in *La Celestina* of 1903 (cat. 100), which shows a procuress of Picasso's acquaintance from Barce-lona cast in the role of a villainous character from a fifteenth-century Spanish play.[10]

Picasso's figures of the social margin also include the madman, a subject that occurs most familiarly in several works on paper from 1904 produced in Barcelona. These clearly reflect first-hand observation, although the most important image in this group, *Madman* of 1904 (fig. 2), was modified by a canon of attenuated bodily proportions that Picasso derived from El Greco, a style he used throughout the Blue and Rose periods to connote an exalted state of being—to transform the physical condition of destitution

and madness into a spiritual one of religious asceticism and prophetic vision. Like madness, blindness is a recurring disability in Picasso's depictions of the poor and is the subject of several important mannerist works from 1903, including the *Old Guitarist* (fig. 26 in Chronology) and *Blind Man's Meal* (cat. 94), which are equally given to overtones of ascetic spirituality.[11] But Picasso's *Madman* also begs comparison with his contemporaneous *Saltimbanque* (fig. 3), a Paris figure—the fairground mountebank—that appears on Marx's list of social outcasts. The acrobat's declamatory gesture lies peculiarly close to the lunatic's, joining the two figures in bohemian kinship: madness and destitution both signify marginality or difference, an affinity that is emphasized by the clinical terminology according to which a turn-of-the-century madman was described as an *aliéné*. This inherent ambiguity is substantiated by a startling image of the asylum at Charenton by Jean Béraud (fig. 4),[12] executed in the artist's belle-époque salon style, a quasi-clinical taxonomy of dementia to which both of Picasso's figures openly correspond. In the bohemian context it is also relevant that, as John Richardson has observed, Picasso appears to project the features of an antagonist in his life—Laurent Debienne, the companion of his lover Fernande Olivier—onto another image of madness or desperation from late 1904, the *Christ of Montmartre* (fig. 5),[13] which represents the suicide leap of a local vagabond.

The café setting is equally subject to varying degrees of specificity. In this case firsthand experience is indicated by the presence of the artist's friends and acquaintances, in contrast to universalized representations of the café-bar as an asylum for the down-and-out. Painted in Barcelona in 1902, Picasso's *Two Women at a Bar* (cat. 83) exemplifies the latter, in a faceless image of destitution that is at once bitterly doleful and emblematically abstract; the only anecdotal detail is a glass of absinthe—"une bleue," in contempo-

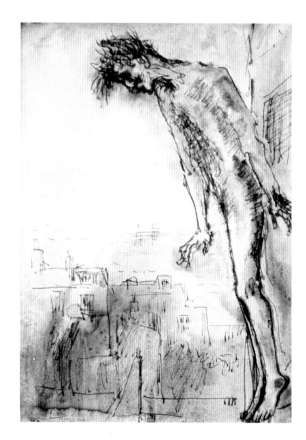

4. Jean Béraud, *The Madmen*, 1885, present whereabouts unknown

5. Picasso, *Christ of Montmartre*, Paris, 1904, pen and watercolor on paper, 36 x 26 (14 1/8 x 10 1/4), present whereabouts unknown

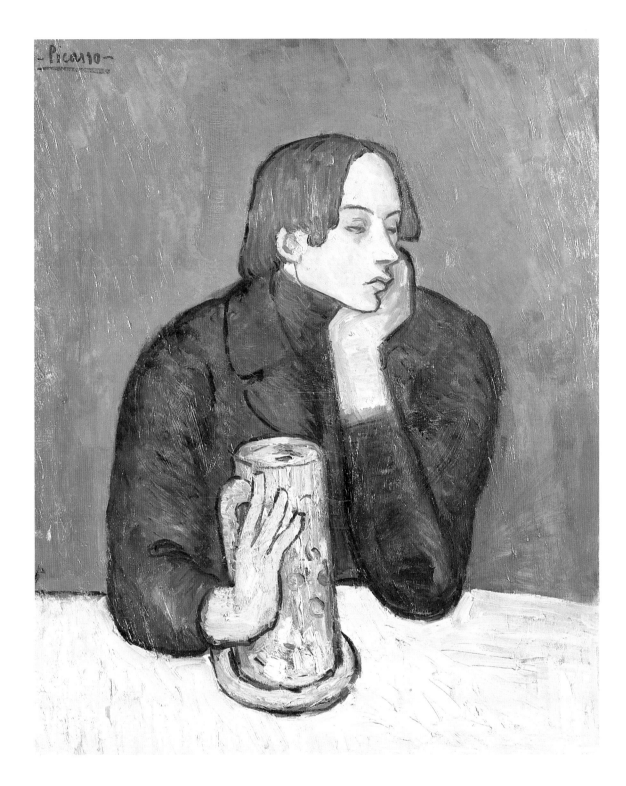

6. Picasso, *The Poet Sabartès ("Le Bock")*, Paris, 1901, oil on canvas, 82 x 66 (32¼ x 26), Pushkin State Museum of Fine Arts, Moscow

rary slang. Works such as this treat the sitter as a type that corresponds to sociological descriptions of the lower-class dive, frequented by "alcoholics . . . vagabonds, those who have been relegated to society's margins, who are little worried about shortening such a harsh and wretched life."[14] In contrast to this picture, *The Poet Sabartès (Le Bock)* of 1901 (fig. 6) is an intimate portrait of the artist's friend. Sabartès is shown in a moment of unselfconscious distraction at the Latin Quarter café La Lorraine, which for a brief period in late 1901 was a gathering place for friends and acquaintances from

the circle of the tavern Els Quatre Gats in Barcelona, including Picasso.[15] The poet recalls having been seized in a moment of boredom by Picasso's gaze, as the artist emerged from the haze of a smoke-filled room. Sabartès' melancholy, which he remembered in pungently romantic terms ("alternating hope and doubt sought gropingly, futilely, for certainty"), closely corresponds to Picasso's depiction of the indigent's ennui, with which a spiritual kinship—a bohemian conceit—is implied.

Picasso's personalization of the café theme is especially significant. The café, cabaret, and

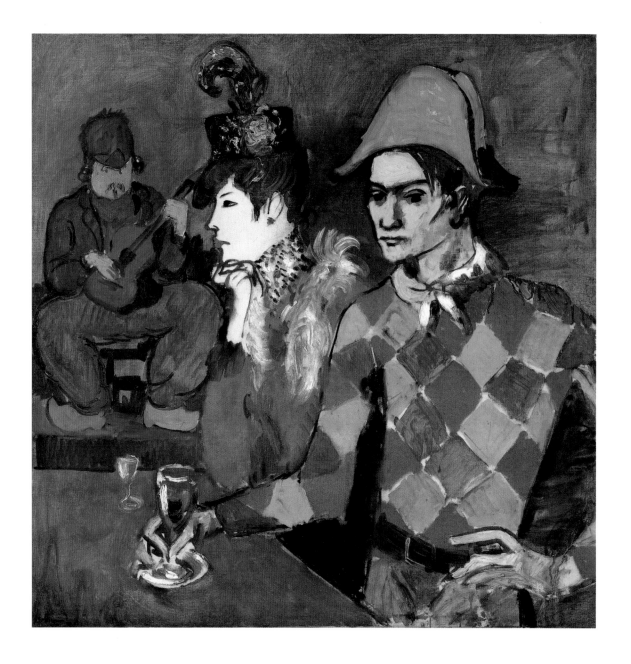

bistro were broadly addressed throughout the period as places of assembly and exchange frequented by various social, political, professional, and working-class groups (including artists and writers as a class, as well as individual factions and schools, which were often identified with a specific café).[16] As public establishments, these gathering places also permitted various circles to intersect: bohemian and underclass society, for example, sometimes shared a café or bar in the poorer sections of the city, which were themselves home to a diverse but related population. Salmon remembers paying regular visits to the Fauvet bar, located on the corner of the rue Ravignan and the rue des Abbesses in Montmartre near the Bateau Lavoir, a rendezvous "where poets and painters fraternized at the counter with *clochards*."[17] Into such a pictorial context Picasso could openly introduce members

of his circle without violating the authenticity of the milieu. By extension, the café portraits that Picasso painted of friends such as Sabartès, Sebastià Junyer Vidal (cat. 91), and Angel de Soto (in Barcelona) join images of anonymous sitters in this genre; the social margin is portrayed as both a tangible place and a literary convention. The culminating work is *Au Lapin Agile* (fig. 7), in which the artist depicts himself dressed as a harlequin saltimbanque, accompanied by Germaine Gargallo (later Pichot). The setting is a cabaret in Montmartre at which the Picasso circle could sometimes be found. Picasso actually painted this work for the proprietor, Frédé (Frédéric Gérard), who prominently displayed it in the main room (Frédé, who previously owned a café bar called Le Zut where Picasso had gathered with his Spanish comrades during 1901–1902, is pictured in the back-

7. Picasso, *Au Lapin Agile*, Paris, 1904–1905, oil on canvas, 99 x 100.3 (39 x 39 ½), The Metropolitan Museum of Art, New York, The Walter H. and Leonore Annenberg Collection, Partial Gift of Walter H. and Leonore Annenberg, 1992

ground with his guitar). *Au Lapin Agile* is a conceptually shrewd, even self-promotional, icon of artistic faith in which Picasso dramatizes his own bohemian identity within the very setting that the picture was intended to occupy, one in which the artist himself could also be encountered on any given night.

Bohemianism not only flourished in the cafés and cabarets of contemporary Paris but was thematized as a historical phenomenon at the *cabarets artistiques* of Montmartre, the progeny of Rodolphe Salis' cabaret Le Chat Noir. Montmartre had escaped the sweeping modernization that transformed central Paris during the Second Empire; apart from the boulevards in the lower sections of the *quartier,* its narrow streets were the object of romantic nostalgia. Less starkly destitute than barren outlying sections of the city that served as a refuge for the displaced urban poor, this milieu could be commercialized in varying degrees at the cabaret, which was populated by artists, writers, and other locals as well as tourists and bourgeois curiosity seekers. Le Lapin Agile had yet to succumb to the tourist trade in this way, although it was clearly trading on its own history as a semirustic bohemian hangout, a reputation dating back to the 1860s that was enhanced by the occasional presence of prostitutes and *mauvais garçons.* Closer to the turn of the century, when it was still called the Cabaret des Assassins, upscale visitors would not make the trip without an escort. By Picasso's time, according to one hanger-on, it hosted a clientele that "made it resemble a tavern from Villon's era" (Villon's circle was closely associated with a specific cabaret, the Pomme de Pin).[18] Nightly performances at Le Lapin Agile appear to have been composed of appropriate fare: verse by Baudelaire and Verlaine, for whom the alienated bohemian was a common theme, as well as by Ronsard and Villon, representing a medieval strain. The actor Charles Dullin specialized in Villon, adopting the poet's persona while reciting *ballades* and excerpts from the

8. Cover illustration for Aristide Bruant's *L'Argot du XXᵉ siècle,* 1901, Bibliothèque Nationale de France, Paris

Grand Testament in a dramatic declamatory style before a crowd now composed of artists, sightseers, and the occasional talent scout.[19]

Villon's spirit inhabited not only Montmartre but old Paris in general, both actual and historical. In this respect it is useful to recognize that historical Paris was a subject of public debate at precisely this time. A municipal commission of antiquarian preservationists, established in 1897, worked to save the palaces, *hôtels,* and monumental vistas of *vieux Paris* from post-Haussmannian modernization; their adversaries at the Société du nouveau Paris, established in 1902, were devoted instead to renovation of the Paris street. For the urbanist Emile Magne, writing in 1905, *nouveau Paris* would be a realm of festivals and *féeries* illuminated by electric light, a "fusion of science and art for maximum magnificence." By contrast, "Villon's Paris," the regretted *vieux Paris,* was a dark, grimy, malodorous maze of pest-ridden streets, a city with its public spaces given over to thieves, ruffians, ragged mountebanks, and itinerant fairground encampments. Much to the benefit of modern Parisians, this urban *physionomie primitive* had vanished for the most part.[20]

In the mythology of modern Paris, Villon represented the retreat of the new. The historicism of his legacy, which lent authenticity to the *villoniste,* was routinely invoked in memoirs by various observers of Picasso and his milieu. For Francis Carco, an acquaintance and chronicler, Villon's spirit was a "halo around the brow of modern bohemians," *noctambules* who "prowled the taverns, bars, and brasseries, the deserted Pont-Neuf, and the narrow streets that zigzagged like lizards between darkened houses. . . ."[21] In a volume of reminiscences, he recalls a bar on the rue Grégoire-de-Tours with earthen floors and graffiti, where "girls answered to the names Yolande, Isabeau, and Guillemette" (archaic names that appear in Villon's work) and the habitués, in whose company Carco would diffidently recite verse, dressed

"like authentic *compaings de la Coquille*."
There, in a "villonesque passage" from a poem
of 1909, Guillaume Apollinaire describes hav-
ing first met André Salmon: " . . . un caveau
maudit / Au temps de notre jeunesse / Fumant
tous deux et mal vetus attendant l'aube. . . ."
Carco declares his faith: "We loved you so
much, François Villon! We sensed that you were
so close to us, at the same table . . . or outside
in the streets, walking by our side at that
moment when daylight fades. . . ."[22]

The bohemian mythology of Villon was
shaped by his association with a criminal band
known as the Coquille, to which Carco refers.
In fact Schwob was among the first to decode
the *ballades* that Villon composed using the *jar-
gon* or *jobelin* of its members, the Coquillards.
Lower-class and underworld argot had been
a subject of serious study throughout the nine-
teenth and early twentieth centuries and was
characterized in the literature as an impenetrable
and mutable dialect that thwarted the scrutiny
of the uninitiated (in particular, the police).[23]
The modern permutation was routinely histori-
cized both by scholars and by the Montmartre
commercial culture with reference to Villon.
Aristide Bruant, who had grown rich performing
songs of the abject poor composed in contem-
porary street slang at his cabaret Le Mirliton
(something of a performance genre throughout
cabarets in Montmartre), published a vast dic-
tionary of argot in 1901; situating the criminal
subculture within a literary tradition, the cover
illustration shows a menacingly dark panorama
of Montmartre emblazoned with the faces of the
modern *mauvais garçon* and the medieval *argo-
tier*—an imaginary portrait of Villon (fig. 8).

Criminal confederates—*rôdeurs, apaches,*
anarchists, and street thugs—came together in
groups known as *bandes,* which flourished in
Montmartre throughout the epoch and provided
a model for Picasso's own circle, impudently
named the "bande à Picasso." Usually identified
by the street on which they were known to lurk

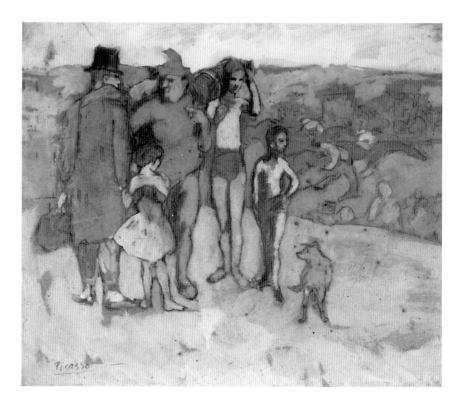

or gather, these groups were often distinguished
by their own language and code.[24] Accordingly,
the Picasso gang spoke a confidential language
that Salmon later described as the "jobelin" or
"jargon de la rue Ravignan" (in reference to
the address of the Bateau Lavoir), a half-joking,
random composite of coarse argot and assorted
regional dialects.[25] No image exists to show the
"bande à Picasso" as such, although an earlier
charcoal drawing (cat. 46) portrays Picasso and
his associates from the journal *Arte Joven* in
Madrid as a semi-destitute fraternity of the *ter-
rain vague*. Picasso revived this format in 1905
for his large *Family of Saltimbanques* (cat. 137),
in which he depicted himself. In the extended
family of *la bohème*, members of the *classe dan-
gereuse* represent the margin and the *bas-fonds*
as a realm of lurking menace, where defiance of
the law constitutes a form of covert dominion
over the city. The implications pertain to the
way in which the community of *villonistes*—by
association with an actual subculture—would
experience Paris as a city seized from within.
A mythology of this theme occurs throughout

9. Picasso, *Saltimbanque
Family,* Paris, 1905,
gouache and charcoal on
cardboard, 51.2 x 61.2
(20 1/8 x 24 1/8), Pushkin
State Museum of Fine
Arts, Moscow. See also
colorplate 136

10. Léon Gimpel, *Family of Acrobats*, 1909, Collection of the Société française de photographie

nineteenth-century literature, from Hugo and Balzac to Eugène Süe, and is incarnated by the "unseen seer," a species of invisible observer that includes the detective and the criminal. As a wearer of disguise, this figure often appears in the costume of the ragpicker, Picasso's first self-portrait incarnation for the *Family of Saltimbanques* according to an early study (fig. 9) that resembles the *Arte Joven* drawing. Along with beggars, vagrants, and ex-convicts, saltimbanques were sometimes recruited by police as informers and spies.[26] Picasso, Salmon, and Jacob (our *villonistes*) would soon form the Société des amis de Fantomas, devoted to a sinister master of disguise, the protean antihero of a series of dime-store thrillers and silent films modeled on Süe's *Mystères de Paris*. The society accomplished nothing of note, Salmon reports, but members were fond of inscribing the crumbling walls of old Montmartre with graffiti, "alarming the *bon bourgeois*" with their mark: the "bloody hand."[27]

Notwithstanding the Société du nouveau Paris and its fear of old Paris, itinerant saltimbanques and their kind still inhabited the public square; Picasso remembered having seen their performances at the Esplanade des Invalides. He depicts them, however, in their encampments on the barren outskirts of the city. This realm was occupied by nomadic bands of mixed (often vaguely central European) origin, descendants of an itinerant culture that had first entered France during the fifteenth century, a population for which the very word *bohémien*, in French, was originally invented. Saltimbanques appear to have "crossed over from the middle ages," one observer wrote;[28] they were, with reference to Magne's complaint about *vieux Paris,* modern occupants of the medieval *bas-fonds*. This lineage was reinforced by the nomad's argot, composed, according to Pierre MacOrlan (another acquaintance of the Picasso group), of various dialects that had been adapted en route; MacOrlan cited Apollinaire's verse for archaic

examples of this patois.[29] A fascinating auto-chrome of performers from the period (fig. 10) shows that Picasso's palette of rose and blue during 1905 was true to the subject. But the image not only reveals that the artist was literal in his choice of colors; it can also be taken to insinuate that the saltimbanque occupied a visual as well as a historical and literary world apart, one that would have corresponded with Picasso's preexisting bohemian interest in closed communities.

The fairground was notoriously populated by pickpockets, swindlers, and *apaches* (the criminal vagabond youth of Paris), in addition to performers, and the entertainment culture included charlatans associated with magic and games of chance and deceit. Apollinaire alluded to this when describing Picasso's acrobats in an exhibition review of 1905: "Beneath the tawdry finery of his slender clowns, one feels the presence of real young men of the people, versatile, shrewd, clever, poor, and deceitful"; and he portrayed them as "sorcerers from Bohemia, fairies and conjurers," in his poem "Crépuscule," which was based on Picasso's images.[30] In the work of 1905 Picasso drew on a contemporary poetic conceit (from Verlaine to Apollinaire) in which the saltimbanque represented a rootless creative soul dwelling in an impoverished but quasi-enchanted realm.[31] In this context medievalism also qualifies the contemporary fairground as a physically, temporally, and affectively liminal world. By association with Villon's Paris and the historical model of bohemian culture, the spectral detachment of Picasso's Blue and Rose period work now acquires an air of suspended animation. Villon was in this respect a modern creature of memory who inhabited a city that had partly vanished, yet was still experienced as preservably real; situated between the timeless and the squalid, *villonisme* was a condition of modern and historical push-pull.

If Picasso was not officially introduced to Villon until late 1904, the poet was available to him

in many forms, and Picasso's attraction would have been grounded in existing correspondences between their work. Both men consistently spoke in the first person, a quality for which Villon was understood to be virtually anomalous in his time. Both derived material almost exclusively from their experience of *la mauvaise vie*—authentic in Villon's case, partly assumed in Picasso's. The element of autobiography, which is so often invoked by Picasso's interpreters, is as much a lyric device as a descriptive one, allowing the artist to be present in his own work as both subject and observer. Villon's tone is primarily tough, crude, bawdy, sarcastic, grittily profane, while Picasso's is perhaps secondarily so. Yet both artists were on close terms not only with bathos and self-pity but with tenderness, pathos, and religious sentiment, qualities that lend their work a reserve of lyrical and emotional depth. In this respect firsthand experience can be transformed into an allegorical lament; Picasso's painting *La Vie* (cat. 93) is such a work, in which the artist had originally cast himself, eventually substituting a portrait of Casagemas. Finally, although Picasso and Villon identified closely with Paris, both were adoptive natives who shared a peripatetic relationship with the city (Villon through exile and flight), an ambiguous identity that is reflected in their work.

Toward the end of Villon's *Grand Testament*, an expansive poem conceived in the form of a mock last will and testament, the dying poet asks "pardon of everyone," of *Celestins*, mendicants, idlers, fashion plates, servants, prostitutes, robbers, and "acrobats with monkeys in tow . . . male and female fools by trade who go about in groups of six."[32] Subjects in the work of Picasso and Villon are indeed closely related throughout: both oeuvres unfold as a running account of the streets, taverns, brothels, and garrets through which they have passed. But Picasso's *villonisme* was not programmatic. Rather, Villon's pervasive presence reveals that bohemian Paris was,

by Picasso's time, a historical milieu; occupying the social and geographical margins of the city, bohemian society had also come to inhabit the precincts of urban memory. Primarily oriented toward Paris, *villonisme* could represent, in relation to Barcelona, a spatially and temporally portable construct. In this sense it served Picasso much as it would the poet Blaise Cendrars, who traveled from Paris to New York in 1910 carrying an old, small-format edition of Villon in his pocket "in place of a Baedecker." Villon, Cendrars wrote, allowed the poet to comprehend behind the electric lights of the nocturnal city

"the superstitious mob of homeless *misérables* and the brazen, caustic company of *mauvais garçons* that Villon had frequented, the same mob and the same company, living in the same medieval conditions." Their slang, he observed, was "worthy of the *jargon des coquillards*."[33] Ultimately Picasso's affinity for Villon suggests that two critical yet somewhat conflicting elements of the artist's early work—its hermeticism and its close proximity to the street—can be reconciled within an existing climate of sociocultural nostalgia.

Notes

1. The details of Schwob's course listing are recorded in John Alden Green, ed., *Marcel Schwob. Correspondance inédite* (Geneva, 1985), 211–213; the poet Paul Fort is also listed among those who attended the class. For a recent edition of Schwob's writings on Villon, including lecture notes for the Sorbonne course, see Marcel Schwob, *Villon François* (Paris, 1990).

2. This account appeared in an arts and letters periodical in conjunction with an item about Pierre Champion's recently published edition of Schwob's writings on Villon, where it was attributed to a "bibliographe érudit qui signe A.S.," doubtlessly referring to Salmon. See "Vie littéraire et artistique," *Le Monde artistique*, 9 August 1913, 511. Salmon lived at 244 rue Saint-Jacques.

3. Salmon 1955, 241.

4. Salmon 1955, 235–241, provides a lengthy account of Schwob.

5. See also Salmon's introduction to Marcel Schwob, *Le Livre de Monelle* (Paris, 1923), 11.

6. For a discussion of the literal and metaphorical meaning of the term *bas-fonds* see Christopher Prendergast, *Writing the City: Paris and the Nineteenth Century* (Cambridge, MA, 1995), 82–84.

7. From *The Eighteenth Brumaire of Louis Bonaparte* (New York, 1963), 75. To designate *la bohème* in German, Marx uses the term *Lumpenproletariat*.

8. Jerrold Seigel, *Bohemian Paris: Culture, Politics, and the Boundaries of Bourgeois Life, 1830–1930* (New York, 1986).

9. See Michael Leja, "'Le Vieux Marcheur' and 'Les Deux Risques': Picasso, Prostitution, Venereal Disease, and Maternity, 1899–1907," *Art History* (March 1985), 66–73.

10. Richardson 1991, 288, 290.

11. Rosenthal 1980, 87–91.

12. The painting was reviewed in Louis Enault, "Jean Béraud: Les Fous," *Paris-Salon* (1885), 33–34. My thanks to Pierre Saurisse, who is collaborating on a catalogue raisonné of Béraud's work, for sharing information about this lost picture with me. Late nineteenth-century advances in the observation and treatment of hysteria had made this subject widely available to both naturalists and symbolists. For an overview see Rodolphe Rapetti, "De L'Angoisse à l'extase. Le Symbolisme et l'étude de l'hystérie," in *Paradis perdus. L'Europe symboliste* [exh. cat., Musée des Beaux-Arts] (Montreal, 1995), 224–234.

13. Richardson 1991, 317.

14. See Léon Bonneff and Maurice Bonneff, *Marchands de folie* (Paris, 1913), 9, 138; and Michael R. Marrus,

"Social Drinking in the Belle Epoque," *Journal of Social History* (Winter 1974), 124–126.

15. Sabartès 1949, 61–63.

16. See René Bizet, "L'Age du zinc. Les Palaces des faubourgs," *Touche à tout* (February 1911), 135; and "L'Age du zinc: La Bourgeoisie n'échappe pas non plus à l'alcoolisme," *Touche à tout* (March 1911), 220.

17. Salmon 1955, 176.

18. For the specific references see André Fontainas, *Mes Souvenirs de symbolisme* (Paris, 1928), 136; and Paul Yaki, "Les Joies fanées du vrai Montmartre. Le plus célèbre cabaret du monde," *Liberté*, 27 April 1929, n.p. For Le Lapin Agile in general see also Seigel 1986, 339–40; and Richardson 1991, 371–375.

19. Pauline Teillon-Dullin and Charles Charras, *Charles Dullin, ou Les Ensorcelés du Chatelard* (Paris, 1955), 209–210. See also Roland Dorgelès' account of Dullin reciting Villon at Le Lapin Agile in *Bouquet de Bohème* (Paris, 1947), 23–24 (cited in Richardson 1991, 375).

20. Emile Magne, "L'Esthétique de la rue," *Mercure de France*, 15 July 1905, 169. For the preservationists' mandate see the "Séance du vendredi 28 janvier 1898," *Commission municipale du vieux Paris: Procès-verbaux 1898*, vol. 1, no. 1 (1899), 1–2. For both organizations see Meredith L. Clausen, *Frantz Jourdain and the Samaritaine: Art Nouveau Theory and Criticism* (Leiden, 1987), 126–128, 255–59; the *vieux Paris* commission is also discussed in Molly Nesbit, *Atget's Seven Albums* (New Haven, 1992), 62–73. For a general discussion from the period see also André Billy, *Paris vieux et neuf* (Paris, 1909), 198–204.

21. Francis Carco, *De Montmartre au Quartier Latin* (Paris, 1927), 10–11. As a spectral quality that distinguishes the Paris of the *flâneur*, the "persistence of the past in the present" would later be a central premise of André Breton's surrealist novel *Nadja* (1928), which drew on this element as it occurred in Parisian "panoramic" literature of the period; see discussion in Margaret Cohen, *Profane Illuminations: Walter Benjamin and the Paris of the Surrealist Revolution* (Berkeley, 1993), 77–119.

22. Carco 1927, 166–167. It comes as a surprise that Apollinaire's name is not on the list of those who attended Schwob's Villon lectures, since his work is often described as *villonesque*.

23. See Ferdinand Brunetière, "La Déformation de la langue par l'argot, à propos de livres récents," *Revue des deux mondes*, 15 October 1881, 934–944; Alfred Delvau, *Dictionnaire de la langue verte* (Paris, n.d.), v–x; Albert Barrère, *Argot and Slang: A New French and English Dictionary . . .* (London, 1889), v, xiv; Gaston Esnault, preface for R. Yve-Plessis, *Bibliographie raisonnée de l'argot et de la langue verte en France du XVᵉ au*

XX^e siècle (Paris, 1901), vii–xv. The folklore of argot, including the modern legacy of Villon, was also treated extensively by acquaintances of the Picasso circle; see, among others, Francis Carco, *Le Destin de François Villon* (Paris, 1931); and Pierre MacOrlan, *Le Mémorial du petit jour. Mémoires* (Paris, 1955). For argot in verse composed in the voice of the underclass see also Richard Dupierreux, "Un Poète de la misère contemporaine. Jehan Rictus," *La Société nouvelle* (April 1911), 64–87. An edition of Rictus' semi-argotic poems, *Soliloques du pauvre,* had been illustrated by Picasso's friend Joaquim Sunyer in 1897 (see Richardson 1991, 170).

24. Louis Chevalier, *Montmartre. Du Plaisir et du crime* (Paris, 1980), 280–290; and Michelle Perrot, "Dans la France de la belle époque, 'les apaches,' premières bandes de jeunes," *Cahiers Jussieu* (1979), 387–407.

25. Salmon 1955, 337; and Salmon, *Max Jacob. Poète, peintre, mystique* (Paris, 1927), 30.

26. For a discussion see Richard D.E. Burton, "The Unseen Seer, or Proteus in the City: Aspects of a Nineteenth-Century Parisian Myth," *French Studies* (January 1988), 50–68; and, for the ragpicker per se in this context, Adrian Rifkin, *Street Noises: Parisian Pleasure 1900–1940* (Manchester, 1995), 38–42. Richardson 1991, 385, identifies Picasso's ragpicker costume in the study for the *Family of Saltimbanques,* comparing it to a figure in Manet's *Old Musician* (National Gallery of Art, Washington), which was probably a source for the final work. Coincidentally, December 1904 marked the centenary of the birth of Eugène Süe, which was widely covered in the press (see "Le Centenaire d'Eugène Süe," *Illustration,* 24 December 1904, 438). Associations with criminal culture inevitably call to mind the milieu of anarchism in Barcelona and Paris, with which Picasso was acquainted at the time (see Leighten 1989).

27. Salmon 1956, 232–234.

28. Hugues Le Roux, *Les Jeux du cirque et la vie foraine* (Paris, 1889), 2.

29. MacOrlan 1955, 130.

30. The first quotation is from Apollinaire, "Picasso, peintre, dessinateur," *La Revue immoraliste* (April 1905); translation from *Apollinaire on Art: Essays and Reviews 1902–1918,* ed. Leroy C. Breunig, trans. Susan Suleiman (New York, 1972), 13. For a discussion of the relationship between Picasso and Apollinaire in the context of the saltimbanque theme in 1905 see Marilyn McCully, "Magic and Illusion in the Saltimbanques of Picasso and Apollinaire," *Art History* (December 1980), 425–434.

31. The classic treatment of this theme is Reff 1971, 30–43.

32. François Villon, *Complete Poems,* ed. and trans. Barbara N. Sargent-Baur (Toronto, 1994), 189, 191.

33. Blaise Cendrars, "Sous Le Signe de François Villon," *La Table ronde* (March 1952), 48–49 (my translation).

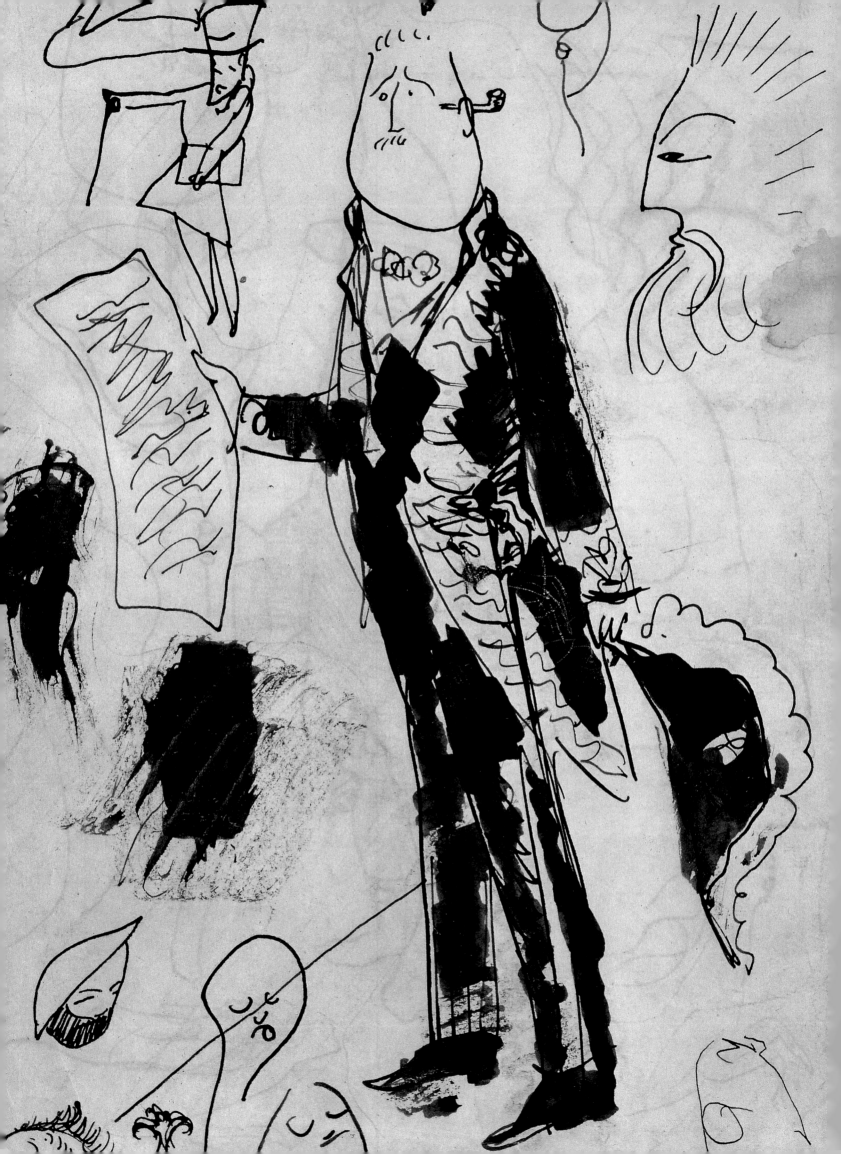

"Au Rendez-vous des poètes": Picasso, French Poetry, and Theater, 1900–1906

Peter Read

Picasso met Max Jacob (fig. 1) in June 1901, at a time when friends staying in the painter's flat at 130 ter Boulevard de Clichy used to sleep on the floor with a two-volume dictionary as a pillow.[1] Picasso's determination to master the French language indicates a desire to reach beyond the world of Spanish expatriates. It was Max Jacob who would introduce him to French literature in the original text, as well as to French theater and opera, and who would remain his literary guide until 1905; in return, Picasso would encourage and foster Max's own vocation as a poet.

From the evidence available, it is possible to piece together some idea of Picasso's access to French literature during this period. Jaime Sabartès recalls an evening in late 1901 when Max read from Paul Verlaine's collection of poetry *Sagesse,* reciting slowly and theatrically, probably as much to facilitate understanding as to do justice to the texts.[2] In 1903, sharing his room on the Boulevard Voltaire with Picasso, Max used to read aloud from the poetry of Alfred de Vigny, moving them both to tears.[3] On

one suitably sorrowful drawing, probably dating from December 1902, which shows a woman lamenting with upraised arms, Picasso copied out the bibliographical details of Vigny's *Complete Works,* no doubt planning to acquire the volume for himself. He repeated this inscription on another drawing from the same time, adding the detail "poème-Moïse."[4] That Picasso and Max should have been touched by this particular poem is no doubt due to their identification with Vigny's Moses, a romantically heroic but solitary figure, uprooted, burdened by divine gifts and by the intuition that he would not reap the material rewards of his efforts, would never enter the "land of milk and honey." Max's recitals made a lasting impression. "Moïse" must have been a perennial favorite, for Picasso referred to it again in 1905 in a brief "Poem" to Max, which ends "je pense à toi au riz de / l'autre soir à te lignes logiques / Moise et Stendhal."[5] The "logical lines" recall Max's talent for palmistry, while the reference to Stendhal reminds us that when Fernande Olivier met Picasso she found only one book in his studio, Stendhal's *De L'Amour,* a collection of aphorisms and reflections on love published in 1853.[6]

These limited but consistent indications suggest that Max's literary education of Picasso reflected the current predilections of Parisian intellectuals, including the continuing popularity of romantic literature (in a 1902 opinion poll, writers and literary critics named Hugo, Vigny, Verlaine, Baudelaire, and Lamartine, in descending order, as their favorite nineteenth-century poets).[7] Picasso in 1905 apparently liked to play the young romantic: he had transformed his bedroom into a chapel to his beloved Fernande (this before she moved in with him), with an item of her lingerie as its devotional centerpiece.[8] Henri Mahaut remembered seeing in the Bateau Lavoir in 1907 a framed portrait of a woman (probably Fernande), dating from an earlier period, with a red rose and a crumpled piece of fine linen under the glass.[9]

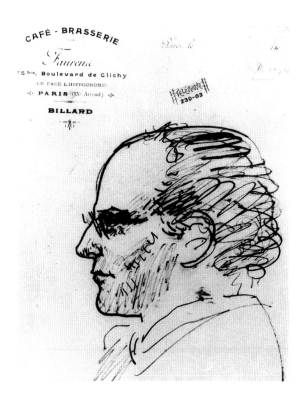

Detail, cat. 118

1. Picasso, *Portrait of Max Jacob,* Paris, 1904–1905, pen on paper, 25.8 x 20.8 (10⅛ x 8⅛), private collection

It has been suggested that works of Picasso's Blue period may have been influenced by literary symbolism.[10] These paintings are indeed marked by a characteristically filtered stillness, and blue was a favorite symbolist color, often suggesting vertical and spiritual aspirations, as in Stéphane Mallarmé's poem "L'Azur." But the suffering individuals, the beggars, prostitutes, and insane who became Picasso's subject matter are reminiscent of the "outsiders" who populate Charles Baudelaire's prose poems or the urban poor of naturalist novels. They have little in common with the swans, lilies, and mythological creatures of symbolist literature. Guillaume Apollinaire defined this Blue period mixture of spirituality and realism in his first article on Picasso in April 1905, in *La Revue immoraliste*: "His naturalism, with its love of precision, is combined with the mysticism that in Spain lies in the depths of the least religious souls."[11] Other early visitors to the Bateau Lavoir also emphasized this essential Spanishness, never mentioning symbolism. For Mahaut, writing in 1930, the pictures he had seen in 1905 suggested "Spain and something of El Greco. A thin, poverty-stricken, suffering, and Gothic Spain."[12] Symbolist literature, with its evanescent imagery, sophisticated syntax, and recondite vocabulary, would have been uncongenial, indeed hardly intelligible, to the young Picasso. French romantic literature, with its emphasis on love and extraordinary individuals, was more attractive.

In mid-February 1905 Picasso met Apollinaire, the poet, journalist, and reluctant bank clerk.[13] From that moment Apollinaire became Picasso's closest friend and ally; Picasso told Christian Zervos that they had immediately used the intimate "tu" form of address, as if they had known each other for years.[14] Apollinaire and André Salmon, who also arrived in February 1905 (fig. 2), joined Max Jacob to form an inner circle at the Bateau Lavoir, around which revolved several talented lesser lights. They included Jean "the Baron" Mollet, the literary

2. Picasso, *André Salmon*, Paris, 1905, pen and ink on paper, 18.5 x 12.5 (7¼ x 4⅞), Musée Picasso, Paris

odd-jobber and go-between who introduced Picasso to Apollinaire; Maurice Cremnitz, a poet and minor civil servant who specialized in conversational punning and wicked irony and would enjoy a second, more successful literary career under the name Maurice Chevrier; the poet Nicolas Deniker, whose father worked at the Paris Botanical Gardens, which facilitated nocturnal expeditions from the Bateau Lavoir to the menagerie there; the poet Maurice Raynal, who turned twenty-one in 1905 and immediately invested a good part of his family fortune in the revue *Vers et prose,* launched in March of that year. Raynal was introduced to Picasso by Max Jacob.[15] Picasso lived almost exclusively in the company of French poets from early 1905 until the spring of 1907 when he met Georges Braque; he welcomed their presence by writing "Au Rendez-vous des poètes" on his door.[16]

Apollinaire and Salmon had known each other since the literary cabaret evenings orga-

nized in 1903 by the review *La Plume* in a Latin Quarter cellar, where these moody young men had shaken off the grip of moribund symbolism, declaimed their poems, and "learned to laugh."[17] With Mollet and others they had published their own literary review, *Le Festin d'Esope*, edited by Apollinaire, which had lasted nine months; its second issue, in December 1903, featured a one-act play by Alfred Jarry entitled *L'Objet aimé*. When Apollinaire and Salmon discovered Picasso, they made his studio their new headquarters. The poets soon launched a new periodical, with its office in a doctor's clinic and financial support from Henry Delormel, a successful popular music publisher and author of such libidinous texts as his 1904 novel *Les Deux Maîtresses de l'étudiant*. The magazine, first titled *La Revue immoraliste*, then *Les Lettres modernes*, ran for two issues, dated April and May 1905. On its first front cover was reprinted Stendhal's intransigently romantic preface (dated 1837) to his novel *Lucien Leuwen*; the second issue featured five poems by Max Jacob, his first published verse since December 1901, including "Le Cheval," dedicated to Picasso.

When Salmon first visited the Bateau Lavoir, Picasso spoke enthusiastically of modern French literature and presented him with two well-thumbed volumes that were lying in a tin bathtub: a slim book of verse by Félicien Fagus, *Testament de ma vie première* (published in 1898), and a collection of plays by Paul Claudel, entitled *L'Arbre* (published in 1901).[18] Picasso is unlikely to have spent much time deciphering Claudel's lengthy and poetic religious dramas. By 1905 Fagus (real name Georges Faillet) had reverted to Catholicism, but in 1898 he was still an anarchist Dreyfusard. More important, Fagus, as art critic at *La Revue blanche*, had written favorable reviews of Picasso's 1901 and 1902 Paris exhibitions. Picasso had shown his gratitude by giving him a fine oil painting that had caught his eye in the 1901 Vollard exhibition, known as *Little Girls Dancing* or *Les Blondes*

Chevelures.[19] Picasso and Fagus had probably remained in contact at the Closerie des Lilas in Montparnasse.

In February 1905, at about the time he met Apollinaire, Picasso wrote to Jacint Reventós in Barcelona expressing an interest in sixteenth- and seventeenth-century French literature: "Tell me whether you know Rabelais' Gargantua. Perhaps you know it in Spanish, but what a difference. La Bruyère and all the classic French writers. One of these days I'll send you a book by Pascal you may not know."[20] Picasso is out to impress his friend back home, but his sensitivity to French literary language was confirmed by Daniel-Henry Kahnweiler: "Picasso had a finely developed feeling for French poetry. Apollinaire used to say to me: 'Even a few years ago, when he could hardly speak French, he was perfectly able to judge and immediately appreciate the beauty of a poem.'"[21] Apollinaire's reported statement implies that Picasso enjoyed listening to French poetry being read aloud. For the poets, this was indeed a normal social activity (with "still too symbolist" being Max's habitually mischievous response).[22] Picasso's reading was thus supplemented by this other access to literary works, and in particular to poetry. Sabartès stated that Picasso was never seen reading a book but nevertheless revealed great knowledge of literature.[23] He was undoubtedly highly receptive not only to the texts he heard but also to the poets' conversation, assimilating a mass of informed opinions.

From André Salmon, Picasso would have heard the poems of Arthur Rimbaud, whose works had first been collected in an edition of 1898, with further unpublished poems appearing in 1905 in the *Revue de Paris et de Champagne*. In the May–June 1906 issue of that same periodical, Salmon published his poem "Arthur Rimbaud" in which he refuted the then-conventional image, promoted by Paterne Berrichon and Rimbaud's sister Isabelle, of the poet as incipient and finally reconverted Catholic.

Salmon glorifies his subject as child genius, rebel angel, African adventurer, and utopian visionary, all aspects that would have struck a chord in Picasso.[24] Elsewhere Salmon adopts Rimbaud's tightrope and circus imagery, reflected in the engraving of two saltimbanques provided by Picasso as frontispiece for deluxe copies of Salmon's 1905 volume *Poèmes*, published by *Vers et prose*.

Fernande Olivier, who moved in with Picasso in September 1905, was a voracious reader, partly because Picasso did not like to let her out alone. And Apollinaire always had his pockets full of books, which he sometimes used to lend.[25] His enthusiasm for all literary highways and by-ways was contagious. In 1905 Picasso drew a portrait of Alice Princet (later to become Alice Derain) reading Apollinaire's copy of Restif de la Bretonne's *L'Anti-Justine*, the eighteenth-century pornographic novel he would bring to the Rue Ravignan but would never let out of his sight.[26] Restif would indeed figure in the disorderly library Picasso eventually accumulated in the Bateau Lavoir: "Detective and adventure novels were there alongside our best poets. Sherlock Holmes, Nick Carter, and Buffalo Bill red-cover paperbacks beside Verlaine, Rimbaud, and Mallarmé. He loved the eighteenth century, represented by Diderot, Rousseau, and Restif de la Bretonne."[27] Picasso's interest in French literature had become increasingly eclectic, including almost everything but prosaic, naturalist fiction (though Picasso retained a lifelong admiration for Emile Zola, both as a writer and as a man).[28]

On Tuesday evenings Apollinaire would drag Picasso across to the *Vers et prose* sessions at the Closerie des Lilas, where he met a roomful of other poets. These included the entrepreneurial Paul Fort, who had been director of the symbolist Théâtre d'Art and editor of the monthly review *Le Livre d'art*, which in 1896 had published the first edition, in two parts, of Jarry's *Ubu Roi*. Another major presence at the Closerie was the poet Jean Moréas, author of the 1886

Symbolist Manifesto, who had subsequently reacted against symbolist obscurity by founding the *Ecole romane*, harking back to a romance tradition epitomized by sixteenth-century French literature. After travels in his native Greece in 1898, he published the two-volume collection *Stances* (1899 and 1901), expressing an impersonal and strictly controlled classical aesthetic. In 1905 Moréas looked back on his break with symbolism and remarked, "Today I have the pleasure of noting that everyone is returning to classicism and antiquity."[29] His influence was indeed pervasive, affecting Apollinaire, Salmon, and also Picasso's friend Manolo, the sculptor who wrote poems in French inspired by Moréas that he used to recite in his heavy Spanish accent: "Et couché, el soir, yo souis comme oune baïyolone dedans sa vouâte." The violin in its case was apparently his most renowned achievement as a poet.[30] Picasso himself was susceptible to this neoclassical trend, producing such "Hellenic" works as *Two Youths*, painted in Gósol in 1906 (cat. 151). The priority given to formal and impersonal harmony in such works is in absolute opposition to romantic idealism and marks an important stage on the path toward cubism.

Social life at the Bateau Lavoir was often theatrical, with Picasso's studio resembling a private club that specialized in satire and burlesque, "making fun of everything," according to Salmon.[31] Not outdone by the influx of newcomers, Max remained the star performer, with a repertoire that included extracts from Offenbach and grand opera, scenes from classic comedies, speeches from Racine, and a scene from Corneille's *Horace* in which he acted all the parts.[32] Max would improvise parodies of Laforgue's mournful complaints and of the misty, Belgian symbolist verse of Maeterlinck, but they would all take turns playing Baudelaire and other illustrious visitors coming to view Picasso's latest output.[33] Raynal recalled how through the windows of Bateau Lavoir studios

they would watch with fascination as Degas or Renoir negotiated the steps of Rue Ravignan, but would never invite them in.[34] These venerable figures would immediately become improvised characters on the creaking boards: "We would 'do Degas.' We would 'do Victor Hugo.' Max was priceless improvising 'a visit from Renoir.'"[35]

For the poets, the private jokes and typically French humor, based on parody and fast-moving wordplay, were a way of bonding the group together and locking Picasso more exclusively into their circle. For Picasso, his place at the center of the group was a step toward acceptance by his adopted country, in company that was very Gallic, albeit bohemian and somewhat cosmopolitan. Sometimes the butt of his jesters' jokes, he accepted a role that was defined by his relative lack of proficiency in French.[36]

After the charades the poets would continue their discussions on art and literature with renewed passion. Salmon stated that he, Apollinaire, and Max used to discuss these subjects with Picasso "as with another poet."[37] In 1905 Picasso's artistic output surged, as the company of the poets helped the painter put behind him the static and solitary imagery of the Blue period. His apparently bohemian lifestyle and accounts of Bateau Lavoir recreational activities should not obscure the reality of his underlying total commitment to his work; the group's usual word of greeting was "How is the work going?" and the word *travail* (in Picasso's case "trabail"), with its derivatives, is one that occurs most frequently in the Apollinaire-Picasso correspondence.[38]

Alfred Jarry did not frequent the Rue Ravignan, and it seems likely that he and Picasso never met.[39] His presence at the Bateau Lavoir was nevertheless pervasive. Cremnitz was a longstanding friend, who at the age of seventeen had played the role of a *palotin* (foot-soldier) in the 1896 premiere of Jarry's *Ubu Roi*.[40] Apollinaire had been a good friend of Jarry's since

the 1903 soirées organized by *La Plume*, and Maurice Raynal was a fervent Jarry disciple.[41] Just as Jarry himself habitually used the burlesque vocabulary and emphatic intonation he had invented for Ubu, so Salmon, Raynal, Cremnitz, and the others readily adopted the same mechanical diction.[42] Jarry thus became known to Picasso not only by reputation but as a palpable presence in his studio, a legendary being whose most extreme mannerisms were accentuated by caricature.

For a while in 1905 Picasso himself adopted Jarry's Ubuesque behavior with respect to firearms. In a letter of 22 April 1905 Jarry asked Apollinaire to take good care of his snub-nosed "bulldog" pistol, confiscated after Jarry shot at the sculptor Manolo during a recent party at Raynal's home.[43] When Apollinaire recalled that evening in an article for *Les Marges* in November 1909, he added that a friend had kept the gun in his studio for six months, until Jarry "came to Montmartre to ask for the gun that our friend had forgotten to return."[44] The friend in question must have been Picasso (Apollinaire could not have taken the gun to his mother's house, which was still his official address), and Picasso must have been away when Jarry called. This gun was probably the browning that, according to Fernande, the painter carried around and used to fire on the street at night.[45]

In 1905 Jarry's engraving of Ubu, published in both of the 1896 editions of *Ubu Roi* (*Le Livre d'art* and then *Mercure de France*), and his pen-and-ink drawing of "Monsieur Ubu" wearing a bowler hat, served as models for six sketches of the comic dictator that Picasso made on the back of a sheet of Rose period circus drawings.[46] *Ubu Roi* was in circulation at the Bateau Lavoir; apparently Leo Stein passed a copy to Marie Laurencin, hoping she would be shocked.[47] Picasso may have been aware of other aspects of Jarry's quite prolific output as a graphic artist and may also have known of his enthusiasm for *images d'Epinal,* often in-

cluded in *L'Ymagier,* the luxurious art journal Jarry had financed in 1894–1895 with money from a family inheritance.[48] Jarry's drawings of Ubu certainly inspired Picasso's pear-shaped caricatures of Apollinaire.

For the poets, Jarry's exuberant black humor had a vivifying influence. For Picasso too, Jarry's prestigious model encouraged him to reject Blue period sentimentality and would validate his most radical aesthetic endeavors. *Ubu Roi* had upset the conventions of theatrical representation by renouncing both historical accuracy and pretenses of realism, as when one actor portrayed the entire Polish army and another played a prison door swinging open. Jarry demonstrated, quite crucially, that truth was not dependent on artistic realism. His iconoclastic use of puppet-show techniques and other forms of popular performance that had been marginalized by bourgeois culture as well as his Rabelaisian vulgarity, which inverted the accepted hierarchy of higher and lower human faculties, further paved the way for Picasso's own 1907 revolution: "No care for grace; good taste repudiated as too narrow a measure!"[49]

Theater was a literary genre to which Picasso had easy access in Paris. According to Fernande Olivier, he found the theater boring and much preferred gypsy guitars, bullfights, boxing matches, and the circus.[50] Nevertheless, young Picasso often went to the theater. In a letter dated 25 October 1900, Carles Casagemas wrote to Ramon Reventós, "Yesterday we saw a horror drama at the Théâtre Montmartre. There was a lot of death, shots, fires, beheadings, thefts, rapes of maidens, and other evil deeds."[51] In 1903 Max took Picasso more than once to see Puccini's *La Bohème,* and they were thrown out of the Théâtre des Batignolles for eating sausages during the performance.[52] Theater could be fun, provided it was not too earnest or naturalistic.

Maurice Raynal provides a perspicacious assessment of Picasso's tastes as well as a useful piece of further information: "Picasso has al-

3. Coussedière, *Le Théâtre de Montmartre,* 1903, engraving, courtesy Jane Voorhees Zimmerli Art Museum

ways liked the theater and the circus, especially when the former bears some resemblance to the latter. Around 1905 we all used to frequent the unpretentious Théâtre Montmartre on place Dancourt. We would attend entertaining performances of popular dramas, notably by Dumas *père,* which were usually more comic than tragic, given the limited resources of the actors, who were not exactly stars."[53] So Picasso stayed faithful to the Théâtre Montmartre, only five minutes walk from Rue Ravignan.

Opened in 1822, the Théâtre Montmartre was Paris' first "suburban theater," specially built for local inhabitants but on a scale worthy of a provincial town (fig. 3). The colonnades of its classical façade overlooked a charming tree-lined square; inside, the stalls and two balconies could seat 850 spectators. The cheapest seats were in the top balcony, where in Picasso's early days the audience maintained a tradition of boisterous behavior, joining in the action to hurl insults at the villain and applaud the hapless heroine. One commentator later recalled how the walls of that balcony were engraved with graffiti dating back to the 1880s that showed "profiles of saucy young girls, tough-looking men wearing caps with ear-flaps, a disturbing world that has now disappeared. . . . And there were initials, dates, hearts, obscenities, all mixed together, telling tales of crime and love, now covered over with vengeful coats of paint."[54]

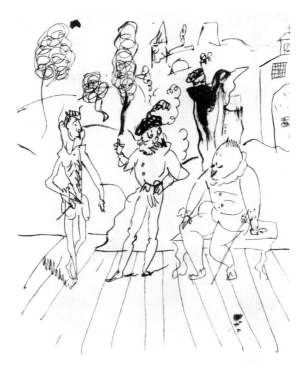

4. Picasso, *Scene from "Henri III et sa cour,"* 1904–1905, india ink on paper, 32 x 25 (12 ⅝ x 9 ⅞), private collection

5. Picasso, *Scene from "Henri III et sa cour,"* 1904–1905, pencil on paper, 25 x 32 (9 ⅞ x 12 ⅝), private collection

The repertoire featured melodramas and plays that had long finished successful runs in town, though the theater had its moments of glory: the first operetta, Hervé's *Don Quichotte et Sancho Pança,* was premièred there in 1847; and in 1907, to mark refurbishment and new management of the theater, Sarah Bernhardt appeared on the Montmartre stage for two nights (8 and 9 September) in *La Dame aux Camélias* by Alexandre Dumas *fils.* Ticket prices, which in 1907 ranged from 50 centimes to 3 francs, were not

increased, and the Théâtre Montmartre retained a reputation for the cheapest seats in Paris.[55]

In 1922 the great actor and director Charles Dullin took over the Théâtre Montmartre, which became known as the Théâtre de l'Atelier, a name it still bears today. When Dullin arrived in Paris in 1904, he first survived by reciting Verlaine and other poets in courtyards, cabarets, and bars, including Le Lapin Agile, living off cheese sandwiches and wine, sleeping wherever he could find a floor for the night. Eyewitnesses later recalled his entertaining visits to Picasso's studio,[56] but Dullin himself never liked to reminisce about a time which for him was marked by humiliating poverty and hardship. He did recount how Théâtre Montmartre melodramas helped him break with naturalist stage techniques, and he recalled the extraordinary suburban-theater atmosphere he encountered in 1904: "You could sense the ghostly presence of the great romantic actors, while the audience was both unsophisticated and passionate; it is not surprising that great painters used to go there to seek what they could not find in naturalism."[57]

The impact of popular theater was diffuse in Picasso's graphic work. His 1905 drawings include several scenes from a doublet-and-hose (in French, *de cape et d'épée*: cape-and-sword, like a bullfight) historical drama. Three others show a malevolent and dwarfish-looking jester, wrapped in his cape, rapier in hand. Another romantic or Shakespearean stage scene dates back to 1904.[58]

Two sketches from this period are of particular interest, for the play they represent can be identified: *Henri III et sa cour* by Alexandre Dumas *père,* a five-act drama first performed in 1829, and the first great popular success of French romantic theater. Set in 1578, the plot revolves around a love affair between one of the king's *mignons,* or "favorites," the comte de Saint-Mégrin, and Catherine, duchesse de Guise. Her wicked husband, the duc de Guise, meanwhile leads a conspiracy against the throne.

Catherine's mislaid handkerchief plays a role similar to Desdemona's in *Othello*. One of Picasso's ink drawings (fig. 4), shows three male dandies on stage, one of them a rotund figure seated on a bench. These characters are undoubtedly the inseparable trio from *Henri III et sa cour*: the baron d'Epernon, comte de Saint-Mégrin, and vicomte de Joyeuse. The latter is a figure of fun because of his laziness and lack of valor; his contributions to the dialogue are invariably delivered from a sitting position. In the background of Picasso's drawing hovers an eavesdropping villain, dressed in black. The other drawing, in charcoal (fig. 5), depicts the same villain wielding a dagger and an accomplice with a rapier, standing over a slim young woman who lies before them at center stage. This represents the play's finale, where the heroine, Catherine de Guise, faints at the feet of her husband, who is followed by his aide de camp, Saint-Paul, while offstage the duke's men murder her faithful page, before setting upon Saint-Mégrin. Just before the curtain falls, the duke will throw the embroidered handkerchief to Saint-Mégrin so that "his death will be sweeter." In his drawing Picasso placed the fatal handkerchief on the boards beside Catherine. He also included the prompter's box, from which emerge the top of the prompter's head and a hand following lines on a script, obtrusive details that reinforce the distance and irony present in the artist's appreciation of the scene. The caricatural style of the drawings also suggests that Picasso was amused by the ham acting and atmosphere.[59] The prompter's hands and script also appear in the painting *The Actor* from the winter of 1904–1905 (fig. 6). The *Henri III* drawings may date from the same time, raising the curtain on the Rose period.

In 1905 the importance of theater in Picasso's work was almost as great as that of strolling tumblers and circus acrobats. A symbiosis of theatrical and literary influences is clearly apparent in the initial project for *The Marriage of*

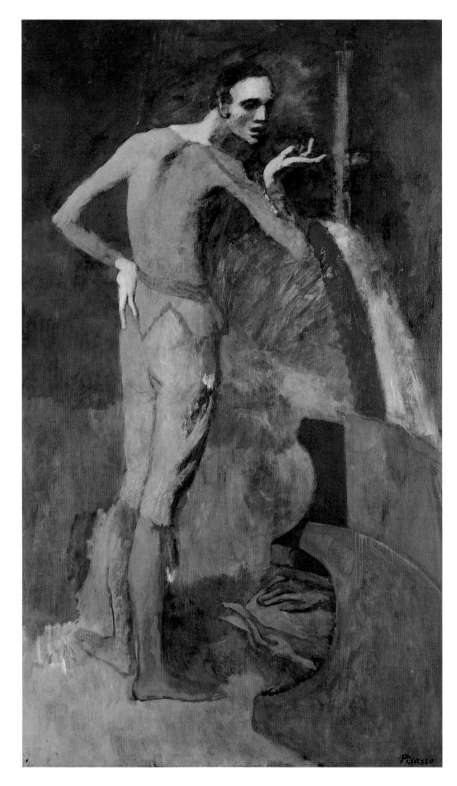

6. Picasso, *The Actor*, Paris, late 1904, oil on canvas, 194 x 112 (76 3/8 x 44 1/8), The Metropolitan Museum of Art, New York, Gift of Thelma Chrysler Foy

Pierrette (fig. 7). Picasso copied the text of Verlaine's "Cortège" from *Fêtes galantes* (1869), a collection of poems setting commedia dell'arte characters in an eighteenth-century decor, into a sketchbook he took with him to Holland in 1905.[60] Brigitte Léal has shown how the poem was a source of inspiration for *The Marriage of Pierrette,* identifying several specific elements from the poem that fed directly into preliminary studies for the painting.[61] Details present in both poem and preliminary drawings include the

lady's lace handkerchief and her black page boy. A handkerchief, the symbol of illicit love, and a page are also present in *Henri III,* a fact Picasso must have noticed, which complicated the web of overlapping sources. The impact of commedia dell'arte is manifest in the drawings and in the painting. But in some of the sketches characters in historical costume also appear, armed with swords, while in another Pierrot (eventually excluded from the painting) is shown drawing a rapier.[62] These details indicate that images from Verlaine's poem and from costume dramas, in particular *Henri III,* merged with commedia dell'arte iconography to shape Picasso's initial conception of *The Marriage of Pierrette.* On canvas the painting developed a new pictorial and narrative logic of its own (fig. 8), while retaining an essential air of theatricality.

Theater clearly made a critical contribution to the burgeoning of the Rose period. The transition from Blue to Rose was marked by a reduction in the overt expression of personal sentiments, or sentimentality, in favor of a more impersonal universe, symbolized by increased

7. Picasso, *Study for "The Marriage of Pierrette,"* Paris, 1905, conté crayon on paper, 25 x 33 (9⅞ x 13), Collection Marina Picasso, courtesy Galerie Jan Krugier, Geneva

8. Picasso, *The Marriage of Pierrette,* Paris, 1905, oil on canvas, 115 x 195 (45¼ x 76¾), private collection

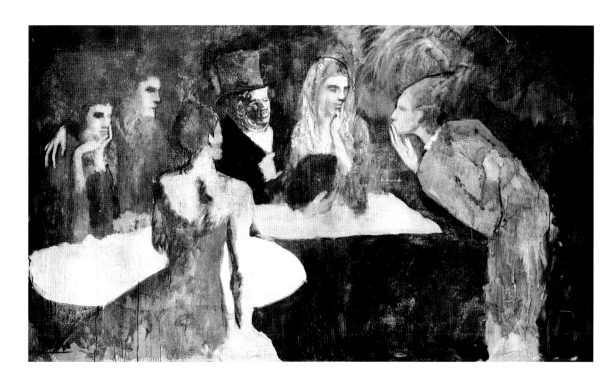

theatricality of gesture and expression, with worn and ragged clothing replaced by delicately chromatic costumes.[63] The Rose period use of the iconography and symbology of literary and theatrical traditions, centered on the idea of performance, increases the distance between painter and subject, making the works less overtly confessional, though they retain an underlying autobiographical element. This increasing degree of impersonality was a step toward the subsequent prioritization of purely formal and compositional considerations.

On 1 November 1905 Apollinaire sent Picasso a plain blue postcard bearing a manuscript poem on each side, one entitled "Spectacle" and the other, "Les Saltimbanques."[64] The poems bring together two different sources of inspiration, combining memories of Rhenish landscapes with references to traditions of magic, popular theater, and performance. Apollinaire thus undoubtedly saluted Picasso's completion of his monumental *Family of Saltimbanques* (cat. 137). He was also expressing his support for an art in which figurative representation was heightened by the truth of the imagination, combining observation and conceptualization. But rather than our seeking a specific influence here, as elsewhere, we should speak of artistic and spiritual complicity. When Picasso does borrow something, be it from Verlaine, Dumas, or Degas, he creatively transforms it into something entirely his own.

Picasso's early experience of French literature established the habits of a lifetime. The library of books and manuscripts he founded in the Bateau Lavoir continued to grow; it still, no doubt, contains unrecorded treasures. He never tired of listening to his favorite works of literature and in the early 1950s would have Geneviève Laporte endlessly recite passages from Molière, La Fontaine, and romantic theater, particularly Victor Hugo's heroic *Ruy Blas*.[65] In 1954 Roland Penrose recorded the events of an evening he had recently spent with Picasso, who was staying at a "newish hotel" in Banyuls, near Collioure. Picasso had a copy of the 1948 edition of Pierre Reverdy's *Le Chant des morts*, in which Picasso's stripes, spots, and circles in red lithographic ink illuminate, like a musical accompaniment, the facsimile manuscript of the forty-three wartime poems. Penrose noted, "We went through it on the floor page by page reading most of the poems. 'Ça, quand même vous rend plus heureux et vous fait plus de bien que de lire les journaux' said P[icasso] and went on to praise the powers of poetry."[66]

Notes

1. Palau 1985, 281.

2. Sabartès 1946, 81.

3. Max Jacob, "Souvenirs sur Picasso contés par Max Jacob," *Cahiers d'art* 2, no. 6 (1927), 200, adds that their tears may have been born of factors more material than the poetry.

4. The two drawings are M.P. 458 (Z.XXI.360) and MPB 110.520.

5. Picasso, *Ecrits* (Paris, 1989), 372–373: "I am thinking of you of the rice / the other evening of your logical lines / Moses and Stendhal."

6. Olivier 1988, 231.

7. "Quel est votre poète?" *L'Ermitage* 13, 2 (February 1902); 125 replies were received.

8. Olivier 1988, 192.

9. Henri Mahaut, *Picasso* (Paris, 1930), 10.

10. Ronald Johnson, "Picasso's *Old Guitarist* and the Symbolist Sensibility," *Artforum* 4 (December 1974), 56–62.

11. Guillaume Apollinaire, *Oeuvres en prose complètes*, vol. 2 (Paris, 1991), 78.

12. Mahaut 1930, 6. See also André Level, *Picasso* (Paris, 1928), 14. Picasso's 1900 portrait of Sabartès as a "Poeta Decadente" (cat. 30), wearing a black cloak, crowned with lilies, standing in a lakeside cemetery, and wanly gazing at a purple iris, implies both an informed and a healthy satirical assessment of the solipsistic and deliquescent values of that other fin-de-siècle avant-garde, the decadent movement, whose greatest literary practitioner in France was Jules Laforgue.

13. For a discussion of the date and circumstances of this meeting see Hélène Seckel, *Max Jacob et Picasso* [exh. cat., Musée Picasso] (Paris, 1994), 35–37; Peter Read, *Picasso et Apollinaire. Les Métamorphoses de la mémoire 1905/1973* (Paris, 1995), 17–22.

14. Christian Zervos, *Pablo Picasso,* vol. I (Paris, 1932), Preface, XXXVI.

15. Maurice Raynal, *Peinture moderne* (Geneva, 1953), 106. In a letter dated 1 June 1905 (postmark), Raynal informed Picasso that he had just become a proud father. Raynal and spouse sent their "Meilleures amitiés" to Picasso on a postcard from Honfleur in Normandy, dated 4 August 1905 (postmark). Cremnitz also signed the card, sending his best wishes to Picasso "ainsi qu'à Jacob et Apollinaire" (Archives Picasso).

16. Salmon 1961, 182.

17. Apollinaire, "Poème lu au mariage d'André Salmon," *Alcools.*

18. Salmon 1955, 75–76. In an earlier version of the same story it was a copy of *Jeunes Fleurs* by Fagus that Salmon noticed on the table, with a paper knife between its pages; see André Salmon, *L'Air de la butte* (Paris, 1945), 21–22. Both of Fagus' books had very small print runs: for instance, only two hundred copies of *Jeunes Fleurs,* marked "Hors commerce" (not for sale), were printed by the *Revue littéraire de Paris et de Champagne* in January 1906. Picasso may then have obtained or been given a copy of that collection of tender and rather effeminate poetry.

19. Daix and Boudaille 1967, 152, 165, 333–334.

20. McCully 1981, 51.

21. Daniel-Henry Kahnweiler, *Mes Galeries et mes peintres. Entretiens avec Francis Crémieux* (Paris, 1961), 65. Apollinaire would refer to Picasso's continuing interest in Blaise Pascal in a letter of September 1918; see Pierre Caizergues and Hélène Seckel, eds., *Picasso/Apollinaire Correspondance* (Paris, 1992), 181.

22. Salmon 1955, 339.

23. Sabartès 1946, 97. Brassaï, *Conversations avec Picasso* (Paris, 1964), 157, maintains that the painter read a lot, but only last thing, late at night.

24. See Michel Décaudin, "Apollinaire et ses amis devant Rimbaud," in Henryk Chudak, ed., *Situation de Rimbaud en 1991* (Warsaw, 1995), 11–20.

25. Olivier 1933, 9; Olivier 1988, 194.

26. Exh. cat. Barcelona 1992, 214, 215.

27. Maurice Raynal, *Picasso* (Paris, 1922), 52–53. Was Picasso allowed to keep *L'Anti-Justine*? It does not figure among other books by Restif in Apollinaire's library. See Gilbert Boudar, Michel Décaudin, *La Bibliothèque de Guillaume Apollinaire* 1 (Paris, 1983).

28. A portrait of Zola, vigorously drawn in green pencil, with the writer's name blazoned in solid capitals across the page, dates from 1900, at the height of the Dreyfus Affair in which Zola made a heroic stand for justice (Palau 1985, 178). In July 1952 Picasso expressed his admiration for the teeming vitality of Zola's novel *Au Bonheur des dames,* which he was then rereading; see Daniel-Henry Kahnweiler, "Huit Entretiens avec Picasso," *Le Point Revue artistique et littéraire* 42 (October 1952), 22–30. Other indications of Picasso's interest in nineteenth-century fiction include his 1905 drawing of a naked couple embracing in a Spanish translation of Flaubert's *Madame Bovary* (Z.XXII.182), an image appropriate to a novel that was prosecuted for obscenity at the time of its publication (1856).

29. Georges Le Cardonnel and Charles Vellay, *La Littérature contemporaine (1905). Opinions des écrivains de ce temps* (Paris, 1905), 38. For a more detailed view of the cultural swing toward classicism see Marilyn

McCully, "Mediterranean Classicism and Sculpture in the Early Twentieth Century," *Catalan Review* 5, no. 1 (July 1991), 145–167.

30. Salmon 1945, 16: "And in bed, at night, I am like a violin in its case."

31. André Salmon, "Testimony against Gertrude Stein," *Transition* 23, pamphlet no. 1 (The Hague, February 1935), quoted in McCully 1981, 63.

32. Olivier 1933, 69–70.

33. Salmon 1956, 261, 199.

34. Raynal, *Peinture moderne,* 1953, 90: "Knowing their art was enough; furthermore, everybody was quite sure of how little the new painting would interest these great masters."

35. André Salmon, "La Jeunesse de Picasso," *Les Nouvelles littéraires* (11 July 1931), 8.

36. Though Raynal 1922, 37, refers to young Picasso's "quite sharp wit," there are numerous accounts of his relative silence on social occasions (for example, Mahaut 1930, 7; Sabartès 1946, 97).

37. Olivier 1988, 193; Salmon 1945, 23–24.

38. Olivier 1933, 12; Caizergues and Seckel 1992.

39. Hélène Parmelin, *Picasso sur la place* (Paris, 1959), 242, says that Picasso regretted not having got to know Jarry. Fernande encountered Jarry at the Closerie des Lilas (Olivier 1933, 47, 95), shortly before Jarry died on 1 November 1907, probably at the time of her temporary separation from Picasso.

40. Salmon 1955, 148, 286.

41. Salmon 1955, 191, 192.

42. See André Billy, *La Terrasse du Luxembourg* (Paris, 1945), 194.

43. Alfred Jarry, *Oeuvres complètes,* vol. 3 (Paris, 1988), 590. Eight surviving letters from Jarry to Apollinaire, covering the period 1903–1906, are mostly apologies for missed appointments.

44. Apollinaire 1991, 1041.

45. Olivier 1933, 38. See also Olivier 1988, 167, 187; and Salmon 1955, 186. Picasso also had a postcard from Alfred Jarry, bearing on one side a photograph of the Porte Bencheresse in Laval and on the other the message "Tout va bien amitiés Jarry." The card is postmarked "Laval 8-5-07." It is addressed, however, to "Monsieur Victor Gastilleur / 17 Rue du Val-de-Grâce, Paris." Picasso must have obtained this card from Gastilleur, probably in 1907, when they were friendly. Picasso received two cards from Gastilleur, both addressed to the Rue Ravignan. One, undated and unstamped, wishes him "Buenas Tardes"; the other, postmarked "Carcas-

sonne 11–6-07," sends best wishes "à todos los amigos" and "grande affeción" and an invitation for Picasso to come to Carcassonne (Archives Picasso). For a portrait of Gastilleur, the Provençal raconteur and lover of poetry, see Salmon 1955, 208–209. In July 1906 Max included news of Jarry, convalescing in Laval, in a letter to Picasso and Fernande (exh. cat. Paris 1994, 49).

46. See M.P. 508v.

47. Olivier 1933, 104–105. This was probably in 1907, when Marie was a newcomer to the Bateau-Lavoir. Picasso owned a copy of the 1900 edition of *Ubu Roi* and its sequel *Ubu enchaîné* (Editions de La Revue blanche), but the date of acquisition is unknown (my thanks to Marilyn McCully for this information). Picasso also owned the manuscript of *Ubu Cocu* (Archives Picasso) as well as the leather-bound manuscripts of *Ubu Roi* and *Ubu enchaîné* and the manuscript of Jarry's *Les Silènes,* acquired in 1936; see Henri Matarasso, "L'Ami des poètes," *XXᵉ siècle,* special issue "Hommage à Pablo Picasso" (1971), 27.

48. Keith Beaumont, *Alfred Jarry: A Critical and Autobiographical Study* (Leicester, 1984), 47–49.

49. André Salmon, *La Jeune Peinture française* (Paris, 1912), 47 (on *Les Demoiselles d'Avignon*).

50. Olivier 1933, 152.

51. McCully 1981, 28. For Picasso's visits to the theater in Barcelona see Palau 1985, 334, 399.

52. Sometimes Picasso obtained free theater tickets from the actor Harry Baur; see Geneviève Laporte, *Sunshine at Midnight* (London, 1975), 5–6, also 22. He had other actor friends, including Charles Dullin, Modot, and Roger Karl.

53. Maurice Raynal, *Picasso* (Geneva, 1953), 67.

54. Marcel Espiau, "Le Théâtre de Montmartre," *L'Ami du peuple,* 13 May 1928.

55. Maurice Artus, *Le Théâtre Montmartre* (Tours, 1904); André Warnod, "Le Centenaire du Théâtre Montmartre," *Avenir,* 23 September 1922; publicity leaflet for *La Dame aux Camélias,* 8 and 9 September 1907. Press cuttings and other documents on the Théâtre Montmartre and Charles Dullin are from the Rondel Collection, Bibliothèque de l'Arsenal, Paris.

56. Olivier 1988, 200; Raynal, *Picasso,* 1953, 29.

57. Charles Dullin, *Souvenirs et notes de travail d'un acteur* (Paris, 1985), 35. See also André Arnyvelde, "Charles Dullin," *Miroir du monde,* 29 June 1932; Gabriel Reuillard, "Charles Dullin au Lapin Agile, sur la Butte sacrée," *Excelsior,* 19 February 1933. The teenage Dullin used to recite poetry in cafés in Lyons, according to his friend Henri Béraud, and he already knew Claudel's *Tête d'or* by heart; see Pierre Scize,

"Charles Dullin raconté par Henri Béraud," *Bonsoir,* 30 November 1922. This may explain how Claudel's *L'Arbre,* an anthology that includes *Tête d'or,* found its way into Picasso's studio in 1905.

58. These drawings are Z.VI.593, 665; Z.VI.667, 669, 670; and Z.VI.594.

59. In the inventory undertaken for the Picasso Estate after 1974, these drawings are both labeled "Scène de théâtre (Drame Henri III)." They both measure 25 x 32 cm, and the verso of each drawing is blank. My thanks to Brigitte Baer for this information.

60. The sketchbook is in the Musée Picasso, Paris (M.P. 1855).

61. Brigitte Léal, *Musée Picasso Carnets. Catalogue des dessins,* vol. 1 (Paris, 1996), 77. Richardson 1991, 340, suggests that lines from Verlaine's poem "Crimen Amoris" may have inspired *Boy with a Pipe* (cat. 138), the 1905 painting of a young artisan crowned with roses. According to Salmon, however, the crown of roses was inspired by the picture on a First Communion card given to Picasso by a child on place Ravignan (Salmon 1931, 8). For a fundamental study of links between 1905 paintings and literary and theatrical traditions see Reff 1971, 30–43.

62. See M.P. 1855 and Z.VI.925.

63. See M. Teresa Ocaña, "From the Blue to the Rose Periods," in exh. cat. Barcelona 1992, 15–28.

64. Caizergues and Seckel 1992, 35–36.

65. Laporte 1975, 21, 58.

66. "That makes you happier and does you more good than reading the newspapers." Picasso also stated that he liked *Le Chant des morts* "better than any other of his illustrated books. . . . He had meant the decorations as an accompaniment, like a musical theme." Picasso gave the book to the couple who owned the hotel. Saturday, 18 September 1954, in Roland Penrose, "Visits to Picasso," unpublished notes and notebooks (Roland Penrose Collection, Scottish National Gallery of Modern Art Archive, Edinburgh).

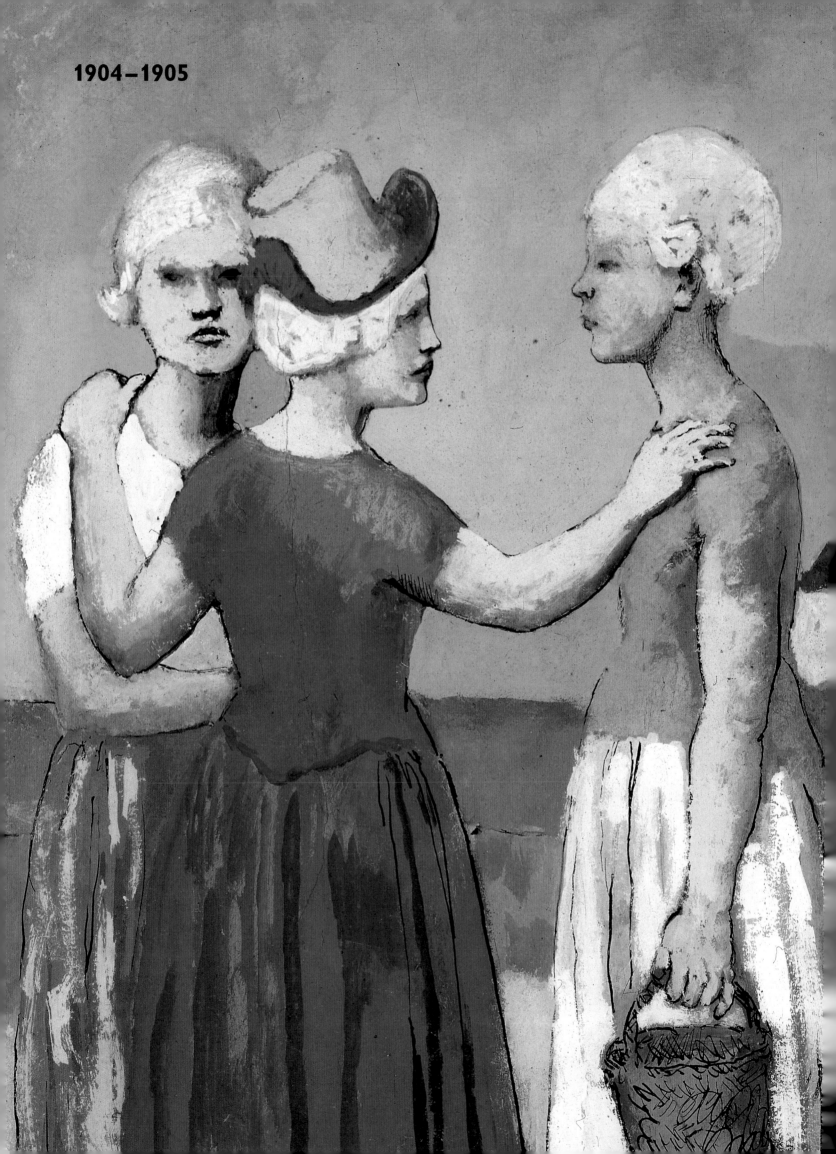

1904–1905

Detail, cat. 134

101. *Picasso and Sebastià
Junyer Vidal*, Paris, April
1904, ink and colored
pencil on paper, five
sketches, each: 22 x 16
(8 ⅝ x 6 ¼), Museu
Picasso, Barcelona

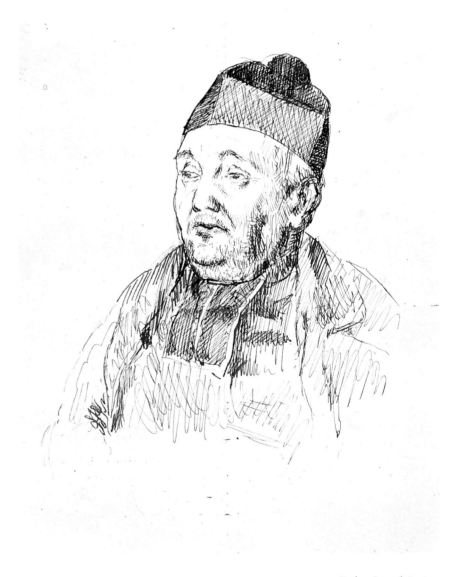

102. *Father Santol*, Paris, April 1904, pen and ink on paper, 27.5 x 21.3 (10⅞ x 8⅜), private collection

103. *The Couple*, Paris, summer 1904, oil on canvas, 100 x 81 (39⅜ x 31⅞), private collection, Switzerland

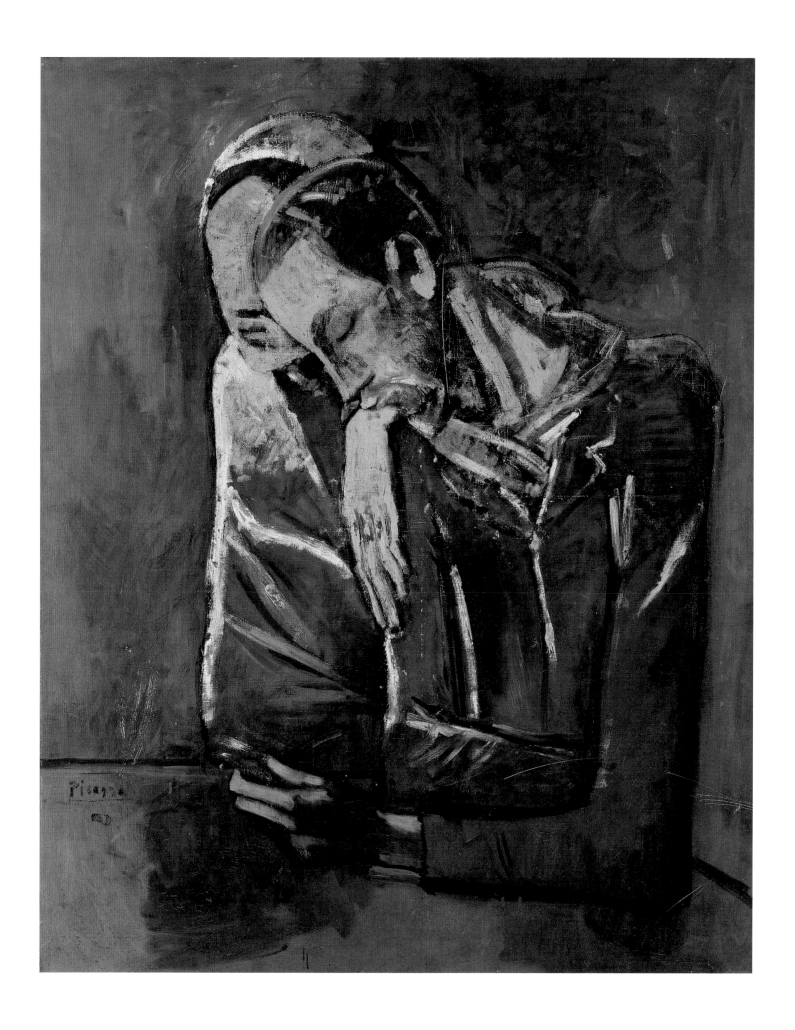

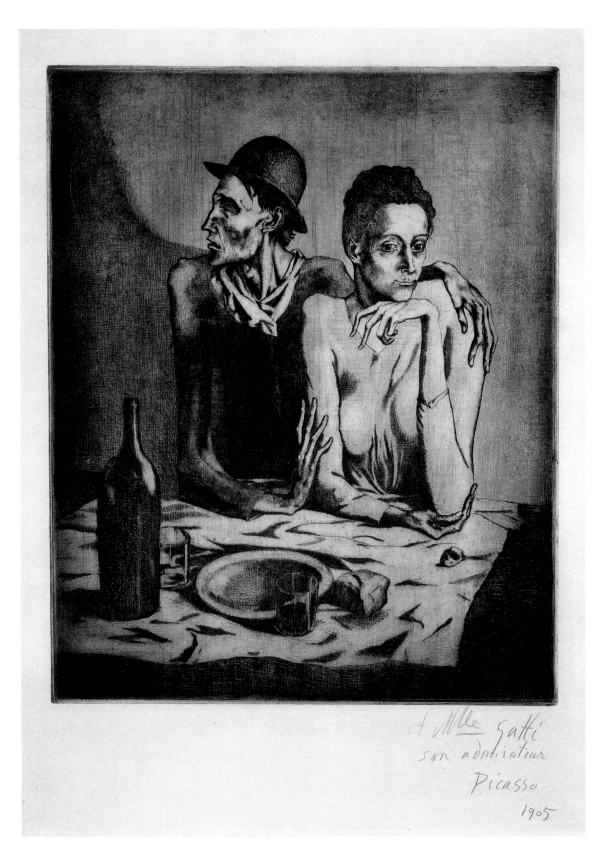

et Mlle Gatti
son admirateur
Picasso
1905

104. *Frugal Repast*, Paris,
summer 1904, etching,
46.3 x 37.7 (18¼ x 14⅞),
Museum of Fine Arts,
Boston, Ellen Frances
Mason Fund

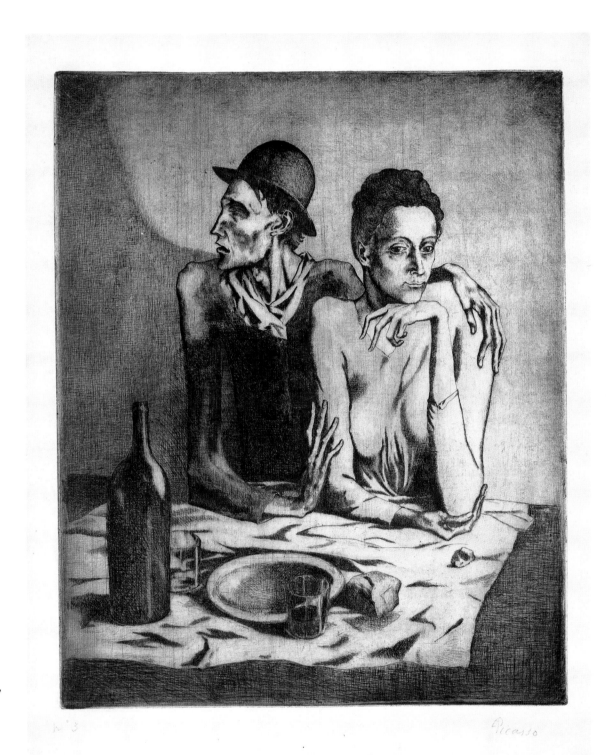

105. *Frugal Repast*, Paris,
summer 1904, etching
(blue-green ink impres-
sion, 1 of 2), 46.3 x 37.7
(18 ¼ x 14 ⅞), private
collection, USA
Washington only

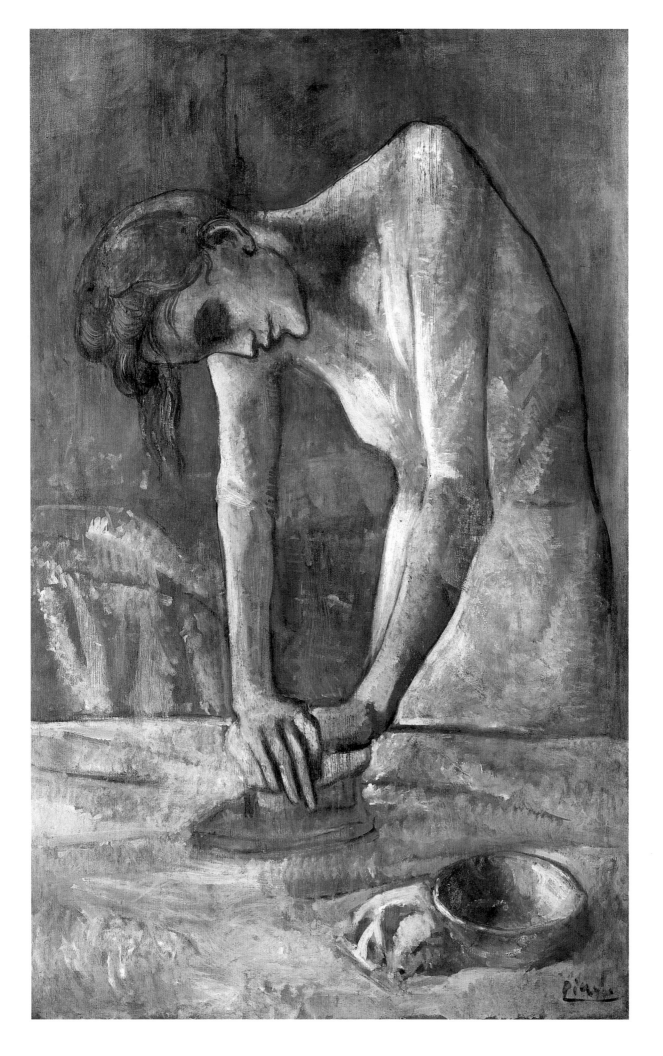

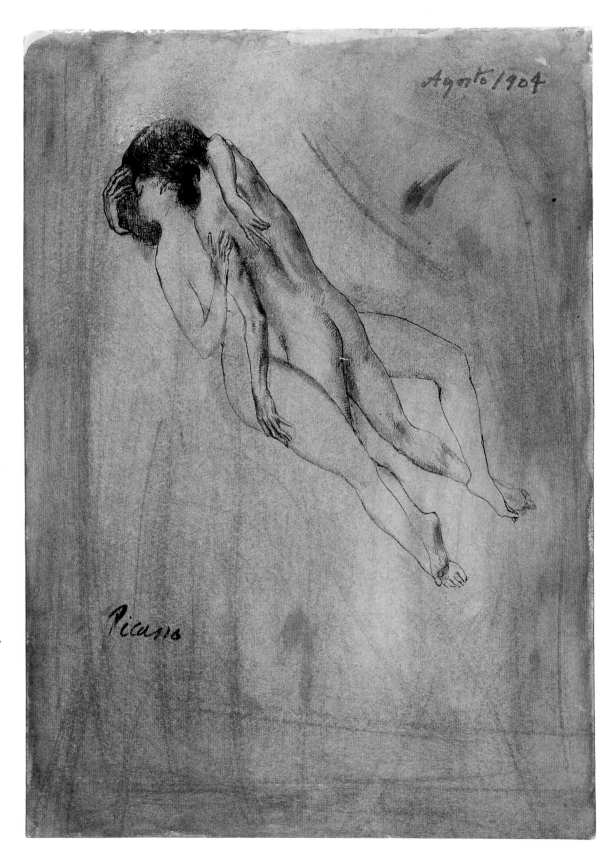

106. *Woman Ironing,*
Paris, 1904, oil on canvas,
116.2 x 72.7 (45 ¾ x
28 ⅝), Solomon R.
Guggenheim Museum,
New York, Thannhauser
Collection, Bequest of
Hilde Thannhauser, 1991

107. *The Lovers,* Paris,
August 1904, ink, water-
color, and charcoal on
paper, 37.2 x 26.9
(14 ⅝ x 10 ⅝), Musée
Picasso, Paris
Washington only

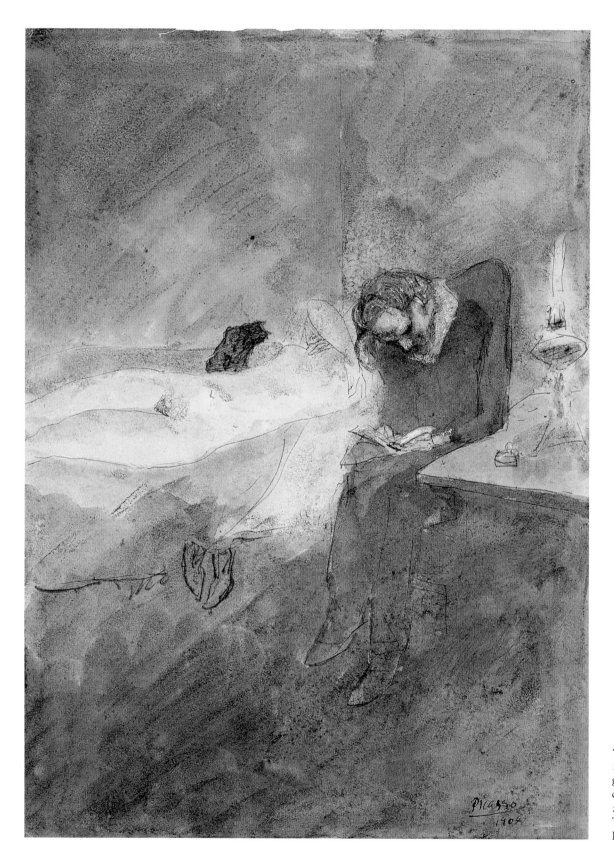

108. *The Poet*, Paris, 1904, pen and ink, gray wash, and water-color on paper, 37.3 x 26.8 (14 5/8 x 10 1/2), The Evergreen House Foundation, Baltimore

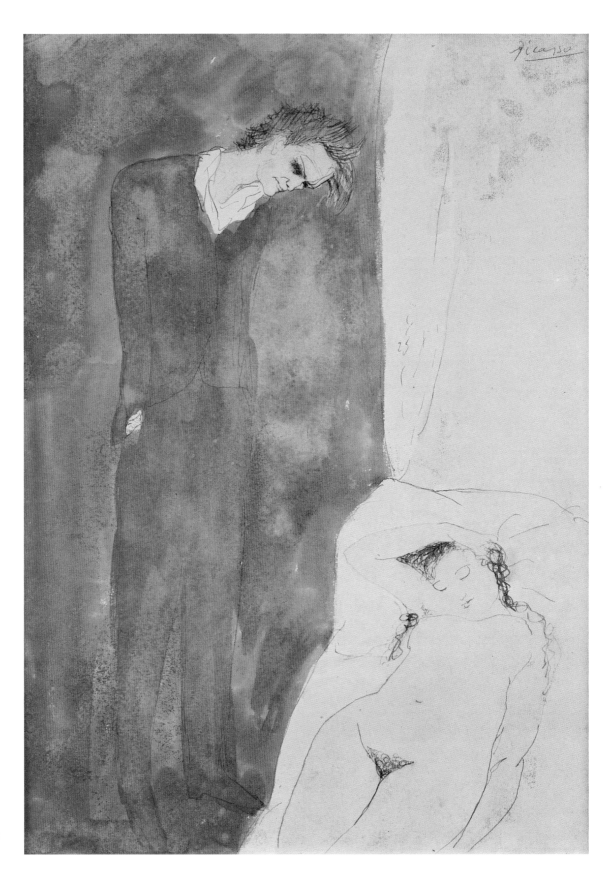

109. *Debienne Watching Fernande Asleep*, Paris, 1904, watercolor and ink on paper, 36 x 27 (14 ⅛ x 10 ⅝), private collection

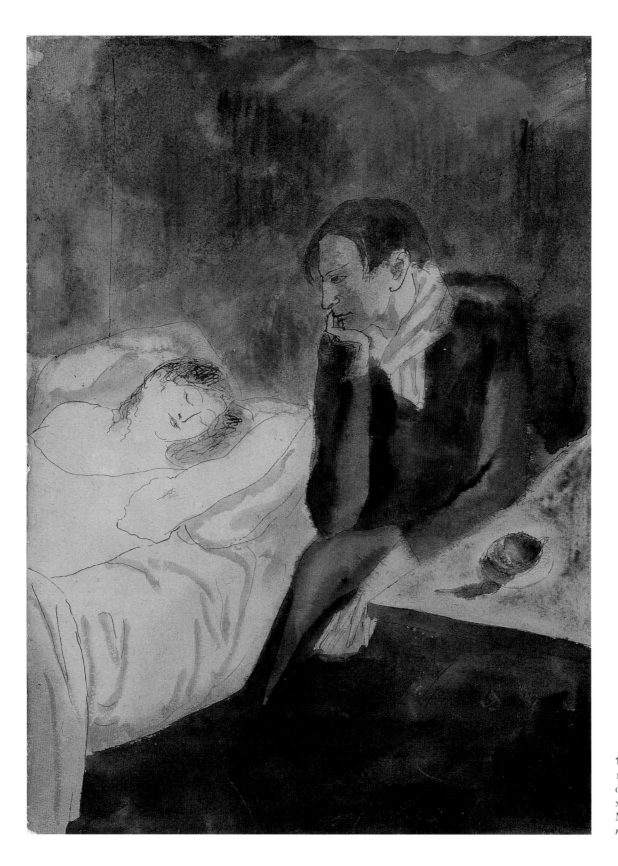

110. *Meditation*, Paris, 1904, watercolor and ink on paper, 36.8 x 27 (14 ½ x 10 ⅝), The Museum of Modern Art, New York
not in exhibition

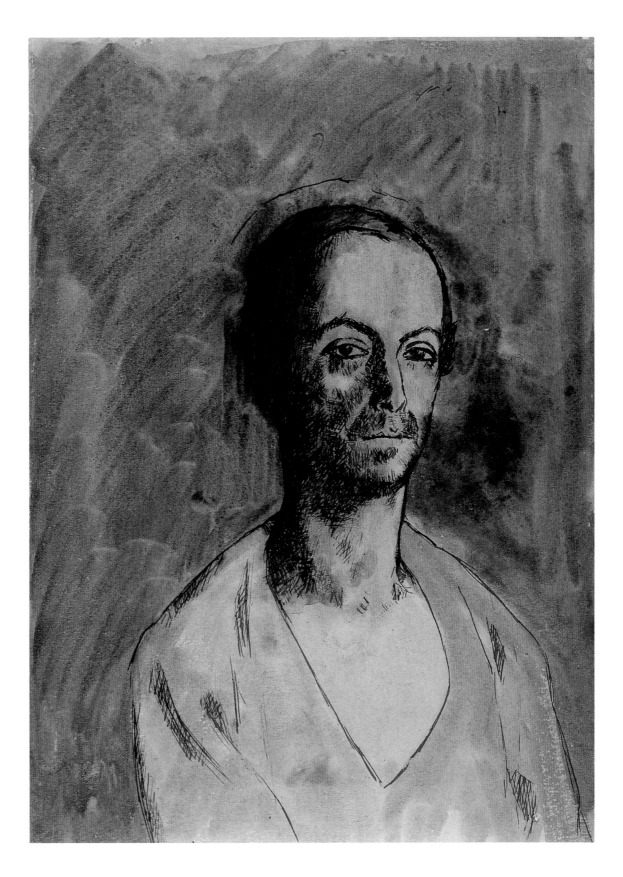

111. *Portrait of Manolo,*
Paris, 1904, ink and
watercolor on paper,
37 x 26.5 (14 ½ x 10 ⅜),
Musée Picasso, Paris
Boston only

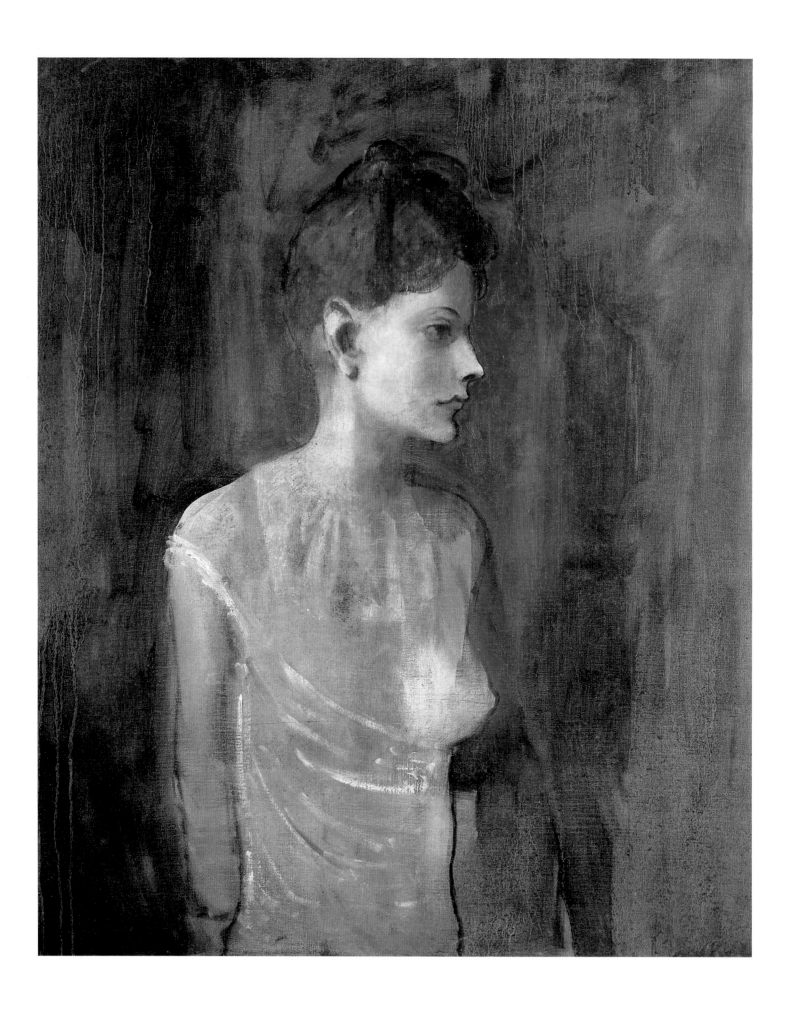

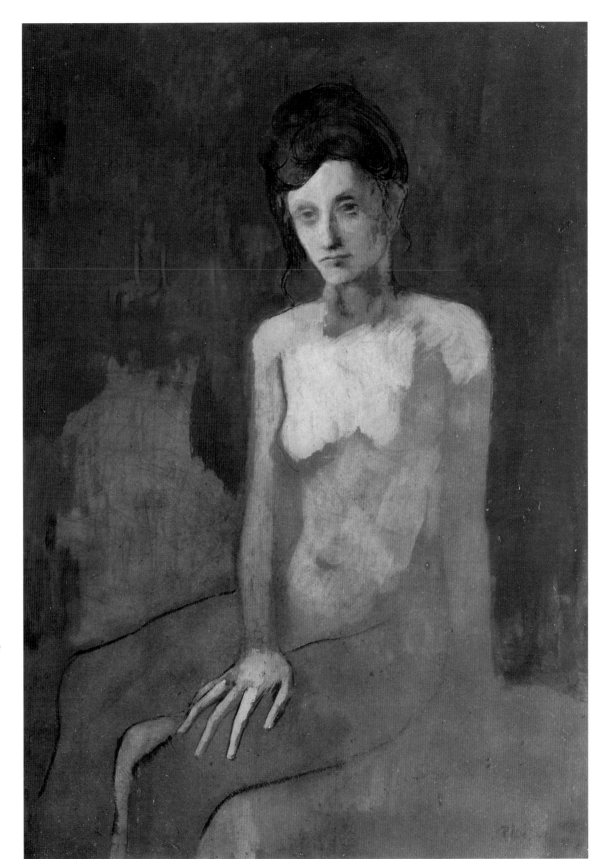

112. *Woman in a Chemise (Madeleine)*, Paris, winter 1904–1905, oil on canvas, 72.5 x 60 (28 ½ x 23 ⅝), Tate Gallery, London, Bequeathed by C. Frank Stoop, 1933

113. *Seated Nude (Madeleine)*, Paris, winter 1904–1905, oil on cardboard, 100 x 76 (39 ⅜ x 29 ⅞), Musée national d'art moderne, Centre Georges Pompidou, Paris, 1954

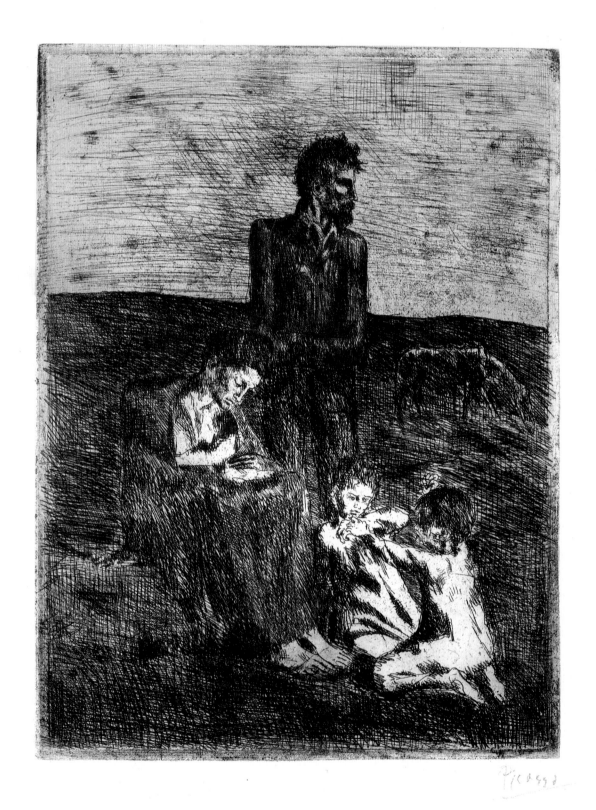

114. *Les Pauvres*, Paris, winter 1904–1905, etching, 23.6 x 18 (9¼ x 7⅛), private collection

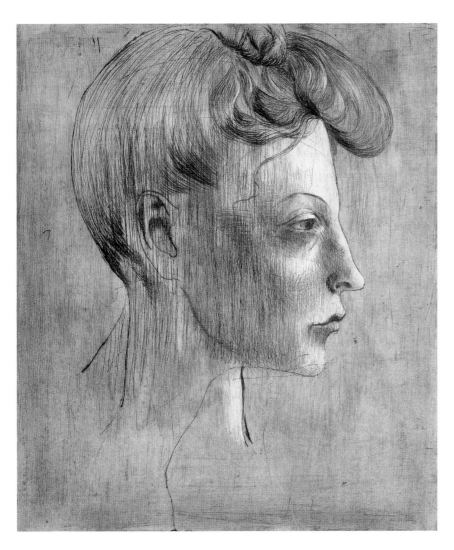

115. *Head of a Woman in Profile (Alice Géry, later Derain)*, Paris, probably February 1905, drypoint, 29.2 x 25 (11 ½ x 9 ⅞), Museum of Fine Arts, Boston, Bequest of Lydia Tunnard, Gift of Carolyn Rowland, Lee M. Friedman Fund

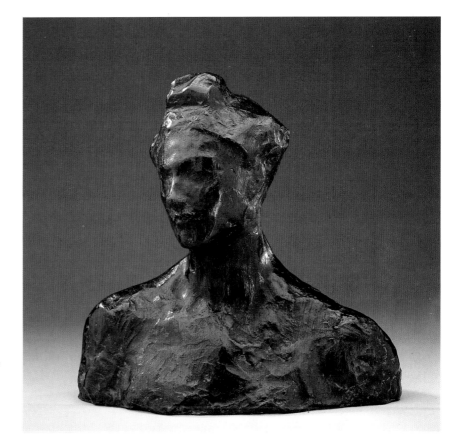

116. *Bust of a Woman (Alice Géry, later Derain)*, Paris, 1905, bronze, 28 x 27 x 14 (11 x 10 ⅝ x 5 ½), Selma W. Black Collection
Boston only

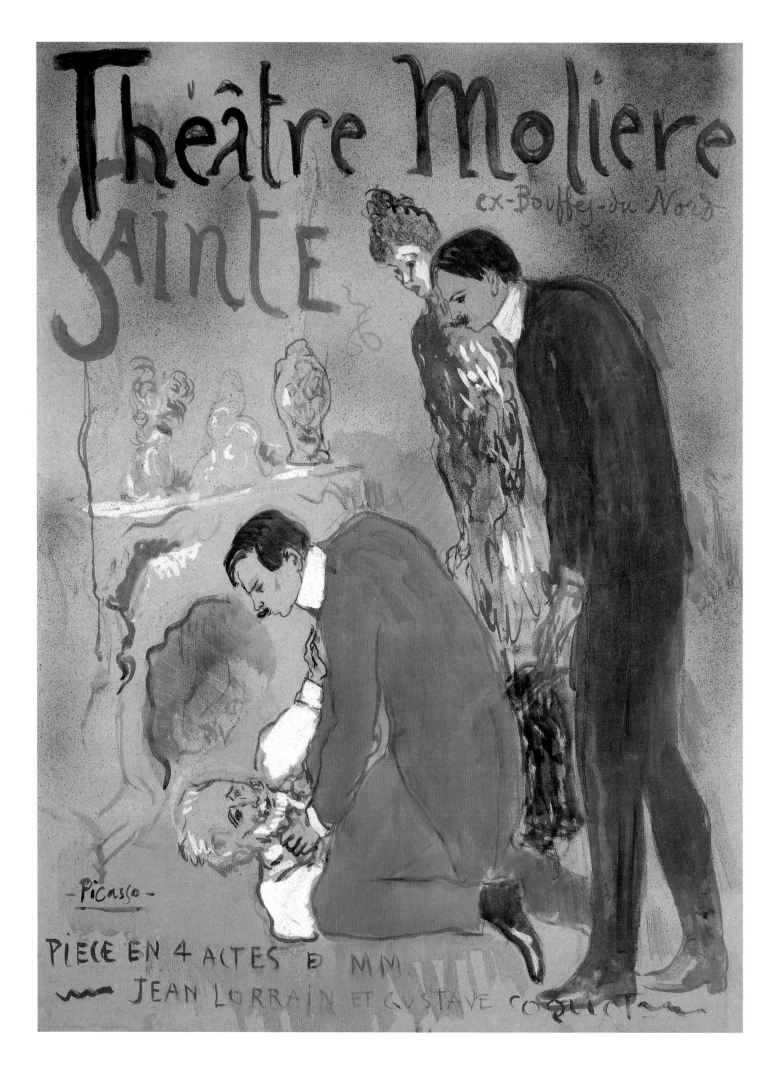

117. *Sainte-Roulette*,
Paris, September/October
1904, gouache on card-
board, 120.5 x 87 (47 ⅜ x
34 ¼), private collection

118. *Apollinaire as an
Academician*, Paris, 1905,
pen and ink and wash on
paper, 22 x 12 (8 ⅝ x
4 ¾), Musée Picasso, Paris
Washington only

119. *Sheet of Caricatures*,
Paris, 1905, pencil and
ink on paper, 25.5 x 32.7
(10 x 12 ⅞), Musée Pi-
casso, Paris
Washington only

120. *The Saltimbanque*, Paris, early 1905, gouache and ink on cardboard, 62 x 47 (24⅜ x 18½), private collection, courtesy Galerie Beyeler, Basel

121. *Circus Family,* Paris,
early 1905, watercolor,
pen, and india ink on
cardboard, 24.1 x 30.5
(9 ½ x 12), The Baltimore
Museum of Art, The
Cone Collection, formed
by Dr. Claribel Cone
and Miss Etta Cone of
Baltimore

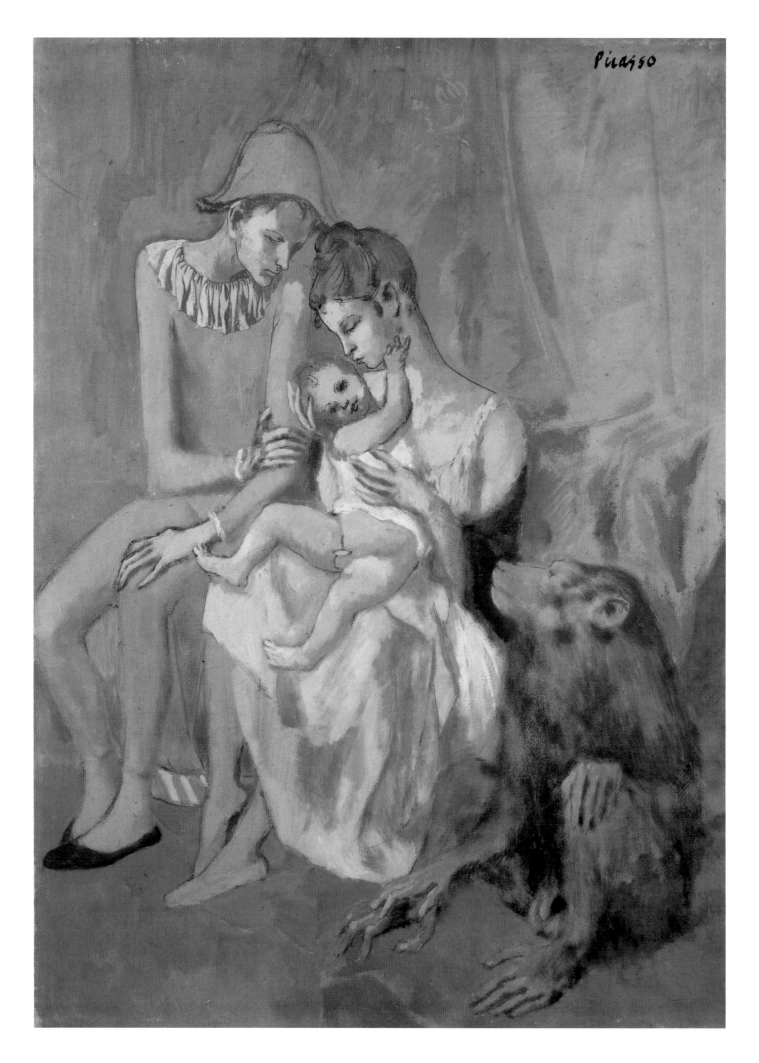

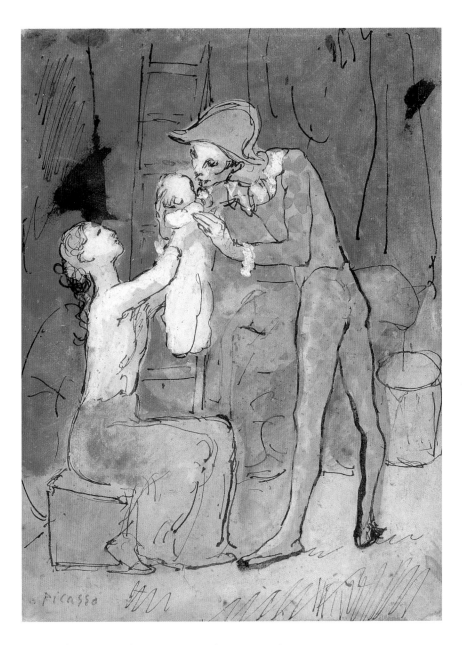

122. *Harlequin's Family with an Ape,* Paris, 1905, gouache, watercolor, pastel, and india ink on cardboard, 104 x 75 (41 x 29 ½), Göteborg Museum of Art

123. *Harlequin's Family,* Paris, 1905, gouache and ink on cardboard, 28.9 x 21.6 (11 ⅜ x 8 ½), The Joan Whitney Payson Collection at the Portland Museum of Art, Maine, lent by John Whitney and Joanne D'Elia Payson *Boston only*

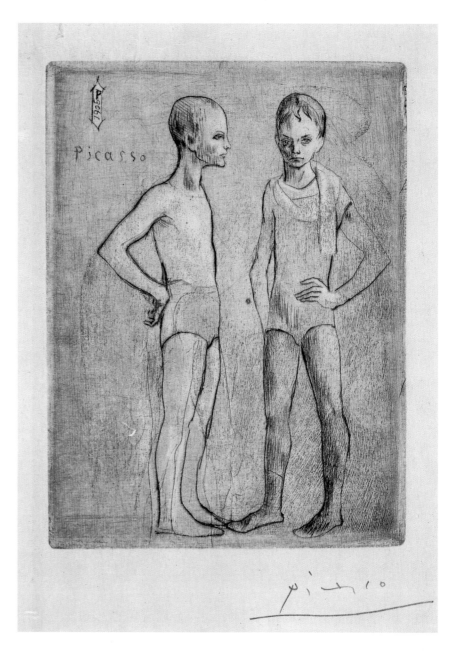

124. *Two Saltimbanques,*
Paris, 1905, drypoint,
12.1 x 9.1 (4¾ x 3½),
Museum of Fine Arts,
Boston, Gift of Mrs.
George R. Rowland Sr.
in honor of Miss Eleanor
Sayre

125. *Young Acrobat on
a Ball,* Paris, 1905, oil on
canvas, 147 x 95 (57⅞
x 37⅜), Pushkin State
Museum of Fine Arts,
Moscow
not in exhibition

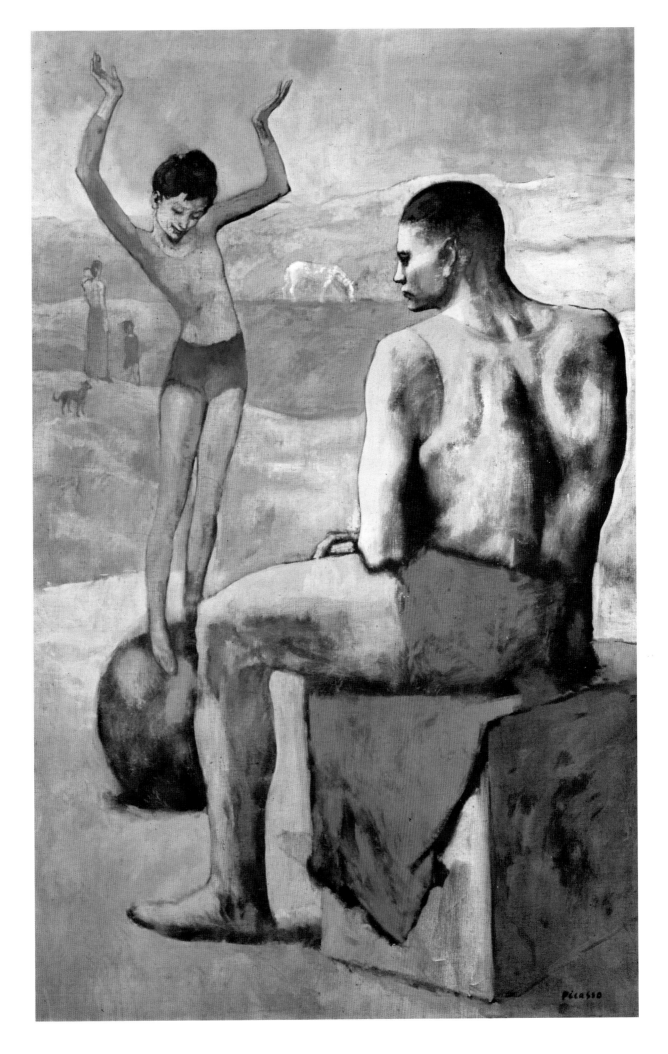

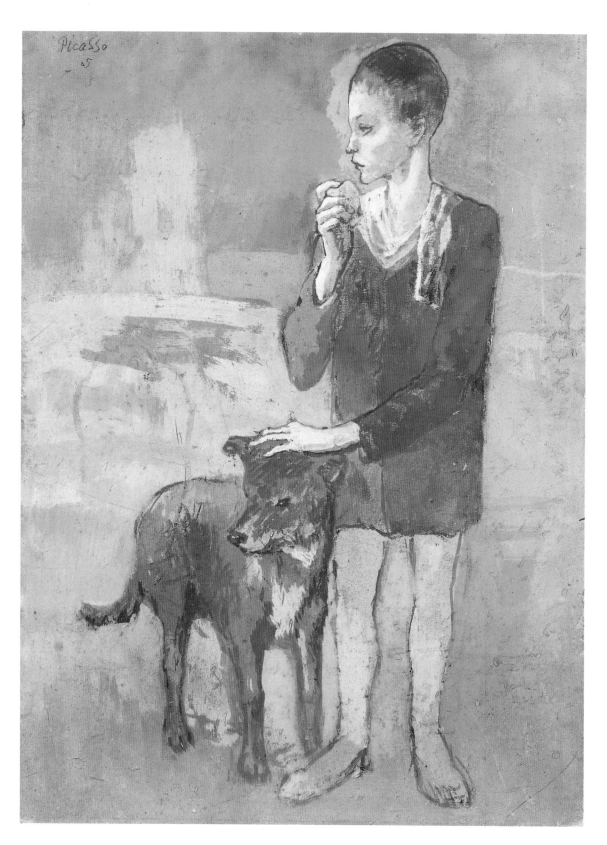

126. *Boy with a Dog*,
Paris, 1905, gouache and
ink on cardboard, 57 x 41
(22 ⅜ x 16 ⅛), The State
Hermitage Museum, St.
Petersburg

127. *Hurdy-Gurdy Man
and Young Harlequin*,
Paris, 1905, gouache on
cardboard, 100.5 x 70.5
(40 x 27 ¾), Kunsthaus
Zurich

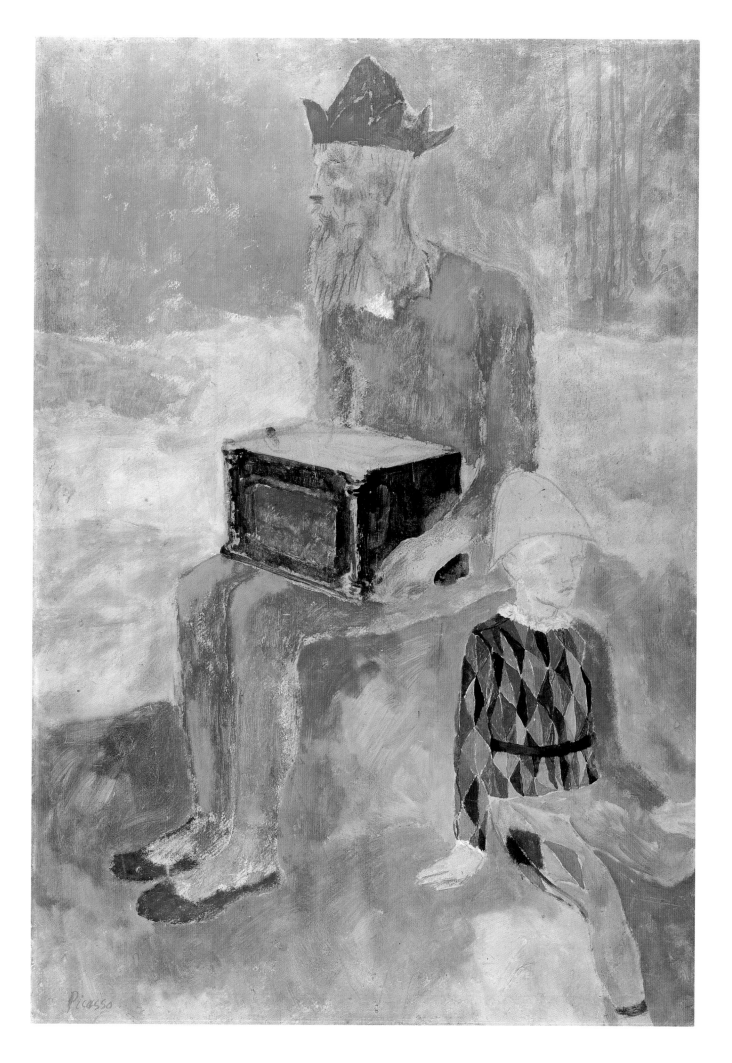

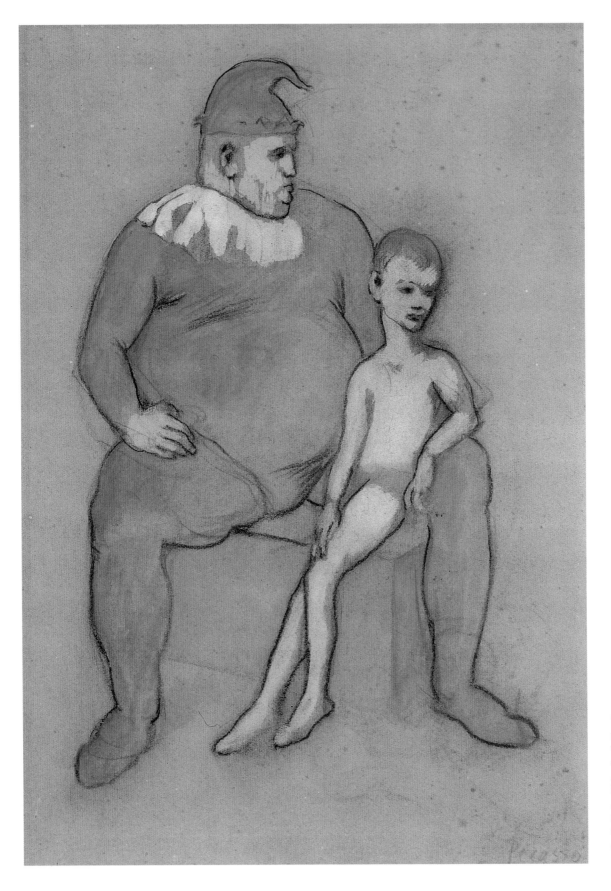

128. *Seated Saltimbanque with Boy*, Paris, 1905, watercolor, pastel, and charcoal on paper, 59 x 47.3 (23 ¼ x 18 ⅝), The Baltimore Museum of Art, The Cone Collection, formed by Dr. Claribel Cone and Miss Etta Cone of Baltimore
Washington only

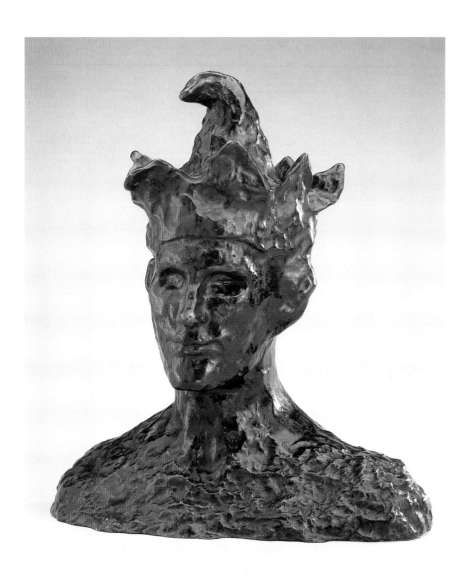

129. *Head of a Jester,*
Paris, spring 1905,
bronze, 40 x 35.9 x 21
(15 ¾ x 14 ⅛ x 8 ¼),
Philadelphia Museum
of Art, Bequest of Lisa
Norris Elkins

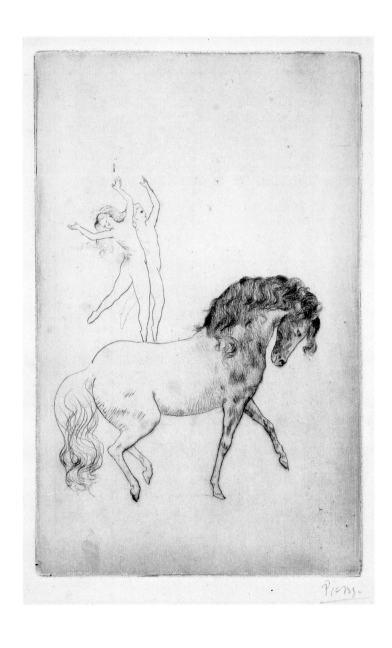

130. *At the Circus,* Paris, 1905, drypoint, 22 x 14 (8⅝ x 5½), Museum of Fine Arts, Boston, Bequest of W. G. Russell Allen

131. *The Jester,* Paris, 1905, ink on paper, 25.2 x 32.9 (9⅞ x 12⅞), National Gallery of Art, Washington, Ailsa Mellon Bruce Fund

132. *Salomé*, Paris, 1905, drypoint, 40 x 38 (15 ¾ x 15), Dr. and Mrs. Martin L. Gecht, Chicago

133. *La Danse barbare*, Paris, 1905, drypoint, 40 x 34.8 (15 ¾ x 13 ¾), Dr. and Mrs. Martin L. Gecht, Chicago

134. *Three Dutch Girls,*
Schoorldam, June–July
1905, oil on cardboard,
77 x 67 (30 ¼ x 26 ⅜),
Musée national d'art
moderne, Centre Georges
Pompidou, Paris, Gift of
Mr. and Mrs. André
Lefevre, 1952

135. *Portrait of Benedetta
Canals,* Paris, late sum-
mer 1905, oil on canvas,
88 x 68 (34 ⅝ x 26 ¾),
Museu Picasso, Barcelona
Washington only

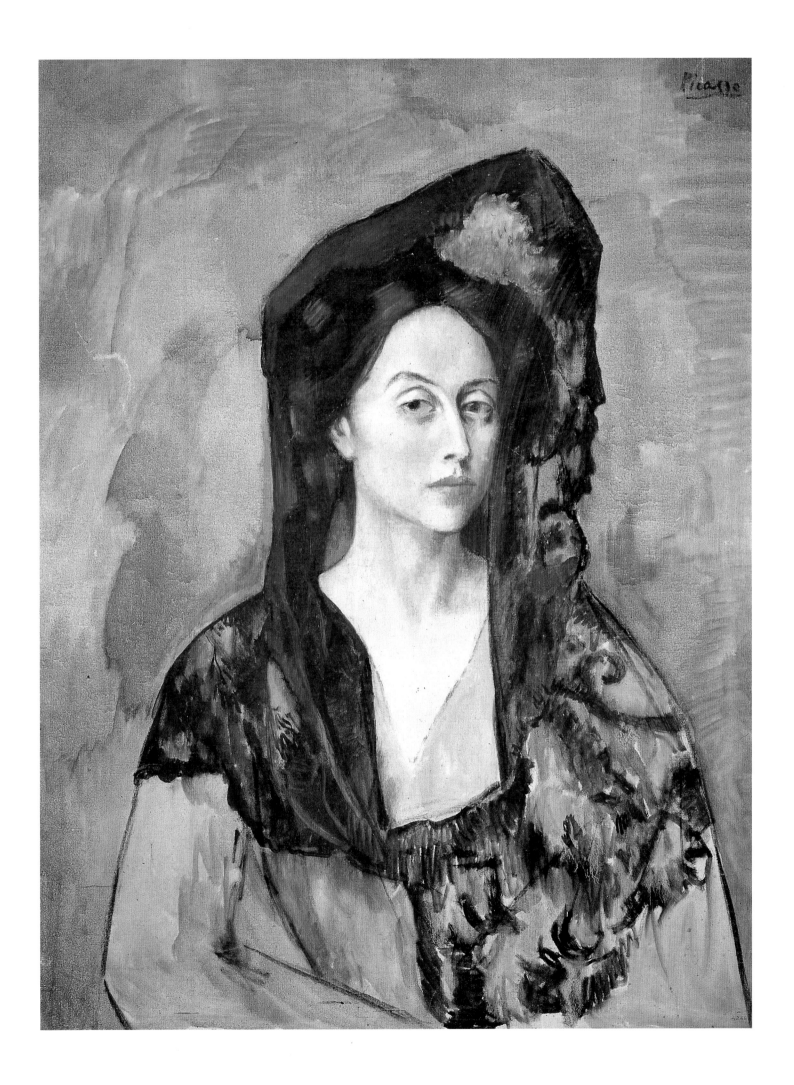

136. *Saltimbanque Family,* Paris, summer 1905, gouache and charcoal on cardboard, 51.2 x 61.2 (20⅛ x 24⅛), Pushkin State Museum of Fine Arts, Moscow

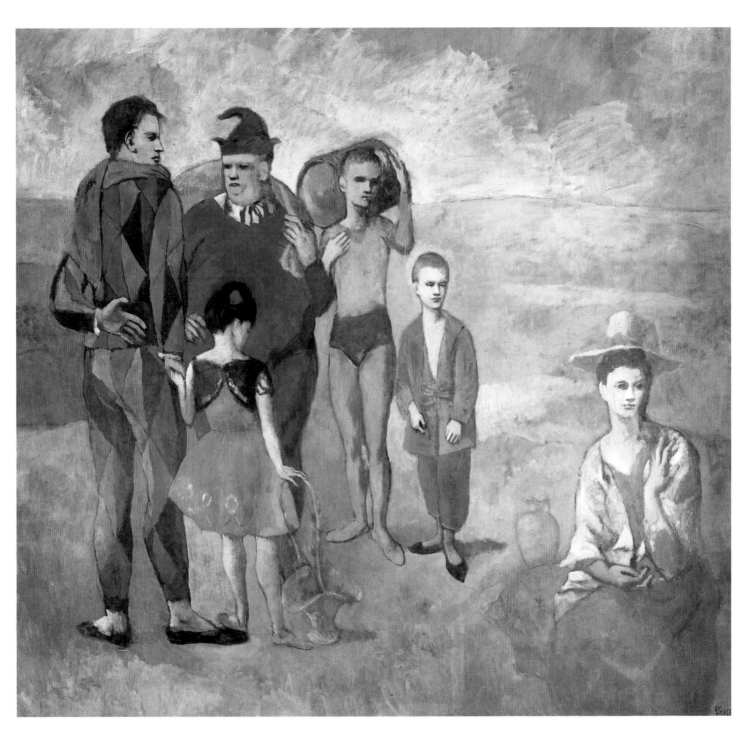

137. *Family of Saltim-banques*, Paris, 1905, oil on canvas, 212.8 x 229.6 (83 ¾ x 90 ⅜), National Gallery of Art, Washington, Chester Dale Collection
Washington only

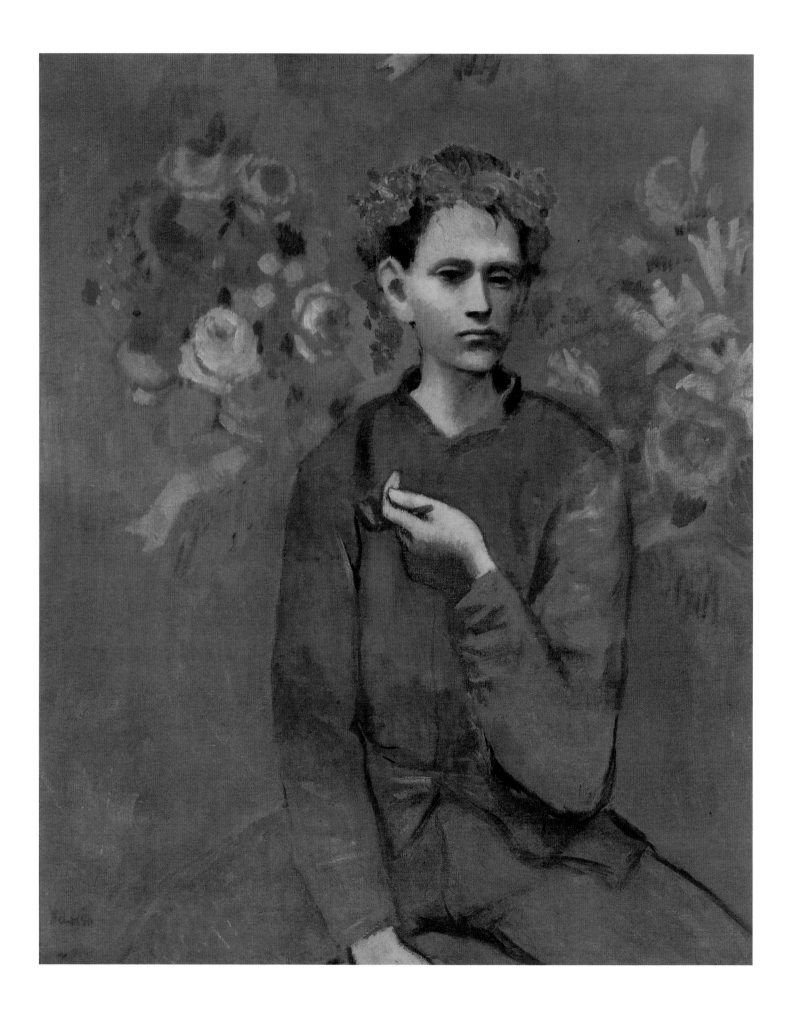

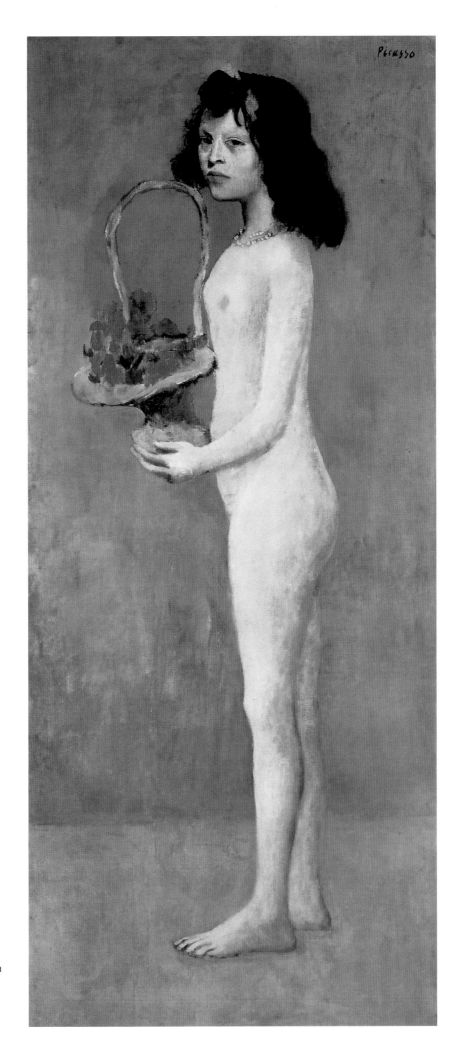

138. *Boy with a Pipe,*
Paris, autumn 1905, oil
on canvas, 100 x 81.3
(39 3/8 x 32), Mrs. John
Hay Whitney
Washington only

139. *Girl with a Basket
of Flowers,* Paris, autumn
1905, oil on canvas,
152 x 65 (59 7/8 x 25 5/8),
private collection
not in exhibition

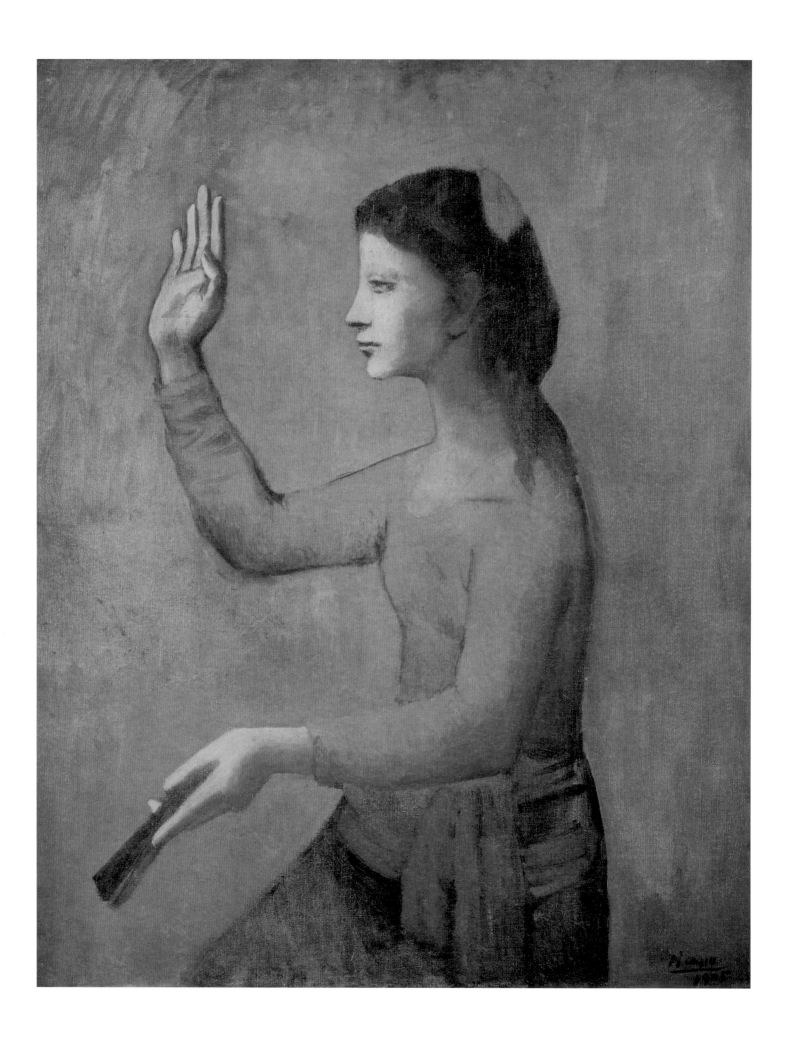

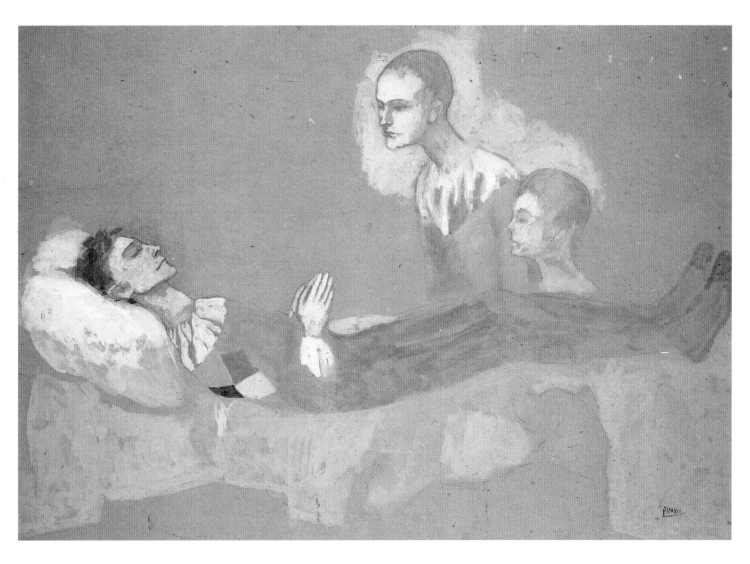

140. *Woman with a Fan,*
Paris, autumn 1905, oil
on canvas, 100.3 x 81
(39 ½ x 31 ⅞), National
Gallery of Art, Washing-
ton, Gift of the W. Averell
Harriman Foundation
in memory of Marie N.
Harriman

141. *The Death of Har-
lequin,* Paris, end 1905/
beginning 1906, gouache
on cardboard, 68.5 x 96
(27 x 37 ¾), National
Gallery of Art, Washing-
ton, Collection of Mr.
and Mrs. Paul Mellon

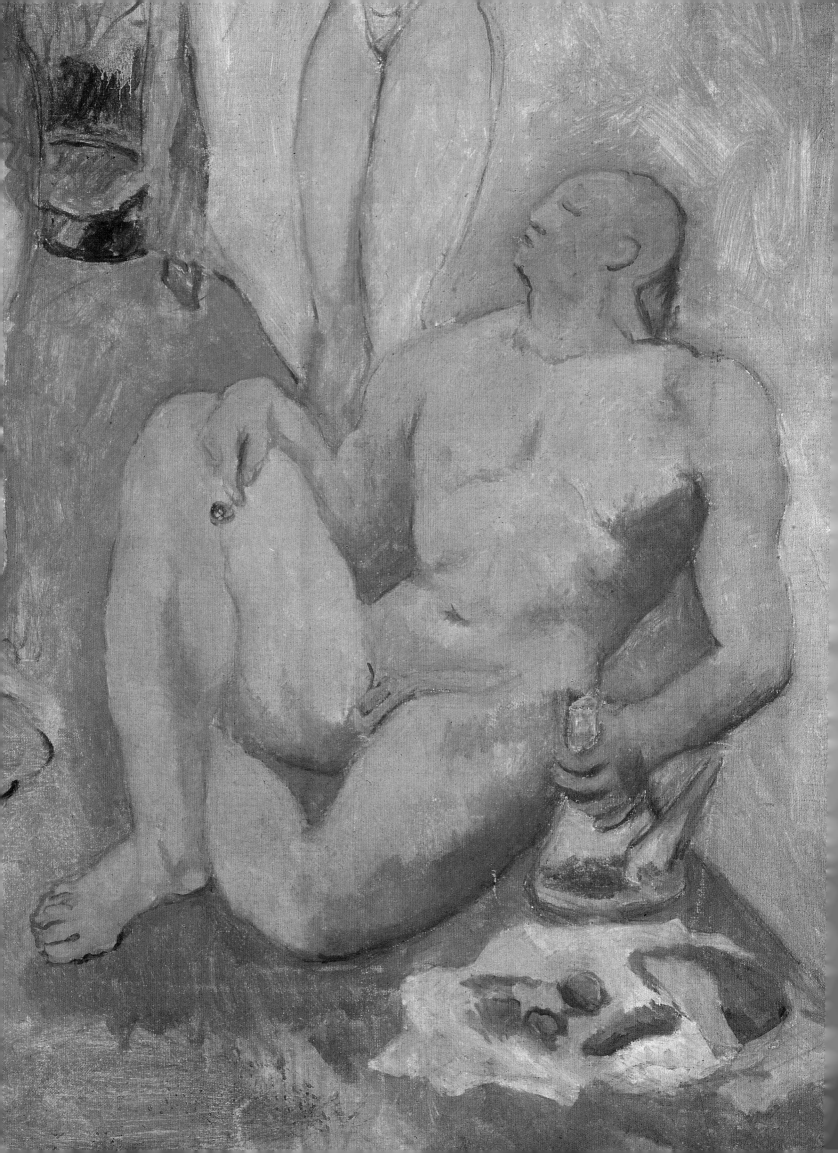

Picasso in Gósol: The Calm before the Storm

Robert Rosenblum

Like the apocalyptic visions by El Greco that helped spark its flickering, hallucinatory intensity, *Les Demoiselles d'Avignon* seems to proclaim, together with the Lord in the Book of the Revelation, "I am the Alpha and the Omega." Carrying the destructive force of an earthquake, the *Demoiselles* splits art historical time into an old and new epoch, BC and AD, as if in 1907 Picasso and, with him, all of art were reborn. What he did before this watershed year might belong to another era, a quiet coda to the nineteenth century.

But as persuasive as such a reading might be, the shattering newness of the *Demoiselles* has also warped our approach to the "BC" Picasso, whose life presumably came to an end in 1906 before the curtains went up on the twentieth century. Of the many things we have been learning about the master in recent decades, the most important may be an understanding of the infinite continuities, rather than the periodic ruptures, in his art. No matter where we look in his more than eight decades of work, we are likely to recognize a Domino-series effect, in which a multitude of styles, motifs, cryptic messages ripple backward and forward throughout his entire career, criss-crossing with countless threads any simple-minded view of an avant-garde artist who, always facing the future, constantly shed the past.

The year 1906 has been a particular casualty of any linear conception of Picasso's art, especially the work stemming from his two-and-a-half month sojourn between 2 or 3 June and 15 August in the remote Pyrenean village of Gósol south of Andorra. The serene and earthy equilibrium, often described as "classical," that marked much, though hardly all, of this summer productivity might appear to be the last gasp of traditional order before the detonation of 1907. But far from being buried forever in the rubble, the wide and experimental range of paintings, drawings, and sculpture from the Gósol months launches a wealth of fresh ideas that would be amplified in the new era inaugurated by the *Demoiselles* and would have many afterlives in Picasso's postcubist career.

We might begin with one of his most ambitious multi-figured canvases of that year, *The Harem* (fig. 1), a fragile, almost reticent preview, as has often been noted, of the bordello theme of the *Demoiselles*,[1] in which the averted glances of those self-absorbed nudes would suddenly be transformed into demonic gazes of sexual confrontation. Typically for Picasso, from youth to old age, this painting fuses life, love, and art history. As for the latter, *The Harem* signals the start of Picasso's never-ending infatuation with Ingres' *Turkish Bath* (fig. 2), freshly topical, thanks to its inclusion in the major Ingres retrospective at the 1905 Salon d'Automne. Picasso recreates not only its theme and figural postures but, more subtly, its precariously constructed corner view of an enclosed space confined to sensual delights. Just as Ingres, defying the logic of one-point perspective, takes three presumably perpendicular planes and muffles their 90-degree spatial junctures so deftly that the tilted floor and two adjoining walls merge into an almost seamless continuity, so too does Picasso reinvent conventions of spatial illusion. Fascinated by Ingres' ambiguous perspective, Picasso exposes more clearly its three-part schema, with the gravity-defiant floor rising at an impossibly steep angle and the two walls, which ought to plunge us into the distant recess of a boxed enclosure, fusing into a flattened, continuous surface at the top of the canvas. In this elementary distillation of a traditional perspective diagram gone askew, Picasso foreshadows the buckling, cubic fragments that he would explore in a more sustained way in 1908 in the still lifes and landscapes of early cubism. Might Picasso have been placing Ingres alongside Cézanne in his search for new spaces that, despite the vestiges of a rational chiaroscuro, seem at once to expand and contract, to be concave and convex?

Detail, cat. 155

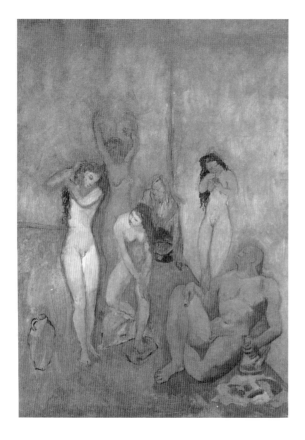

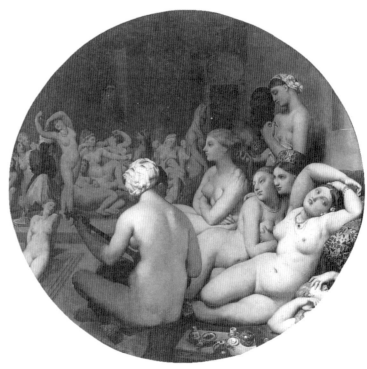

Just as Picasso bared the props of Ingres' interior to its three warped planes, he also distilled its abundant population of female nudes to four, each of whom offers a variation on Ingres' infinite repertory of postures dedicated to sensual languor and cosmetic adornment. Moreover, he has added two new characters to Ingres' theater of pleasure: a clothed woman crouched in the corner over a wash basin (a relative of *La Celestina* [cat. 100], it appears, and the archetypal Spanish procuresses of Picasso's early work); and prominent in the foreground, an anatomically undersexed and overmusculated male. With one leg tucked behind the other in a pose that once again reflects Ingres' female nudes (especially the almost Indian figure in the middle ground at the left of the *Turkish Bath*), he holds a flower in his limp right hand and enjoys the simplest of working-class lunches (the sausage and bread that would later turn up on Parisian cubist still-life tables).[2] But the meal has been emphatically Hispanicized, thanks to the conspicuous *porrón*, nearly emptied of red wine, the most earthy and popular drinking vessel of Catalonia that would be the focus of several still lifes of 1906 that similarly reflect Picasso's reawakened awareness of his national roots while summering in Gósol.[3] Half a century later

the artist would draw another large *porrón* on a postcard sent to his Barcelona dealers, the Gaspars, on 16 November 1956.[4]

Picasso's metamorphic wizardry, already triumphant in the veiled and layered identities of the *Family of Saltimbanques* (cat. 137), is particularly puzzling in *The Harem*'s reclining nude, for everything about this figure remains elusive, even in sexual terms. A male odalisque, he is yet another example of Picasso's effecting a sex change when quoting Ingres. In one of Picasso's first responses to the French master, *Woman with a Fan* of 1905 (cat. 140), he transformed, as Meyer Schapiro first noted, the staid, ritual posture of Ingres' lapidary portrait of Augustus into the static gesture of a young woman;[5] and in 1906, in a witty manner more relevant to the physique and sexual persuasion of the sitter, he recreated Gertrude Stein (cat. 168) as Ingres' hulking *Monsieur Bertin*.[6] Such slippery sexual boundaries, familiar to the symbolist myths of androgyny,[7] are particularly suggestive in a harem or bordello theme, so that the indolent male nude may evoke, as well as literally expose, the exotic androgyny of the many clothed eunuchs who accompany the countless depictions of odalisques by nineteenth-century orientalist painters, including Ingres. There may even be

1. Picasso, *The Harem*, Gósol, 1906, oil on canvas, 154.3 x 110 (60¾ x 43¼), The Cleveland Museum of Art, Bequest of Leonard C. Hanna Jr. See also colorplate 155

2. Ingres, *Turkish Bath*, 1862, oil on canvas on wood, diameter: 108 (42½), Musée du Louvre, Paris

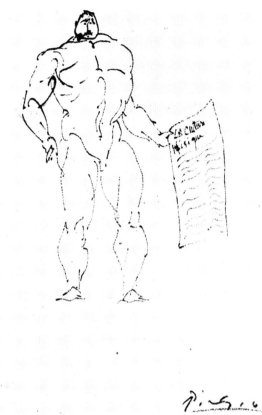

3. Beardsley, *The Kiss of Judas*, 1893, Victoria and Albert Museum, London

4. Picasso, *Portrait of Guillaume Apollinaire*, Paris, 1905, pen and india ink on paper, 31 x 23.5 (12 ¼ x 9 ¼), Collection Lionel Prejger, Paris

a whiff of the erotic and anatomical perversities of Aubrey Beardsley, especially his bizarre little homunculus with its infant genitalia (fig. 3).[8] And speaking of Beardsley, Picasso's own illustration of *Salomé* (cat. 132), a drypoint of 1905 that follows in the footsteps of the short-lived British master, presents in the lower right foreground a floor-bound slave holding John the Baptist's head, a figure whose role as a voluptuous but passive spectator to a sexual performance is usurped in *The Harem* by this strange male nude, whose only physical exertion is grasping the upright handle of his *porrón,* as if it were a vital extension of his body. In Picasso's hands this Spanish commonplace could become more and more assertively a symbol of machismo.[9] In the large gouache *Three Nudes* of 1906 (cat. 156), a variation on *The Harem* scene intended for a never-realized painting, a squatting naked youth reaches down to grasp between his legs another *porrón* that outsizes his own genitals, while two whores observe his ritual gesture (the adjacent inscription on the study

reads: *El tiene un porrón en el mano / un plato de frutas aquí,* or "he holds a *porrón* in his hand / a plate of fruit here"). And in less than a year, in the spring of 1907, the *porrón* and a plate of fruit will reappear in some of the preparatory drawings for the brothel parlor in the *Demoiselles,* with an erotically charged ambiance that further underlines the specifically Spanish virility Picasso could evoke from the most ordinary still-life objects.

Given Picasso's chameleon versatility at projecting himself into his own fictional characters, whether harlequins, minotaurs, or classical profiles, it is tempting to read the oddly athletic yet lethargic spectator in *The Harem* as part self-portrait—a Spanish pasha who, comfortably grounded with the pleasures of food, wine, and tobacco at hand, watches his women in their thralldom. Soon, we feel, these women might be staging the kind of sexual performances depicted in a coarse, caricatural style in many of Picasso's earlier pornographic drawings or described in his friend Apollinaire's revival of the Marquis de Sade's erotic fantasies, *Les Onze Mille Verges.*[10] The figure also evokes other earlier athletes of 1905, such as the circus performers or Picasso's caricature of Apollinaire as a nude, pipe-smoking, pin-headed muscleman sporting a copy of *La Culture physique* (fig. 4).[11] But if the

male's identity remains fluid, that of the females
is much clearer. Each of the four nudes—one
combing her tresses, another stretching herself
upward, a third bathing her thigh with one foot
in a wash basin, and a fourth looking into a
mirror[12]—is based not only on an inventory
of classical prototypes recreated by Ingres and
perhaps on modern counterparts recorded by
Degas[13] but, closer at hand, on posing sessions
with Picasso's girlfriend Fernande Olivier, whose
features thereafter keep slipping in and out of
recognizability in the infinite mutations of Pi-
casso's art. In a way, Picasso has constructed
here a macho image of his own little Spanish
summer harem, surveying his willing and naked
captive, Fernande, in four postures of feminine
grace, sensuality, and beautification. Decades
later Picasso would often repeat this pictorial
theater of sexual delight, mixing the present
tense of his erotic life with the timelessness of
earlier art, as when, in the early 1930s, he re-
incarnated his new mistress Marie-Thérèse Wal-
ter as the supine, sleeping odalisques of Ingres,[14]
or when, beginning in 1954, he populated his
own variations on Delacroix's *Women of Algiers*
with houris clearly inspired by his new love,
Jacqueline Roque.[15]

Fernande in fact inspired a wide range of
art historical paraphrases, paintings and draw-
ings that recreate her in an inventory of guises
culled from antiquity through the nineteenth
century. In a full-length standing nude (fig. 5)
whose sculptural presence is belied by the most
nuanced fragility of line and roseate hue, she
becomes a new version of the Venus de' Medici,
except that the postural modesty of the classical
prototype, who covers her breast with one hand
and her sex with the other, is subtly undermined
by the unexpected union of this figure's coupled
hands directly over her groin, one thumb lock-
ing them tightly in place. It is a gesture repeated
with more erotically suggestive variations in
other related nudes where the joined hands drop
down a notch to reveal rather than conceal her

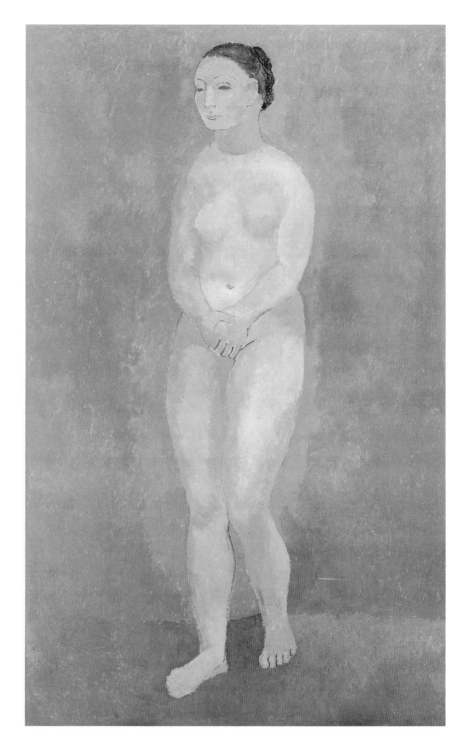

sex. Elsewhere the features of these nudes be-
come so generic and masklike that Fernande dis-
appears, to be replaced by a newly created ideal,
as in the *Woman with a Pitcher* (cat. 152), which
resurrects the ritual of a classical libation as pre-
served perhaps in the motions of a local girl seen
pouring wine or oil, an elegantly measured pos-
ture of grace that echoes throughout the history
of art, recalling, for instance, an early portrait
by Manet of his wife, which in turn is predicated
on Renaissance sources.[16]

Playing such charades involved moving, like
the artist himself, from French to Spanish terri-
tory; and it may well have been that Picasso's

5. Picasso, *Standing Nude
(Fernande)*, Gósol, 1906,
oil on canvas, 153.7 x
94.3 (60½ x 37⅛), The
Museum of Modern Art,
New York, The William
S. Paley Collection

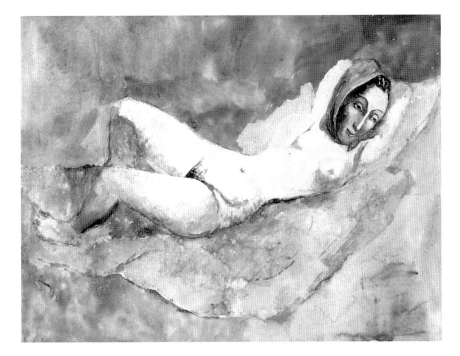

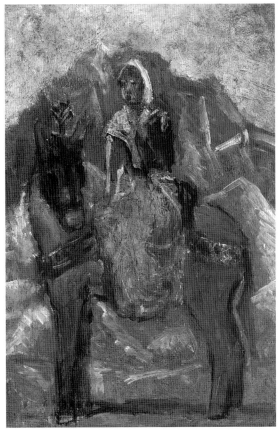

6. Picasso, *Reclining Nude (Fernande)*, Gósol, 1906, gouache on paper, 47.3 x 61.3 (18 ⅝ x 24 ⅛), The Cleveland Museum of Art, Gift of Mr. and Mrs. Michael Straight. See also colorplate 160

7. Goya, *The Naked Maja*, c. 1805, oil on canvas, 97 x 190 (37 ⅜ x 74 ¾), Museo del Prado, Madrid

8. Picasso, *Fernande on a Mule*, Gósol, 1906, oil on wood panel, 30 x 20.5 (11 ¾ x 8 ⅛), Collection Marina Picasso, courtesy Galerie Jan Krugier, Geneva

return to his homeland in the summer of 1906 (his first visit to Spain since leaving Barcelona for Paris in the spring of 1904) rekindled his allegiance to his national pictorial heritage. So it was that during the same Gósol sojourn, he tapped his magic wand and turned Fernande (fig. 6) into the most notorious of Spanish nudes, Goya's *Naked Maja* (fig. 7).[17] With a humorous economy, he telescoped his venerable compatriot's two "before and after" canvases, the clothed and naked Majas, into a single painting that showed Fernande still wearing the regional kerchief, which we know from photographs was part of her wardrobe[18] and which was depicted in a clothed portrait of her from the same time. The rest of her, however, is divested of clothing, mimicking in many ways her prototype in the Prado—the startling presence of a fringe of pubic hair (chastely absent in the idealized Ingresque nudes Picasso drew and

painted at the same time); the position of the arms shamelessly tucked behind her head; the odd alignment of the breasts, one frontal and one in profile; and above all, the impudent display, on a sensuous cascade of pillows and linens, of a relaxed body that has no wish to defend itself against a male taker.

If Picasso (via Goya) could turn his French lover not only into his sexual property but into his compatriot, he could also root her to the Spanish soil by depicting her wearing a mantilla and seated on a mule in front of the Pyrenean backdrop of the Pedraforca mountain range outside Gósol (fig. 8), almost a generic image of a local peasant woman. This also became a souvenir of the couple's arduous 15-kilometer voyage by mule from the end of the railway tracks to the tiny mountain village,[19] here transformed into a neo-Giottesque version of the Flight into Egypt. (In a preparatory drawing Fernande

267

still holds one of the family dogs that Picasso always took along on his travels.)[20] In this rough painted sketch Fernande, like the mule on which she sits sidesaddle, is camouflaged by the rugged and ruddy patterns of dry earth and stone, which, like the large monochrome facets of the early cubist paintings and sculpture for which she was a convenient model, absorb her identity almost beyond recognition. And as usual, even the most casual of Picasso's works can establish connections far afield in his life and art. We are reminded of the way that he would Hispanicize his new girlfriend, Olga Khokhlova, in the summer of 1917 on a visit to Barcelona, by dressing and painting her in a far fancier mantilla than Fernande's[21] and how in 1923 he would have his two-year-old son Paulo pose on a donkey for a picturesque snapshot and would then transform the image into a finely detailed painting that looks like the descendant of *Fernande on a Mule*[22] or, even more to the point, of a little drawing Picasso had also made in Gósol of a child riding a mule.[23]

For Picasso the Gósol summer, prefaced by a few weeks in Barcelona, prompted many kinds of regression to ethnic and primitive roots, the Spanish equivalent, we might say, of Gauguin's and Bernard's sojourns in Pont-Aven. Not only did it stir in him a fresh sense of his Spanish origins but it triggered a broader fascination with a remote world, unpolluted by modern history, that echoed back to classical antiquity. Once again Picasso's private discoveries intersected with a more public domain, in this case coinciding with the many nationalist manifestos and publications of 1906 that reasserted a wide range of Iberian traditions, from the ancestral grandeur of El Greco to a renewed consciousness of Spain's ancient Mediterranean heritage.[24] Even the modest still lifes Picasso executed in Gósol are in harmony with this new nationalism and archaism, often focusing on the *porrón* and local pottery—the simplest vases, bowls, and jugs—that seem to derive from the ancient,

weathered ceramics we might find in the vitrines of a regional Spanish museum's archaeological displays. (Later, in 1919, Picasso would paint another kind of classicizing still life with the simplified, time-worn components—a jug and a plate—that reflect the ancient Roman still lifes he had seen in Pompeii and Herculaneum in the spring of 1917.)[25] Thus when Picasso includes still-life objects in his Gósol figure paintings of nudes, such as the National Gallery of Art's *Two Youths* (see fig. 11), we are tempted to identify them either as contemporary pottery from a rural Catalan village or as provincial Iberian survivors of such ancient forms as the kylix, amphora, or oenochoe. And again looking ahead to early cubism, these elemental vessels, rooted in both Spanish and classical cultures, will reappear in many still lifes of 1908–1909,[26] where geometric simplification establishes a more cerebral kinship with the ready-made vocabulary of lucid volumes in the rudimentary pottery shapes available in Gósol.

In its landscape and architecture Gósol itself was in perfect harmony with the search for centuries-old Iberian foundations; and the views Picasso painted and drew of the little village (fig. 9) evoke a Spanish version of Mother Earth.[27] Typical of Picasso's stance of keeping one foot north and one foot south of the Pyrenees, his Gósol landscapes can recall such French prototypes as Cézanne's views of Provence and, perhaps more relevant, some of Degas' late views of the Channel resort town of Saint-Valéry-sur-Somme (fig. 10), in which the constantly shifting perspective webs of agitated lines and planes strike a protocubist chord.[28] At the same time, the parched colors and almost troglodytic architecture of rudimentary building blocks and minimal fenestration in the Gósol landscapes create the aura of an untouched Iberian time capsule or an outpost of an ancient empire. With 20/20 hindsight, we may discern in the buckling, interlocking networks of intensely sunned and shadowed monochrome planes a preview of early

9. Picasso, *Gósol Landscape*, Gósol, 1906, oil on canvas, 69.8 x 99 (27 ½ x 39), private collection. See also colorplate 148

10. Degas, *View of Saint-Valéry-sur-Somme*, c. 1896–1898, oil on canvas, 51 x 61 (20 ⅛ x 24), The Metropolitan Museum of Art, New York

cubist landscape, whether from the verdant northern French terrain Picasso painted at La Rue-des-Bois in the summer of 1908 or from the bleached, sun-dried highland village of Horta de Ebro that greeted him when he returned to Spain in the summer of 1909. And looking backward, we may find more distant previews of cubism in some of the Barcelona cityscapes that Picasso painted in 1903, with their muted scaffoldings of high and low, near and far rooftops further camouflaged by the nocturnal pall of monochrome blue.[29]

However much the Gósol landscapes and still lifes mirrored the contemporary fascination with

archaic style and culture, it was above all the human figure—always the center of Picasso's pictorial stage—that was most subject to regression. In Gósol, Picasso, the most protean of Frankensteins, spawned a whole new race of humanity that would evoke many family trees of Western art and end up planted in Iberian soil. The *Woman with Loaves* (cat. 161) is a synthesis of past and present: a tourist's response to the female villagers' timeless tradition of carrying their burden of food and vessels on top of a solid headpiece designed to support such weights (which Picasso recorded in many casual drawings),[30] but also a generalized and ennobled image that fuses Christian and classical memories. This austere yet serene peasant woman might well be seen as the descendant of the twelfth-century polychrome wooden Madonna at Gósol, whose immobile grandeur and crowned head, with its stark, masklike features, must have inspired many of Picasso's recreations of the human face and body.[31] Yet the load-bearing peasant woman might equally take her place in an evolution that leads back to the classical world. There she could easily function as a caryatid carved on a provincial Iberian version of the Erectheum in a local acropolis, yielding the kind of crude but forceful Iberian sculptures that were put on view at the Louvre probably as early as 1905, where they helped to fire Picasso's passion for both the archaic in antiquity and the ethnic in Spain.[32]

It was primarily through classical prototypes, male and female, that Picasso forged his way backward into a pre-Christian world, offering vital and earthy regional variants on a familiar repertory of ancient marbles and their infinite progeny in Western art. Already in 1905 there had been intimations of this direction, especially during his summer sojourn in the remote northern Dutch village of Schoorl, where, as in Gósol the next summer, he was attracted to the folkloric detail of costume and vernacular architecture but could also transform such touristic

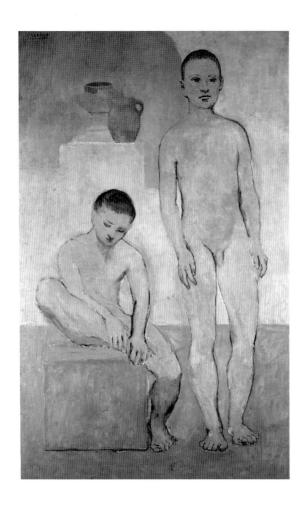

observations into a more generic, classical seren-ity.[33] In the most ambitious of his paintings exe-cuted in Schoorl, *Three Dutch Girls* (cat. 134), we may sense that for Picasso such distant, unpolluted pockets of ethnicity in twentieth-century Europe could easily conjure up antique ghosts: the Three Graces survive here as stocky northern peasant girls beside a similarly earth-bound and primitive farmhouse;[34] and the pleats of their red, white, and blue skirts (an allusion, perhaps, to the Dutch national colors)[35] recall the fluting of the sturdiest Doric columns.

To be sure, such reversions to history's first steps are very much part of what might be called an international Doric revival in early twentieth-century art. This historicizing backlash against the neo-baroque excesses of late nineteenth-century styles encompassed phenomena like the search for archaic stone clarity by sculptors ranging from Aristide Maillol and Antoine Bourdelle in France to Gustav Vigeland in Nor-way (not to mention Picasso's own Catalan sculptor friend, Enric Casanovas)[36] and the lit-eral revival of the Greek Doric order in the early

work of such pioneers of modern architecture as Peter Behrens.[37] But predictably, Picasso's back-ward evolution to the pure and vigorous origins of classical art has a more personal inflection than that of his contemporaries; and his familiar quotations from ideal beauty are imbued with a quivering physical and psychological life that reflects his mysterious, Pygmalion-like power as their creator. In *Two Youths* (fig. 11) the setting itself strips Mediterranean antiquity to its lucid essentials. On the most rudimentary of socles a museumlike display of ostensibly ancient pots is enshrined like a relic beneath the suggestion of the simplest of arches; and in the foreground a pure cube of a block recalls the standard prop for models in the tradition of academic studies of the nude dating back to the era of Jacques-Louis David and offers an almost literal preview of cubism in its contradictory mix of rational, solid geometry with weightless, planar ambigui-ties. Within this both firm and insubstantial environment two nude youths who might once have been plaster casts or models in the art academies where Picasso had studied a decade

11. Picasso, *Two Youths*, Gósol, 1906, oil on can-vas, 151.5 x 93.7 (59 5/8 x 36 7/8), National Gallery of Art, Washington, Chester Dale Collection. See also colorplate 151

12. *Spinario*, bronze, height: 73 (28 3/4), Musei Capitolini, Rome

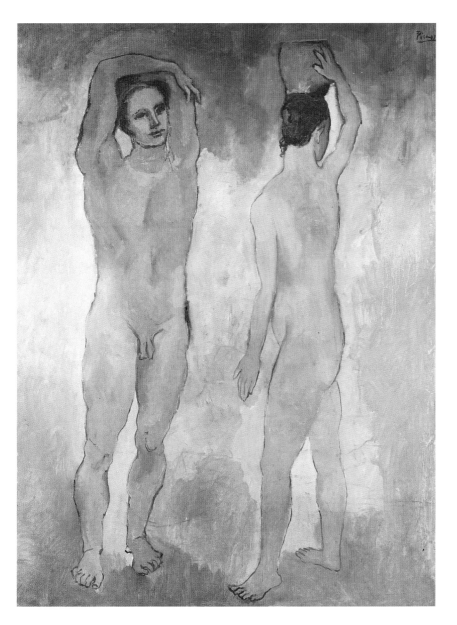

13. Picasso, *Two Youths*, Gósol, 1906, oil on canvas, 157 x 117 (61¾ x 46), Musée de l'Orangerie, Paris, Jean Walter and Paul Guillaume Collection

14. Picasso, *Swineherd*, Gósol, 1906, pencil and ink, 21 x 20 (8¼ x 7⅞), Galerie Louise Leiris, Paris

earlier in La Coruña, Barcelona, and Madrid come to quiet, contemplative life. The left-hand figure, seated with an invisible foot nestled between his hands, recalls the famous *Spinario (Thorn-Puller)* (fig. 12), an antique sculpture that had been a postural staple for many late nineteenth-century female nudes—by Bouguereau and Renoir among others[38]—and would be used again by Picasso for a female nude in 1921.[39] But far from being merely an academic quotation, this youth conveys inward yearnings of adolescent sexuality, with both head and hands directed toward his concealed groin, a more secretive variation of the overtly sexual context of the nude youth grasping the *porrón* beside his genitals in the unfinished gouache *Three Nudes*. Such pubescent emotions can be intuited as well in the youth's companion, a standing figure who resurrects the *kouros* type used more literally in the earlier *Boy Leading*

a Horse (cat. 145) but instills it with a far greater complexity of mind and body. Any memories of archaic geometry and rigidity are melted here by the supple contours, which become strangely nervous in the fingers that press against the thighs; and any clarity of archaic expression is veiled by a sense of restless inner stirrings that unbalance the figure's equilibrium. As Picasso had shaved his head for the summer months at Gósol (a standard protection against lice),[40] it is hard not to find some subliminal aspect of psychological self-portraiture in both this figure and his equally close-cropped companion. Such a projection of an artist's interior life into an antique statue has a close literary parallel in Rainer Maria Rilke's poem "Archaic Torso of Apollo," written in Paris in the summer of 1908. Evoking the mysteries of the sculpture's luminous, quietly smiling sexuality, it ends with the phrase: *Du musst dein Leben ändern* (You must change your life). It may even be that Rilke, who in 1905 had met Picasso in Paris and who in 1915 was to recreate the *Family of Saltimbanques* in his "Duino Elegies,"[41] had had his own responses to antique sculpture quickened by seeing Picasso's paintings of 1905–1906. In any

case, Picasso, like the great poet, had the power to bring these museum-bound images to life, and usually to a life animated by the kind of erotic awakenings that were part of the repertory of the symbolist generation that flourished in his youth, when writers like Frank Wedekind and artists like Edvard Munch explored the terrors and mysteries of puberty.

The sexual voltage is still stronger in a painting in the Orangerie of two nearly life-size adolescents (fig. 13) that almost provides a pendant to the National Gallery picture. The male figure at the left, whose flesh is as earthy as a terracotta statue, strikes a strangely voluptuous pose of desire and availability, his fingers, like those in the other painting, surprisingly agitated, and his arms around his head. Such provocative body language, though used by Cézanne for both male and female bathers, is more familiar in the languorous, stretching postures of nude women, reaching its peak of sexual intensity in Munch's seductresses. It is a posture even more unexpectedly provocative in a little drawing Picasso made of a Gósol swineherd, who has stopped work, put his crook in the ground, and assumed the same pose of erotic display (fig. 14), a pose that Picasso also singled out for almost iconlike scrutiny in a related drawing of a lone male nude framed in a niche or doorway.[42] In the painting the relationship of this figure to its companion is strangely ambiguous, for that standing figure, who bears a pot on its head as a village woman might, is presumably but not explicitly female, as the front view of the body is totally concealed.[43] Averting her head and gaze but not her body from her male partner, she extends her left hand tensely in his direction, as if desiring but not quite daring physical contact.

The psychological rumblings of Eros we often discern under the deceptive calm of Picasso's statuesque, classicizing nudes may have more overt parallels in the domain of art photography at the turn of the century. An article published in 1980 points out the surprisingly apparent

dependency of Picasso's *Pipes of Pan* (1923) on a photograph by the flamboyant Wilhelm von Gloeden,[44] who had left Berlin for Sicily, where, between 1898 and 1913, in a villa in Taormina he realized an overtly homosexual variation of neoclassicism that brought to a living climax Winckelmann's more covert sexual attraction to the antique nude male.[45] Enjoying the pleasures offered by the finest specimens of naked Sicilian youth, with whom he succeeded in sharing both his days and his nights, he would also have them pose as singles, pairs, trios, and still larger groups for arty photographs that often repeated the postures of antique statues and usually included such props as ancient pots, classical sculpture and ornament, and even an occasional Dionysian thyrsus. Von Gloeden's fame was legendary, and his guest book included a wide spectrum of names, from King Alfonso XIII of Spain and Alexander Graham Bell to Anatole France and Richard Strauss. His photographs were no less widely disseminated. If Picasso used one for his mysterious *Pipes of Pan*, another male duo that, like many classicizing pairings of the 1920s,

15. Wilhelm von Gloeden, *Two Sicilian Boys*, c. 1900, from Roland Barthes, *Wilhelm von Gloeden* (Naples, 1978)

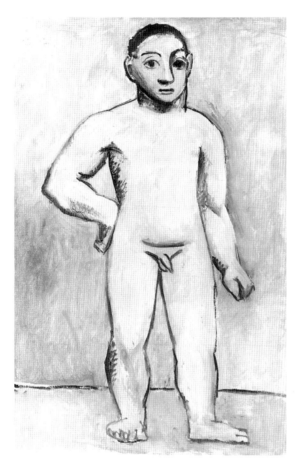

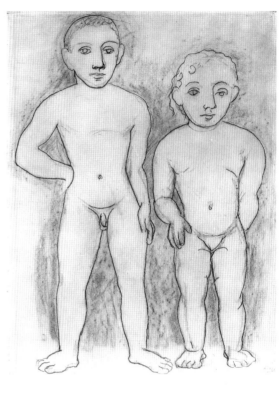

16. Picasso, *Nude Boy,* Gósol, 1906, oil on canvas, 67 x 43 (26⅜ x 16⅞), Musée Picasso, Paris

17. Picasso, *Nude Boy and Girl,* Gósol, 1906, charcoal on paper, 63 x 47 (24¾ x 18½), Museum Ludwig, Cologne

radiates an unspoken scenario, it may well be that in 1905–1906, the heyday of von Gloeden, he was already aware of these photographic reincarnations of antiquity in which ideal male nudes, an endangered species still surviving on the coast of Sicily, became embodiments of homosexual desire (fig. 15). But even if Picasso were unaware of these photographs (or the many others of the same genre, such as those by Guglielmo Plüschow),[46] such popular images provide a revealing glimpse of the fin-de-siècle cultural milieu that also nurtured Picasso's classicizing inventions, combining as they do a late mutation of the academic tradition of male models in antique poses with the exposure of sexual longings explored by many symbolist artists. In Picasso's work this unveiling of sexuality can be quite literal. In one Gósol drawing the swineherd with hands over head takes another pose, with crook now in hand like an art-

school model echoing a club-bearing Hercules or a caduceus-bearing Hermes, and wittingly or not, lets his genitals be exposed through his knee-length shorts.[47] In two other Gósol drawings a youth that belongs to the same race as the archaizing nudes of the paintings (and also suggests a self-portrait) is seen from both front and behind, dropping his shorts and thereby showing his sex in a bluntly confrontational way, a male counterpart to Picasso's transformation of the Venus Pudica into the Venus Impudica.[48] This posture is resumed in a painting of a frontal male nude who looks like the primordial source for Adam (fig. 16), a caveman, and, as always, Picasso himself. And having created this miraculous new cycle of artistic life, Picasso could even show us its first progeny, in a starkly simple frontal presentation of two naked children, male and female (fig. 17), who, like the crudest but most potent of Adams and Eves,

might become the first parents of Picasso's own race of humanoids.

It was a godlike energy that Picasso took with him from Gósol to Paris in mid-August, an energy soon to be compacted into the titanic self-portrait that presents him, palette in hand, bursting with imminent power, on the verge of revitalizing a world still haunted by the historical ghosts he had conjured up during his sojourn on Spanish soil (cat. 182). El Greco himself might soon be resuscitated in the eight-foot-high *Blind Flower Seller* Picasso had begun to sketch in Gósol but was to complete in Paris.[49] Both Eve and Venus were reborn in a canvas like his *Nude on Red Background* (cat. 173). And a whole new population of female nudes was to be created whose encyclopedic diversity embraced everything from prehistory through Michelangelo. Sometimes they were presented as lone, quasi-academic models on a cube; more often they were shown as provocatively joined pairs, whose identities might be construed as sisters, friends, lovers, or even common whores, and whose equally ambiguous silences extend the nuanced mysteries of symbolism. Made from a protean clay, they could be fashioned into infinitely malleable anatomies, at times so lithe and long-waisted as to appear to float; but more commonly, so weighty as to warp the very ground on which they stand or sit, compressed to the point of explosion. Having reinvented the human body for his own version of the Book of Genesis, what would Picasso's next creation be?

Notes

1. The relationship of Picasso's *Harem* to Ingres' *Turkish Bath* and the *Demoiselles d'Avignon* is fully and succinctly reviewed in Rubin 1994, 35–36.

2. See, most conspicuously, the painted wooden still life of 1914 (Tate Gallery, London), in Pierre Daix and Joan Rosselet, *Picasso: The Cubist Years, 1907–1916* (Boston, 1979), no. 746.

3. See Palau 1985, nos. 1250–1252. I have also discussed the specifically Spanish symbolism in this choice of a still-life object in "The Spanishness of Picasso's Still Lifes," in Brown 1996, 61–93.

4. See Josep Palau i Fabre, *Picasso in Catalonia* (New York, 1968), 210.

5. This essay of 1976 is most conveniently reprinted in Meyer Schapiro, *Modern Art: 19th & 20th Centuries* (New York, 1978), 111–120.

6. The comparison is by now a familiar one and was already suggested by me in *Ingres* (New York, 1967), 137. It should be added that the similarity between Ingres' portrait and Gertrude Stein clearly struck Félix Vallotton as well when in 1907 he painted his own portrait of the writer (Baltimore Museum of Art). See Sasha M. Newman et al., *Félix Vallotton* [exh. cat., Yale University Art Gallery] (New Haven, 1991), 117–118.

7. The question of symbolist androgyny as related to Picasso is succinctly presented in Richardson 1991, 339–340.

8. This strange creature, clothed and unclothed, appears in *The Kiss of Judas* and *Enter Herodias,* among other Beardsley illustrations.

9. Leo Steinberg, in "The Philosophical Brothel, Part I," *ArtNews* 71, no. 5 (September 1972), 25–26, was the first to emphasize the sexual implications of the *porrón* (reprinted, with revisions, in Steinberg 1988).

10. On Picasso and Apollinaire's erotica see Richardson 1991, 464–465.

11. See D.XII.24.

12. Palau 1985, 452, suggests less convincingly that the fourth female nude is eating an ice.

13. Degas created many images of female nudes stealthily observed at their toilette, works that had inspired Picasso as early as 1901. See especially *Le Tub (The Blue Room)* (cat. 71). On the availability of Degas' later work in early twentieth-century Paris see Richard Kendall, *Degas: Beyond Impressionism* [exh. cat., National Gallery] (London, 1996), 48.

14. On this see my "Picasso's Blond Muse: The Reign of Marie-Thérèse Walter," in exh. cat. New York 1996, 360.

15. See especially William Rubin, "The Jacqueline Portraits in the Pattern of Picasso's Art," in exh. cat. New York 1996, 463.

16. See Juliet Wilson-Bareau and Henrik Bjerre, "Transformations of an Early Manet Painting," in *Manet* [exh. cat., Ordrupgaard] (Copenhagen, 1989), 168–171.

17. The resemblance to the Goya is also briefly pointed out in exh. cat. Barcelona 1992, 342.

18. See, for instance, the photograph of c. 1906 in Richardson 1991, 400.

19. For a vivid account of the trip see Richardson 1991, 434ff.

20. See D.XV.20.

21. See exh. cat. New York 1996, 304.

22. Exh. cat. New York 1996, 322–333.

23. On this and related drawings see M. Teresa Ocaña, *Picasso Landscapes 1890–1912: From the Academy to the Avant-Garde* (Boston, 1994), 254–255.

24. This resurgence of nationalism in Catalonia is discussed in Palau 1985, 439–440, and more recently in Marilyn McCully, "Picasso y el clasicismo mediterraneista en 1906," in *Picasso clásico* [exh. cat., Palacio Episcopal] (Málaga, 1992), 69–91.

25. I have discussed this still life in its classicizing context in *Picasso from the Musée Picasso, Paris* [exh. cat., Walker Art Center] (Minneapolis, 1980), 53–55.

26. For example, Daix and Rosselet 1979, nos. 173–178 or nos. 209–213.

27. For more on these Gósol landscapes and their position in the evolution of cubism see Claustre Rafart, "Towards Cubism," in Ocaña 1994, 259–267.

28. Such a connection is briefly suggested in Kendall 1996, 171.

29. See D.IX.2–3.

30. See Palau 1985, nos. 1210–1212, 1214–1215. These drawings come mainly from the *Carnet Catalan*, first published by Douglas Cooper (Paris, 1958).

31. On the importance of this Romanesque Madonna for Picasso, see Richardson 1991, 451–452.

32. Richardson 1991, 428.

33. On this Dutch sojourn see Marilyn McCully, "Picasso in North Holland: A Journey of Artistic Discovery," and Gerrit Valk, "Picasso in the Low Countries," both in exh. cat. Barcelona 1992, 51–61 and 63–73.

34. Picasso depicted the Three Graces in explicitly classical terms in the 1920s. For characteristic examples see exh. cat. Málaga 1992, nos. 33, 38, 39. There is also a *Three Graces* drawing from 1906 (D.XV.24).

35. As persuasively suggested by Valk in exh. cat. Barcelona 1992, 69.

36. For more on Casanovas see Elizabeth Cowling and Jennifer Mundy, *On Classic Ground: Picasso, Léger, de Chirico, and the New Classicism 1910–1930* [exh. cat., Tate Gallery] (London, 1990), 59–62.

37. This revival of the Doric order was particularly strong in Germany. For a useful summary of the question see Robert Judson Clark, "The German Return to Classicism, after Jugendstil," *Journal of the Society of Architectural Historians* 29, no. 3 (October 1970), 273.

38. For example, Bouguereau's *Bather* of 1879 (Collection of Robert Isaacson, New York); Renoir's *Blue Nude* of c. 1880 (Albright-Knox Gallery, Buffalo) and *Seated Bather* of 1895–1900, also known as *Eurydice* (Musée Picasso, Paris), which actually belonged to Picasso.

39. A pastel illustrated in Richard Kendall et al., *Van Gogh to Picasso: The Berggruen Collection at the National Gallery* [exh. cat., National Gallery] (London, 1991), no. 49.

40. On this and aspects of psychological projection in Picasso's self-portraiture see Kirk Varnedoe, "Picasso's Self-Portraits," in exh. cat. New York 1996, 132 ff.

41. See Richardson 1991, 337.

42. See Palau 1985, nos. 1237, 1238, 1240.

43. For more on these sexual ambiguities see Hans Christoph von Tavel, "Man and Woman in Picasso's Work in 1905 and 1906," in exh. cat. Barcelona 1992, 89–96.

44. Robert Judson Clark and Marion Burleigh-Motley, "New Sources for Picasso's *Pipes of Pan*," *Arts Magazine* 55, no. 2 (October 1980), 92–93.

45. On von Gloeden see Ulrich Pohlmann, *Wilhelm von Gloeden. Sehnsucht nach Arcadien* (Berlin, c. 1987); and Charles Leslie, *Wilhelm von Gloeden, Photographer* (New York, 1977).

46. See Ulrich Pohlmann, *Guglielmo Plüschow (1852–1930). Ein Photograph aus Mecklenburg in Italien* [exh. cat., Mecklenburgisches Künstlerhaus] (Mecklenburg, 1995).

47. This sexually provocative drawing, to my knowledge, was reproduced for the first time in Richardson 1991, 442.

48. See D.XV.11–12.

49. For the most recent discussion of this understudied painting, originally titled simply *Composition*, see *Great French Paintings from the Barnes Foundation* (New York, 1993), 200–202.

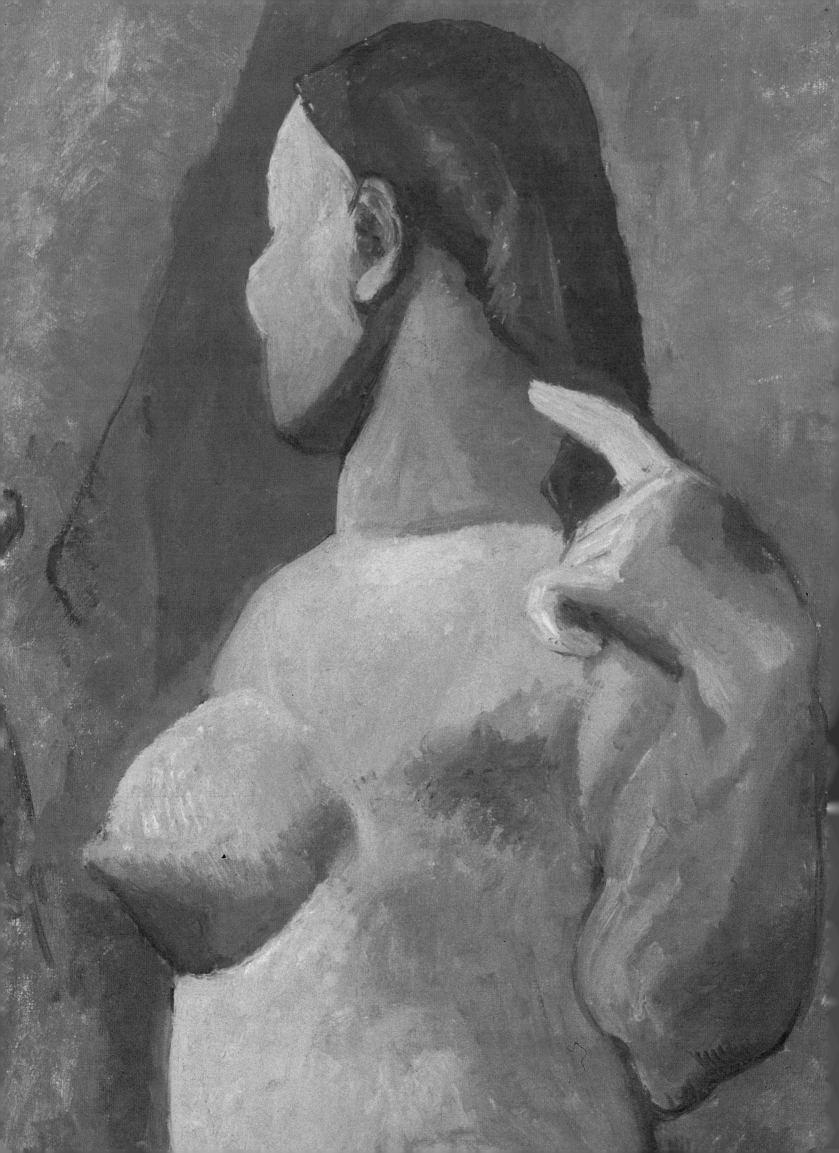

Representing the Body in 1906

Margaret Werth

Picasso's *Two Nudes* (fig. 1) stands at the nexus of a diverse set of pictorial investigations the artist undertook in 1906–1907. Emerging out of a series of studies of two female figures (cats. 175, 176) that had their origins in studies of peasant girls at Gósol in the summer of 1906—with roots as far back as *Two Sisters* of 1902 (see fig. 2 in Rosenthal essay)—the depiction of two female nudes in a shallow interior, standing before a curtain, also foreshadowed the brothel space of *Les Demoiselles d'Avignon* of 1907 (fig. 2).[1] In Gósol *The Harem* and *Three Nudes* (cats. 155, 156) were the most recent precedents for the subject of nudes in an interior, but Picasso was also actively exploring the representation of the body in nude studies devoted to traditional themes such as *La Toilette* and *Nude Combing Her Hair* (cat. 154; fig. 44 in Chronology) and in works that evoked a classical or Mediterranean sensibility such as *Two Youths* (see fig. 13 in Rosenblum essay) or *Woman with Child and Goat* (fig. 4).[2] These nude studies were developed in tandem with a series of self-representations (both overt and disguised)—such as *Self-Portrait with Palette* (fig. 9) and *Man, Woman, and Child* (Kunstmuseum, Basel)—a dialogue that anticipated the artist's concurrent exploration of male figures and female nudes in the winter and spring of 1907. This essay will also consider *Two Nudes* in relation to other major works completed in Paris in the late summer and autumn of 1906: from *La Coiffure* and *Portrait of Gertrude Stein* (figs. 10, 11)—both begun before the trip to Gósol and completed after Picasso's return to Paris—to the monumental *Seated Nude* (fig. 12).

While *Two Nudes* constitutes a high point in Picasso's strictly pictorial investigation of the possibilities and limits of figuration in 1906—with resonances connecting it to figure paintings by Puvis de Chavannes, Cézanne, and Gauguin as well as to Hellenistic, classical Greek, archaic Iberian, and Spanish Romanesque art—it is certainly more than a formal exercise.[3] Like the pic-

torial space Picasso represents, the work itself is liminal, marking the threshold between the transformations at Gósol during the summer of 1906 and those of the *Demoiselles* in the spring and summer of 1907.[4] The painting is also liminal in that it situates itself between formal investigation and allegorical or narrative subject; between the classical and the archaic or primitive; between materialization and dematerialization of the body; between figuration and defiguration; and between masculine and feminine.

Two massive figures are crammed into the space of the picture, their cone-shaped breasts, the abbreviated bas-relief modeling of their legs, torsos, and arms, and their massive breadth locating them in a world of physical extension, volume, and, to some degree, mass. Both figures flex their arms, gesturing toward themselves, touching themselves, and displaying muscular forearms. Their masculine muscularity recalls earlier studies like *The Two Giants* of 1905 (fig. 3), in which Picasso explored in a caricatural drawing style the charms of gigantism and physical culture. The masklike schematization of the faces, stubby calves, enlarged thighs and hips, extended chests, and cylindrical necks of *Two Nudes* had already been manifest in several works produced in Gósol, such as *Standing Nude* (see fig. 5 in Rosenblum essay).

In *Two Nudes* the figures stand in a shallow space marked out with great economy by a curtain that materializes only at the top center as it is grasped by the nude on the left, after which it dissolves into the nearly monochromatic background. Entry into the picture—and also any imagined entry through the curtain into the potential space beyond—is blocked by the massive, squat bodies that push against the four sides of the picture, pressing its limits. The two figures bear down on the viewer, confrontational rather than seductive. The freely opening curtain in *Woman with Child and Goat* (fig. 4) through which the emergence of the figures has been gracefully choreographed is replaced in *Two*

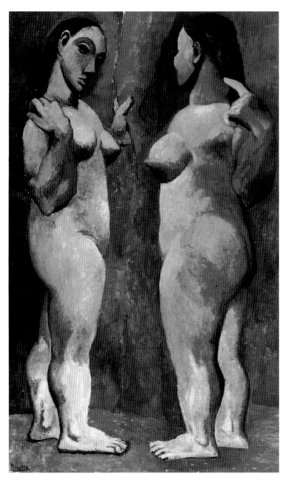

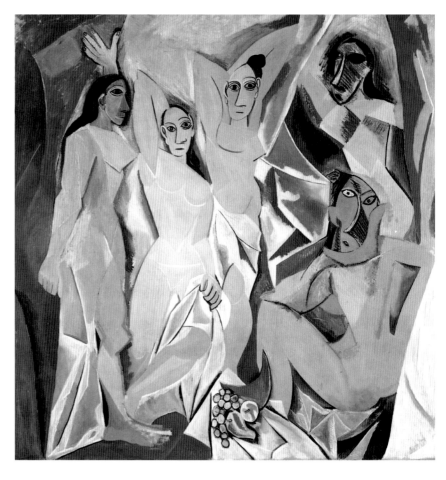

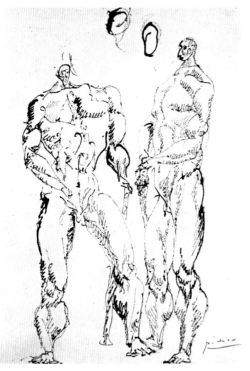

Nudes with a claustrophobic, pressurized space with no exit. Access to the space behind the curtain is further compromised by the ambiguous folds bunched together at the top center—more of a pocket than an opening—and by the fading of the curtain elsewhere into the flat pictorial field.[5] This curtain will not, cannot, open, Picasso seems to say: it can be grasped, gestured toward, offered as a possibility, but in the end we will not pass through it.[6] If it opens, it will not open onto a space beyond—the bedroom space that most interpreters have imagined in the background of both *Two Nudes* and *Les Demoiselles d'Avignon*—but rather into the nonspace of the mottled, diffuse monochrome of the picture's surface.[7] If this is a threshold, it is an ornery one: it will not let us in or out.

Two Nudes has often been described as "sculptural" in contrast to the flat, weightless

1. Picasso, *Two Nudes*, Paris, 1906, oil on canvas, 151.3 x 93 (59 ½ x 36 ⅝), The Museum of Modern Art, New York, Gift of G. David Thompson in honor of Alfred H. Barr Jr. See also colorplate 177

2. Picasso, *Les Demoiselles d'Avignon*, Paris, 1907, oil on canvas, 243.9 x 233.7 (95 ⅝ x 92), The Museum of Modern Art, New York, Acquired through the Lillie P. Bliss Bequest

3. Picasso, *The Two Giants*, Paris, 1905, pen and india ink on paper, 32 x 22 (12 ⅝ x 8 ⅝), private collection

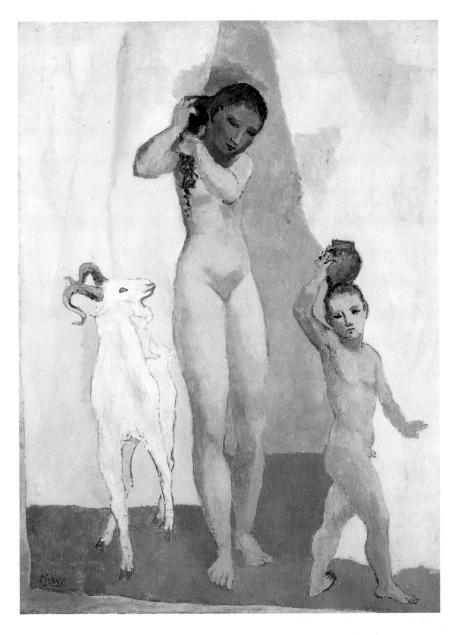

4. Picasso, *Woman with Child and Goat,* Gósol, 1906, oil on canvas, 146 x 114 (57½ x 44⅞), Barnes Foundation, Merion, PA

5. Picasso, *Nude and Faun,* Paris, 1906, water-color on paper, 20.5 x 13.5 (8 x 5¼), The Alex Hillman Family Foundation

figures of the Blue and Rose periods.[8] But close study of the picture reveals that Picasso suggests both sculpturality and flatness, materiality and immateriality in this work. The painting is certainly sculptural in comparison with the flat handling of *Two Youths* (fig. 13 in Rosenblum essay), painted in Gósol only a few months earlier, a precedent for the later work with its two nudes and right-hand figure in *profil perdu*.[9] In addition, materiality—as both volume and raw material—is represented through the gesture of the hand that grasps the curtain. The left nude's embodiment is figured further by the self-directed gesture of her other arm as she flexes to touch her shoulder. But the massiveness of her form and the activity of her gesture are counterbalanced by the extreme spatial compression of her body, further exaggerated by her outstretched left hand, protruding like a flipper

from her left breast.[10] Similar contradictions appear in the figure on the right, in the contrast of her bulky presence, thick neck, and conical breast with the turn of her head back into *profil perdu*, and in the contrast between her two legs: the left one, a massive pillar modeled in bas-relief, overlaps a twin back leg that is a flat ribbon with no claims to solidity or volume.[11]

Two Nudes also represents an important stage in Picasso's experimentation with obscure gestures signifying both touch and communication.[12] The pointing finger of the figure on the right exemplifies the ambiguities and overdetermination of gesture in his work.[13] The hand raised to the hair is a convention that Picasso explored repeatedly in 1906: in *Woman with Child and Goat, Nude on a Red Background,* and *Nude Combing Her Hair* (fig. 4; cat. 173; fig. 44 in Chronology), for example. It is a ges-

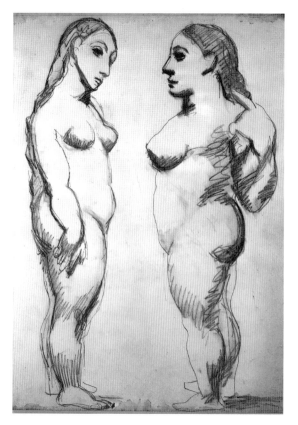

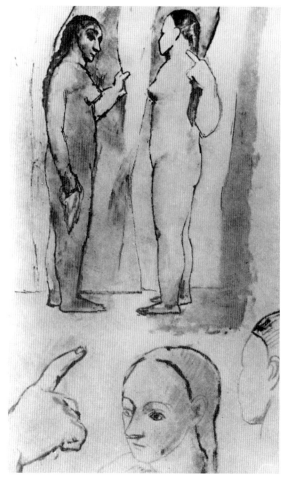

ture common to the *toilette* or *coiffure* motif and
to classical subjects like the Venus Anadyomene,
where an idealized nude wrings her hair as she
emerges from the sea. By the end of the summer
the gesture appeared in a series of small sketches
of an increasingly voluptuous and massive fe-
male nude accompanied by a satyr, her left hand
brought up to her head and her fingers crooked
over her hair (fig. 5), that would eventually be
developed into a series of drawings of two nudes
standing together in either frontal or profile
view (fig. 6).[14] The conventional narcissistic
gesture is wedded in the final studies for *Two
Nudes* to an all-too-emphatic finger that points
toward the head and the curtain beyond. Sev-
eral sketches for the painting isolate the hand
and head and test the possible relations between
pointing hand and *profil perdu* (fig. 7 and
cat. 176).

In the final composition Picasso draws the
arm back behind the head and overlaps the hand
and finger over the hair. The figure both touches
herself and points to herself, to her own absent
countenance, and to the curtain folds held by
her partner. The gesture suggests a degree of
identification with the activity of the artist, rep-

resented in one of the studies for *Self-Portrait
with Palette* (fig. 8), where Picasso depicts his
free-floating right hand, the brush hand, not as
seen in the mirror, but as he saw it directly be-
fore him and bounded by a linear frame, sketch-
ing his bowed head, seen in mirror reflection.
This dialogue of hand and head articulates the
heightened opposition between subject/object
and activity/passivity in the self-portrait.[15] The
hands are altered in the final painting, however
(fig. 9): there the left hand is truncated and de-
formed by the palette—an indistinct smear of
white paint indicating the thumb—while the
brush hand is gathered into a fist quite unlike
the poised and precise tool that appears in the
study, the force of the artist's gesture magnified
but also latent, incomplete, and bound to the
torso.[16] The artist no longer needs the brush, it
seems: his body is his instrument. But this broad
body—hieratic, inert, fragmented, insubstantial,
and deformed—is as equivocal a construction
as the *Two Nudes*.

The odd pointing gesture of the figure on
the right in *Two Nudes* is made more extreme
by the positioning of the arm and shoulder.
Wrenched backward, they open up an area

6. Picasso, *Two Nudes*,
Paris, 1906, pencil on
paper, 63 x 47 (24 3/4 x
18 1/2), The Art Institute
of Chicago, Gift of
Mrs. Potter Palmer

7. Picasso, *Study for
"Two Nudes,"* Paris,
1906, present where-
abouts unknown

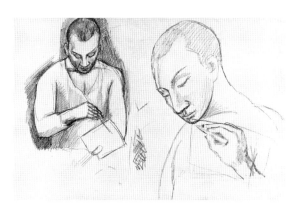

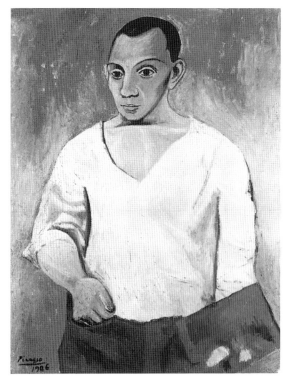

8. Picasso, *Studies for "Self-Portrait with Palette,"* Paris, 1906, pencil on paper, 32.5 x 48 (12¾ x 18⅞), Musée Picasso, Paris

9. Picasso, *Self-Portrait with Palette*, Paris, 1906, oil on canvas, 92 x 73 (36¼ x 28¾), Philadelphia Museum of Art, A. E. Gallatin Collection. See also colorplate 182

between the breast and back, hip and neck that is expanded far beyond any plausible anatomy.[17] A *terrain vague* opens up at the center of the torso, not belonging to front, side, or back. In the area bounded by the prosthesis-like protuberant breast, the muscularly flexed and seemingly detached arm, and the rounded buttocks—prime examples of Picasso's sculptural passages—figuration comes to a halt. The figure is assimilated to the "curtain," to arbitrary modulations that do not adhere to any bodily anatomy. The two bodies rendered sculptural by the modeling of their forms are confronted with the anti- or pre-figurative. As the form dissolves, the mottled, matte surface asserts itself. An area of marks and modulations that expands coextensively with the overall pictorial field, it affirms the body of the painting as material object. The relation of figurative and nonfigurative here suggests opposed versions of materiality: fictions of volume and mass versus mere paint-matter on a surface.

The left-hand figure—grasping the curtain/canvas with one hand and touching her own body with the other—supports the fiction of the body's materiality and presence, and, metaphorically, the painter's activity and the materiality of painting itself. The gesture of the figure on the right both supports that materiality, presence, and activity and produces the "space of lack" in the picture. The pointing finger, moti-

vated in part by the narcissistic *coiffure* gesture, directs the viewer to "look this way." It points to the curtain that materializes momentarily at the center and that veils the space beyond, without allowing imaginary passage through it; it also points to the profile, disappearing from view; and it produces the dissolution of figuration in the torso. This self- and outward-directed gesture subverts the assertion of bodily presence suggested by the massive inflation and muscularity of the two nudes. The monumentality and sculptural modeling of the figures, coupled with the unifying terra-cotta monochrome, compensate only partially for the pull to defiguration, weightlessness, and invisibility. Picasso's use of the emphatic and obscure gesture of the right-hand figure in *Two Nudes* ends up pointing to the picture's high degree of irresolution, to its own processes of negation.

The signifiers of sex and gender in *Two Nudes* are equally ambiguous and contradictory. The figure on the left retains something of the seductive femininity of the Gósol nudes, a seductiveness enhanced by the promise of unveiling. But the gigantism, muscularity, and aggressive spatial presence of *Two Nudes* can also be read as signs of masculinity, linking it to the physical culture drawings of a year earlier, and also to the portrait of the lesbian writer Gertrude Stein, with its imposing presence and indeterminate gendering.[18] The sexed and gendered body is

also represented in the phallic arm and pointing finger, the vaginal curtain opening, and the breast conveniently detaching itself from the torso on the right. But these vividly realized and familiar signifiers appear as displaced body parts, juxtaposed to an image of the body that is at points formless and derealized, within a pictorial space that repeatedly resists the viewer's imaginary access. The viewer's difficulties are exemplified by the characterization of *Two Nudes* as virginal by one writer and as lesbians by another.[19] Such characterizations register Picasso's subversion of the normative accessibility of the eroticized female nude to the (male) viewer's imagination. But what is at work in *Two Nudes* is less the elimination of one set of sexual signifiers than the conjunction of several. Multiple genders and sexualities are offered, and both sexual difference and indifference structure this representation of the body. The figure of narcissism and seduction on the left invites us in, while her twin both emphatically asserts the materiality and legibility of the body and displays its disembodiment and illegibility. If the two figures "mirror" one another at all, it is a doubling based on metamorphosis, not duplication. The body appears as a compelling physical presence that nonetheless dissolves, as a generalized totality that breaks up into fragments, and as a sexuality that unfixes the orders of sexual difference. The residual beauty and sensuality of the Gósol nudes is transformed here into something altogether more primal, more disturbing, and more contradictory—a representation of the body that is on the verge of the incoherent and even the grotesque. The painting equivocates between embodiment and disembodiment, presence and absence, figuration and defiguration, masculinity and femininity.[20]

The fluctuating morphology of the body and testing of the limits of figuration in *Two Nudes* cannot be fully understood apart from the other works Picasso produced in Paris during the critical months after his return from Gósol. The un-

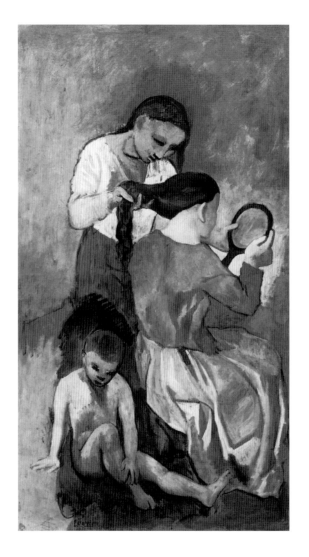

canny quality of Picasso's figuration is evident again in *La Coiffure* (fig. 10), which most scholars now agree was probably reworked during the summer or autumn of 1906.[21] Three figures —a seated woman having her hair combed, a standing maidservant, and a young child—occupy an undefined, empty space. The maidservant's roughly sketched, grotesque, masklike face contrasts sharply with the smooth curves of faceless Beauty's *profil perdu*. The unnaturally high hairline at the nape of the latter's neck creates the unsettling impression that the maid is peeling her mistress' hair away from her head as she grooms it: the *coiffure* is dangerously close to unmasking Beauty.[22] The length of hair at the center of the canvas that the maid holds in her dissolving right hand disintegrates into fluid brush strokes and marks the point of maximum disembodiment. Meanwhile, seated Beauty, her face averted and masked by the blankness of her *profil perdu*, gazes into an empty mirror that echoes the shape of her head without reflecting her features. Something of the disturbance

10. Picasso, *La Coiffure*, Paris, 1906, oil on canvas, 174.9 x 99.7 (68⅞ x 39¼), The Metropolitan Museum of Art, New York, Catharine Lorillard Wolfe Collection, Wolfe Fund. See also colorplate 147

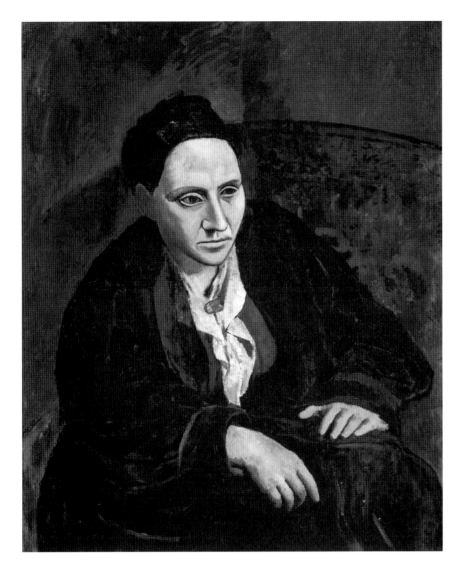

11. Picasso, *Portrait of Gertrude Stein,* Paris, 1906, oil on canvas, 100 x 81.3 (39 ⅜ x 32), The Metropolitan Museum of Art, New York, Bequest of Gertrude Stein. See also color-plate 168

The masking of the figure is a critical component of Picasso's figuration in late 1906— whether this masking is understood as the schematization of the facial features alone or as the production of a complex, unstable image of the body that holds in tension, often to the point of incoherence, differing degrees of reduction, stylization, and embodiment as well as oppositions of gender and sexuality.[26] The mask doubles and obscures, simplifies and stylizes, abstracts and depersonalizes. It fosters layered, mobile, unstable identities and articulates oppositions between inner and outer, true and false, self and other, presence and absence, order and disorder, protection and threat. The mask both exaggerates and undermines the legibility of representation; it both dramatizes voyeurism and obstructs the gaze; it both simplifies and defamiliarizes. Picasso characteristically explores the myriad possibilities of masking—formal, expressive, and conceptual—long before the infamous repainting of *Les Demoiselles d'Avignon.*[27]

Portrait of Gertrude Stein and *Self-Portrait with Palette* (figs. 11 and 9) exemplify the range of Picasso's masking in the autumn of 1906. Stein's head was effaced when Picasso declared "I can't see you any longer" after some eighty or ninety sittings in the Bateau Lavoir studio, and was repainted without further consultation of the model after the artist's return to Paris from Gósol.[28] *Self-Portrait with Palette* is the most important and overt of a series of self-representations produced in late 1906.[29] There are a number of similarities between these two portraits: the impenetrability of the mask-face, the splitting of the head from the torso, and the immense expanse of the figure that is contradicted by the absence of signs of volume or mass.[30] But there are also important differences. The mask in *Self-Portrait with Palette* is blank, rigid, and childlike—effects that are reinforced by the contrast of the overlarge torso and small head, the prominent high forehead, the ear that sticks out on the right, the stiff and silhouetted

caused by the "flipper" of the figure on the left in *Two Nudes* is produced by the hand holding the left side of the mirror in *La Coiffure*: protruding from Beauty's neck, it could belong to either woman.[23] The child, reminiscent of the boys painted at Gósol, lounges in the lower left, complicating the themes of beauty and vanity with those of childhood and maternity.[24] Functioning as a witness and surrogate for the viewer, he is disconnected from the women but reconnected materially to the scene of femininity and to Beauty's (the Mother's) tresses by the hairlike facture and brown color of the broad band of parallel brush strokes that marks him off from the women. The conventional meanings of the *coiffure*—femininity, vanity, artifice, sensuality, eroticism—are still in circulation in Picasso's painting, but sensuality is now associated with disintegration, the female body with fragmentation and loss, the act of representation with blindness and invisibility, the pleasures of the masquerade with the dread of unmasking.[25]

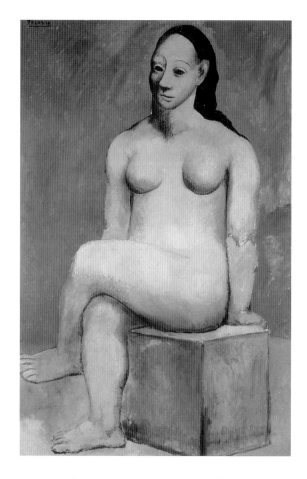

12. Picasso, *Seated Nude*, Paris, 1906, oil on canvas mounted on panel, 151 x 100 (59 ⅜ x 39 ⅜), National Gallery, Prague. See also colorplate 178

pose, the simple studio clothing, and the clumsy suturing of the head onto the body.[31] The mask in *Gertrude Stein* elicits different associations: obscurity, remoteness, obdurateness, implacability.[32] In *Self-Portrait with Palette* the eyes are wide open but unfocused: the usually penetrating, mesmerizing eyes of the artist no longer see. Picasso represents himself as a fixated visionary whose interior hallucination has imprinted itself rigidly on his features. Stein's mask is much more sculptural: dark angular wedges define the brow area as if it had been carved; deep grooves mark either side of the sharply delineated mouth and prominent nose; and a precise outline marks off the right side of the face from the background. Stein's hooded eyes are arrayed at different heights, the right eye larger than the recessive left eye, and Picasso has carefully differentiated between them by coloring the white area of the smaller left eye a subtle gray blue that contrasts with the flesh tone he uses in the right eye and the face itself, thereby increasing the effect of dissymmetry and distance. The emphasis in *Gertrude Stein* is on the dissembling power of the mask: the "real" eyes lie behind the mask, unreadable, a property of the "true" self in distinction to the "false" mask that both shields and blocks. Despite the depersonalizing effect of the mask, the oscillating oppositions it generates animate the portrait and create a vivid and disturbing psychological presence. In *Self-Portrait with Palette*, on the other hand, there is no suggestion of a "true" self behind the mask. The artist presents himself fully objectified, inert, and devoid of consciousness: the body a flimsy monument, the self an effigy. Here the double has fully effaced the original.[33]

Picasso expanded on his study of the nude in the autumn and winter of 1906. In the extraordinary and highly finished drawing *Woman Seated and Woman Standing* (cat. 181), for example, a work that postdates *Two Nudes,* two figures in a curtained interior signal enigmatically toward one another with mirroring hand

gestures that suggest some obscure form of address. These figures are more restrained in their balanced proportions, more stiff in their hieratic postures, more abstract and sculptural in their geometric forms and masked faces than in *Two Nudes.*[34] *Seated Nude* (fig. 12) moves in a very different direction.[35] A large painting of a single giantess presented facing the viewer, the figure is all the more imposing in that, although seated, she is the same height as the standing figures of *Two Nudes.* Like the strongman in the foreground of *Young Acrobat on a Ball* of 1905 (cat. 125), she occupies a cubic throne, her massive silhouette set off against the blue gray background. She tests her swelling volumes against the fixed geometry of her seat.

The inflation of the torso, geometric simplification of the breasts, abrupt suturing of the head, neck, and chest, and schematic mask with its blank expression—all characteristic of *Two Nudes*—reappear in exaggerated form in *Seated Nude.* While the gigantism of *Two Nudes* prevails, there is little emphasis on muscularity, and sculptural bas-relief is activated only in discrete areas like the breasts and legs. The figure is somewhat pneumatic in character, the left hip and thigh bulging ominously.[36] The broad left shoulder descends brokenly to the right, its con-

tour marked off by the dark cascades of hair, while the two arms are stiff, insubstantial, and pinned to the sides.[37] The absence of gesturing hands seems programmatic. The torso is rigidly upright, the abdomen undefined, and the crossing of the legs achieved with a brutal twisting of the hips that wrenches the figure into position, a manipulation equal in violence to the contorted arm of the figure on the right in *Two Nudes*. The bulging surface of the figure stretches against the disproportionate anatomy and inconsistent posture, accommodating itself to the strains of expansion, contraction, and distortion. The scratchy modeling and blurred contours contain the body's boundaries incompletely. The spherical breasts, widely separated and tentatively joined to the torso, are cursory markers of gender that simulate the female body without naturalizing it.[38] As in *Two Nudes*, the figure in *Seated Nude* has itself become a mask: splitting, obscuring, and distorting the body and binding oppositions within a single form.[39]

Picasso's figuration in late 1906 was unprecedented in the rapidity and complexity of its transformations. He expanded on the compositional experiments, figural distortions, gender ambiguities, and sexual tensions of his Blue and Rose period works in a pictorial language that was increasingly purged of *symboliste* personas, attributes, settings, and atmosphere.[40] In works like *Two Nudes, La Coiffure, Portrait of Gertrude Stein, Self-Portrait with Palette,* and *Seated Nude.* Picasso represented the body as an unstable entity, its mass, volume, materiality, integrity, unity, sex, and gender affirmed in one way only to be negated in another. The contradictory liminality of the curtained interior of *Two Nudes* is an apt figure for the representation of the body in Picasso's work in late 1906. Full or empty, unified or fragmented, animated or entropic, monumental or slight, masculine or feminine: such oppositions are alternately articulated, eroded, and conflated in Picasso's image of the body.

Notes

1. The Gósol studies of two figures standing side by side begin as a clothed male/female couple (with the larger male figure on the right) and develop into two clothed peasant women, then two female nudes (Palau 1985, 465, 470–471). Postscripts to *Two Nudes*, like *Woman Seated and Woman Standing* (cat. 181), merge with the first studies for *Les Demoiselles d'Avignon* (see Rubin 1994, 69–71). In addition, there is a sheet of nude studies (D.XVI.20) that includes the *Two Nudes* on the left but expands the number of figures to four and places them within a more articulated interior space that anticipates the brothel of *Les Demoiselles d'Avignon.*

2. The latter work locates the girl arranging her hair, the boy elegantly balancing his vase, and the alert goat on the left in front of a curtained, tent-like interior reminiscent of Picasso's circus pictures of the previous year, and also within the general atmosphere of Mediterranean classicism by virtue of the classical poses, the soft ocher coloring, the unspecific temporality, and the evocation of the beauty and sensuality of the body.

3. Unraveling the multiplicity and contradictions of the sources for Picasso's stylistic transformations in 1906 is not the aim of this essay. Suffice it to say that "classicism" in 1906 was inseparable from diverse forms of "primitivism" and that Picasso was reading both with and against the grain of his artistic precursors and sources. The starting point for any examination of the Iberian component is James Johnson Sweeney's "Picasso and Iberian Sculpture," *Art Bulletin* (September 1941), 190–198.

4. Steinberg 1988, 47–52, interprets this to mean that it is the *demoiselles d'Avignon* who are on the other side of the curtain depicted in *Two Nudes*. The Two Nudes stand on the "sheltered side of the curtain, antecedent to the strains of experience." He has also described the picture as of "a person on the threshold of an encounter, about to pass through the curtain that screens the unmated self." The idea that *Two Nudes* represents "a condition of woman alone," as Steinberg puts it, is one I will counter below.

5. The shardlike shape that extends upward from this pocket adumbrates the drapery facets of *Les Demoiselles d'Avignon.*

6. In the studies for the *Demoiselles* in Sketchbook 42 (pp. 27–36) Picasso would imagine a childlike male figure parting the curtains that roughly matches the generic self-portraits produced in late 1906. See Robert Rosenblum, "The *Demoiselles* Sketchbook No. 42, 1907," *Je suis le cahier: The Sketchbooks of Picasso* [exh. cat., Pace Gallery] (New York, 1986), 76–77. In the final painting the Africanized *demoiselle* on the right performs this role.

7. See, for example, Ron Johnson, "The *Demoiselles d'Avignon* and Dionysian Destruction," *Arts Magazine* 55 (October 1980), 95. Johnson also points to the impenetrability of the space.

8. Rubin 1994, 41, for example, characterizes *Two Nudes* as "Picasso's Iberianism at its most sculptural." See also Daix and Boudaille 1967, 102.

9. *Two Youths* also manifests the mirroring relation and indeterminate gendering of *Two Nudes*.

10. Steinberg 1988, 50, points to the spatial compression and the "disconnection" motif of the hand of the figure on the left.

11. The *profil perdu* was a solution arrived at in the final stages of work on the painting; all of the drawings and sketches that include both figures present the right-hand figure either in profile or frontally (see cat. 175). The *profil perdu*, however, appears in several studies done at Gósol (and after): see Palau 1985, 460, no. 1301, and D.XV.24.

12. The most striking early example would be the gesturing hand and pointing finger of the male figure in *La Vie* of 1903.

13. For several examples of Picasso's preoccupation with the position and gesture of hands see D.XV.4, 19, 22, D.XVI.7, and 9.

14. See the discussion in Palau 1985, 466–467.

15. In *Two Nudes*, however, it is the left hand that points (i.e., the palette hand). Given the distortion of the figure and in particular the detachment of the arm and twisting of the hand itself, this reversal from right to left, from mirror to direct vision, is not irreconcilable with my suggestion that the hand can be interpreted metaphorically as the artist's own. In both *Two Nudes* and the study for *Self-Portrait with Palette* the active hand is matched with a deflected countenance. To complicate matters, in one of the studies for *Two Nudes* (fig. 7) Picasso isolates the pointing hand in the lower left as a right hand, with the two figures above in the same orientation as in the final painting.

16. See Kirk Varnedoe, "Picasso's Self-Portraits," in exh. cat. New York 1996, 132–136. I disagree with his interpretation of the thumb of the palette hand as a "displaced surrogate phallus": the palette hand is too deformed by the palette and, in the context of this kind of reading, would be a better candidate for an image of castration. The smudged white thumb only emerges through the palette indistinctly, hardly registering as part of Picasso's body (although it does appear distinctly in many of the sketches for the painting). The arms of the self-portrait are programmatically differentiated: the thinly painted arm on the right is rigidly straight and aligned with the torso, pinned to it, while on the left the arm is marked off from the torso by a dark curve and the sleeve itself is heavily worked and actively modeled with an abstract faceting that does not register volume or mass. As Varnedoe points out, Picasso aligns the edge of the sleeve on the right with the palette edge, arranging forms autonomously. On the left he produces a clumsy broadening of the torso by extending the blue fabric of the trousers out too far, increasing the impression of the figure as broad, flat, and insubstantial. The forearm and fist hang at the waist, with no sense of potential force or movement. See text for further discussion of *Self-Portrait with Palette*.

17. The degree of distortion and willful manipulation of the body is close to the deformations to come in *Les Demoiselles d'Avignon* (fig. 2)—particularly the squatting figure on the right, shown from both front and back.

18. Robert Lubar explores the question of identity in his unpublished paper on *Portrait of Gertrude Stein*, "Unmasking Pablo's Gertrude: Queer Desire and the Origins of Cubism."

19. See Steinberg 1988, 47; and Richardson 1991, 469.

20. For a related discussion of Matisse's *Le Bonheur de vivre*—a work Picasso would have seen in the spring of 1906 at the Salon des Indépendants—in terms of the breakdown of normative oppositions of gender and sexuality, see my "Engendering Imaginary Modernism: Henri Matisse's *Le Bonheur de vivre*," *Genders* 9 (Fall 1990), 49–74.

21. The reworking is visible on the surface of the painting. The *coiffure* subject originates in the circus studies of 1905 and was first dated to that year. On the dating see Alfred H. Barr, *Picasso: Fifty Years of His Art* [exh. cat., Museum of Modern Art] (New York, 1946), 43; Daix and Boudaille 1967, 102; Richardson 1991, 428; and exh. cat. Barcelona 1992, 364–367.

22. A comparison of this passage in *La Coiffure* with the gesture of the right-hand figure *Two Nudes* suggests "unmasking" as another layer of meaning for the latter.

23. In one of the preparatory sketches in the Barnes Foundation, the left hand on the mirror is clearly that of the maid.

24. A child, often an infant, sometimes accompanies the *coiffure* motif in the circus studies of 1905, but I know of no composition studies with a child like the one in the final canvas.

25. *Man, Woman, and Child* (Kunstmuseum, Basel), probably painted in late 1906 or early 1907, includes a similarly charged triangle, one that is more explicitly oedipal. The child is rejoined to the mother and looks directly out at the viewer, while the father (one of the disguised self-portraits) looks down at the seated mother, seen in profile.

26. Picasso's masking of the figure begins in earnest at Gósol, with the studies after Fernande and the innkeeper Josep Fontdevila. A recent discussion of the impact of the Gósol masking appears in William Rubin, "Reflections on Picasso and Portraiture," in exh. cat. New York 1996, 28–29.

27. On the masking of *Les Demoiselles d'Avignon* see Rubin 1994, 91–95, 103–116.

28. For Stein's account see Stein 1961, 53, 57.

29. Other examples include *Self-Portrait* (Musée Picasso, Paris), *Nude Boy* (fig. 16 in Rosenblum essay), and *Man, Woman, and Child* (Kunstmuseum, Basel).

30. In *Portrait of Gertrude Stein* the sitter's imposing presence is certainly a match for the monumentality of the *Two Nudes,* and it has been suggested that there may be a connection between Gertrude and the expanding girth of Picasso's figures in late 1906. Johnson 1980, 94, suggests the bodies of *Two Nudes* are in part a composite of Gertrude and Fernande. See also Richardson 1991, 469. The monumental breadth of the figure in *Gertrude Stein* is contradicted, however, by the absence of any sense of the weight, mass, or anatomy of the body underneath the all-consuming brown robe. There is no "sculptural" treatment of the figure apart from the mask itself.

31. Both Palau 1985, 477, and Richardson 1991, 452 and 519 n. 45, suggest that the flat mask, hieratic posture, and unfocused eyes of Picasso's figures in the summer and autumn may owe more to the twelfth-century Gósol Madonna than to Iberian stone sculpture.

32. Several authors have associated the Stein mask with Picasso's studies of the old innkeeper Josep Fontdevila (see Palau 1985, 469). Richardson 1991, 453, 456, adds Ingres' *Tu Marcellus Eris* and the sculpture *Bust of Josep Fontdevila* as sources possibly as important as the Iberian reliefs Picasso would have seen in the Louvre in the spring of 1906. See also Pierre Daix, "Portraiture in Picasso's Primitivism and Cubism," in exh. cat. New York 1996, 266–268.

33. Varnedoe's characterization of the *Self-Portrait with Palette* (in exh. cat. New York 1996, 135) comes closest to my own. His emphasis on "blankness" and "stoniness" is appropriate, but my reading also seeks to register the morbidity of this self-portrait, due to the petrification, insubstantiality, and passivity of the figure.

34. See Gary Tinterow in exh. cat. Cambridge [MA], 1981, 76–77.

35. While *Seated Nude* was most likely painted before the drawing just mentioned, its exact dating is uncertain. I would date it to the period just after *Two Nudes.*

36. See John Golding and Elizabeth Cowling, *Picasso: Sculptor/Painter* [exh. cat., Tate Gallery] (London, 1994), 18.

37. The latter feature links *Seated Nude* to *Bust of a Woman* (cat. 179), *Self-Portrait with Palette* (fig. 9), and *Self-Portrait* (Musée Picasso, Paris).

38. Picasso explores this androgynous handling of the chest again in a related work, *Bust of a Woman* (cat. 179), as well as in two studies entitled *Bust of a Woman* (D.XVI.23, 24). *Seated Male Nude* (Barnes Foundation, Merion, PA), presenting in a pose similar to that seen in *Seated Nude,* also attests to the mobility of gender in Picasso's figuration at this time.

39. Perhaps the most explicit manifestation of the latter tendency is the study for the seated *demoiselle* on the right in *Les Demoiselles d'Avignon* that conflates the mask-face with the "masked" torso. See Rubin 1994, 88, figs. 182–184.

40. The gender ambiguities of Picasso's figuration seem to have undergone a reversal, from the femininized male figures of the Rose period to the masculinized female figures of 1906.

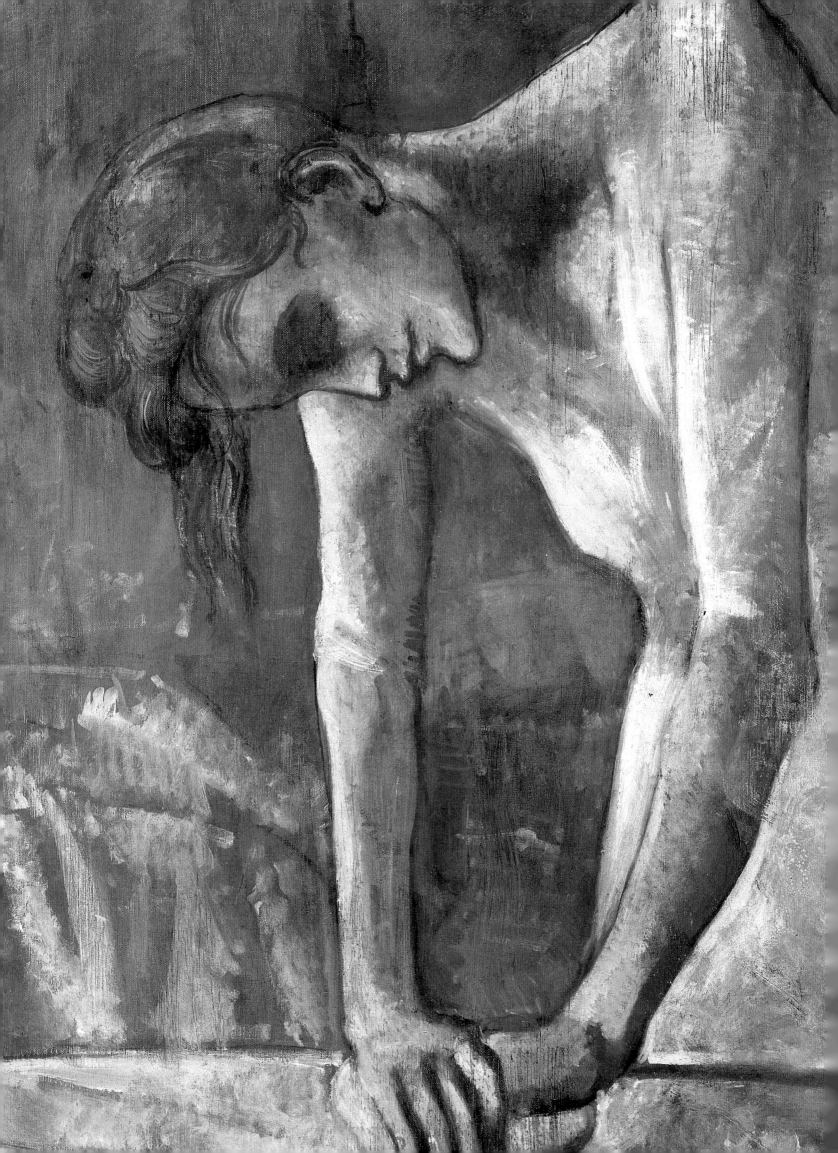

Barging into Art History:
Subject and Style in Picasso's Early Work

Mark Rosenthal

Picasso was an immensely talented, intuitive artist who produced a remarkable body of work even in what amounts to his youth, an oeuvre that is at once inventive, expressive, and pictorially varied. To do so, he searched with determination throughout the history of art for inspiration. He once explained to a friend, "In art one must kill one's father."[1] But this is misleading in its brevity. Picasso first had to assimilate a host of stylistic sources and to master the lessons of his artistic forefathers. Only then could he figuratively commit murder—that is, dominate, manipulate, parody, pastiche, and reinvent these models to produce something new. It was in this way that he, together with Georges Braque, was able to create cubism, the revolutionary movement that changed the course of art history. Scholars have shown how Picasso absorbed and "Picassified" the styles of earlier painters[2] but have less often discussed the artist's equally deliberate appropriation of art historical subjects. Inventing new themes, he would say, was nearly impossible—for Picasso, subjects like styles were a matter of interpretation and reinterpretation.

Picasso's initial stylistic and thematic assimilation was enacted literally in relation to his father, José Ruiz Blasco, a conservative art teacher. Having demonstrated in his adolescence that he could draw with enormous mastery, Picasso surpassed his father's academic formulas, establishing the pattern of first practicing then either rejecting or subsuming a source of inspiration. Some of his earliest and largest compositions done for exhibition were traditional subjects: *First Communion* of 1896 and *Science and Charity* of 1897 (see figs. 8 and 10 in Chronology), which presage a persistent tendency in his work toward themes of religion, mortality, filial relationships, and grief. Notwithstanding the specificity of the subjects of these two paintings, Picasso soon came to prefer the possibilities of suggestion. He later cited an old Spanish proverb to explain: "'If it has a

beard, it's a man; if it doesn't have a beard, it's a woman.' Or, in another version: 'If it has a beard, it's Saint Joseph; if it doesn't have a beard, it's the Virgin Mary.' Wonderful proverb, isn't it? When I have a blank sheet of paper in front of me, it runs through my mind all the time."[3] It ought to instruct the minds of his viewers as well.

Whether honorific or playful, a central aspect of Picasso's methodology was to copy or work "in the manner of" other artists, for by doing so, he was able to define his own particular style. As he later exclaimed, "What does it mean . . . for a painter to paint in the manner of So-and-So or actually to imitate someone else? What's wrong with that? On the contrary, it's a good idea. You should constantly try to paint like someone else. But the thing is, you can't! You would like to. You try. But it turns out to be a botch. . . . And it's at the very moment you make a botch of it that you're yourself."[4] Such an approach, while respectful of the past and its precedents, also shows how Picasso rooted himself in history. He had no interest in confining himself to his own work as a source,[5] for that would have resulted in hermeticism and separation from the mainstream of art history. To the extent that pastiche suggests a certain promiscuity with regard to style, Picasso's work can be seen as extravagant, because he took ideas from everywhere, adapting them as his purpose demanded. This almost postmodern attitude toward coopting, parodying, or caricaturing another's work was common at the time.[6]

When Picasso arrived in Paris for the first time at the beginning of this century, he discovered a new world of subject matter that celebrated modern life. But the charms of French impressionism became anathema to this disciple of Nietzsche,[7] Jarry, and other rebellious souls, including Bottini, Toulouse-Lautrec, and Steinlen, who offered views that contrasted powerfully with those of the impressionists. Picasso's views of flower sellers, beggars, and the forlorn

streets of Montmartre bear scant resemblance to the colorful, light-filled scenes by the impressionists that convey the delights of urban life. Picasso's violent *Embrace* of 1900 (cat. 41)[8] should be seen as a critique of the romantic odes of Renoir and his generation. In Picasso's words, "art is never chaste."[9] Although his own *Moulin de la Galette* of 1900 (cat. 40) is in the mold of many contemporary views of lively café life and his subsequent absinthe drinkers are variations on these themes, such images depict a demimonde far removed from the conventional pleasures of Renoir's riverside gatherings. While the mood of Picasso's *Frugal Repast* of 1904 (cats. 104, 105) builds on the expressions of alcoholic despair in works such as *At "La Mie,"* of 1891 by Toulouse-Lautrec (Museum of Fine Arts, Boston), the bohemian existence the young Picasso lived from 1901 through 1904 led him to imbue the café theme with a gloom and an emotional and financial destitution that are yet more palpable.

Picasso respected his predecessors but was eager to replace their achievements with his own. Already in 1900 he had signed several small works "Yo el Rey" (I, the King).[10] Although the claim was still premature, soon enough Picasso was like a rampaging river, overtaking art history. The subject that would embody his tremendous ego was of course the self-portrait. *Self-Portrait in a Wig* of c. 1897 (cat. 12) gives an early indication of Picasso's desire to transform and transcend history through playful mockery. A self-portrait of 1901 inscribed with the familiar "Yo" (fig. 1) is similarly defiant. For its romanticized intensity the canvas can be compared to Poussin's bold *Self-Portrait* (Musée du Louvre, Paris).[11] A year later Picasso conveys the self-assurance and determination of an artist entering his maturity in his blue *Self-Portrait* (cat. 77). Producing his first sustained body of work during the Blue period that followed, Picasso offered sympathetic depictions of the plight of the poor, with the primary

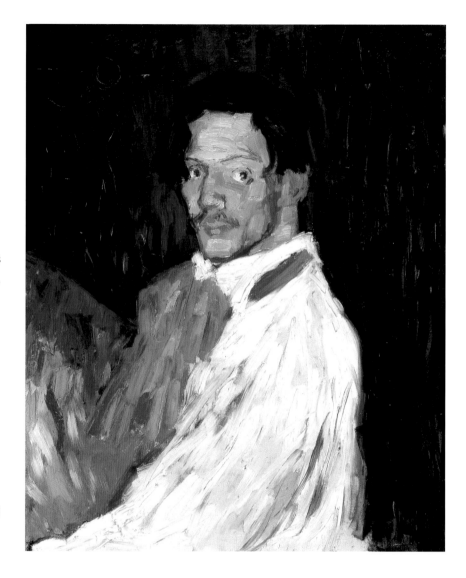

exceptions to the blue world of futility being the self-portraits. Not abject in the least, these works provide a view of the creator coming into his own.

If there was an ego among an older generation of artists in Paris as omnipresent as Picasso's, it belonged to Auguste Rodin. In 1902 Picasso photographed some of his own works in his atelier, and noticeable on the wall behind them is a reproduction of Rodin's *Thinker.*[12] This is but one indication of the younger artist's admiration for the great sculptor. At about this time Picasso's work had begun to integrate Rodin's expressive use of physical poses to reveal psychological states.[13] One of the sculptor's most distinctive and notable poses shows a figure with its head grotesquely bent over, as if in resignation to either the human condition in general or old age specifically; prominent examples are his *Shades* of 1880 atop *The Gates of Hell, Adam* of 1880, and *Eve* of 1881. Although Picasso first used this pose in

1. Picasso, *Self-Portrait "Yo Picasso,"* Paris, 1901, oil on canvas, 73.7 x 59 (29 x 23 ¼), private collection

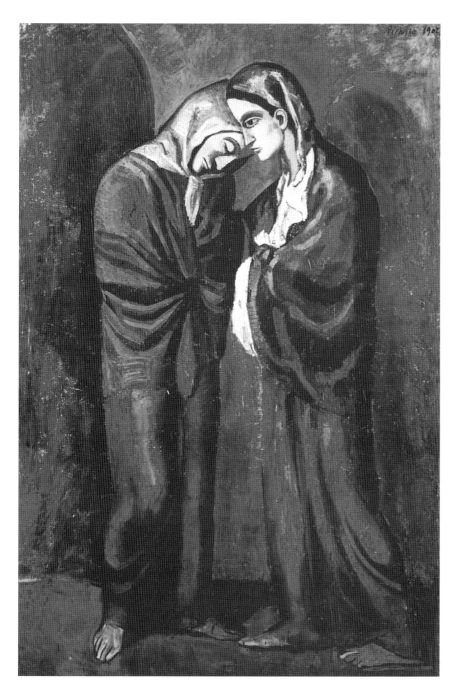

2. Picasso, *Two Sisters*, Barcelona, 1902, oil on panel, 152 x 100 (59⅞ x 39⅜), The State Hermitage Museum, St. Petersburg

3. Rodin, *The Three Shades*, 1880, bronze, The Museum of Modern Art, New York, Mary Sisler Bequest

conventional and appropriate situations—for instance, a woman washing herself in *Le Tub (The Blue Room)* of 1901 (cat. 71)[14]—he soon invested it with a more dramatic and content-driven meaning, following Rodin's example. In the drawn and painted versions of *Two Sisters* of 1901–1902 (cat. 78 and fig. 2) the humbled condition of the women is implied by the exaggerated position of the expressive heads.[15] Many

other works of the Blue period—including *La Soupe* of 1902, *Tragedy* and *Blind Man's Meal* of 1903, and *Woman Ironing* of 1904 (cats. 86, 92, 94, 106)—incorporate this pose, reflecting once again the impact of Rodin (see fig. 3).[16]

As the hopelessness expressed by the bent-over pose relates specifically to the subject of the damned in Rodin's *Gates of Hell*, Picasso's figures may be seen in a similar light. Picasso portrayed a real-life hell in his depictions of the suffering and doomed prostitutes in the Saint-Lazare prison who were infected with venereal disease. Along with many of his other subjects from 1902 through 1904, these images have a purgatorial tone that suggests a poverty-stricken and guilt-ridden world. Abandoned or crying out, Picasso's Blue period figures project an inestimable but dignified sadness. They describe the state of Adam and Eve after the Fall.[17]

The many couples and families that Picasso depicted clinging to one another or wandering in desolate places—in *Tragedy*, for instance—can be interpreted as the damned, expelled from Eden.[18] The absence of vegetation or visual lushness in the settings defines a hellish world, at a time when the earthly garden has died. Although

many expulsion scenes could have influenced Picasso, Masaccio's painful, iconic image of Adam and Eve in the Brancacci Chapel, c. 1427 (fig. 4), with its barren landscape, would be an especially apt model for the despairing couples in *The Embrace* (fig. 5) or *La Vie* (cat. 93), both of 1903.

Rodin's well-known *Crouching Woman* of 1880–1882 and van Gogh's drawing of *Sorrow* are further contemporary examples that Picasso would have known. He would repeat and synthesize these images,[20] using the bent-over pose to express inhibited action or circumscribed existence. The screaming figures of Rodin's *The Cry* and Masaccio's Eve communicate another level of suffering, but this expression occurs often in the history of art.[21]

Michelangelo's *Last Judgment* could also have served as an obvious precedent for a repre-

4. Masaccio, *Expulsion from Paradise*, c. 1427, fresco, Brancacci Chapel, Florence

5. Picasso, *The Embrace*, Barcelona, 1903, pastel on paper, 98 x 57 (38 5/8 x 22 3/8), Musée de l'Orangerie, Paris, Jean Walter and Paul Guillaume Collection

sentation of the damned. Yet Picasso said of this work in 1946 that it could not be "truly worked out" in all its details, that such a task was more than any one artist could accomplish.[22] He determined that the best way for him to convey the concept of hell was through poignant vignettes.[23] The two exceptions during the Blue period were *The Burial of Casagemas (Evocation)* from 1901 and *La Vie* (cats. 70, 93), both of which encompass complex narratives.

Through 1903 Picasso imbued his characters with many of the qualities he discovered in Velázquez, whose early figures generally display a venerable, if impoverished condition. Velázquez' baroque realism, by which religious or godly personages are rendered in humble settings, inspired the younger Spaniard. Like Velázquez, Picasso often incorporated a lowly still-life motif to characterize figures in his Blue period compositions, such as *Blind Man's Meal*.[24] And his *Old Guitarist* of 1903 (fig. 26 in Chronology) recalls the sympathetic treatment of elderly figures of wisdom in the golden age of Spanish art. One should also remember the proverb Picasso cited about images of bearded men, for here and elsewhere in the Blue period simple poverty takes on the aura of saintliness. The *Old Guitarist* represents an amalgam of sources, including perhaps Titian's great *Saint Sebastian* of 1520–1522 (Santi Nazaro e Celso, Brescia), with its claustrophobic space crowding the figure, although Picasso has substituted a hero from the streets with the slumped head of a Rodin *Shade*.

As Theodore Reff has observed, *La Vie* may represent the most complete statement of the Tree of Life theme in Picasso's work.[25] Adam and Eve appear at the left, Mary at the right, and the fallen couple (depicted on a canvas) in the upper center. As a portrayal of life, the painting also subsumes old age (shown on another canvas) at the bottom center. Although Picasso may have wanted to eulogize his friend Casagemas' suffering and eventual suicide, the work underwent the process Picasso described as follows: "There

are, basically, very few subjects. Everybody is repeating them. Venus and Love become the Virgin and Child, then—maternity, but it's always the same subject. It's magnificent to invent new subjects."[26] One theme converges with another; a specific couple (Carles Casagemas and Germaine Gargallo) becomes Adam and Eve, and then an expression of the human condition in general. Although styles of the past might appear and disappear in Picasso's oeuvre, earlier subjects remained in play.

Within the Blue period's miasma of melancholy Picasso was on occasion commissioned to paint portraits. Sometimes, as was the case with the *Soler Family* of 1903 (Musée des Beaux-Arts, Liège),[27] the artist worked on these from photographs. The simple setting and the subject of the picnic added a sense of the fundamental values, prosperity and family stability, that the client might have desired. Yet in other compositions that depict family groups, such as *Family at Supper* of 1903 (cat. 97), Picasso effects a transformation that is closer in spirit to compositions by van Gogh, notably his *Potato Eaters* (Rijksmuseum Vincent van Gogh, Amsterdam). It is typical of the artist's progress during the Blue period that what began as an anecdotal rendering on paper becomes in the painted version an iconic image in which the subject has the force of a moral lesson for the viewer.

During 1904, however, there is a transition from the cast of saintly or condemned personages to a more secular company. This change coincides with the emergence of the Rose period and Picasso's permanent move from Barcelona to Paris in April. Picasso painted several two-figure compositions—some of them sleeping women—and opened up their meaning to a variety of interpretations. Building on examples such as Toulouse-Lautrec's *Two Friends* of 1895 (Bührle Collection, Zurich) and Courbet's *Sleep* of 1866 (Petit Palais, Paris), Picasso represented lesbian relationships. Picasso's rendering of *Two Friends* (Collection Lionel Prejger) has a wanton

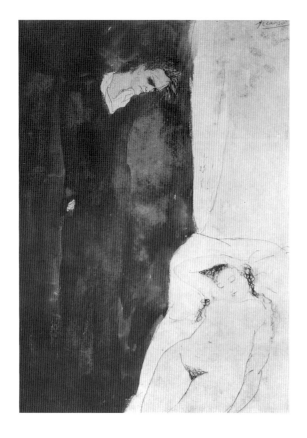

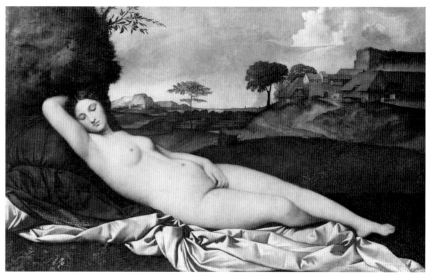

aspect, reflecting his thoughts about chasteness. By contrast, his slumbering women often have a Gauguinesque air of innocence. These figures introduce the subject of a sleeping nymph or perhaps a Venus, which evoke numerous familiar precedents. The position of the arm behind the head of the woman in *Debienne Watching Fernande Asleep* of 1904 (fig. 6) or in *Meditation* of 1904 (cat. 110) recalls the pose of Giorgione's and Titian's *Sleeping Venus* of c. 1505–1510 (fig. 7). Whereas Titian's many depictions of Venus usually show her awake, Picasso's nymphs sleep. The nymph or Venus is usually attended or watched by secondary figures.[28] Picasso's seemingly innocent—even chaste—nudes of 1904 echoed and merged with the Madonna and Child subjects that appeared in the same year.[29]

As Reff has pointed out, the contrast between two types of women in Picasso's work of the Blue period reveals the artist's fascination with the theme of sacred versus profane love.[30] Mary Mathews Gedo and Gary Tinterow suggest that this idea lies at the heart of *Two Sisters*,[31] and it likely informs a great deal more of his imagery. Picasso was reluctant to treat both sacred and profane love—let alone hell—within the same work, as Titian had (although he attempted it

in *The Burial of Casagemas*). Whereas Titian established a kind of dialectical tension between, in effect, celestial and terrestrial realms, Picasso tended to isolate one or the other. Numerous Blue period figures recall the female on the left in Titian's *Sacred and Profane Love* of c. 1514 (Galleria Borghese, Rome): an earthly, materially happy goddess. Picasso's nudes, while often understood as prostitutes at work, could at the same time signify divine love. Picasso thus created a great mélange of oppositions and linkages—Madonna/whore, Venus/fallen Venus, Eve before/Eve after—as he played with the precedents established by Titian, Gauguin, and others, transforming them into contemporary renderings.

In 1905 Picasso brought the theme of innocence to the fore in the saltimbanque series. But filled as these images are with real-life destitution, they counter the paradisaical outlook of artists such as Gauguin. The presence of clothing suggests a fettered if not damned innocence, yet the melancholy series is nevertheless replete with a profoundly felt, domestic bliss. A favorite saltimbanque theme concerns the woman/mother, and in this case Picasso's reverence for Raphael and his tender scenes of the Madonna and Child could have provided inspiration.[32]

6. Picasso, *Debienne Watching Fernande Asleep*, Paris, 1904, watercolor and ink on paper, 36 x 26 (14 1/8 x 10 5/8), private collection. See also colorplate 109

7. Titian and Giorgione, *Sleeping Venus*, c. 1507–1510, oil on canvas, 108.6 x 175.3 (42 3/4 x 69), Gemäldegalerie Alte Meister, Dresden

As a symbol of Picasso's bohemian existence, the saltimbanque persona also became a camouflaged identity for the artist. Picasso usually depicted the traveling comedians in costume, but off-duty, as it were. While the costume may evoke the life of an artist compelled to perform for an unappreciative audience, these figures are still free to partake of the simple pleasures of the family. This kind of representation of costumed individuals had precedents that Picasso unquestionably knew: Degas had shown dancers offstage, as Toulouse-Lautrec had shown prostitutes relaxing in brothel settings. Older masters such as Velázquez in *Mars* of 1640–1642 (Museo del Prado, Madrid) sometimes depicted mythical figures with a few of their accoutrements, but partly unclothed and in repose. Picasso followed this convention, but his purpose was to reveal a domestic privacy and even melancholy. It is noteworthy that no defiant or even confident self-portrait appeared at this time; Picasso showed himself as a saltimbanque, surrounded by family.

In the great work of 1905, *The Family of Saltimbanques* (cat. 137), the blank background again conjures up the sense of a bereft world after the Fall, with the figures as ciphers of the human condition. The artist is present, with his back to the viewer. This composition might be seen as Picasso's thematic response to a nexus of works—including Bellini's *Feast of Gods* of 1514 (National Gallery of Art, Washington) and Titian's *Bacchanal of the Andrians* of c. 1518 (Museo del Prado, Madrid)[33]—in which the revelry of the gods occurs in a lush landscape, with a nude, sleeping nymph at the right. Picasso's variant is utterly chaste; clothed human figures full of domestic gravitas and pensive melancholy, inhabit a barren setting, and a woman at the right subtly and yet authoritatively dominates the scene. There is no joy, only dignity and perhaps peace.

For *The Harem* of 1906 (cat. 155) Picasso based the exotic whorehouse atmosphere and individual figures on Delacroix' *Death of Sardanapolis* from 1827 and *Women of Algiers* from 1834 and on Ingres' *Turkish Bath* from 1862 (all Musée du Louvre, Paris),[34] but his vision is more bizarre and confusing. A male in the right foreground, by virtue of his enormous size, presides like a sultan or keeper over the quasi-bacchanalian events. The size difference between this figure and the females creates the impression of a meeting between two kinds of beings. The architecture of this pleasure palace suggests a prison or hospital, recalling the Saint-Lazare theme, or Goya's *Madhouse* of c. 1800 (Museo del Prado, Madrid), in which delirium has replaced suffering. The painting depicts a harem, a place for guiltless debauchery, as practiced by the gods and painted by earlier masters. It represents a first step (culminating in *Les Demoiselles d'Avignon*) toward the invention of Picasso's "magnificent" new subject, one that states and resolves the opposition of sacred and profane presented in images as ambiguous as Titian's and as multivalent as Gauguin's.

Another massive figure appears as a strongman in *Young Acrobat on a Ball* of 1905 (cat. 121), where a profound domestic tranquillity exists between two beings of different scale and hue. Two types have likewise been conjoined in *La Toilette* of 1906 (cat. 154), a work that owes much to Rubens' *Toilet of Venus* (Museo del Prado, Madrid). As in Titian's *Sacred and Profane Love*, it is not certain whether the figures in *La Toilette* belong to the same sphere or whether one might be godly and one human. Gods as humans, humans as gods, Picasso in 1906 conflates historical models and creates a new race of beings. Whether nude or clothed, the members of this pantheon have an inherent purity that represents Picasso's response to Gauguin's imagery of the pure Tahitians.

Human and divine aspects coalesce in such classicizing figures as *Boy with a Pipe* and *Woman with a Fan*, both of 1905, and *Nude with Clasped Hands* of 1906 (cats. 138, 140,

153), imparting the virtues and monumentality of gods and goddesses. Instead of the exaggerated expressive poses of the Blue period, silent and inscrutable demeanors characterize the solitary figures of 1905 and 1906. Isolated from any narrative, each gesture becomes an inexplicable pantomime. Picasso used anecdotal drawings to develop the figures in both *Majorcan Girl* of 1905 (Pushkin Museum, Moscow) and *Woman with Loaves* of 1906 (cat. 161), molding them into icons of primitive yet enduring values. The former can be seen as Picasso's reformulation of Cézanne's *Four Seasons: Fall* of c. 1860–1862 (Musée de la Ville de Paris), and the latter as his version of Goya's *Milkmaid of Bordeaux* from 1827 (Museo del Prado, Madrid). In *Majorcan Girl* and *Woman with Loaves* Corot's and Ingres' forms of beauty have been replaced with that of the exotic, rural princess.

Notwithstanding that Ingres' portrait of *Louis Bertin* from 1832 (Musée du Louvre, Paris) is a probable model for the imposing *Portrait of Gertrude Stein* of 1906 (cat. 168), Picasso has brought into question if not reconceived the notion of beauty and all forms of classicizing. A kind of plainspokenness prevails that is not only anti-classical and anti-beautiful but solid, assertive, and unrelenting. Similarly, the Prague *Seated Nude* (cat. 178) and the Philadelphia *Woman Seated and Woman Standing* (fig. 8) depict oversized, godlike creatures, yet they are awkwardly defined, with thick necks out of kilter in relation to the heads. The Hermitage *Ephebe* of 1906 (cat. 144) suggests a perversion of heroic figuration in which the antique and Rodin are turned on their heads in favor of a new, deliberately ungainly ideal. Goya's Nude Maja become all-too-human in *Reclining Nude (Fernande)* of 1906 (cat. 160).[35] In these works we witness a sort of caricature, applied not randomly, but for the purpose of creating a new understanding of beauty.

Perhaps the "father" who would never be rejected was Cézanne. The distracted melancholy

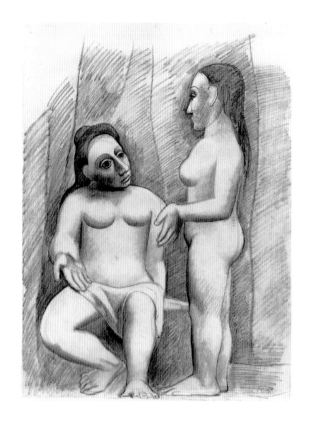

of Picasso's early figures—the blind seers, harlequins, and godlike humans—all echo Cézanne. The older artist's "torment" fascinated Picasso, but the evolution from the anguish of Cézanne's earlier years to his more taciturn formalism and desolate, yet monumental, figure style may have also preoccupied him.

Having absorbed the lessons of his artistic forebears by 1906, Picasso made good on his 1900 boast, "Yo el Rey." His self-portraits stand apart from the rest of his work, telling of his unabashed confidence and ambition. The series culminates with his 1906 *Self-Portrait with Palette* (cat. 182), in which the artist, with one hand a fist, is the Nietzschean figure who will do as he wants. Picasso said of himself: "A tenor hits a note higher than that written in the score— I!"; "God is really another artist . . . like me"; "I am God, I am God, I am God."[36] Such grandiloquence is bewildering and delusional, but it enabled Picasso to "kill [his] . . . father." In the process of committing the "crime," Picasso produced some of his most compelling works and revealed that an essential aspect of his creativity would always concern an active engagement with art history.

8. Picasso, *Woman Seated and Woman Standing,* Paris, 1906, charcoal on Ingres paper, 67 x 48 (26 3/8 x 18 7/8), Philadelphia Museum of Art, The Louise and Walter Arensberg Collection. See also colorplate 181

Notes

1. Richardson 1991, 95.

2. Richardson 1991, 95, 126, 269.

3. Picasso to Brassaï (Ashton 1972, 107).

4. Quoted by Hélène Parmelin (Ashton 1972, 53).

5. See Ashton 1972, 51–53.

6. For further discussion see Jeffrey Weiss, *The Popular Culture of Modern Art: Picasso, Duchamp, and Avant-Gardism* (New Haven and London, 1994), 146–149.

7. See Rosenthal 1980, 87–91.

8. Picasso's scenes of an embrace might have started from a study of Bernini. Note the similarity between the violent *Embrace* (reproduced in Palau 1985, pl. 472) and Bernini's *Pluto and Prosperpina* and *Apollo and Daphne* (both Galleria Borghese, Rome).

9. Quoted by Antonina Vallentin (Ashton 1972, 15).

10. See his *Self-Portrait* of 1900 in the Metropolitan Museum of Art, New York. The same designation appears in a sketchbook of 1900, in the collection of the Musée Picasso, Paris (see Richardson 1991, 156–157).

11. Richardson 1991, 228.

12. Reproduced in Anne Baldassari, *Picasso Photographe 1901–1916* (Paris, 1994), 142.

13. Albert Elsen quotes Rodin saying about certain poses of the human body, "I seek its psychology," in *Rodin* [exh. cat., Museum of Modern Art] (New York, 1963), 57.

14. See also *Drunk Woman Drowsing* (Palau 1985, pl. 732).

15. El Greco also plays a role in relation to *Two Sisters* (see Richardson 1991, 429–431).

16. See also *Christ of Montmartre* (fig. 5 in Weiss essay) and *Sleeping Nude* (Z.I.234), both of 1904. Richardson 1991, 302, emphasizes the mannerist character of this pose.

17. There are a few images of an apparently guiltless Eve, before the Fall (see Reff 1980, 27, and Palau 1985, pl. 761). But the Blue period is dominated by figures after the Fall.

18. See also Z.I.381; Z.VI.440; and Z.XXI.409.

19. The comparison with van Gogh is made in Richardson 1991, 211.

20. Compare Rodin's *Old Woman* with Picasso's *Old Woman Stretching Out Her Hands to the Fire* of 1903 (Museu Picasso, Barcelona).

21. Richardson 1991, 254, proposes that the open-mouthed figures may derive from Poussin's *Massacre of the Innocents* and *Rape of Sabines*; compare Z.VI.533, 539; Z.XXII.49; 533; and Spies 1983, 2.

22. Quoted by Daniel-Henri Kahnweiler (Ashton 1972, 170).

23. Religious art per se held sporadic interest for Picasso; he admired Raphael for his ability to paint such subjects "without being himself religious"; and he expressed the opinion that "two statements can exist at the same time" (quoted by Felipe Cossio Del Pomar, in Ashton 1972, 121).

24. See, for example, Velázquez' *An Old Woman Cooking Eggs* of 1618 (National Gallery of Scotland, Edinburgh.

25. Reff 1980, 27.

26. Quoted by Daniel-Henri Kahnweiler (Ashton 1972, 36).

27. Picasso's focus in this painting appropriates the sincerity of Cézanne and van Gogh, artists whom Picasso admired for their integrity as much as for their "torment" (see Ashton 1972, 11).

28. See also Gauguin's *Manao tupapau* of 1892 (Albright-Knox Art Gallery, Buffalo) in which the attendant is a specter.

29. See Z.I.229; Z.VI.654; and Z.XXII.93.

30. Reff 1980, 19.

31. Mary Mathews Gedo, *Art as Autobiography* (Chicago, 1980), 45; Gary Tinterow in exh. cat. Cambridge [MA], 1981, 46.

32. Ashton 1972, 121. Reff 1971, 38, specifically notes that Raphael's *Holy Family* may have served as a model for *Harlequin's Family with an Ape* (cat. 122).

33. Numerous other sources may have inspired this work, including the Le Nain brothers (see Richardson 1991, 385), Manet, Watteau, Cézanne, and Seurat, among others; see E. A. Carmean, *Picasso: The Saltimbanques* [exh. cat., National Gallery of Art] (Washington, 1980).

34. Titian's *Venus Anadyomene* of c. 1520–1525 could have been the inspiration for the large figure at the left in *The Harem*, apparently combing or drying her hair; indeed numerous other figures of this time have the same pose (see Z.I.249, 336, 337, 341, 344; Z.VI.627, 743, 751; Z.XXII.438; and Spies 1983, 7).

35. Compare also Z.I.348 and Z.XXII.463.

36. So grand would Picasso's thinking become that he would describe another "father," Michelangelo, as "a shackled hero"; see André Malraux, *Picasso's Mask*, trans. June and Jacques Guicharnaud (New York, 1976), 32. For other quotations see Ashton 1972, 80, and Richardson 1991, 463.

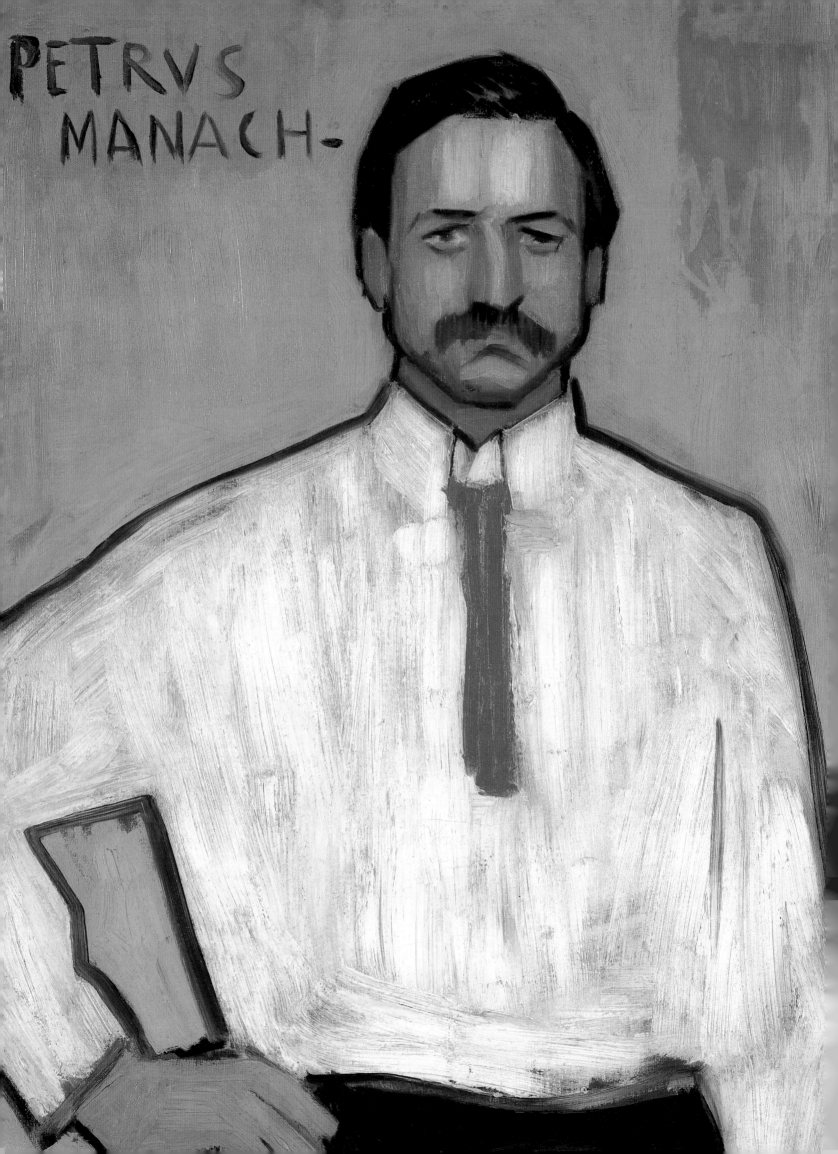

PETRVS
MANACH·

Works in Progress: Pablo Picasso's Hidden Images

Ann Hoenigswald

More than fifty years after completing the 1901 *Seated Woman and Child* (cat. 73), Picasso was asked to discuss the painting. It is reported that he replied with a "touch of regret," mentioning a lost work that lay beneath it. "Maybe one could still see it if one radiographed the painting," he suggested.[1] Picasso had painted a portrait of a friend, the poet Max Jacob, which he later painted over, and he recognized that there was a means of revealing the earlier picture. In addition to alerting us in this way to the existence of a hidden image, however, Picasso left visual clues on the surface of the final painting, as he did on many others.

Researchers can often recognize that alterations have been made in a painting by observing variations in the paint surface with the naked eye alone. Pentimenti, or artists' changes, may be clearly visible, as in *The Harem* (cat. 155), where the figures' arms are seen in several positions. A certain crackle pattern or reticulation of the paint film can be characteristic of variations in the drying rates of layered oil paints, which may suggest another painting or a change beneath the visible paint layer. One such localized area of crackle is above the head of the left-most figure in *Family of Saltimbanques* (cat. 137). We can also identify colors that do not correspond to the top layer of paint but show through cracks or at the edges of the image. In *Blind Man's Meal* (cat. 94) areas of blue paint that are brighter than the tones of the visible image suggest another paint layer beneath and presumably another design. Often the prominent texture of impasto or heavily applied paint with active brushwork from an earlier image remains discernible even through the subsequent paint surface. Impasto at the bottom of *Moulin de la Galette* (cat. 40) as well as reticulation and drying cracks imply earlier paint layers.

Whereas physical alterations indicate that changes have been made, related drawings, reminiscences, letters, and photographs can provide clues to the character of the changes. For example, after seeing a letter with a sketch that describes a blind man at a table with a dog at the lower left corner, researchers can easily discern the head of a dog that has been painted over in *Blind Man's Meal*.[2] In much the same way, a study for *Family of Saltimbanques* that depicts the left-most figure in a top hat (cat. 136) suggests that the artist might have painted over the hat while it was not yet dry, causing the crackle to form in the top layer of paint.[3]

To confirm that anomalies on the surface result from an earlier image, conservators are able to use a number of technical means to look beneath the visible image. X-rays and infrared light can penetrate the layers of a painting to reveal paint changes and an artist's reworking that are normally hidden from view. In x-radiographs, or the x-ray image, the degree of penetration depends on the density of materials and varies with the elemental composition of each paint layer and the fabric or wood support. In infrared photographs and infrared reflectograms the degree of penetration varies with the chemical structure of the paint layers, revealing different compositional changes from those discernible in x-radiographs. Whereas x-radiographs read through all the layers of a painting, including the support, infrared images usually only penetrate the top paint layers. X-ray fluorescence is a nondestructive technique used in the present study to identify pigments. Cross-section analysis—that is, taking microscopic samples from the painting and examining them under magnification—confirms the structure and sequence of the painting materials.[4]

Artists often make changes on a painting or reuse a canvas or panel with an image already painted on it. Many times the supports are reworked because an artist cannot afford to purchase new materials and uses what is available. When this is the case, however, an artist will generally turn a painting over and paint on the other side of the canvas or panel rather than paint over an image. Picasso did this on occa-

Detail, cat. 59

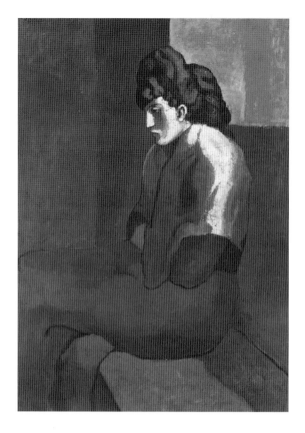

sion. The x-radiograph of *Young Acrobat on a Ball* (cat. 125) shows the full-length figure of a man seated in an armchair on the reverse, which can be identified as a portrait he painted of fellow artist Francisco Iturrino.[5] An artist also has the option of scraping off an earlier painting and starting again or covering an abandoned image with a uniform coat of ground. Picasso did this very rarely. For the most part, when he reworked his paintings, he did so directly over earlier images, neither using a "clean side" nor obliterating the abandoned attempt. Early in his career financial constraints were certainly part of his motivation for reusing supports. But for Picasso the initial subject, the shape or form on the canvas, often revealed itself to him in a different guise as he worked or as he returned to a picture, and it served as a new inspiration. Picasso admitted that he often worked on more than one painting at a time, adding, "I even take up old ones that I have not seen for years."[6]

Many times an initial shape from an earlier subject was incorporated into a new image to exaggerate the form Picasso ultimately depicted on the canvas. In *Saint-Lazare Woman by Moonlight* (figs. 1 and 2) the artist used the reserve he had left for an earlier figure, seen in profile in the x-radiograph (closer to the right edge of the canvas than the current painting),

but transformed the contour of the earlier head into the expansive hairstyle seen in the final painting.

On other occasions a figure would be retained from one painting to another, but the context would be changed. In *Family of Saltimbanques* the child with her hand on the handle of a basket (fig. 3) was taken directly from an earlier pastel, except that there the child's hand had been caressing the head of a dog (fig. 4). The position of the girl's hand and her posture were unchanged, but the object of her attention was transformed.[7] Changes were more dramatic in *Two Sisters* (see fig. 2 in Rosenthal essay), where examination with the naked eye reveals and x-radiography has confirmed that the left-hand figure was initially conceived as naked, as Picasso depicted it in a drawing (fig. 5). The drapery placed over the body in the final painting changed not only the visual impact but the meaning as well.[8]

Colors from the earlier image can also be allowed to merge into the next composition. The blue shadows in the faces of the two middle figures in *Family of Saltimbanques,* for example, originated from the sky in the previous composition. Rather than adding dark tones to create contour, Picasso left negative spaces around the applied paint layers to read as shadow (fig. 6).

1. Picasso, *Saint-Lazare Woman by Moonlight,* Paris, 1901, oil on canvas, 100 x 69.2 (39 ⅜ x 27 ¼), The Detroit Institute of Arts, Bequest of Robert M. Tannahill. See also colorplate 74

2. X-radiograph of *Saint-Lazare Woman by Moonlight,* showing outline of head in earlier composition, incorporated into the hairstyle in the final painting

3. Detail from Picasso's *Family of Saltimbanques*. See also colorplate 137

4. Detail from Picasso's *Girl with a Dog*, 1905, pastel, 70.5 x 47.5 (27¾ x 18¾), private collection

5. Picasso, *Two Sisters*, 1902, ink and wash on paper, 33.5 x 22.8 (13⅛ x 9), Museo Picasso, Barcelona

6. Detail from Picasso's *Family of Saltimbanques*

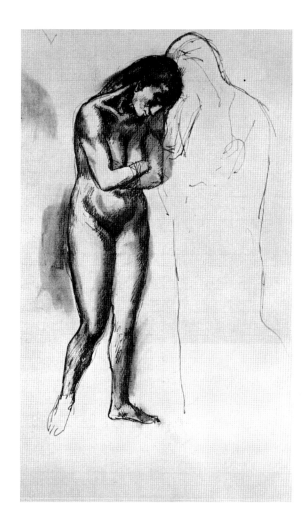

7. Raking light detail from *Tragedy,* showing impasto discernible under final image. See also colorplate 92

8. Detail from *Tragedy,* showing yellow and orange paint of the 1901 composition beneath brush strokes of blue paint used for the final image

9. Detail from composite infrared reflectogram of *Tragedy* (1.5–2.0 microns), showing sketches from 1899 drawn directly on the surface of the panel

X-radiographs and infrared photographs or reflectograms may indicate that changes were made, but many of the images are indecipherable. Often it is only an intimate knowledge of Picasso's oeuvre that enables researchers to recognize clues and imagine what the underlying form may be.

When *Tragedy* (cat. 92), painted in Barcelona in 1903, was initially examined in 1983, two visual clues suggested the existence of changes or another painting beneath the three solemn figures on the beach. First, raking light defined an area of impasto that cuts across the horizontal part of the man's folded right arm (fig. 7), bearing no relation to the drape of his garment; similar instances of impasto unrelated to the surface image appear throughout the painting. Second, vivid yellow and orange tones could be seen in areas of minor abrasion and through cracks and brush strokes in the top layer of paint, having no visual connection to the monochromatic blue of the final painting (fig. 8). Infrared reflectography[9] revealed numerous sketches, caricatures, and lettering beneath the

paint (fig. 9), which appear to have been drawn hastily, directly on the wood support. Presumably Picasso had the large panel in his studio when waiting to prepare it for painting.[10] The orientation of the sketches is random, although the panel seems to have been worked in a horizontal fashion at this stage, in contrast to the present vertical format of the painting. The elongated faces and the grouping of the drawings are reminiscent of those in his 1899 sketchbooks, which contained pages of similar figures in the style of El Greco. The lack of cohesion, the irregular scale, and the humorous and distorted shapes suggest that these were merely sketches (almost doodles) rather than any specific composition. Picasso was known to draw on any surface, and he must have seen this blank panel as an invitation to draw whatever came to mind.[11] But these images were not created with paint thick enough to account for the impasto discernible beneath the surface of the painting, and they probably did not incorporate any color, much less the bright orange and yellow showing through at the surface; they were most likely sketched with brush and ink, crayon, or thinned paint. Therefore, another painted image at an intermediate level must have produced the impasto and color showing through from beneath *Tragedy*.

X-radiography of *Tragedy* revealed several clues. With the image again in a horizontal orientation, a number of elements can be identified (fig. 10). At the lower right-hand corner is a horse on its side, with its head and neck stretched back unnaturally and its legs twisted awkwardly around its body, looking as if it is being tortured. Another horse appears to the left, prancing, but it can only be recognized by the delineation of its front legs and hindquarters; two heads are associated with this body. Farther to the left an arc curves upward from the lower left edge and behind the prancing horse. Toward the top of the work are a series of arches. The fallen horse bears a close resemblance to the

horse depicted in *Bullfighting Scene (The Victims)* (fig. 11), which Picasso painted in the spring of 1901; and the arches resemble those defining the architecture of an arena in another painting from the same year, *La Corrida* (fig. 12). More significant is the tonality of the two earlier canvases: the orange red of the barrier in the former and the bright yellow of the light hitting the arena in the latter match the colors glimpsed beneath the surface blue of *Tragedy*.[12] In both 1901 paintings energetic brushwork created high impasto like that apparent beneath the surface of the 1903 panel painting.

It is not clear if Picasso completed the image under *Tragedy,* with its high impasto and vivid colors depicting the activities of the bullring. But there is ample evidence to suggest that he developed here a composition that is similar to what we know only from smaller versions. The arc in the x-radiograph defines a bullring, and the arches form the walls of a stadium.

Infrared reflectography at a different wavelength[13] was then used to enhance what the x-radiograph had revealed, and it establishes that Picasso abandoned the 1901 image of horses not to paint *Tragedy* but to produce yet another scene of the bullring. The infrared reflectogram clarifies the form of the prancing horse (fig. 13). It shows the back legs firmly planted on the ground, a bound tail, and a fully bridled head. Arches are again evident at the top of the painting, but human figures are present as well. A small figure in profile seems to follow the horse, and the legs of another figure in motion appear in front of the horse. The reflectogram image is similar to a drawing Picasso did in Barcelona in 1902, *Corrida de toros: El Arrastre* (fig. 14), and to a sketch he added on the reverse of a letter to Max Jacob in July 1902. The drawing defines the decorative wrapping of the tail and the ceremonial style of the bridle. It also shows a figure behind the horse wielding a whip and another leading the horse by the bridle, which correspond to the profile figure and to the legs of the

figure in front of the horse seen in the infrared reflectogram.

Many artists make changes as they work, but Picasso thoroughly intertwined process and image. In his words, "a picture is not thought out and settled beforehand. While it is being done, it changes as one's thoughts change."[14] The identification of three distinct layers of images beneath *Tragedy* suggests how the process developed, in terms of both form and subject matter. The 1899 drawings were merely sketches, but the 1901 and the 1902 bullfight scenes were sequential images. The first painting, colorful and high-impastoed, depicted the action of the bullfight in the ring, whereas the second, in a more archaic style, represented the next phase in the ritualized event, when the gored bull is ceremoniously dragged out of the arena. Just as Picasso moved from one time frame to the next, incorporating like elements, he also transformed shapes and forms from one design to another. The arches at the top of the painting define the walls of the arena in the 1901 image, for example, yet the same rounded shapes became plumed headdresses for the horses leaving the ring in 1902. Even in 1903, when Picasso painted *Tragedy* and shifted to a vertical format, he continued to incorporate contours from the previous image into the new one: the shape of the bridled horse's head defines the bowed neck and head of the man on the beach.

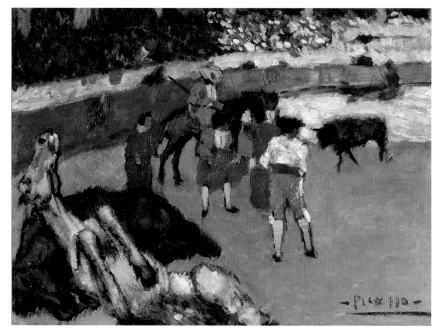

Picasso had other ways of creating a new painting out of elements from an earlier composition. Yet as in *Tragedy* he left visual clues to his earlier ideas as he produced the new work.

In Paris in 1900 Picasso met the Catalan Pere Mañach, who was selling modern Spanish art and was particularly impressed by Picasso's bullfighting scenes. Mañach paid Picasso a regular stipend and effectively served as his first dealer in Paris. But their common passion for the bullring cemented a friendship, too, and prompted Picasso to pay homage in his *Portrait of Pere Mañach* (cat. 59) (which became part of a series

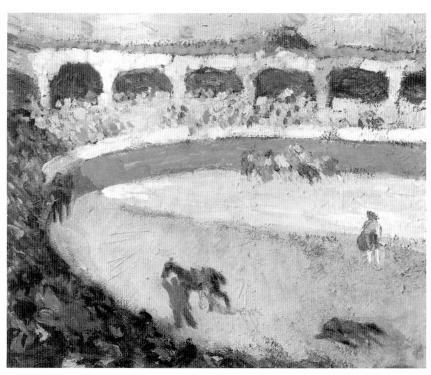

of portraits he would paint of his dealers and patrons such as Sagot, Kahnweiler, Vollard, Stein, etc.). The initial visual examination of the portrait suggested that changes had been made. A variety of colors appears under the top layer of the shirt; the background consists of two distinct layers of paint, the top one slightly yellower than the bottom one; the inscription at the upper left corner—*Petrus Manach*—is included in both layers, with the earlier inscription only fainter. Initial examination of the painting by x-radiography gave no suggestion that changes had been made, but the infrared reflectogram revealed drawing beneath the jacket (fig. 16).[15] On Mañach's proper left shoulder Picasso had drawn in the *hombrera*, or epaulets, of a bullfighter's costume. We can also see the diagonal lines of a short cutaway jacket on either side of the necktie tapering down to the waist and horizontal strokes across the waist that most likely depict the folds in a sash. Evidently Picasso had initially represented his friend as a bullfighter. The bold scale of the image and the subject's name written in large letters across the top of the painting recall commercial posters produced to advertise well-known bullfighters.

Something must have prompted Picasso to abandon the image of Mañach as a bullfighter and present him in more familiar attire. But the artist did not completely restore his friend to the guise of a common man. He eliminated certain elements but retained others exactly as they were and painted around them: thus he covered the *hombrera*, jacket, and sash, but he kept the thin orange red tie—and not only because of the boldness of the color. This tie, the *corbata*, was not commonly worn in 1901 (other portraits show Mañach wearing the fuller tie of his contemporaries); it was part of a bullfighter's costume, and Picasso generally depicted bullfighters wearing it. Although he added layers of white paint to obscure the jacket and sash, he did not disturb the area of the tie. Because the handling of the white paint is so rich, a measurable differ-

N.º 90. — Ptas. 10.
Antonio Fuentes.

ence in thickness can be discerned between the paint of the shirt and that of the tie, confirming that the orange red color lies in a lower plane. By preserving the tie, Picasso retained the association of Mañach with a bullfighter.

Picasso retained another aspect of the first presentation as well: the stance. Conventional portrayals of bullfighters had been formalized to such an extent that many photographs and portraits follow a pattern. Famous Spanish bullfighters were characteristically shown with their feet in a certain position, holding their hat in a ceremonial pose, clothed in their *traje de luces,* and pompously placing hand on hip (fig. 16). Even without all of the accoutrements, Picasso alluded to these conventions by placing Mañach's hand on his hip. Allowing the original bullfighter's tie to remain was only one way for Picasso to tease the viewer and—presumably— please the sitter. These remnants of the first

image confirm Picasso's comment, "When you begin a picture, you often make some pretty discoveries. . . . In each destroying of a beautiful discovery, the artist does not really suppress it but rather transforms it, condenses it, makes it more substantial. What comes out in the end is the result of the discarded finds."[16]

Although Fernande Olivier recalled that Picasso frequently did not have enough money to buy materials early in his career and that he painted over existing paintings,[17] it is important to recognize that the artist continued his practice of reusing supports long into his career; it was not only a matter of what he could afford. Picasso viewed his art as a work in progress, indicating at one point that the end of one painting was the beginning of the next. He substantiated this by continuing to make changes on his canvases throughout his career. The changes did not necessarily stem from his dissatisfaction with

15. Composite infrared reflectogram of *Pere Mañach* (1.5–2.0 microns), showing sketching beneath the final painting. See also colorplate 59

16. Image of Antonio Fuentes from *Viñetas Taurinas,* 1910, Madrid, Richard Gans fundación tipográfica

an image but from his active engagement with his art. And the changes did not involve only the reapplication of paint to canvas. Picasso is known to have cut down canvases and to have made additions to canvases to enlarge his works. Again he left visual evidence of his changes, drawing attention to the construction either by altering the surface texture at the join or extension[18] or by allowing two parts of a detached canvas to be reunited (although he never intended them to be joined).[19] He was so taken with the idea of transforming images that he even reworked those of other artists. When he was offered an old painting from the reserves of the museum in Antibes, a portrait of a General Vandenburg, he transformed it into an urchin eater, *Le Gobeur d'Oursins*. An x-radiograph revealed that the shoulder of the officer initiated the curve of the raised knee of the urchin eater, and the hand that had been formally placed on top of the military sword now clutched the knife used to open the spiny shells.[20] By this time in his career Picasso was able to purchase canvas, but he seems to have been so intrigued with the idea of reusing a found object that he took the existing forms and reconfigured the image.

The clearest evidence not only that Picasso worked in layers but that each layer developed from the previous one was documented in Georges Clouzot's film *La Mystère Picasso* (1955). The filmmaker recorded the artist as he began by painting flowers or a fish and transformed the image into a rooster and eventually into a horned face. The changes did not appear magically, however. The shapes were there to be reinterpreted and altered into another object, similar in form but different in meaning from the one initially portrayed.

As important to Picasso as the change was the process. The process of transformation so fascinated him that when he painted *Guernica* in 1937 he had Dora Maar photograph the work in seven stages over a six-week period to document the changes. This allowed Picasso to fulfill an idea he had expressed earlier: "it would be very interesting to preserve photographically, not the stages, but the metamorphosis of a painting. Possibly one might then discover the path followed by the brain in materializing a dream. But there is one very odd thing—to notice that basically a picture doesn't change. That the first vision remains almost intact in spite of appearances."[21]

This "vision" is what Picasso preserved by allowing the tie of a bullfighter to remain on his portrait of Pere Mañach and by transferring shapes and elements from his 1901 and 1902 sequential images of the bullring under *Tragedy* to the final composition. Even without the aid of analytical equipment, we can recognize clues on the surface of his paintings, either pentimenti or dried impasto showing through thin paint layers. Picasso did not mask the creative process. When it was brought to Picasso's attention that wide cracks had formed on the *Three Dancers* of 1925 because of the drying strain of the paint layers and that colors from an earlier layer of paint were now visible, he remarked with a certain delight, "some people might want to touch them out, but I think they add to the painting. On the face you see how they reveal the eye that was painted underneath."[23] Picasso had no desire to hide the process of painting. It intrigued him and ultimately it became part of the final image itself.

Notes

I would like to thank the following people for their assistance throughout my research: Elizabeth Walmsley, Catherine Metzger, Elizabeth Freeman, Axel Ruger, Kristi Dahm, and Melanie Gifford at the National Gallery of Art; A. Babin and A. Kostenevich, Hermitage Museum, St. Petersburg; Frank Zuccari at the Art Institute of Chicago; Suzanne Penn at the Philadelphia Museum of Art; Marcia Steele at the Cleveland Museum of Art; Stephen Hackney at the Tate Gallery, London; Alfred Ackerman at the Detroit Institute of Arts; Kate Olivier at the Fogg Art Museum, Cambridge; Lucy Belloli at the Metropolitan Museum of Art, New York; and Michael C. Mays, Mitsubishi Electronics Ameria, Inc. This work results from the combined resources of the art historian and the conservator, and I am particularly grateful to Marilyn McCully and Jeffrey Weiss, who have shared my enthusiasm and filled in missing pieces whenever needed.

1. Vallentin 1957, 62. The x-radiograph is published in Hélène Seckel, *Max Jacob et Picasso*, Editions de la réunion des musées nationaux (Paris, 1994). Max Jacob also refers to "a huge canvas that has since been lost or covered over" and describes it as "my portrait seated on the floor among my books in front of a large fire" (McCully 1981, 19).

2. The letter dated 6 August 1903 exists in the Barnes Collection, Merion, Pennsylvania.

3. This is discussed in the "Study Section" by E. A. Carmean and Ann Hoenigswald with Barbara Miller in *Picasso: The Saltimbanques* [exh. cat., National Gallery of Art] (Washington, 1980).

4. Early works by Picasso have occasionally been examined from a technical point of view. Published studies include:

A. Babin, "O protsesse rabotoy Pikasso nad kartinoi *Svidaniye*" ["About the Process of Picasso's Work on *The Visit*"], *Proceedings of the State Hermitage Museum*, no. 42 (1977), 14–18.

A. Babin, "Novye dannye o *Portrete molodoi zhenshchiny* P. Pikasso" ["New data on *The Portrait of a Young Woman*" by P. Picasso"], *Proceedings of the State Hermitage Museum*, no. 44 (1978), 24–26.

Exh. cat. Washington 1980.

Suzy Delbourgo, *Etude de la matière picturale de Pablo Picasso*. Comité pour la conservation de l'ICOM 6^{ème} réunion triennale (Ottawa, 1981).

Mary Mathews Gedo, "A Youthful Genius Confronts His Destiny: Picasso's *Old Guitarist* in the Art Institute of Chicago," *Museum Studies, Art Institute of Chicago* 12, no. 2 (1986).

F. Manchón and A. Modolell, "La Radiografía de un cuadro de Picasso," *Miscellanea Barcinonensia*, no. 19 (July 1968).

Marilyn McCully and Robert McVaugh, "New Light on Picasso's *La Vie*," *Cleveland Museum of Art Bulletin* (February 1978).

Anatoly Podoksik, *Picasso: The Artist's Work in Soviet Museums* (Leningrad and New York, 1989).

5. The x-radiograph is reproduced in Podoksik 1989.

6. Sir John Rothenstein, "A Letter on Paris," *Cornhill Magazine* [London] (1964), reprinted in Ashton 1972.

7. See exh. cat. Washington 1980.

8. See Babin 1977, 14–18.

9. The infrared images were acquired with a Kodak 310-21X PtSi thermal imager configured to 1.5–2.0 microns and connected to a Macintosh computer. The sub-images, each an average of eight frames, were composited with Adobe Photoshop.

10. These early sketches confirm that this panel cannot be the one Jaime Sabartés describes as having been prepared by Picasso's father in 1903 presumably for *Tragedy* (see Sabartés 1949, 92).

11. Sabartés 1949, 43, asserts that "paper and canvas did not suffice [for] Picasso. He covered the walls with pictures as well."

12. X-ray fluorescence done by Lisha Glinsman of the scientific research department of the National Gallery of Art identified the pigments as vermilion and cadmium yellow.

13. The infrared images were acquired with a Mitsubishi M600 configured to 1.2–5.0 microns and connected to a Macintosh computer.

14. Picasso to Christian Zervos in Ashton 1972, 8.

15. The infrared images were acquired with a Kodak 310-21X PtSi thermal imager configured to 1.5–2.0 microns and connected to a Macintosh computer. The sub-images, each an average of eight frames, were composited with Adobe Photoshop.

16. Ashton 1972, 9.

17. Olivier 1965, 28.

18. This is evident on *Man with Mandolin* of 1911 (Musée Picasso, Paris).

19. This was the case with *Mother and Child* of 1921 (Art Institute of Chicago).

20. The x-radiograph of the painting is published in *L'Oeuvre de Picasso à Antibes. 4. Travers Picasso. Contribution à l'étude de l'oeuvre en collaboration avec le*

laboratoire de recherches des musées de France (1981). The interpretation is my own.

21. Ashton 1972, 8.

22. From notes made by Sir Roland Penrose after conversations with Picasso at Mougins on 29–31 January 1965, in *Tate Gallery Report* (1964–1965), 49–50.

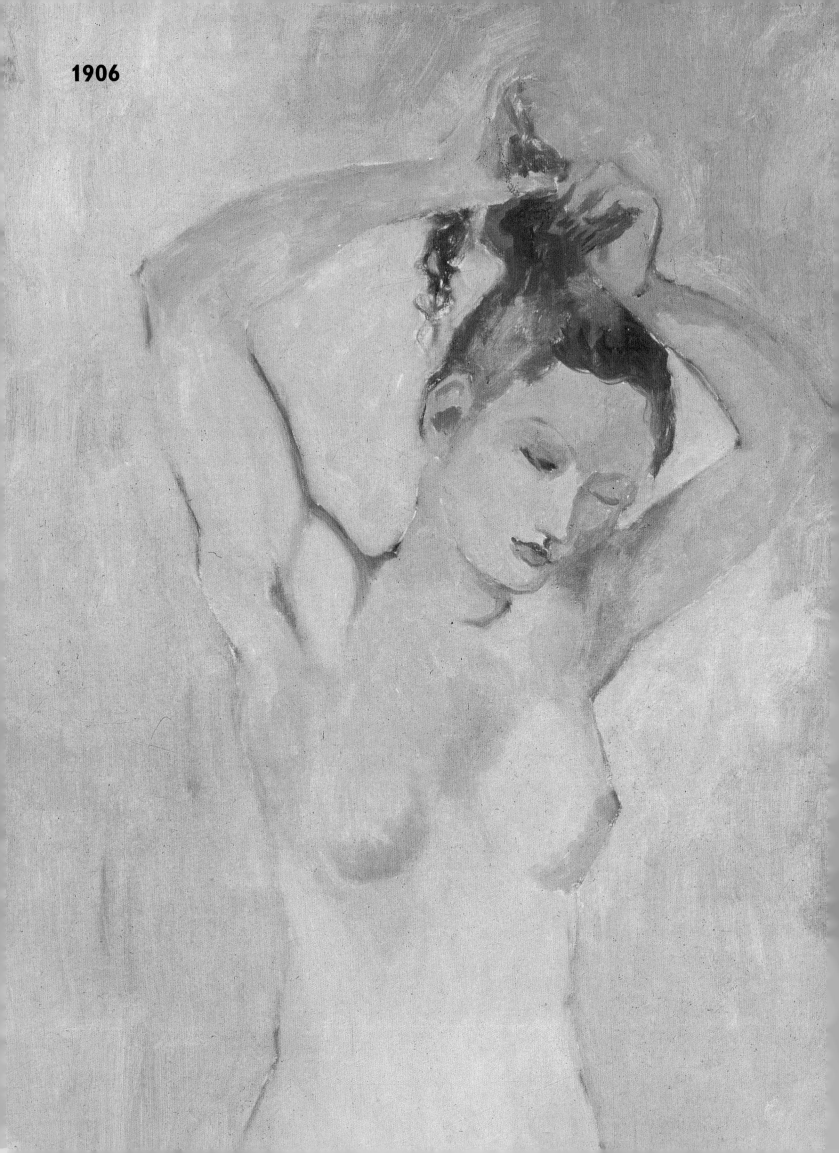

1906

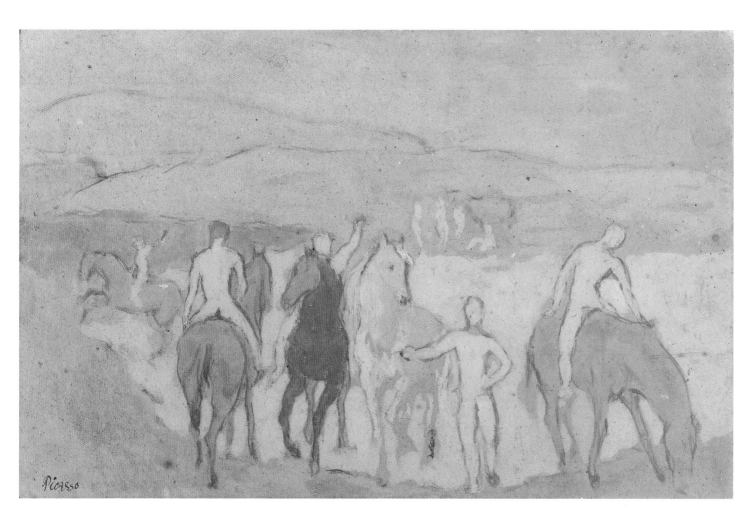

142. *The Watering Place,*
Paris, spring 1906,
gouache on cardboard,
38.1 x 57.8 (15 x 22 ¾),
The Metropolitan Mu-
seum of Art, New York,
Bequest of Scofield
Thayer, 1982
Boston only

Detail, cat. 154

143. *The Watering Place,*
Paris, spring 1906, dry-
point, 12.2 x 18.8 (4 ¾ x
7 ⅜), private collection

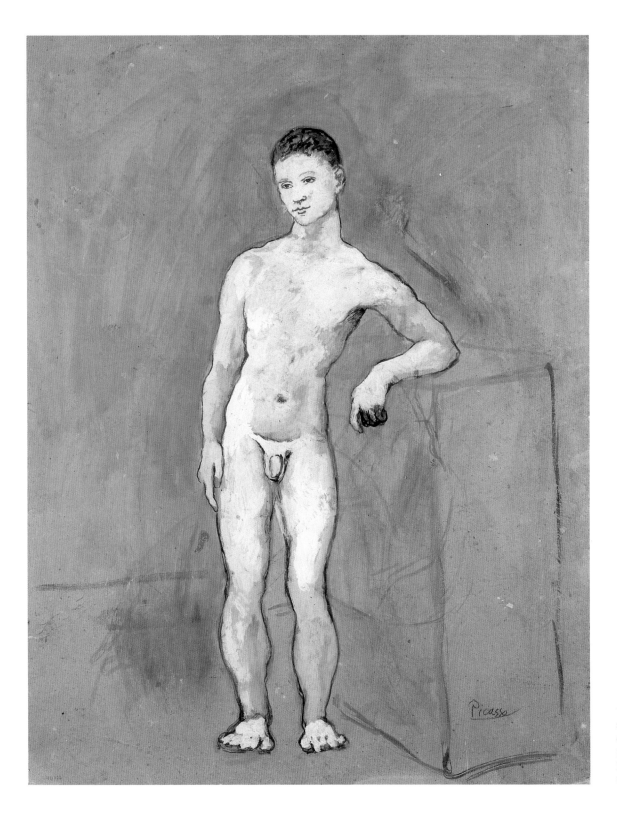

144. *Ephebe*, Paris,
spring 1906, gouache
on cardboard, 68 x 52
(26¾ x 20½), The State
Hermitage Museum,
St. Petersburg

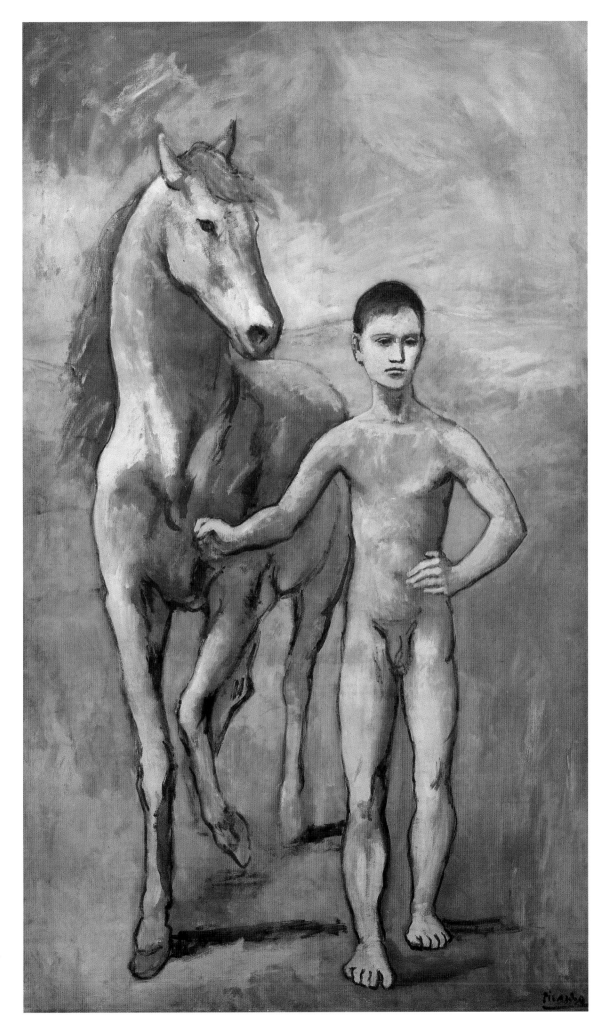

145. *Boy Leading a Horse*, Paris, spring 1906, oil on canvas, 221 x 130 (87 x 51 ⅛), The Museum of Modern Art, New York, The William S. Paley Collection
not in exhibition

146. *Study of a Nude Woman*, Paris or Gósol, spring–summer 1906, gray brown ink on brown paper, 38.1 x 29.9 (15 x 11 ¾), Museum of Fine Arts, Boston, J. H. and E. A. Payne Fund
Boston only

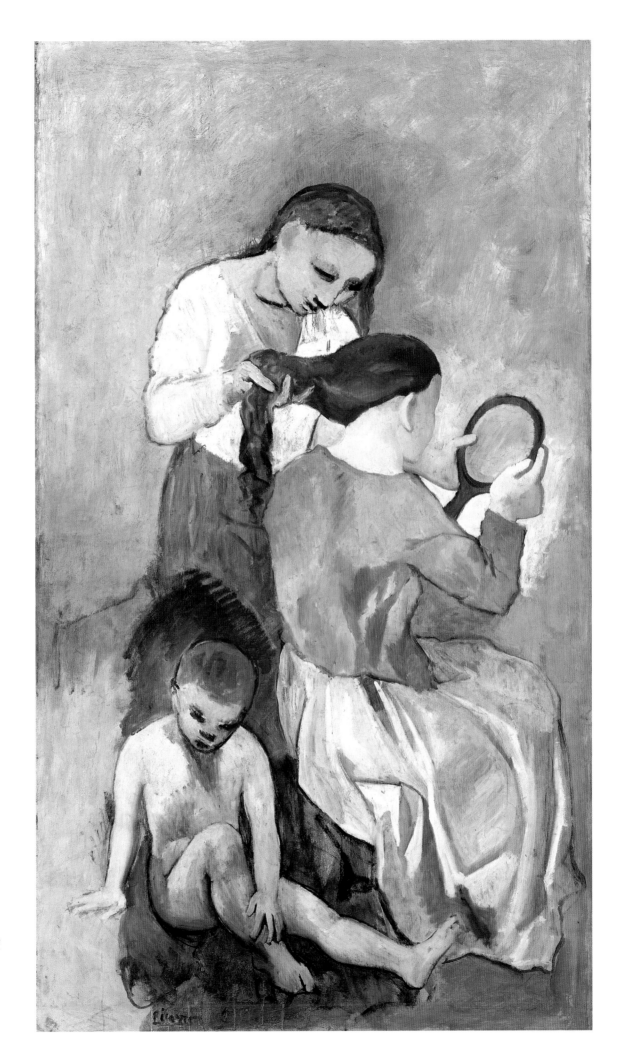

147. *La Coiffure,* Paris, spring 1906 (finished early autumn), oil on canvas, 174.9 x 99.7 (68⅞ x 39¼), The Metropolitan Museum of Art, Catharine Lorillard Wolfe Collection, Wolfe Fund; acquired from The Museum of Modern Art, Anonymous Gift
Boston only

148. *Gósol Landscape,*
Gósol, summer 1906,
oil on canvas, 69.8 x 99
(27 ½ x 39), private
collection

149. *Houses at Gósol,*
Gósol, summer 1906,
oil on canvas, 54 x 38.5
(21 ¼ x 15 ⅛), Statens
Museum for Kunst,
Copenhagen
Boston only

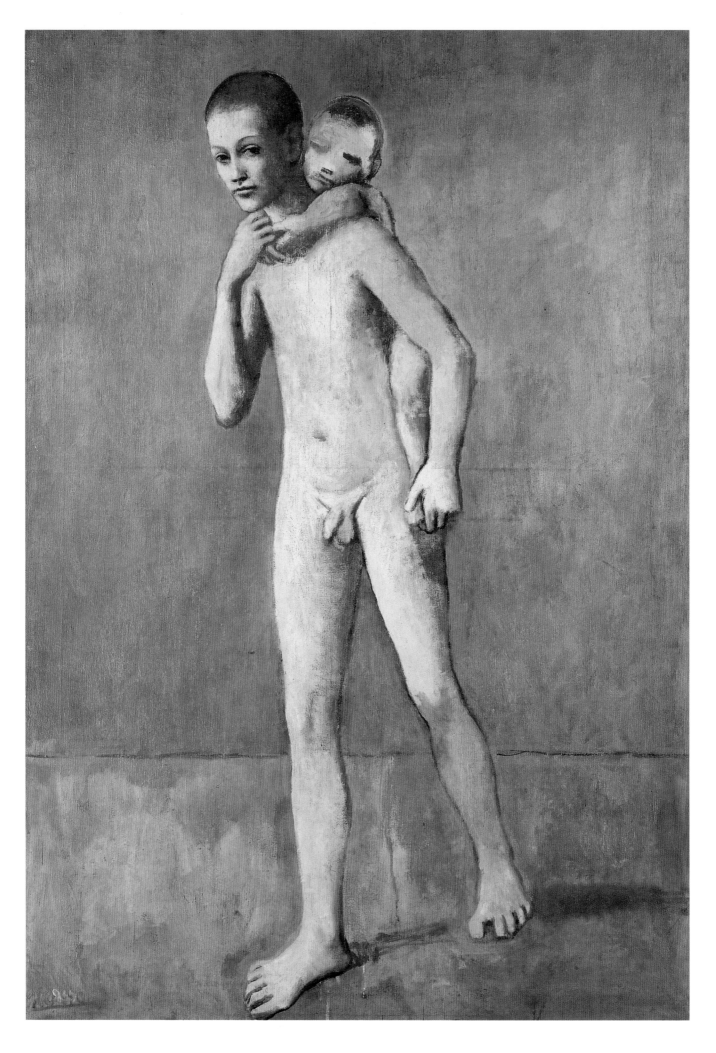

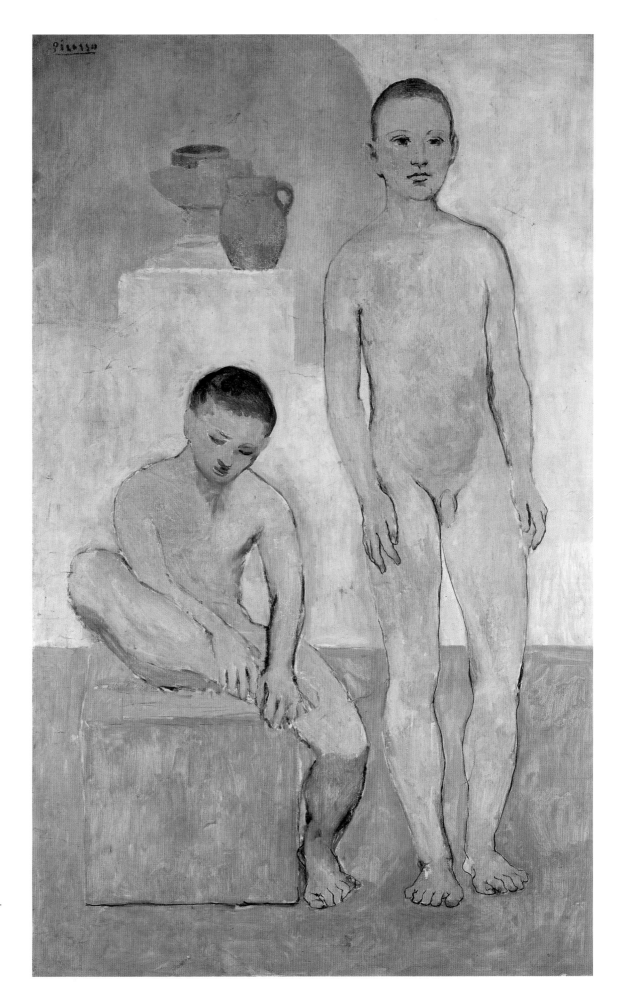

150. *Two Brothers*, Gó-sol, summer 1906, oil on canvas, 142 x 97 (55 ⅞ x 38 ⅛), Öffentliche Kunstsammlung Basel, Kunstmuseum
Washington only

151. *Two Youths*, Gósol, summer 1906, oil on canvas, 151.5 x 93.7 (59 ⅝ x 36 ⅞), National Gallery of Art, Washington, Chester Dale Collection
Washington only

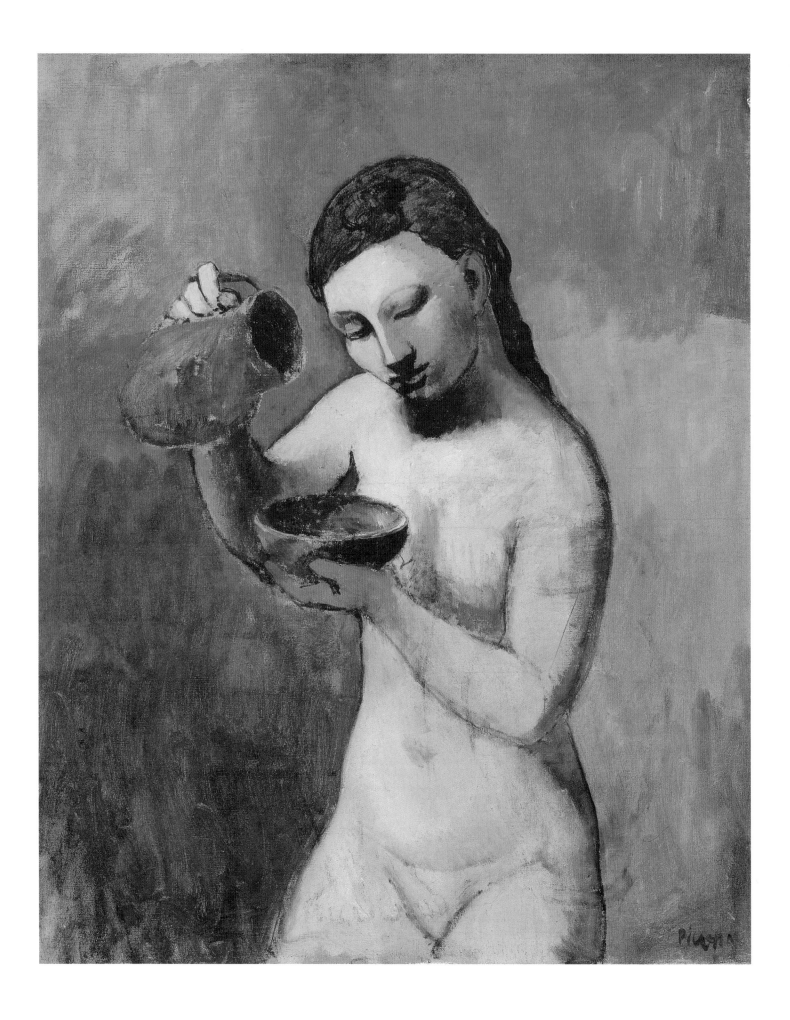

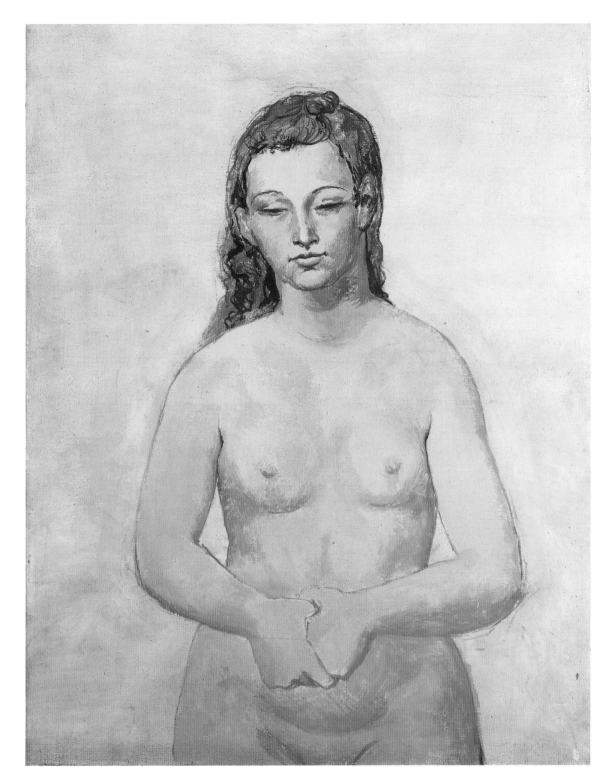

152. *Girl with a Pitcher*,
Gósol, summer 1906,
oil on canvas, 100 x 81
(39⅜ x 32), The Art In-
stitute of Chicago, Gift of
Mary and Leigh B. Block

153. *Nude with Clasped
Hands (Fernande)*, Gósol,
summer 1906, gouache
on canvas, 95.8 x 75.5
(37¾ x 29¾), Collection
Art Gallery of Ontario,
Toronto, Gift of Sam and
Ayala Zacks, 1970

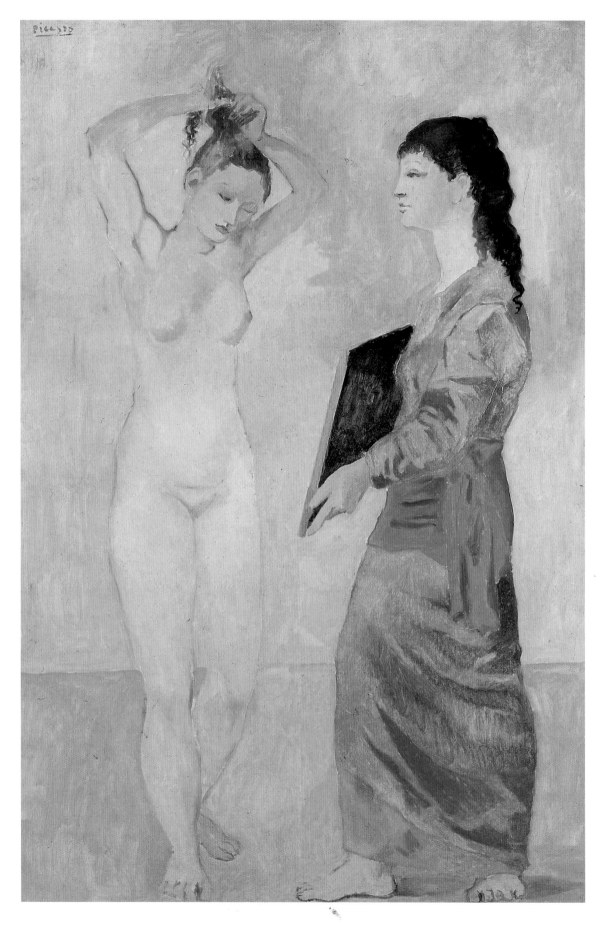

154. *La Toilette*, Gósol, summer 1906, oil on canvas, 151.1 x 99.1 (59 ½ x 39), Albright-Knox Art Gallery, Buffalo, New York, Fellows for Life Fund, 1926

155. *The Harem*, Gósol, summer 1906, oil on canvas, 154.3 x 110 (60 ¾ x 43 ¼), The Cleveland Museum of Art, Bequest of Leonard C. Hanna Jr.

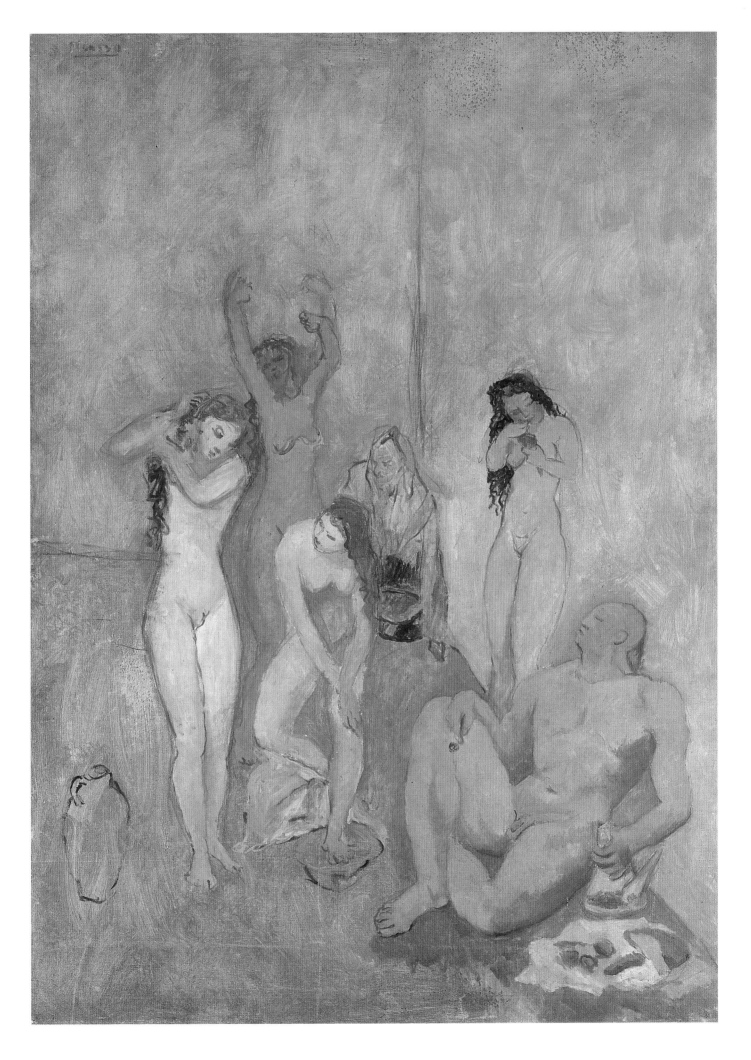

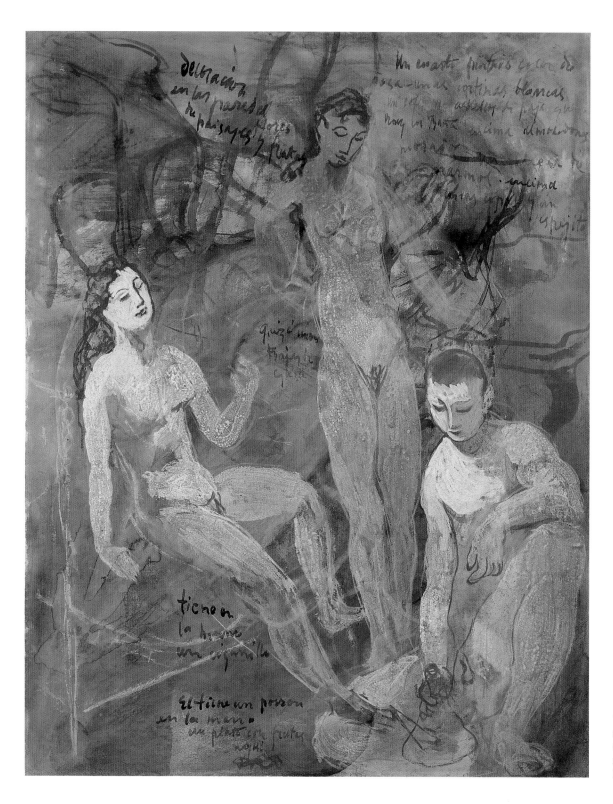

156. *Three Nudes*, Gósol,
summer 1906, gouache
on paper, 63 x 48.3 (24 ¾
x 19), The Alex Hillman
Family Foundation

157. *The Lieutenant*,
Gósol, summer 1906,
watercolor on paper,
21 x 13 (8 ¼ x 5 ⅛),
private collection

158. *Peasant Woman with Shawl*, Gósol, summer 1906, charcoal on paper, 62 x 40.4 (24⅜ x 15⅞), The Art Institute of Chicago, through prior bequest of Janis H. Palmer
Washington only

159. *Head of a Woman (Fernande)*, Gósol, summer 1906, gouache on paper, 62 x 47 (24 ³/₈ x 18 ¹/₂), Susan and Lewis Manilow
Washington only

160. *Reclining Nude (Fernande)*, Gósol, summer 1906, gouache on paper, 47.3 x 61.3 (18⅝ x 24⅛), The Cleveland Museum of Art, Gift of Mr. and Mrs. Michael Straight

161. *Woman with Loaves*, Gósol and Paris, late summer 1906, oil on canvas, 100 x 69.8 (39⅜ x 27½), Philadelphia Museum of Art, Gift of Charles E. Ingersoll

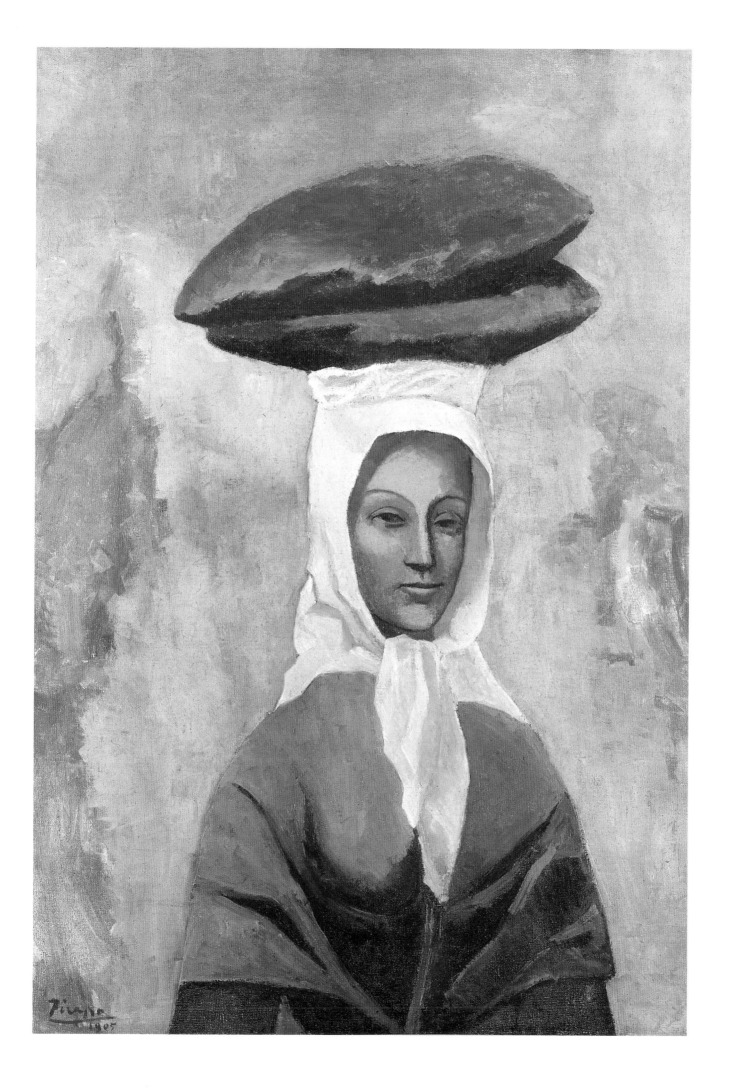

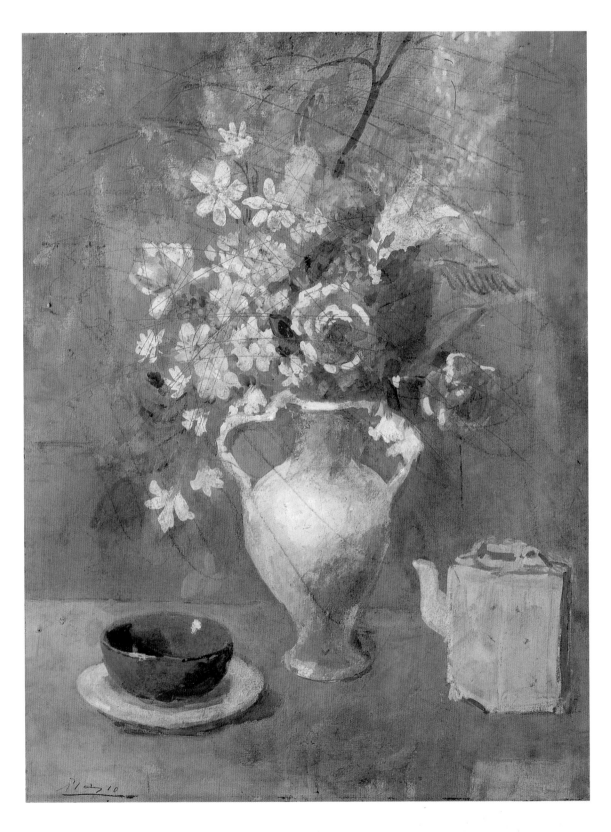

162. *Still Life*, Gósol,
summer 1906, gouache
on cardboard, 70.5 x 54
(27 ¾ x 21 ¼), Solomon
R. Guggenheim Museum,
New York, Thannhauser
Collection, Gift, Justin K.
Thannhauser, 1978
Boston only

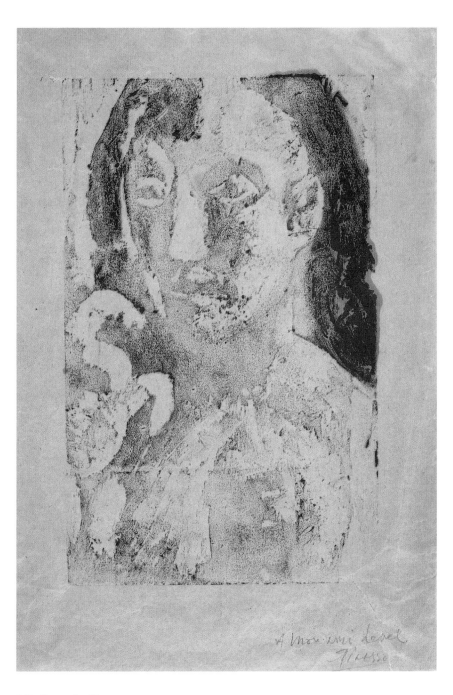

163. *Bust of a Woman
with Raised Hand*, Gósol
or Paris, summer 1906,
woodblock print, oil on
paper, 21.9 x 13.8 (8 ⅝
x 5 ⅜), Museum of Fine
Arts, Boston, Gift of
Lois and Michael Torf
Boston only

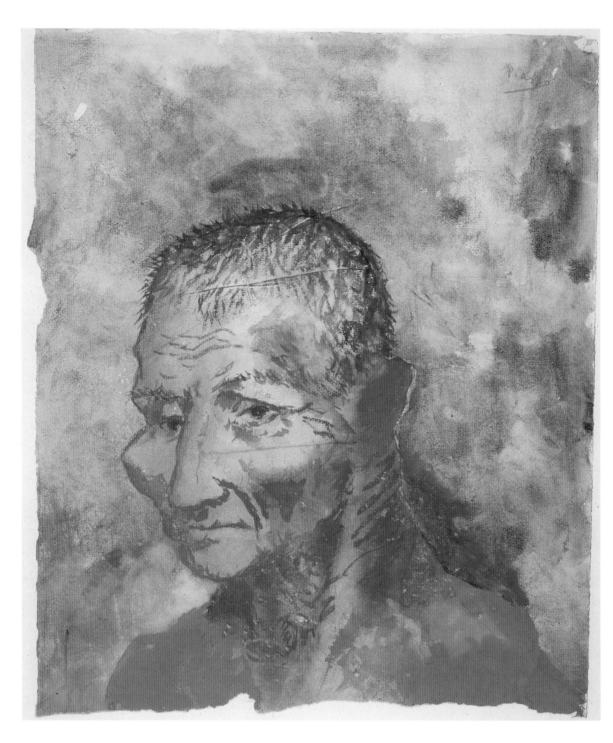

164. *Portrait of Josep
Fontdevila*, Gósol, sum-
mer 1906, gouache and
watercolor on paper,
49.7 x 35 (19 ½ x 13 ¾),
private collection

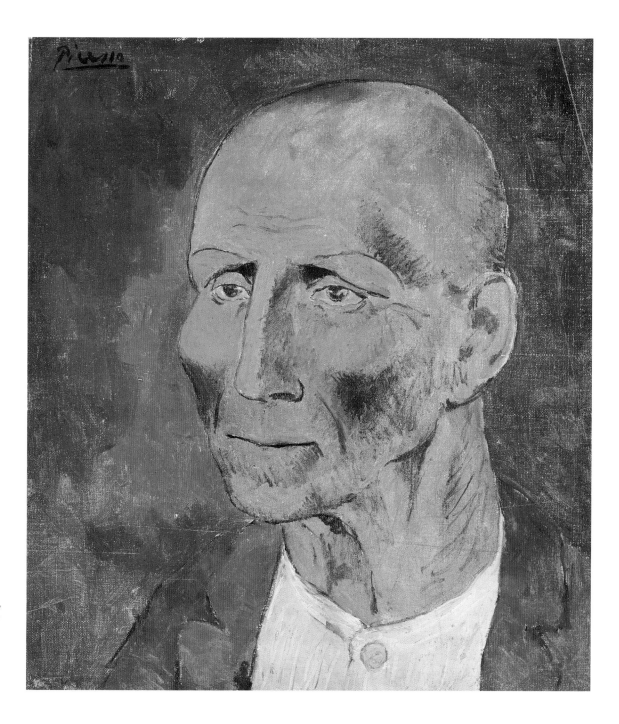

165. *Head of a Peasant (Josep Fontdevila)*, Gósol, summer 1906, oil on canvas, 40.3 x 45.1 (15 7/8 x 17 3/4), The Metropolitan Museum of Art, Gift of Florene M. Schoenborn, 1992

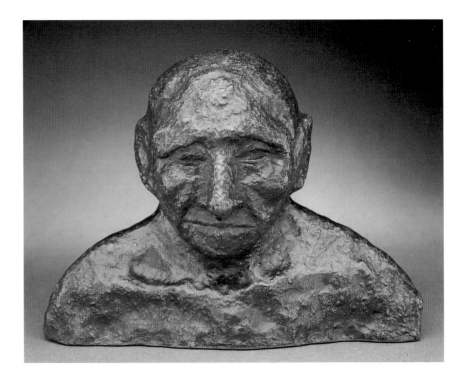

166. *Bust of Josep Font-devila*, Paris, autumn 1906, bronze, 16.8 x 22.9 x 11.7 (6⅝ x 9 x 4⅝), Hirshhorn Museum and Sculpture Garden, Smithsonian Institution, Gift of Joseph H. Hirshhorn, 1966

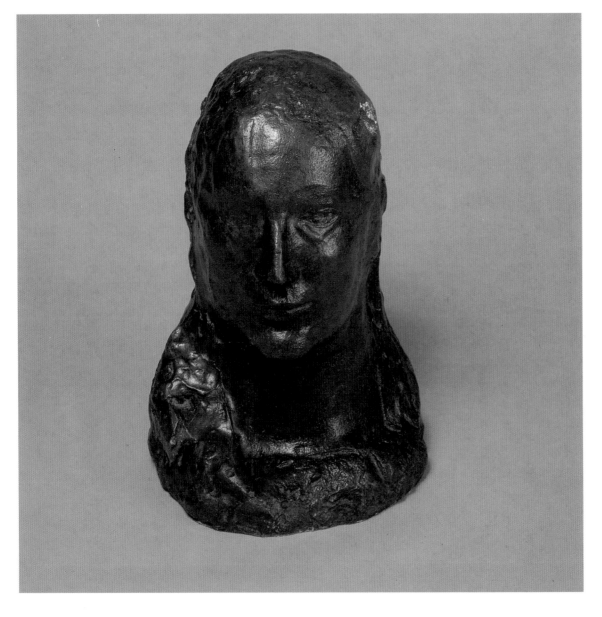

167. *Head of Fernande*, Paris, before May 1906, bronze, 36.1 x 23.5 x 23.1 (14¼ x 9¼ x 9⅛), Hirshhorn Museum and Sculpture Garden, Smithsonian Institution, Gift of Joseph H. Hirshhorn, 1966

168. *Portrait of Gertrude Stein*, Paris, 1906 (begun spring, finished early autumn), oil on canvas, 100 x 81.3 (39⅜ x 32), The Metropolitan Museum of Art, New York, Bequest of Gertrude Stein *not in exhibition*

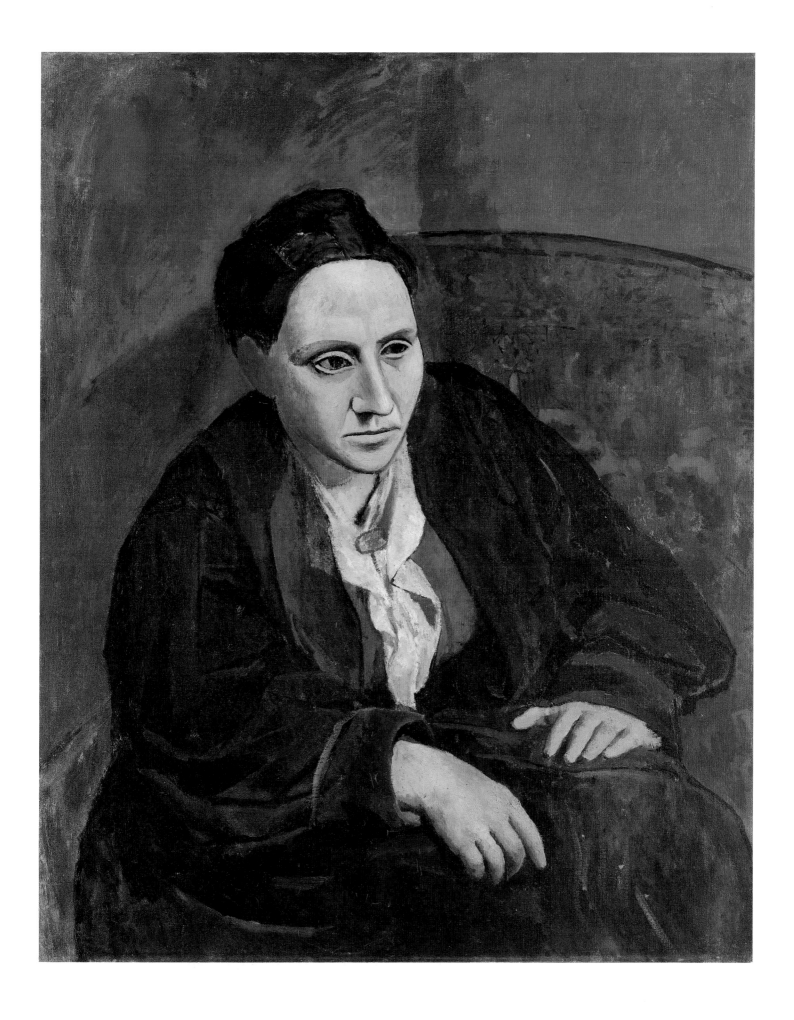

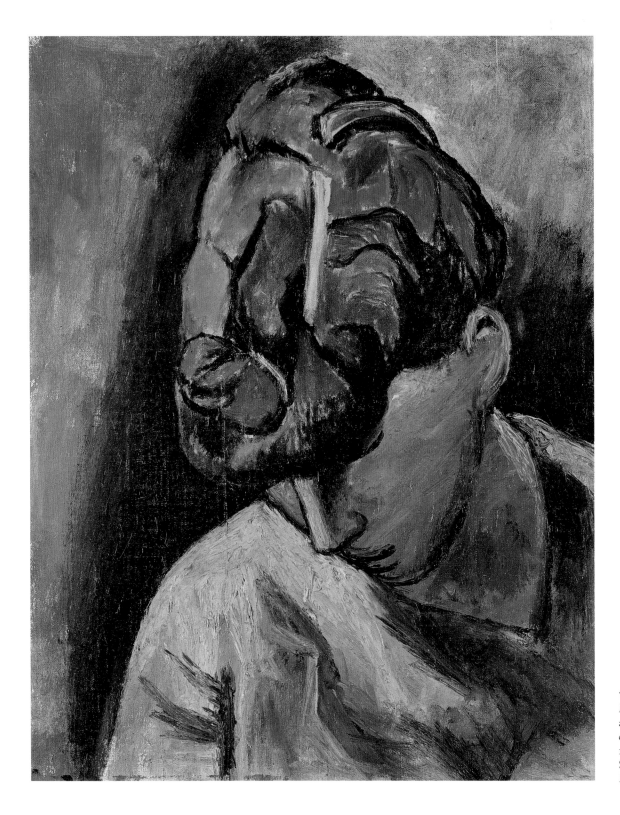

169. *Woman with Her
Head Bent*, Paris, early
autumn 1906, oil on
canvas, 51 x 39.5 (20⅛
x 15 ½), Staatsgalerie
Stuttgart
Boston only

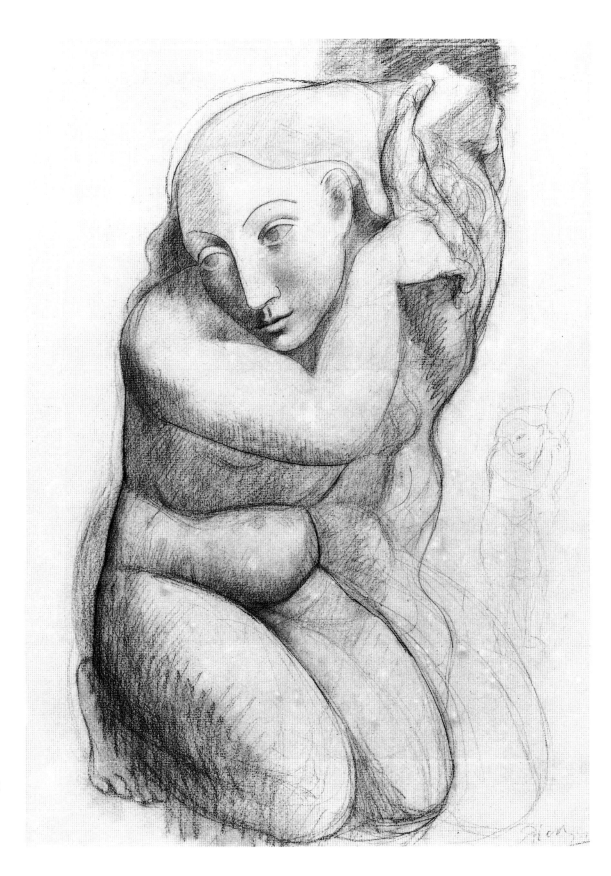

170. *Woman Combing Her Hair*, Paris, autumn 1906, pencil and charcoal on paper, 55.8 x 40.7 (22 x 16), University of East Anglia, The Robert and Lisa Sainsbury Collection

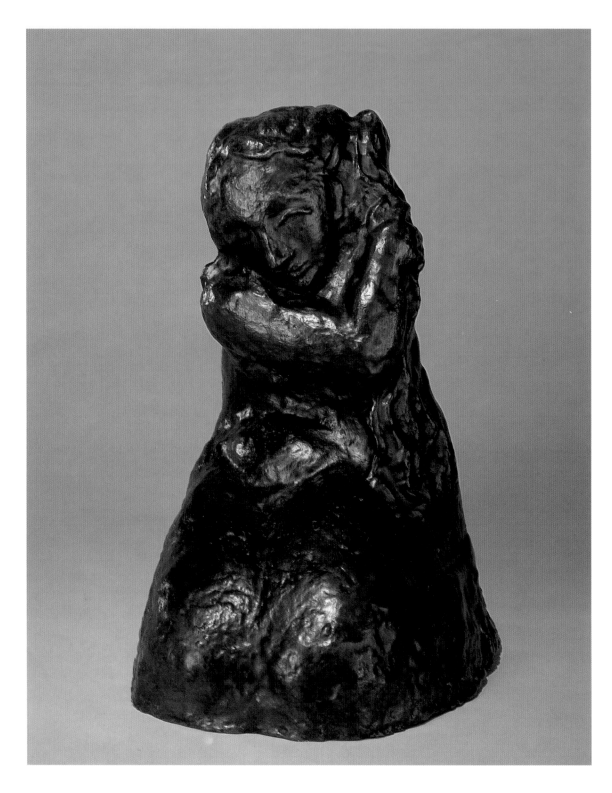

171. *Woman Combing Her Hair*, Paris, autumn 1906, bronze, 41.3 x 26 x 31.1 (16¼ x 10¼ x 12¼), Hirshhorn Museum and Sculpture Garden, Smithsonian Institution, Gift of Joseph H. Hirshhorn, 1972

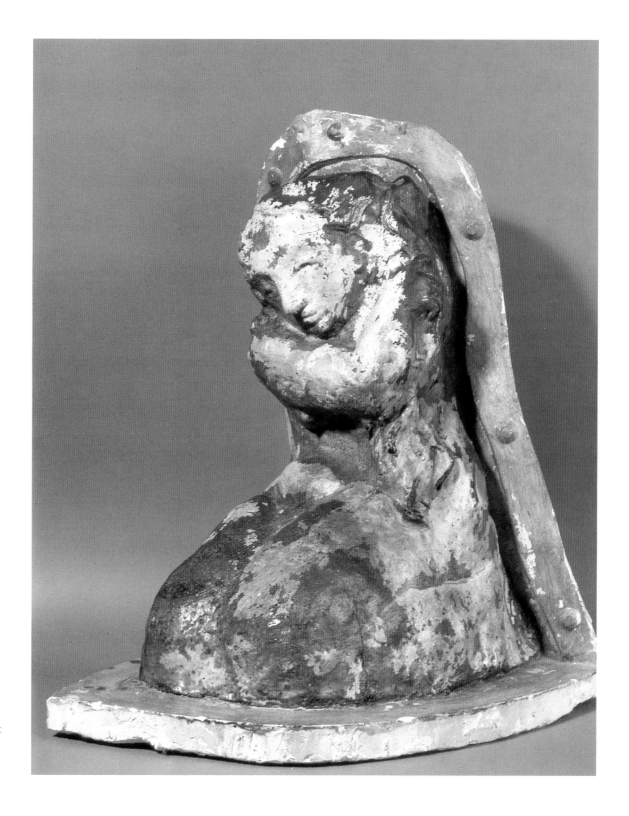

172. *Woman Combing Her Hair,* Paris, autumn 1906, ceramic, 43 x 26 x 32 (16⅞ x 10¼ x 12⅝) Mr. Georges Pellequer, Paris

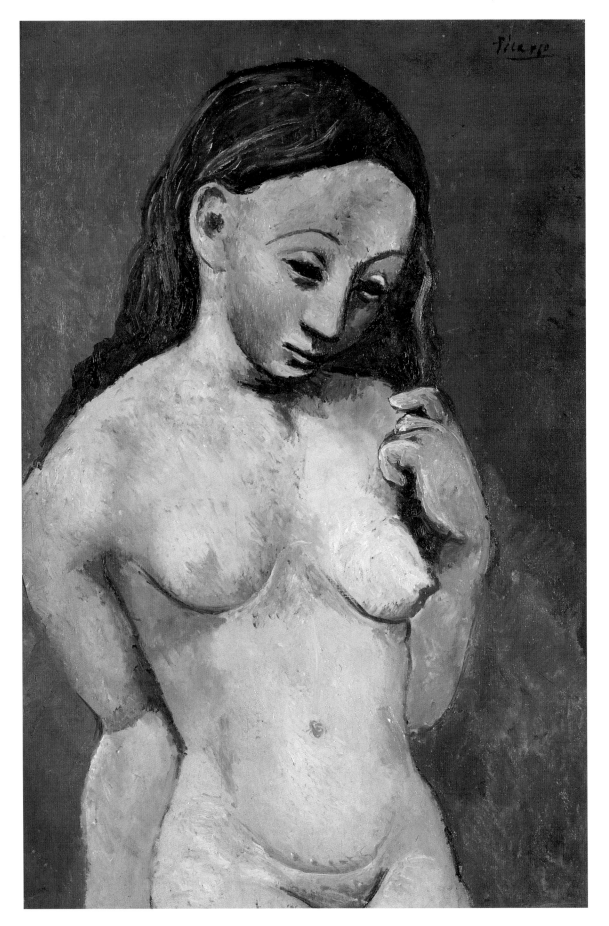

173. *Nude on Red Background*, Paris, autumn 1906, oil on canvas, 81 x 54 (31 ⅞ x 21 ¼), Musée de l'Orangerie, Paris, Jean Walter and Paul Guillaume Collection

174. *Nude Combing Her Hair*, Paris, autumn 1906, oil on canvas, 105.4 x 81.3 (41 ½ x 32), Kimbell Art Museum, Fort Worth

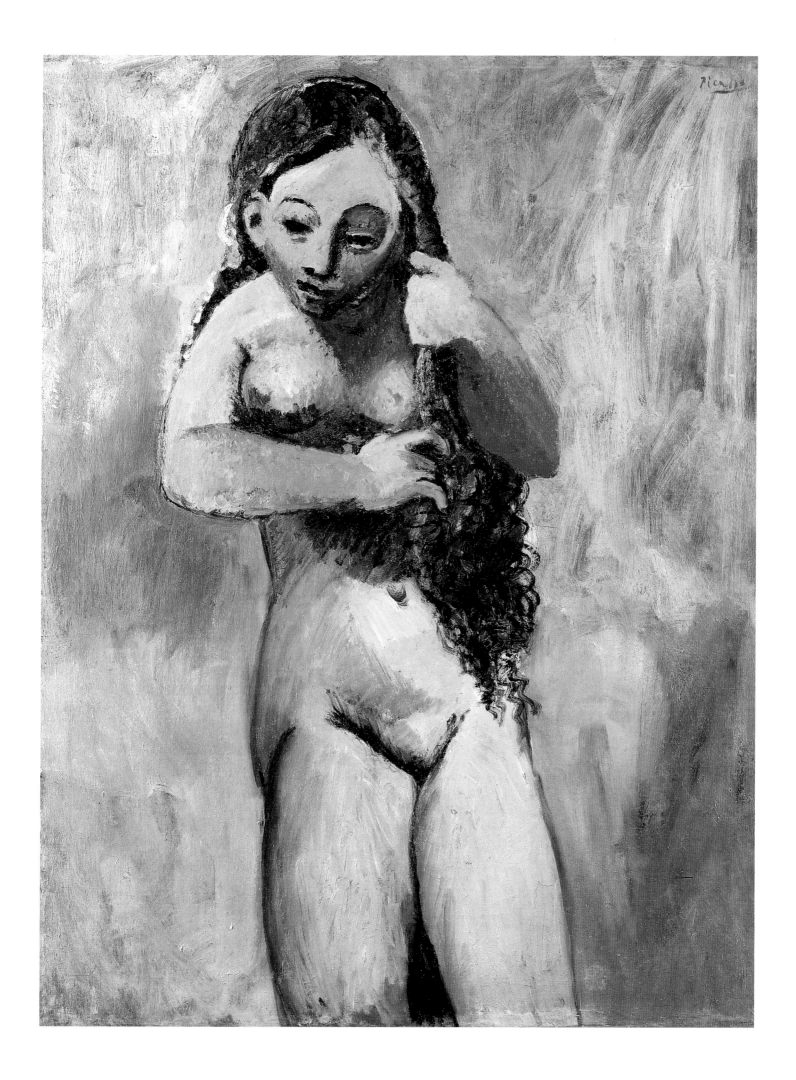

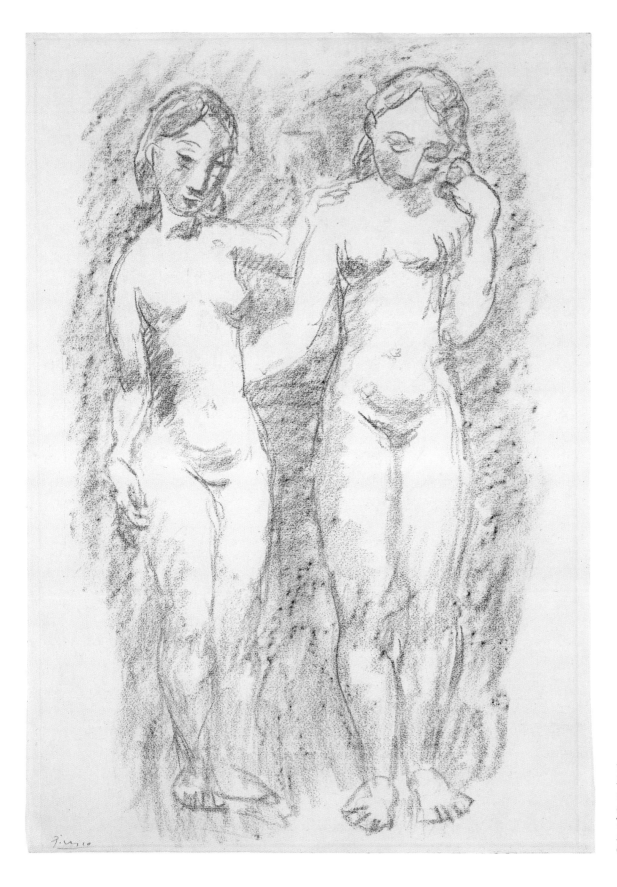

175. *Study for "Two Nudes,"* Paris, autumn 1906, charcoal on paper, 62.2 x 45.7 (24 ½ x 18), The Museum of Fine Arts, Houston, Gift of Oveta Culp Hobby

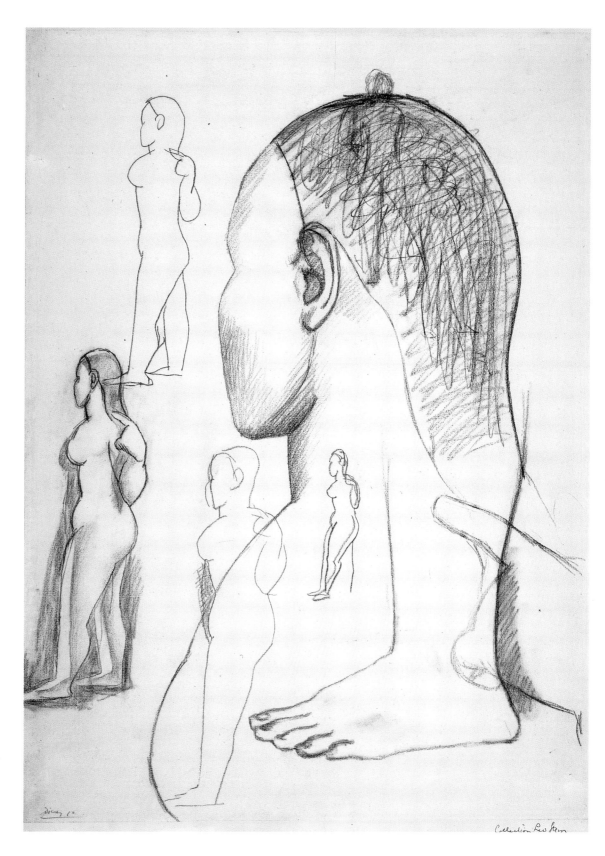

176. *Studies for "Two
Nudes,"* Paris, autumn
1906, conté crayon on pa-
per, 61 x 45 (24 x 17¾),
Museum of Fine Arts,
Boston, Arthur Tracy
Cabot Fund
Boston only

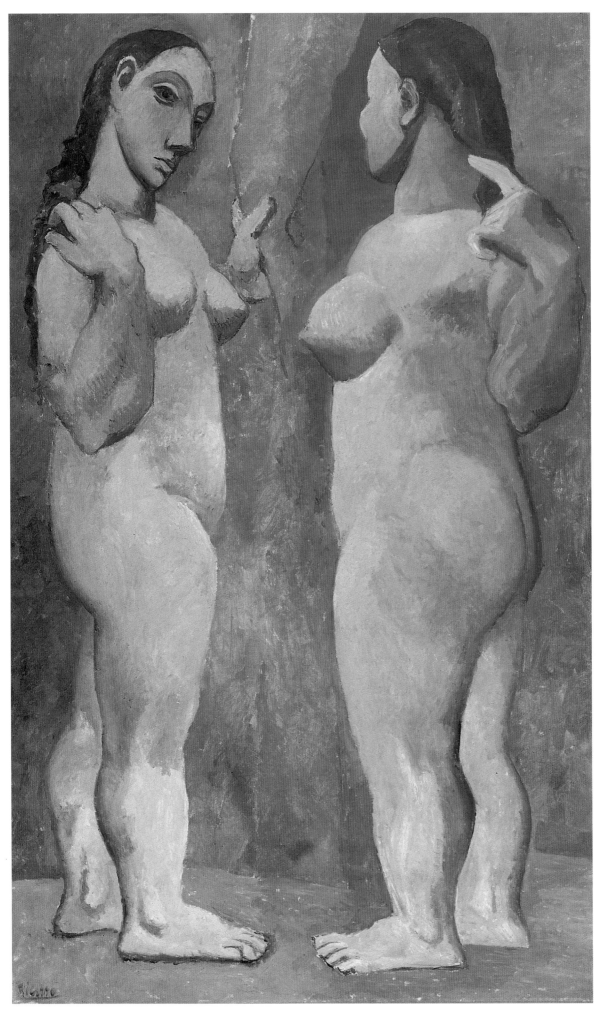

177. *Two Nudes*, Paris, autumn 1906, oil on canvas, 151.3 x 93 (59 1/2 x 36 5/8), The Museum of Modern Art, New York, Gift of G. David Thompson in honor of Alfred H. Barr Jr. *Washington only*

178. *Seated Nude*, Paris, autumn 1906, oil on canvas, 151 x 100 (59 3/8 x 39 3/8), National Gallery, Prague *Washington only*

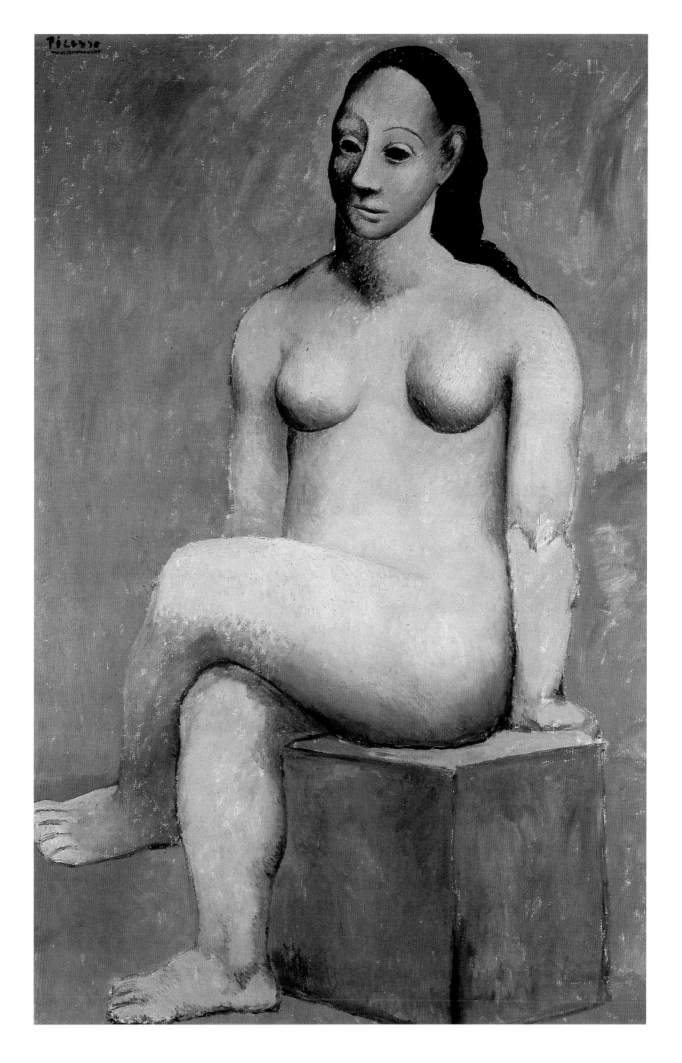

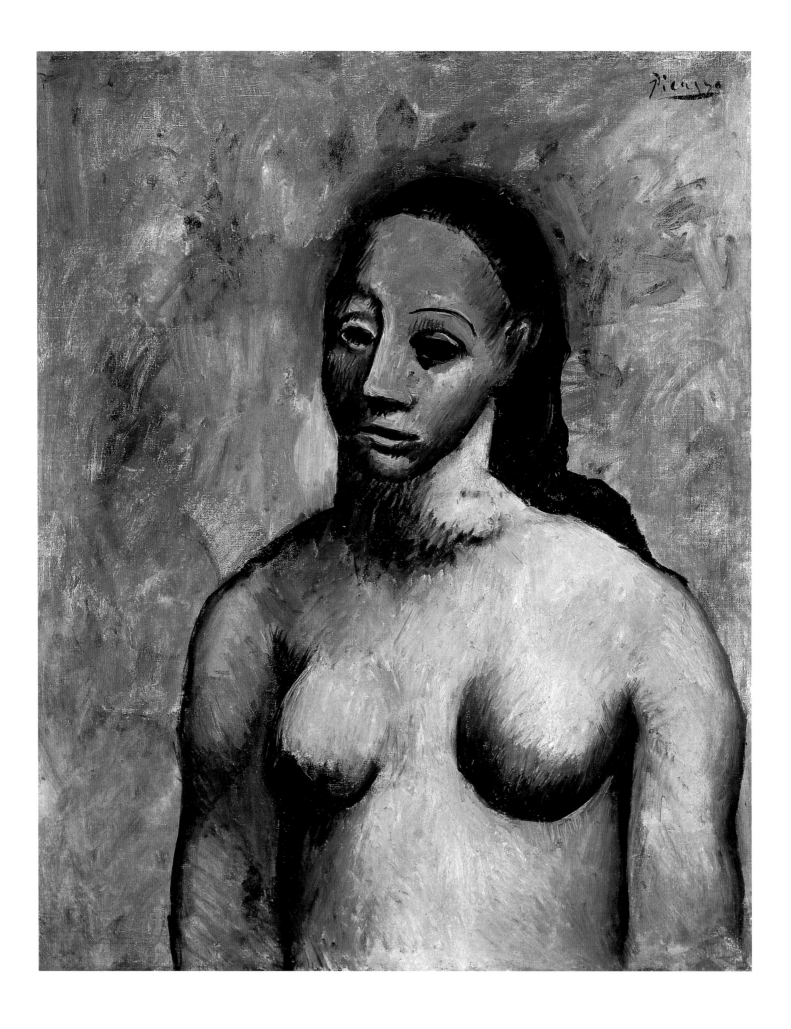

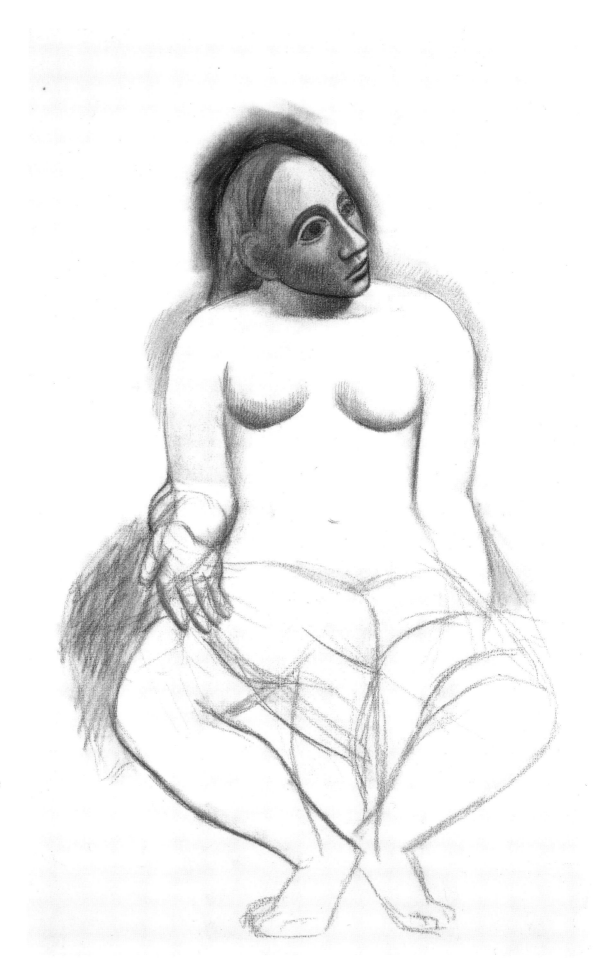

179. *Bust of a Woman,*
Paris, autumn 1906, oil
on canvas mounted on
panel, 80.2 x 64.2 (31 ½
x 25 ¼), The Art Institute
of Chicago, Florene May
Schoenborn and Samuel
A. Marx, Gift

180. *Study for "Woman
Seated and Woman
Standing,"* Paris, autumn
1906, charcoal crayon
on Ingres paper, 47.4 x
29.4 (18 ⅝ x 11 ⅝),
Staatsgalerie Stuttgart,
Graphics Collection

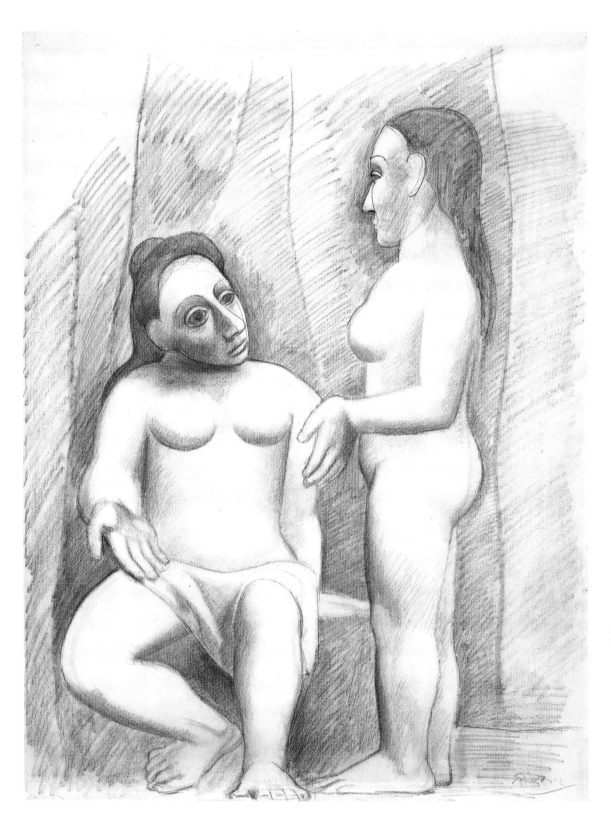

181. *Woman Seated and Woman Standing,* Paris, autumn 1906, charcoal on Ingres paper, 67 x 48 (26⅜ x 18⅞), Philadelphia Museum of Art, The Louise and Walter Arensberg Collection

182. *Self-Portrait with Palette,* Paris, autumn 1906, oil on canvas, 92 x 73 (36¼ x 28¾), Philadelphia Museum of Art, A. E. Gallatin Collection

Checklist of the Exhibition

1 *The Little Picador*
Málaga, 1892
oil on panel
24 x 19 (9 3/8 x 7 1/2)
private collection

2 *Study of a Torso, after a Plaster Cast*
La Coruña, 1893–1894
charcoal on paper
49 x 31.5 (19 1/4 x 12 3/8)
Musée Picasso, Paris

3 *Azul y Blanco*
La Coruña, 1894
pencil on paper
20.5 x 26.5 (8 1/8 x 10 3/8)
Musée Picasso, Paris
Boston only

4 *La Coruña*
La Coruña, 1894
ink and pencil on paper
21 x 26 (8 1/4 x 10 1/4)
Musée Picasso, Paris
Washington only

5 *Girl with Bare Feet*
La Coruña, early 1895
oil on canvas
75 x 50 (29 1/2 x 19 5/8)
Musée Picasso, Paris

6 *Portrait of a Bearded Man*
La Coruña, 1895
oil on canvas
57 x 42 (22 3/8 x 16 1/2)
private collection

7 *The Old Fisherman (Salmerón)*
Málaga, summer 1895
oil on canvas
83 x 62 (32 5/8 x 24 3/8)
Museu de Montserrat, Barcelona
Washington only

* *Male Nude*
Barcelona, 25 September 1895
pencil on cardboard
50.2 x 32.5 (19 3/4 x 12 3/4)
private collection
Boston only

8 *Male Nude*
Barcelona, 1896
charcoal and conté crayon on paper
60 x 47.4 (23 5/8 x 18 5/8)
Museu Picasso, Barcelona

9 *Academic Nude*
Málaga, 1895–1897
oil on canvas
82 x 61 (32 1/4 x 24)
Museu Picasso, Barcelona

10 *Seascape with Houses in Foreground*
Málaga, summer 1896
oil on canvas
23.5 x 29.4 (9 1/4 x 11 5/8)
Museu Picasso, Barcelona

11 *Self-Portrait*
Barcelona, 1896
oil on canvas
32.7 x 23.6 (12 7/8 x 9 1/4)
Museu Picasso, Barcelona

12 *Self-Portrait in a Wig*
Barcelona or Madrid, c. 1897
oil on canvas
55.8 x 46 (22 x 18 1/8)
Museu Picasso, Barcelona

* *Sketch for "Science and Charity"*
Barcelona, early 1897
oil on canvas
38 x 48 (15 x 18 7/8)
private collection
Washington only

** not illustrated*

Detail, cat. 58

13 *Portrait of a Woman*
Barcelona or Madrid, c. 1897
colored pencil and charcoal on paper
20.7 x 15.5 (8 ⅛ x 6 ⅛)
private collection, courtesy Galerie
Berès, Paris
Boston only

* *Mountains of Málaga*
Málaga, 1897
oil on canvas
60.5 x 82.5 (23 ¹³/₁₆ x 32 ½)
Estate of Georges Encil
Boston only

14 *Shed with Carriages and Barrels*
Horta de Ebro, 1898
oil on canvas
31.2 x 47.5 (12 ¼ x 18 ¾)
Museu Picasso, Barcelona

15 *La Chata*
Málaga, summer 1899
charcoal, watercolor, and gouache
on paper
31.6 x 7.6 (12 ⅜ x 3)
Museu Picasso, Barcelona

16 *Lola in a Spanish Dress*
Barcelona, 1899
oil on canvas
46.7 x 37.5 (18 ⅜ x 14 ¾)
The Cleveland Museum of Art, Gift of
Mr. and Mrs. David S. Ingalls

17 *Portrait of Josep Cardona*
Barcelona, 1899
oil on canvas
100 x 63 (39 ⅜ x 24 ¾)
Collection Valentin, São Paulo

18 *Face in the Style of El Greco*
Barcelona, 1899
oil on canvas
34.7 x 31.2 (13 ⅝ x 12 ¼)
Museu Picasso, Barcelona

19 *Portrait of Casagemas*
Barcelona, 1899
oil on canvas
55.8 x 46 (22 x 18 ⅛)
Museu Picasso, Barcelona

20 *Don José (The Artist's Father)*
Barcelona, 1899
crayon on paper
30.5 x 24.7 (12 x 9 ¾)
Museu Picasso, Barcelona

21 *Lola (The Artist's Sister)*
Barcelona, 1899–1900
charcoal and colored pencil on paper
45 x 29.5 (17 ¾ x 11 ⅝)
Museu Picasso, Barcelona

22 *Women Crossing a Plaza*
Barcelona, 1899–1900
black chalk on paper
16.4 x 23 (6 ½ x 9)
Museum of Fine Arts, Boston, Gift of
Mrs. Charles Sumner Bird
Boston only

23 *The End of the Road*
Barcelona, 1899–1900
oil washes and conté crayon on paper
47.1 x 30.8 (18 ½ x 12 ⅛)
Solomon R. Guggenheim Museum,
New York, Thannhauser Collection,
Bequest of Hilde Thannhauser, 1991
Washington only

** not illustrated*

24 *Eveli Torent*
Barcelona, 1899–1900
charcoal on paper
48.8 x 32.3 (19 ¼ x 12 ¾)
The Detroit Institute of Arts, Founders
Society Purchase, Dexter M. Ferry Jr. Fund
Boston only

25 *Joan Fonte*
Barcelona, 1899–1900
charcoal and oil-based wash on
cream paper
46.8 x 27.5 (18 ⅜ x 10 ⅞)
Fogg Art Museum, Harvard University
Art Museums, Bequest of Meta and
Paul J. Sachs
Boston only

26 *Josep Cardona*
Barcelona, 1899–1900
conté crayon and oil wash on paper
51.8 x 36.5 (20 ⅜ x 14 ⅜)
private collection, Zurich
Boston only

27 *Unidentified Man*
Barcelona, 1899–1900
conté crayon and oil wash on paper
48.5 x 32 (19 ⅛ x 12 ⅝)
private collection, Zurich
Boston only

28 *Josep Rocarol*
Barcelona, 1899–1900
charcoal and oil-based wash on
cream paper
47 x 31 (18 ½ x 12 ¼)
Fogg Art Museum, Harvard University
Art Museums, Gift of Arthur Sachs
Boston only

29 *Sabartès Seated*
Barcelona, 1899–1900
watercolor and charcoal on paper
48 x 32 (18 ⅞ x 12 ⅝)
Museu Picasso, Barcelona

30 *Portrait of Sabartès ("Poeta Decadente")*
Barcelona, 1899–1900
charcoal and color wash on paper
48 x 32 (18 ⅞ x 12 ⅝)
Museu Picasso, Barcelona

31 *Poster Design for "Dramas Criollos"*
Barcelona, 1900
charcoal and pastel on paper
57.8 x 38.1 (22 ¾ x 15)
Staatliche Museen zu Berlin,
Kupferstichkabinett
Washington only

32 *Spanish Couple Before an Inn*
Barcelona, summer 1900
pastel on paper
40 x 50 (15 ¾ x 19 ⅝)
Kawamura Memorial Museum of Art,
Sakura

33 *Bullfight*
Barcelona, summer 1900
pastel and gouache on canvas
45.8 x 65.6 (18 x 25 ⅞)
private collection

34 *Els Quatre Gats*
Barcelona, 1900
printed menu (with drawing of Romeu
by Ramon Casas on back cover)
21.8 x 32.8 (8 ½ x 12 ⅞)
Museu Picasso, Barcelona

35 *Before*
Barcelona, 1900
pencil and watercolor on paper
26.7 x 15.7 (10½ x 6⅛)
private collection, courtesy Yoshii Gallery,
New York

36 *After*
Barcelona, 1900
pencil and watercolor on paper
27 x 17.5 (10⅝ x 6⅞)
private collection, courtesy Yoshii Gallery,
New York

37 *Self-Portrait*
Barcelona, 1900
charcoal on paper
22.5 x 16.5 (8⅞ x 6½)
Museu Picasso, Barcelona

38 *Picasso and Pallarès Arriving in Paris*
Paris, autumn 1900
ink on paper
8.8 x 11.1 (3½ x 4⅜)
Museu Picasso, Barcelona

39 *Self-Portrait*
Barcelona or Paris, summer/autumn 1900
pen on paper
32 x 22 (12⅝ x 8⅝)
Museu Picasso, Barcelona

40 *Moulin de la Galette*
Paris, autumn 1900
oil on canvas
88.2 x 115.5 (34¾ x 45½)
Solomon R. Guggenheim Museum,
New York, Thannhauser Collection, Gift,
Justin K. Thannhauser, 1978

41 *The Embrace*
Paris, autumn 1900
oil on cardboard
53 x 56 (20⅞ x 22)
Pushkin State Museum of Fine Arts,
Moscow

42 *Montmartre Street Scene*
Paris, autumn 1900
oil on canvas
47.6 x 66.7 (18¾ x 26¼)
San Francisco Museum of Modern Art,
Bequest of Harriet Lane Levy

43 *Stuffed Shirts*
Paris, autumn 1900
oil on panel
13.6 x 22.5 (5⅜ x 8⅞)
Museum of Fine Arts, Boston, Gift of
Julia Appleton Bird
Boston only

44 *Man in a Spanish Cloak*
Paris, autumn 1900
oil on canvas
80.8 x 50 (31¾ x 19⅝)
Von der Heydt-Museum, Wuppertal

45 *Café Scene*
Madrid, published in *Arte Joven*,
10 March 1901
charcoal on paper
30 x 42 (11¾ x 16½)
private collection
Boston only

46 *Arte Joven Group*
Madrid, published in *Arte Joven*,
15 April 1901
charcoal on paper
23.5 x 30.5 (9¼ x 12)
private collection, Canada

47 *Two Women*
Barcelona, 1900 (or Madrid 1901)
charcoal with stumping and erasure
on paper
41.4 x 24.5 (16 ¼ x 9 ⅝)
Woodner Collections, on deposit at the
National Gallery of Art, Washington

48 *Lady in Blue*
Madrid, 1901
oil on canvas
113 x 101 (44 ½ x 39 ¾)
Museo Nacional Centro de Arte
Reina Sofía, Madrid

49 *Self-Portrait in Front of the Moulin
Rouge*
Paris, May 1901
ink and crayon on paper
18 x 11.5 (7 ⅛ x 4 ½)
private collection

50 *Self-Portrait with Jaume Andreu Bonsons*
Paris, May 1901
crayon on paper
31 x 37 (12 ¼ x 14 ½)
private collection, London

* *Two Figures Sleeping on a Sofa*
Paris (?), c. 1901
colored pencil on paper
22.9 x 32.1 (9 x 12 ⅝)
private collection
Boston only

51 *Mother and Child*
Barcelona or Paris, late spring or early
summer 1901
oil on cardboard
74.4 x 50.4 (29 ¼ x 19 ⅞)
The Saint Louis Art Museum

52 *Blue Roofs*
Paris, early summer 1901
oil on cardboard
40 x 57.5 (15 ¾ x 22 ⅝)
Ashmolean Museum, Oxford
Boston only

53 *On the Upper Deck*
Paris, early summer 1901
oil on canvas
49.2 x 64.2 (19 ⅜ x 25 ¼)
The Art Institute of Chicago, Mr. and
Mrs. L. L. Coburn Memorial Collection

54 *The Absinthe Drinker*
Paris, early summer 1901
oil on cardboard
65.5 x 51 (25 ¾ x 20 ⅛)
Mrs. Melville Wakeman Hall
Washington only

55 *Le Divan japonais*
Paris, early summer 1901
oil on cardboard mounted on panel
69.9 x 53 (27 ½ x 21)
private collection

56 *Woman in Stockings*
Paris, early summer 1901
oil on cardboard
65 x 48.3 (25 ⅝ x 19)
private collection
Boston only

* *not illustrated*

* *Woman with a Chignon* (recto) and
 Young Girl Wearing a Large Hat (verso)
 Paris, summer 1901
 oil on canvas
 75 x 51 (29 ½ x 20 1/16)
 Fogg Art Museum, Harvard University Art
 Museums, Bequest from the Collection of
 Maurice Wertheim, Class of 1906
 Boston only

57 *Portrait of Minguell*
 Paris, early summer 1901
 oil on cardboard
 52 x 32 (20 ½ x 12 5/8)
 private collection

58 *Still Life*
 Paris, early summer 1901
 oil on canvas
 60 x 80.5 (23 5/8 x 31 5/8)
 Museu Picasso, Barcelona
 Boston only

† *Portrait of Gustave Coquiot*
 Paris, 1901
 oil on canvas
 100 x 81 (39 3/8 x 31 7/8)
 Musée national d'art moderne, Centre
 Georges Pompidou, Paris, Gift of
 Mrs. Gustave Coquiot, 1933

59 *Portrait of Pere Mañach*
 Paris, early summer 1901
 oil on canvas
 105.5 x 70.2 (41 ½ x 27)
 National Gallery of Art, Washington,
 Chester Dale Collection
 Washington only

60 *Woman with a Cape (Jeanne)*
 Paris, early summer 1901
 oil on canvas
 73 x 50.2 (28 ¾ x 19 ¾)
 The Cleveland Museum of Art, Bequest of
 Leonard C. Hanna Jr.

61 *Boulevard de Clichy*
 Paris, early summer 1901
 oil on canvas
 61.5 x 46.5 (24 ¼ x 18 ¼)
 Maspro Denkoh Museum, courtesy of
 Christie's

62 *Fourteenth of July*
 Paris, July 1901
 oil on cardboard mounted on canvas
 48.3 x 62.8 (19 x 24 ¾)
 Solomon R. Guggenheim Museum,
 New York, Thannhauser Collection,
 Gift, Justin K. Thannhauser, 1978

63 *Child Holding a Dove*
 Paris, summer 1901
 oil on canvas
 73 x 54 (28 ¾ x 21 ¼)
 private collection, on loan to the National
 Gallery, London

64 *The Greedy Child*
 Paris, summer/autumn 1901
 oil on canvas
 92.8 x 68.3 (36 ½ x 26 7/8)
 National Gallery of Art, Washington,
 Chester Dale Collection
 Washington only

65 *The Absinthe Drinker*
 Paris, summer/autumn 1901
 oil on canvas
 73 x 54 (28 ¾ x 21 ¼)
 The State Hermitage Museum,
 St. Petersburg

* *not illustrated*
† *illustrated p. 145*

66 *Self-Portrait*
Paris, summer/autumn 1901
oil on cardboard
51.5 x 31.7 (20 ¼ x 12 ½)
Mrs. John Hay Whitney
Washington only

67 *Head of the Dead Casagemas*
Paris, autumn 1901
oil on panel
27 x 35 (10 ⅝ x 13 ¾)
Musée Picasso, Paris

68 *Casagemas in His Coffin*
Paris, autumn 1901
oil on cardboard
72.5 x 57.8 (28 ½ x 22 ¾)
private collection, Switzerland
Washington only

69 *Head of the Dead Casagemas*
Paris, autumn 1901
oil on cardboard
52 x 34 (20 ½ x 13 ⅜)
private collection

70 *The Burial of Casagemas (Evocation)*
Paris, autumn 1901
oil on canvas
150 x 90 (59 x 35 ⅜)
Musée d'Art Moderne de la Ville de Paris

71 *Le Tub (The Blue Room)*
Paris, autumn 1901
oil on canvas
50.4 x 61.5 (19 ⅞ x 24 ¼)
The Phillips Collection, Washington, D.C.

72 *Mother and Child by a Fountain*
Paris, autumn 1901
oil on canvas
40.6 x 32.4 (16 x 12 ¾)
The Metropolitan Museum of Art, New
York, Bequest of Scofield Thayer, 1982

73 *Seated Woman and Child*
Paris, autumn 1901
oil on canvas
112.3 x 97.5 (44 ¼ x 38 ⅜)
Fogg Art Museum, Harvard University
Art Museums, Bequest from the Collection
of Maurice Wertheim, Class of 1906
Boston only

74 *Saint-Lazare Woman by Moonlight*
Paris, autumn 1901
oil on canvas
100 x 69.2 (39 ⅜ x 27 ¼)
The Detroit Institute of Arts, Bequest of
Robert H. Tannahill

75 *Woman with a Cap*
Paris, autumn 1901
oil on canvas
41.3 x 33 (16 ¼ x 13)
Museu Picasso, Barcelona

76 *Self-Portrait*
Paris, end 1901/beginning 1902
crayon with color washes on paper
30.4 x 23.8 (12 x 9 ⅜)
National Gallery of Art, Washington,
Ailsa Mellon Bruce Collection
Washington only

77 *Self-Portrait*
Paris, end 1901
oil on canvas
81 x 60 (31 ⅞ x 23 ⅝)
Musée Picasso, Paris

78 *Two Sisters*
Barcelona, 1902
pencil on paper
61.4 x 46.4 (24 ⅛ x 18 ¼)
private collection

79 *Pere Romeu—4 Gats*
Barcelona, 1902
ink on paper
31 x 34 (12 ¼ x 13 ³/₈)
private collection, Canada

80 *Portrait of Corina Romeu*
Barcelona, 1902
oil on canvas
60 x 50 (23 ⁵/₈ x 19 ⁵/₈)
Dation Picasso, assigned to Musée d'art
moderne, Céret

81 *Mother and Child*
Barcelona, 1902
oil on canvas
40.7 x 33 (16 x 13)
Scottish National Gallery of Modern Art,
Edinburgh
Boston only

82 *Woman and Child by the Sea*
Barcelona, 1902
oil on canvas
81.5 x 60 (32 x 23 ⁵/₈)
private collection, Japan

83 *Two Women at a Bar*
Barcelona, 1902
oil on canvas
80 x 91.5 (31 ½ x 36)
Hiroshima Museum of Art

84 *Seated Woman*
Barcelona, 1902
bronze
14 x 7.6 x 7 (5 ½ x 3 x 2 ¾)
The Fine Arts Museums of San Francisco,
Memorial Gift from Dr. T. Edward and
Tullah Hanley, Bradford, Pennsylvania

85 *Crouching Woman*
Barcelona, 1902
oil on canvas
100.3 x 66 (39 ½ x 26)
Collection Art Gallery of Ontario,
Toronto, Anonymous Gift, 1963

86 *La Soupe*
Paris, winter 1902
oil on canvas
38.5 x 46 (15 ⅛ x 18 ⅛)
Collection Art Gallery of Ontario,
Toronto, Gift of Margaret Dunlap
Crang, 1983

87 *Mistletoe Seller*
Paris, winter 1902
gouache and watercolor on paper
55 x 38 (21 ⁵/₈ x 15)
private collection

88 *Simian Self-Portrait*
Paris, 1 January 1903
ink on paper
11.8 x 10.7 (4 ⁵/₈ x 4 ¼)
Museu Picasso, Barcelona

89 *Mateu and Angel de Soto, with Anita*
Barcelona, 1903
conté crayon, colored pencil, and
watercolor on paper
31 x 23.7 (12 ¼ x 9 ¼)
Museu Picasso, Barcelona

90 *Self-Portrait with Reclining Nude*
Barcelona, 1902–1903
ink and watercolor on paper
17.6 x 23.3 (6 ⅞ x 9 ⅛)
Museu Picasso, Barcelona

91 *Portrait of Sebastià Junyer Vidal*
 Barcelona, 1903
 oil on paper
 56 x 46 (22 x 18 ⅛)
 Museu Picasso, Barcelona

92 *Tragedy*
 Barcelona, 1903
 oil on panel
 105.4 x 69 (41 ½ x 27 ⅛)
 National Gallery of Art, Washington,
 Chester Dale Collection
 Washington only

93 *La Vie*
 Barcelona, 1903
 oil on canvas
 197 x 127.3 (77 ½ x 50 ⅛)
 The Cleveland Museum of Art, Gift of the
 Hanna Fund

94 *Blind Man's Meal*
 Barcelona, late summer 1903
 oil on canvas
 95.3 x 94.6 (37 ½ x 37 ¼)
 The Metropolitan Museum of Art, New
 York, Purchase, Mr. and Mrs. Ira Haupt,
 Gift, 1950

95 *Mask of a Picador with a Broken Nose*
 Barcelona, 1903
 bronze
 19.5 x 14.7 x 11.5 (7 ¾ x 5 ⅞ x 4 ½)
 Hirshhorn Museum and Sculpture
 Garden, Smithsonian Institution, Gift
 of Joseph H. Hirshhorn, 1966

96 *Practicing the Jota*
 Barcelona or Tiana, summer 1903
 watercolor, ink, and gouache on paper
 13 x 21 (5 ⅛ x 8 ¼)
 Musée Picasso, Paris
 Boston only

97 *Family at Supper*
 Barcelona or Tiana, summer 1903
 pen and ink with watercolor on paper
 32.7 x 44.5 (12 ⅞ x 17 ½)
 Albright-Knox Art Gallery, Buffalo,
 New York, Room of Contemporary
 Art Fund, 1941

98 *Picasso Painting Carlota Valdivia*
 Barcelona, 1904
 conté pencil and colored pencil on paper
 26.7 x 20.6 (10 ½ x 8 ⅛)
 private collection
 Boston only

99 *Sketch for "La Celestina"*
 Barcelona, 1904
 colored crayon and charcoal on paper
 38 x 27.3 (15 x 10 ¾)
 Mrs. Alex Lewyt

100 *La Celestina*
 Barcelona, 1904
 oil on canvas
 70 x 56 (27 ½ x 22)
 Musée Picasso, Paris

101 *Picasso and Sebastià Junyer Vidal*
 Paris, April 1904
 ink and colored pencil on paper
 five sketches, each: 22 x 16 (8 ⅝ x 6 ¼)
 Museu Picasso, Barcelona

102 *Father Santol*
 Paris, April 1904
 pen and ink on paper
 27.5 x 21.3 (10 ⅞ x 8 ⅜)
 private collection

103 *The Couple*
 Paris, summer 1904
 oil on canvas
 100 x 81 (39 ⅜ x 31 ⅞)
 private collection, Switzerland

104 *Frugal Repast*
Paris, summer 1904
etching
46.3 x 37.7 (18 ¼ x 14 ⅞)
Museum of Fine Arts, Boston, Ellen
Frances Mason Fund

105 *Frugal Repast*
Paris, summer 1904
etching (blue-green ink impression, 1 of 2)
46.3 x 37.7 (18 ¼ x 14 ⅞)
private collection, USA
Washington only

106 *Woman Ironing*
Paris, 1904
oil on canvas
116.2 x 72.7 (45 ¾ x 28 ⅝)
Solomon R. Guggenheim Museum,
New York, Thannhauser Collection,
Bequest of Hilde Thannhauser, 1991

107 *The Lovers*
Paris, August 1904
ink, watercolor, and charcoal on paper
37.2 x 26.9 (14 ⅝ x 10 ⅝)
Musée Picasso, Paris
Washington only

108 *The Poet*
Paris, 1904
pen and ink, gray wash, and watercolor
on paper
37.3 x 26.8 (14 ⅝ x 10 ½)
The Evergreen House Foundation,
Baltimore

109 *Debienne Watching Fernande Asleep*
Paris, 1904
watercolor and ink on paper
36 x 27 (14 ⅛ x 10 ⅝)
private collection

110 *not in exhibition*

111 *Portrait of Manolo*
Paris, 1904
ink and watercolor on paper
37 x 26.5 (14 ½ x 10 ⅜)
Musée Picasso, Paris
Boston only

112 *Woman in a Chemise (Madeleine)*
Paris, winter 1904–1905
oil on canvas
72.5 x 60 (28 ½ x 23 ⅝)
Tate Gallery, London, Bequeathed by
C. Frank Stoop, 1933

113 *Seated Nude (Madeleine)*
Paris, winter 1904–1905
oil on cardboard
100 x 76 (39 ⅜ x 29 ⅞)
Musée national d'art moderne, Centre
Georges Pompidou, Paris, 1954

114 *Les Pauvres*
Paris, winter 1904–1905
etching
23.6 x 18 (9 ¼ x 7 ⅛)
private collection

115 *Head of a Woman in Profile (Alice Géry,
later Derain)*
Paris, probably February 1905
drypoint
29.2 x 25 (11 ½ x 9 ⅞)
Museum of Fine Arts, Boston, Bequest of
Lydia Tunnard, Gift of Carolyn Rowland,
Lee M. Friedman Fund

116 *Bust of a Woman (Alice Géry, later
Derain)*
Paris, 1905
bronze
28 x 27 x 14 (11 x 10 ⅝ x 5 ½)
Selma W. Black Collection
Boston only

117 *Sainte-Roulette*
Paris, September/October 1904
gouache on cardboard
120.5 x 87 (47 $\frac{3}{8}$ x 34 $\frac{1}{4}$)
private collection

118 *Apollinaire as an Academician*
Paris, 1905
pen and ink and wash on paper
22 x 12 (8 $\frac{5}{8}$ x 4 $\frac{3}{4}$)
Musée Picasso, Paris
Washington only

119 *Sheet of Caricatures*
Paris, 1905
pencil and ink on paper
25.5 x 32.7 (10 x 12 $\frac{7}{8}$)
Musée Picasso, Paris
Washington only

120 *The Saltimbanque*
Paris, early 1905
gouache and ink on cardboard
62 x 47 (24 $\frac{3}{8}$ x 18 $\frac{1}{2}$)
private collection, courtesy Galerie
Beyeler, Basel

121 *Circus Family*
Paris, early 1905
watercolor, pen, and india ink
on cardboard
24.1 x 30.5 (9 $\frac{1}{2}$ x 12)
The Baltimore Museum of Art, The Cone
Collection, formed by Dr. Claribel Cone
and Miss Etta Cone of Baltimore

122 *Harlequin's Family with an Ape*
Paris, 1905
gouache, watercolor, pastel, and india ink
on cardboard
104 x 75 (41 x 29 $\frac{1}{2}$)
Göteborg Museum of Art

123 *Harlequin's Family*
Paris, 1905
gouache and ink on cardboard
28.9 x 21.6 (11 $\frac{3}{8}$ x 8 $\frac{1}{2}$)
The Joan Whitney Payson Collection
at the Portland Museum of Art, Maine,
lent by John Whitney and Joanne
D'Elia Payson
Boston only

124 *Two Saltimbanques*
Paris, 1905
drypoint
12.1 x 9.1 (4 $\frac{3}{4}$ x 3 $\frac{1}{2}$)
Museum of Fine Arts, Boston, Gift of
Mrs. George R. Rowland Sr. in honor of
Miss Eleanor Sayre

125 *not in exhibition*

126 *Boy with a Dog*
Paris, 1905
gouache and ink on cardboard
57 x 41 (22 $\frac{3}{8}$ x 16 $\frac{1}{8}$)
The State Hermitage Museum,
St. Petersburg

127 *Hurdy-Gurdy Man and Young Harlequin*
Paris, 1905
gouache on cardboard
100.5 x 70.5 (40 x 27 $\frac{3}{4}$)
Kunsthaus Zurich

128 *Seated Saltimbanque with Boy*
Paris, 1905
watercolor, pastel, and charcoal on paper
59 x 47.3 (23 $\frac{1}{4}$ x 18 $\frac{5}{8}$)
The Baltimore Museum of Art, The Cone
Collection, formed by Dr. Claribel Cone
and Miss Etta Cone of Baltimore
Washington only

129 *Head of a Jester*
Paris, spring 1905
bronze
40 x 35.9 x 21 (15 ¾ x 14 ⅛ x 8 ¼)
Philadelphia Museum of Art, Bequest of
Lisa Norris Elkins

130 *At the Circus*
Paris, 1905
drypoint
22 x 14 (8 ⅝ x 5 ½)
Museum of Fine Arts, Boston, Bequest of
W. G. Russell Allen

131 *The Jester*
Paris, 1905
ink on paper
25.2 x 32.9 (9 ⅞ x 12 ⅞)
National Gallery of Art, Washington,
Ailsa Mellon Bruce Fund
Washington only

132 *Salomé*
Paris, 1905
drypoint
40 x 38 (15 ¾ x 15)
Dr. and Mrs. Martin L. Gecht, Chicago

133 *La Danse barbare*
Paris, 1905
drypoint
40 x 34.8 (15 ¾ x 13 ¾)
Dr. and Mrs. Martin L. Gecht, Chicago

134 *Three Dutch Girls*
Schoorldam, June–July 1905
oil on cardboard
77 x 67 (30 ¼ x 26 ⅜)
Musée national d'art moderne, Centre
Georges Pompidou, Paris, Gift of Mr. and
Mrs. André Lefevre, 1952

135 *Portrait of Benedetta Canals*
Paris, late summer 1905
oil on canvas
88 x 68 (34 ⅝ x 26 ¾)
Museu Picasso, Barcelona
Washington only

136 *Saltimbanque Family*
Paris, summer 1905
gouache and charcoal on cardboard
51.2 x 61.2 (20 ⅛ x 24 ⅛)
Pushkin State Museum of Fine Arts,
Moscow

137 *Family of Saltimbanques*
Paris, 1905
oil on canvas
212.8 x 229.6 (83 ¾ x 90 ⅜)
National Gallery of Art, Washington,
Chester Dale Collection
Washington only

138 *Boy with a Pipe*
Paris, autumn 1905
oil on canvas
100 x 81.3 (39 ⅜ x 32)
Mrs. John Hay Whitney
Washington only

139 *not in exhibition*

140 *Woman with a Fan*
Paris, autumn 1905
oil on canvas
100.3 x 81 (39 ½ x 31 ⅞)
National Gallery of Art, Washington,
Gift of the W. Averell Harriman
Foundation in memory of Marie N.
Harriman

* *Study for "The Death of Harlequin"*
Paris, 1905
pen and watercolor on paper
10.5 x 17.5 (4⅛ x 6⅞)
National Gallery of Art, Washington,
Collection of Mr. and Mrs. Paul Mellon

141 *The Death of Harlequin*
Paris, end 1905/beginning 1906
gouache on cardboard
68.5 x 96 (27 x 37¾)
National Gallery of Art, Washington,
Collection of Mr. and Mrs. Paul Mellon

142 *The Watering Place*
Paris, spring 1906
gouache on cardboard
38.1 x 57.8 (15 x 22¾)
The Metropolitan Museum of Art, New
York, Bequest of Scofield Thayer, 1982
Boston only

143 *The Watering Place*
Paris, spring 1906
drypoint
12.2 x 18.8 (4¾ x 7⅜)
private collection

144 *Ephebe*
Paris, spring 1906
gouache on cardboard
68 x 52 (26¾ x 20½)
The State Hermitage Museum,
St. Petersburg

145 *not in exhibition*

146 *Study of a Nude Woman*
Paris or Gósol, spring–summer 1906
gray brown ink on brown paper
38.1 x 29.9 (15 x 11¾)
Museum of Fine Arts, Boston, J. H. and
E. A. Payne Fund
Boston only

147 *La Coiffure*
Paris, spring 1906 (finished early autumn)
oil on canvas
174.9 x 99.7 (68⅞ x 39¼)
The Metropolitan Museum of Art,
New York, Catharine Lorillard Wolfe
Collection, Wolfe Fund; acquired
from The Museum of Modern Art,
Anonymous Gift
Boston only

148 *Gósol Landscape*
Gósol, summer 1906
oil on canvas
69.8 x 99 (27½ x 39)
private collection

149 *Houses at Gósol*
Gósol, summer 1906
oil on canvas
54 x 38.5 (21¼ x 15⅛)
Statens Museum for Kunst, Copenhagen
Boston only

150 *Two Brothers*
Gósol, summer 1906
oil on canvas
142 x 97 (55⅞ x 38⅛)
Öffentliche Kunstsammlung Basel,
Kunstmuseum
Washington only

* *not illustrated*

151 *Two Youths*
Gósol, summer 1906
oil on canvas
151.5 x 93.7 (59 ⅝ x 36 ⅞)
National Gallery of Art, Washington,
Chester Dale Collection
Washington only

152 *Girl with a Pitcher*
Gósol, summer 1906
oil on canvas
100 x 81 (39 ⅜ x 32)
The Art Institute of Chicago, Gift of
Mary and Leigh B. Block

153 *Nude with Clasped Hands (Fernande)*
Gósol, summer 1906
gouache on canvas
95.8 x 75.5 (37 ¾ x 29 ¾)
Collection Art Gallery of Ontario,
Toronto, Gift of Sam and Ayala Zacks,
1970

154 *La Toilette*
Gósol, summer 1906
oil on canvas
151.1 x 99.1 (59 ½ x 39)
Albright-Knox Art Gallery, Buffalo,
New York, Fellows for Life Fund, 1926

155 *The Harem*
Gósol, summer 1906
oil on canvas
154.3 x 110 (60 ¾ x 43 ¼)
The Cleveland Museum of Art, Bequest of
Leonard C. Hanna Jr.

156 *Three Nudes*
Gósol, summer 1906
gouache on paper
63 x 48.3 (24 ¾ x 19)
The Alex Hillman Family Foundation

157 *The Lieutenant*
Gósol, summer 1906
watercolor on paper
21 x 13 (8 ¼ x 5 ⅛)
private collection

158 *Peasant Woman with Shawl*
Gósol, summer 1906
charcoal on paper
62 x 40.4 (24 ⅜ x 15 ⅞)
The Art Institute of Chicago, through
prior bequest of Janis H. Palmer
Washington only

159 *Head of a Woman (Fernande)*
Gósol, summer 1906
gouache on paper
62 x 47 (24 ⅜ x 18 ½)
Susan and Lewis Manilow
Washington only

160 *Reclining Nude (Fernande)*
Gósol, summer 1906
gouache on paper
47.3 x 61.3 (18 ⅝ x 24 ⅛)
The Cleveland Museum of Art, Gift of
Mr. and Mrs. Michael Straight

161 *Woman with Loaves*
Gósol and Paris, late summer 1906
oil on canvas
100 x 69.8 (39 ⅜ x 27 ½)
Philadelphia Museum of Art, Gift of
Charles E. Ingersoll

162 *Still Life*
Gósol, summer 1906
gouache on cardboard
70.5 x 54 (27 ¾ x 21 ¼)
Solomon R. Guggenheim Museum,
New York, Thannhauser Collection,
Gift, Justin K. Thannhauser, 1978
Boston only

163 *Bust of a Woman with Raised Hand*
Gósol or Paris, summer 1906
woodblock print, oil on paper
21.9 x 13.8 (8 ⅝ x 5 ⅜)
Museum of Fine Arts, Boston, Gift of
Lois and Michael Torf
Boston only

164 *Portrait of Josep Fontdevila*
Gósol, summer 1906
gouache and watercolor on paper
49.7 x 35 (19 ½ x 13 ¾)
private collection

165 *Head of a Peasant (Josep Fontdevila)*
Gósol, summer 1906
oil on canvas
40.3 x 45.1 (15 ⅞ x 17 ¾)
The Metropolitan Museum of Art,
New York, Gift of Florene M.
Schoenborn, 1992

166 *Bust of Josep Fontdevila*
Paris, autumn 1906
bronze
16.8 x 22.9 x 11.7 (6 ⅝ x 9 x 4 ⅝)
Hirshhorn Museum and Sculpture
Garden, Smithsonian Institution,
Gift of Joseph H. Hirshhorn, 1966

167 *Head of Fernande*
Paris, before May 1906
bronze
36.1 x 23.5 x 23.1 (14 ¼ x 9 ¼ x 9 ⅛)
Hirshhorn Museum and Sculpture
Garden, Smithsonian Institution,
Gift of Joseph H. Hirshhorn, 1966

168 *not in exhibition*

169 *Woman with Her Head Bent*
Paris, early autumn 1906
oil on canvas
51 x 39.5 (20 ⅛ x 15 ½)
Staatsgalerie Stuttgart
Boston only

170 *Woman Combing Her Hair*
Paris, autumn 1906
pencil and charcoal on paper
55.8 x 40.7 (22 x 16)
The Robert and Lisa Sainsbury Collection,
University of East Anglia

171 *Woman Combing Her Hair*
Paris, autumn 1906
bronze
41.3 x 26 x 31.1 (16 ¼ x 10 ¼ x 12 ¼)
Hirshhorn Museum and Sculpture
Garden, Smithsonian Institution,
Gift of Joseph H. Hirshhorn, 1972

172 *Woman Combing Her Hair*
Paris, autumn 1906
ceramic
43 x 26 x 32 (16 ⅞ x 10 ¼ x 12 ⅝)
Mr. Georges Pellequer, Paris

173 *Nude on Red Background*
Paris, autumn 1906
oil on canvas
81 x 54 (31 ⅞ x 21 ¼)
Musée de l'Orangerie, Paris,
Jean Walter and Paul Guillaume
Collection

174 *Nude Combing Her Hair*
Paris, autumn 1906
oil on canvas
105.4 x 81.3 (41 ½ x 32)
Kimbell Art Museum, Fort Worth

175 *Study for "Two Nudes"*
Paris, autumn 1906
charcoal on paper
62.2 x 45.7 (24 ½ x 18)
The Museum of Fine Arts, Houston,
Gift of Oveta Culp Hobby

176 *Studies for "Two Nudes"*
Paris, autumn 1906
conté crayon on paper
61 x 45 (24 x 17 ¾)
Museum of Fine Arts, Boston,
Arthur Tracy Cabot Fund
Boston only

177 *Two Nudes*
Paris, autumn 1906
oil on canvas
151.3 x 93 (59 ½ x 36 ⅝)
The Museum of Modern Art, New York,
Gift of G. David Thompson in honor of
Alfred H. Barr Jr.
Washington only

178 *Seated Nude*
Paris, autumn 1906
oil on canvas
151 x 100 (59 ⅜ x 39 ⅜)
National Gallery, Prague
Washington only

179 *Bust of a Woman*
Paris, autumn 1906
oil on canvas mounted on panel
80.2 x 64.2 (31 ½ x 25 ¼)
The Art Institute of Chicago, Florene May
Schoenborn and Samuel A. Marx, Gift

180 *Study for "Woman Seated and
Woman Standing"*
Paris, autumn 1906
charcoal crayon on Ingres paper
47.4 x 29.4 (18 ⅝ x 11 ⅝)
Staatsgalerie Stuttgart, Graphics
Collection

181 *Woman Seated and Woman Standing*
Paris, autumn 1906
charcoal on Ingres paper
67 x 48 (26 ⅜ x 18 ⅞)
Philadelphia Museum of Art, The Louise
and Walter Arensberg Collection

182 *Self-Portrait with Palette*
Paris, autumn 1906
oil on canvas
92 x 73 (36 ¼ x 28 ¾)
Philadelphia Museum of Art,
A. E. Gallatin Collection

Frequently Cited Titles

Ashton 1972
Ashton, Dore. *Picasso on Art: A Selection of Views.* New York, 1972.

Exh. cat. Barcelona 1992
M. Teresa Ocaña and Hans Christof von Tavel, eds. *Picasso 1905–1906: From the Rose Period to the Ochres of Gósol.* Exh. cat., Museu Picasso. Barcelona, 1992.

Blunt and Pool 1962
Blunt, Anthony, and Phoebe Pool. *Picasso: The Formative Years.* London, 1962.

Brown 1996
Brown, Jonathan, ed. *Picasso and the Spanish Tradition.* New Haven and London, 1996.

Exh. cat., Cambridge, MA, 1981
Tinterow, Gary. *Master Drawings by Picasso.* Exh. cat., Fogg Art Museum. Cambridge, MA, 1981.

Daix and Boudaille 1967
Daix, Pierre, and Georges Boudaille. *Picasso: The Blue and Rose Periods.* Trans. Phoebe Pool. Greenwich, CT, 1967.

Kaplan 1992
Kaplan, Temma. *Red City, Blue Period: Social Movements in Picasso's Barcelona.* Berkeley, 1992.

Leighten 1989
Leighten, Patricia Dee. *Re-Ordering the Universe: Picasso and Anarchism, 1897–1914.* Princeton, 1989.

McCully 1981
McCully, Marilyn. *A Picasso Anthology.* Princeton, 1981.

Exh. cat. New York 1996
William Rubin, ed. *Picasso and Portraiture.* Exh. cat., The Museum of Modern Art. New York, 1996.

Olivier 1965
Olivier, Fernande. *Picasso and His Friends.* Trans. Jane Miller. New York, 1965. [originally published as *Picasso et ses amis*, Paris, 1933]

Olivier 1988
Olivier, Fernande. *Souvenirs intimes.* Ed. Gilbert Krill. Paris, 1988.

Palau 1985
Palau i Fabre, Josep. *Picasso: Life and Work of the Early Years 1881–1907.* Trans. Kenneth Lyons. Oxford, 1985.

Reff 1971
Reff, Theodore. "Harlequins, Saltimbanques, Clowns, and Fools." *Artforum* 10 (October 1971), 30–43.

Reff 1980
Reff, Theodore. "Themes of Love and Death in Picasso's Early Work." In Roland Penrose and John Golding, eds. *Picasso in Retrospect.* New York, 1980.

Richardson 1991
Richardson, John, with Marilyn McCully. *A Life of Picasso.* Vol. 1, *1881–1906.* New York, 1991.

Rosenthal 1980
Rosenthal, Mark. "The Nietzschean Character of Picasso's Early Development." *Arts Magazine* (September 1980), 87–91.

Rubin 1994

Rubin, William. "*Les Demoiselles d'Avignon*." *Studies in Modern Art* 3, Museum of Modern Art. New York, 199.

Sabartès 1949

Sabartès, Jaime. *Picasso: An Intimate Portrait*. London, 1949. [originally published as *Picasso: Portraits et souvenirs*, Paris, 1946]

Salmon 1955

Salmon, André. *Souvenirs sans fin: Première époque (1903–1908)*. Paris, 1955.

Salmon 1956

Salmon, André. *Souvenirs sans fin: Deuxième époque (1908–1920)*. Paris, 1956.

Salmon 1961

Salmon, André. *Souvenirs sans fin: Troisième époque (1920–1940)*. Paris, 1961.

Stein 1961

Stein, Gertrude. *The Autobiography of Alice B. Toklas*. New York, 1961.

Steinberg 1988

Steinberg, Leo. "The Philosophical Brothel." *October* 44 (Spring 1988), 7–74.

Vallentin 1957

Vallentin, Antonina. *Pablo Picasso*. Paris, 1957.

Index of Illustrated Works by Picasso

Photographic Credits

Jack Abraham: Cate figs. 5, 7, 8, 10, and 23; *Jörg P. Anders*: cat. 31; *M. Bellot*: cat. 96; *Ricardo Blanc*: cat. 95; *Michael Bodycomb*: cat. 174; *Ken Brown*: cat. 46; *Martin Bühler*: cat. 150; *J. Calafell/R. Feliu*: cats. 14, 29; *Carlo Catenazzi*: cat. 154; *Gasull Fotografia*: cat. 101; *Béatrice Hatala*: Staller fig. 12; *Luiz Hossaka*: Chronology fig. 40; *Kate Keller*: cat. 66; *Madrissa Investment Trust Inc., Monaco*: Chronology fig. 38; *Bernard C. Meyers*: cat. 123; *MNAC Photographic Service* (J. Calveras/J. Sagristà): Lubar fig. 6; *Ramon Muro*: cats. 9, 91; *Hans Peterson*: cat. 149; *Photo Arxiu Fotogràfic de Museus Ajuntament de Barcelona*: cats. 8-12, 14, 15, 18-21, 29, 30, 34, 37-39, 58, 75, 88-91, 101, 135; Chronology figs. 4, 5, 8, 9, 10 (Jordi Calafell), 11, 19; Staller figs. 1, 6-10, 11 (Gasull Fotografia), 13, 16; Lubar figs. 1-3, 10; Cate fig. 4; Weiss fig. 2; *Quesada/Burke*: cat. 54; *Réunion des musées nationaux, Paris, Arnaudet*: cats. 2-5, 67, 77, 96, 100, 107, 111, 118, 119, 173; Chronology figs. 2, 3, 7, 28, 43-45; Staller figs. 14, 15; Cate figs. 1, 2 (Béatrice Hatala), 9; Boardingham figs. 1, 3 (Béatrice Hatala); Read fig. 2; Rosenblum figs. 2, 13, 16; Werth fig. 8; Rosenthal fig. 5; Hoenigswald fig. 14; *Rheinisches Bildarchiv, Cologne*: Rosenblum fig. 17; *Lynn Rosenthal*: cat. 129; *Lee Stalsworth*: cats. 167, 168; *Jim Strong, Inc.*: cat. 134; *Malcolm Varon, NYC*: cat. 139; *Ellen Page Wilson*: cat. 109.